BAY AREA FIGURATIVE ART

1950-1965

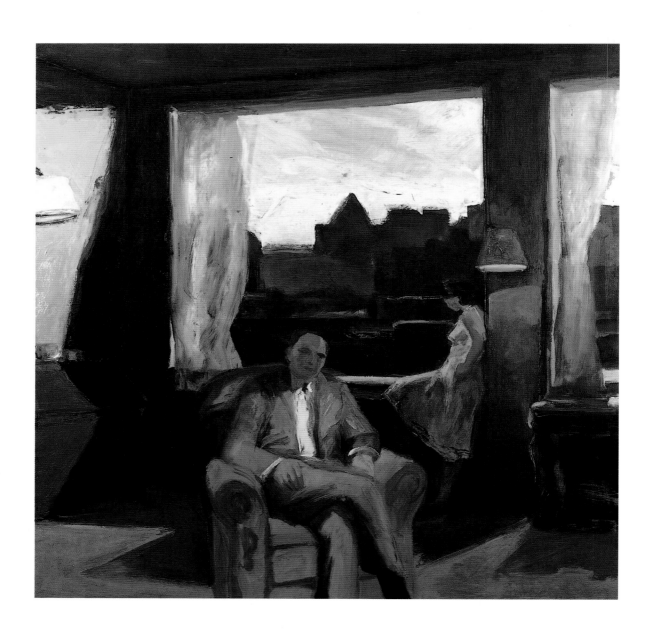

BAY AREA FIGURATIVE ART

1950-1965

CAROLINE A. JONES

SAN FRANCISCO MUSEUM OF MODERN ART

UNIVERSITY OF CALIFORNIA PRESS

BERKELEY · LOS ANGELES · OXFORD

This book serves as a catalogue for an exhibition organized
by the San Francisco Museum of Modern Art.

San Francisco Museum of Modern Art
14 December 1989–4 February 1990

Hirshhorn Museum and Sculpture Garden
Smithsonian Institution
13 June–9 September 1990

Pennsylvania Academy of the Fine Arts
5 October–30 December 1990

University of California Press
Berkeley and Los Angeles, California

University of California Press, Ltd.
Oxford, England

Library of Congress Catalog Card Number: 89-40571
ISBN 0-520-06841-6 (alk. paper)
ISBN 0-520-06842-4 (pbk. : alk. paper)

Printed in Japan
1 2 3 4 5 6 7 8 9

The exhibition and catalogue were made possible through the
generous support of The Henry Luce Foundation, Inc.,
The Roberts Foundation, the Modern Art Council of the
San Francisco Museum of Modern Art, and
the National Endowment for the Arts, a Federal agency.

Cover: David Park, *Couple*, 1959. Oil on canvas, 25 1/2 × 47 in.
(64.8 × 119.4 cm).
Flagg Family Foundation, Monterey, California.

Frontispiece: Elmer Bischoff, *Interior with Two Figures*, 1968.
Oil on canvas, 80 × 80 in. (203.2 × 203.2 cm).
The Lobell Family Collection, New York.

CONTENTS

LIST OF LENDERS

Anonymous

Mr. and Mrs. Harry W. Anderson

Archer M. Huntington Art Gallery, The University of Texas at Austin

The Michael and Dorothy Blankfort Collection

Joan Brown

Theophilus Brown

Mr. and Mrs. Charles Campbell

The Chrysler Museum, Norfolk, Virginia

Harry Cohn

Flagg Family Foundation

The Morgan Flagg Family Collection

Hirshhorn Museum and Sculpture Garden, Smithsonian Institution, Washington, D.C.

Hayward King

Mr. and Mrs. David Lloyd Kreeger

La Jolla Museum of Contemporary Art, California

The Lobell Family Collection

Los Angeles County Museum of Art

The Lowe Art Museum, The University of Miami

Bruce McGaw

Daniel and Virginia Mardesich

Byron R. Meyer

Mr. and Mrs. Roy Moore

Adolph Mueller

The Museum of Modern Art, New York

National Museum of American Art, Smithsonian Institution, Washington, D.C.

The Nelson-Atkins Museum of Art, Kansas City, Missouri

Manuel Neri; John Berggruen Gallery, San Francisco; Charles Cowles Gallery, New York

New Orleans Museum of Art

Newport Harbor Art Museum, Newport Beach, California

The Oakland Museum, California

Pennsylvania Academy of the Fine Arts, Philadelphia

Phoenix Art Museum

Private collection, courtesy Salander-O'Reilly Galleries, New York

The Regis Collection, Minneapolis, Minnesota

Mr. and Mrs. Lawrence Rubin

City and County of San Francisco, courtesy San Francisco Arts Commission

San Francisco Museum of Modern Art

Santa Barbara Museum of Art, California

Norma H. Schlesinger

Stanford University Museum of Art, California

William and Penny True

Thomas W. Weisel

Whitney Museum of American Art, New York

Yale University Art Gallery, New Haven, Connecticut

For two decades, from the mid-1940s to the mid-1960s, a particularly vital situation for painting existed in the San Francisco Bay Area. The region was the center for a group of Abstract Expressionists that looks now to be sufficiently independent from the New York School painters to be credited with having forged a distinct variant on what was the first American style to have international importance. The Bay Area Figurative movement, which grew out of and was in reaction to both West Coast and East Coast varieties of Abstract Expressionism, was a local phenomenon and yet was responsive to the most topical national tendencies. Many thoughtful younger artists on both coasts, distressed by the rapid degeneration of Abstract Expressionism in the 1950s, sought to infuse fresh meaning into the style by introducing recognizable imagery. But it was only in San Francisco that this enterprise took on the characteristics of a coherent movement. *Bay Area Figurative Art, 1950–1965* aspires to deal thoroughly and seriously with this important moment in the development of the visual arts in California, particularly placing it in the broader context of American art at the time, and to recognize the high achievements of the artists who were involved in making this development an important contribution to the history of modern American art.

The San Francisco Museum of Modern Art has, in the course of its fifty-four-year history, balanced a lively interest in the leading artists of our region with its role of presenting a sophisticated program of national and international art, both historically modernist and contemporary. *Bay Area Figurative Art, 1950–1965* is an exhibition that addresses both the local and the broader aspects of our mission. It is especially gratifying to the Museum to mount a project celebrating and interpreting the achievements of a community of artists that brought very significant cultural distinction to themselves and to our region. We are proud, too, of the active and supportive part that the Museum has played in this history by exhibiting and collecting the work of many of the artists who participated in the Bay Area Figurative movement. We greatly appreciate the cooperation of the members of the Bay Area art community who were so generous with their recollections as we researched the period, and, most particularly, we thank the artists who are represented in the exhibition for their cooperation and participation.

It is now more than thirty years since the exhibition *Contemporary Bay Area Figurative Painting* organized by Paul Mills for the Oakland Art Museum in 1957 first gave a name and a shape to this remarkable artistic movement. We acknowledge with respect Mr. Mills's pioneering work. Our exhibition, *Bay Area Figurative Art, 1950–1965*, was conceived by Henry T. Hopkins, director of the San Francisco Museum of Modern Art from 1973 to 1986, and it was the most important of several project ideas I happily inherited from him. In 1987, Graham W. J. Beal, Elise S. Haas Chief Curator here from 1984 until the spring of 1989, assumed responsibility for finding a curator for the exhibition who could combine an informed enthusiasm for the art with a rigorous and balanced scholarly approach to the history of the period. I am beholden to him for his dedicated attention to every aspect of the project's development and for his advocacy of Caroline A. Jones as the right individual to organize the exhibition. She has more than fulfilled our hopes to realize a definitive assessment of the Bay Area Figurative movement and it is a pleasure to voice to her the Museum's most sincere appreciation. Express thanks are due, too, to Janet Bishop and Karin Victoria, respectively Curatorial Assistant for the exhibition and Publications Coordinator, to Librarian Eugenie Candau, who prepared this publication's bibliography, and to newly appointed Deputy Director for Curatorial Affairs and Chief Conservator Inge-Lise Eckmann.

The Henry Luce Foundation, Inc., which has done so much through its Luce Fund for Scholarship in American Art program to promote the study of American art, has very generously supported the exhibition and the publication of the catalogue. We are very grateful to the Modern Art Council of the San Francisco Museum of Modern Art, The Roberts Foundation, and the National Endowment for the Arts for their major grants to this exhibition project.

The exhibition will travel to two very appropriate venues after its San Francisco showing: the Pennsylvania Academy of the Fine Arts, Philadelphia's famous museum and school that has, since the time of Thomas Eakins's presence on its faculty, represented one of the strongest and most enduring commitments

to serious modern figurative art in America; and the Hirshhorn Museum and Sculpture Garden, Smithsonian Institution, in Washington, D.C., whose founder, New Yorker Joseph Hirshhorn, was one of the great collectors of Bay Area art. I thank my colleagues Linda Bantel, director of the Pennsylvania Academy, and James Demetrion, director of the Hirshhorn Museum, for their interest in presenting this exhibition at their institutions.

We have enjoyed working with our copublisher, the University of California Press, where our collaboration has been with James H. Clark, Director, and Marilyn Schwartz, Managing Editor. The staff of Wilsted & Taylor Publishing Services provided editorial and production supervision. The manuscript was edited by Fronia Simpson, and we acknowledge her contribution with special thanks. The book was designed by Catherine Mills, the Museum's excellent Director of Graphic Design, and the publication project enjoyed the general supervision of Barbara L. Phillips, Deputy Director for Administration and head of the Museum's publications program. Professors Albert Elsen and Wanda Corn of Stanford University read the catalogue manuscript and made valued suggestions. For this project and for the study of American art in general, the Archives of American Art is a rich resource; the access we have enjoyed to the West Coast Regional Center of the Archives has been of particular importance.

We are deeply obliged to the lenders to the exhibition, who are acknowledged on a special page in this catalogue, for sharing their works of art.

John R. Lane, Director

The first debt of any art historian is owed the artists, whose productions challenge and inspire all our insights, theories, and debates. Despite their redoubtable individualism and disdain for curatorial or academic groupings, each of the artists included chose to cooperate with the planning and execution of an exhibition and publication on Bay Area Figurative Art. Elmer Bischoff, Joan Brown, Theophilus Brown, Richard Diebenkorn, Bruce McGaw, Manuel Neri, Nathan Oliveira, James Weeks, and Paul Wonner were all extremely generous with their time, their memories, their papers, and their art. David Park's widow, Lydia Park Moore, and her husband, Roy Moore, were equally responsive, as were the families of the other artists. Fellow artists George Stillman and Hayward King shared their works and insights into the period; Terry St. John and Wally Hedrick were also helpful.

Scholarly research into the period, its art, and its criticism was enabled by the capable staffs of several libraries and archives: Paul J. Karlstrom and Victoria Ricciarelli of the West Coast Regional Center of the Archives of American Art; Alex Ross and Amanda Bowen of the Stanford Art Library; Christine Droll of The Oakland Museum; and Jeff Gunderson of the San Francisco Art Institute. To Stanford professors Wanda Corn and Albert Elsen I owe special thanks for their willingness to read and discuss the manuscript; other scholars and curators assisted by sharing their research or bringing others' work to my attention, by commenting on sections of my manuscript, and by facilitating my access to works of art and curatorial records: Richard Armstrong, Roger Clisby, Bolton Colburn, Nancy Doll, Richard Field, Judi Freeman, Paula Friedman, Betsy Fryberger, Amelia Jones, Harvey Jones, Beatrice Kernan, Andrea Kirsh, Bruce Kurtz, Susan Klein Landauer, Ira Licht, Paul Mills, George Neubert, Valerie Olsen, Carol Osborne, Harry Rand, Millard F. Rogers, Cora Rosevear, Sandra Leonard Starr, Sidra Stich, Charlotte Wellman, and Judith Zilczer. Other museum and foundation staff members provided physical access to works of art, or reproductions when a visit proved impossible: Laura Catalano, Andrea Clark, Marla Daily, Jane Falk, Joseph Holbach, Mary Johnson, Chandra King, Marge Klein, Lisa Leary, Margaret McCarthy, Denise McColgan, Patricia Magnani, Jill Manton, Maureen Megerian, Linda Post, Olga Preisner, Eloise Ricciardelli, Renee Ater Roberts, Susan Roberts-Manganelli, Jill Robertson, Cindy Rom, Betsy Severance, Anne L. Strauss, Pam Tippman, and Patricia Woods.

Various dealers and agents were helpful in locating important works of art: Paule Anglim, John Berggruen, Rena Bransten, Phillip Bruno and George Staempfli, Charles Campbell, Charles Cowles, Adrienne Fish, Alan Frumkin and George Adams, Anne Kohs, William O'Reilly and Lawrence Salander, and Eleanor Fuller Poindexter. Many collectors went out of their way to accommodate my visits or answer my inquiries, sharing their own insights and enthusiasm for Bay Area Figurative art: Mr. and Mrs. Harry Anderson, Dorothy Blankfort, Harry Cohn, Dr. and Mrs. Jay Cooper, Julian Eisenstein, Eric Estorick, Mr. and Mrs. Jack Falvey, Morgan Flagg, Edwin Jaffe, Edwin Janss, Mrs. Robert Kassow, Barbara and Ron Kaufman, Mr. and Mrs. David Lloyd Kreeger, Modesto Lanzone, Katherine and Carl Lobell, Mr. and Mrs. Daniel Mardesich, Martin Margulies, Byron Meyer, Adolph Mueller, Mrs. James Patton, David N. Pincus, Rene di Rosa, Robert Rowan, Mr. and Mrs. Lawrence Rubin, Mrs. Walter Salant, Norma Schlesinger, Suzanne Strid, Thomas Weisel, Paul and Elizabeth Wilson, Mrs. David Yerkes, and Jimmy J. Younger.

Although the bibliography and footnotes demonstrate the extent of my debt to prior scholars, I would like to take special note of the research and publications of Thomas Albright, Joan Chambliss Bossart, Jan Butterfield, John Elderfield, Tom Garver, Susan Larsen, Mary Fuller McChesney, Paul Mills, George Neubert, Gerald Nordland, Noreen Mary Richeda, Yvette Friedli Shaak, and Sandra Leonard Starr. The interviews and essays by these scholars and critics were crucial in forming my understanding of Bay Area Figurative art as reflected in this publication. The book was produced by the staff of the University of California Press, among them Jim Clark and Marilyn Schwartz. The considerable tasks of coordinating and editing were performed by Christine Taylor and Fronia Simpson of Wilsted & Taylor Publishing Services, Oakland. New photography was professionally completed by Ben Blackwell; the former Publications

Coordinator at the San Francisco Museum of Modern Art, Karin Victoria, made the book possible through her indefatigable efforts on its behalf.

The museum's Curatorial Assistant Janet Bishop was also indispensable in producing both the book and the exhibition. With the help of the independent scholar Jo Ortel, Janet Bishop researched and compiled the extensive chronologies; she also perfected the exhibition checklist and pursued the countless other details of a loan exhibition. The museum's Librarian Eugenie Candau put together the bibliography and helped locate many an abstruse journal; Library Assistant Karen Brungardt was also helpful. Michael Schwager, former Exhibitions Coordinator and devoted partisan of Bay Area art, steered the project in its earliest phases and continued to offer sage advice from his current position as curator of the Richmond Art Center; his successor at the museum, Barbara Levine, has capably taken over the task of organizing the exhibition's tour.

As the museum's Chief Curator, Graham Beal guided the selection of works of art and read several drafts of the manuscript; I have benefited from his intelligence and his friendship in equal measure. Former director Henry T. Hopkins and current Director John R. Lane supported the project in every way possible, recognizing its importance within the museum's overall program; Deputy Director for Administration Barbara L. Phillips offered her experience in publishing and management. Deputy Director for Curatorial Affairs and Chief Conservator Inge-Lise Eckmann, Senior Conservator William Shank, Head Registrar Tina Garfinkel, Associate Registrar Mindy Holdsworth, Graphic Designer Catherine Mills, and Installation Supervisor Kent Roberts all contributed their considerable skills to the realization of the present book and exhibition.

My deepest personal thanks go to Peter Galison, for tirelessly reading drafts and supporting their author throughout, and to Sam, for being there.

C.A.J.

BAY AREA FIGURATIVE ART

1950-1965

CHAPTER ONE

INTRODUCTION TO A MOVEMENT

PICTURES AND PAINTINGS · In the spring of 1951, one of San Francisco's most respected Abstract Expressionist painters shocked the art community when he submitted a small figurative canvas to a competitive exhibition and won a prize. The painter was David Park, and the astonished reaction of his fellow artists signaled that something dramatic had occurred. At a time when non-objective, abstract painting seemed to be the only possible route for progressive artists, Park's turn to the figure was perplexing, and even enraging. Most of his colleagues saw it simply as a "failure of nerve," an inability to summon the deep inner resources that contemporary abstract painting was felt to require. Few knew then that Park's "defection" was to be the first of many; still fewer could have guessed that the figurative art it prompted would grow to be one of the most salient postwar developments on the West Coast.

If the full impact of Park's new work was slow to emerge, it became clear that his move away from Abstract Expressionism had been both prescient and courageous for 1950. Although it was a peak year for the gestural style in New York, with Franz Kline painting his first black-and-white abstractions and Jackson Pollock pouring his first wall-sized horizontal canvases, San Francisco's Abstract Expressionists were already beginning to experience the tensions that would emerge in the new painting, which was on its way to being identified as a national style. Institutional and social support for experimental abstract work was eroding in the Bay Area, and local painters experienced a crisis of belief—"the end of a love affair," as Elmer Bischoff described it (fig. 1.1).[1] By 1953, when the New York art world was shaken by both Willem de Kooning's "Paintings on the Theme of Woman" and Pollock's loosely figurative canvas *Portrait and a Dream*, Bischoff and Park were already deep into their new figurative work. But where Pol-

lock's and de Kooning's figures seemed to represent the return of the repressed within their established signature styles, Bischoff and Park both felt that they were embarking on a whole new adventure. Given the rigorously non-objective nature of Abstract Expressionism in San Francisco, their switch to the figure was by necessity complete and unequivocal. As Park expressed it, he was now making *pictures*, whereas his earlier works had been *paintings*:

> What the paintings told me was that I was a hard-working guy who was trying to be important. . . . I have found that in accepting and immersing myself in subject matter I paint with more intensity and that the "hows" of painting are more inevitably determined by the "whats."[2]

The new figurative "pictures" created by the Bay Area artists were neither reactionary nor merely illustrational. Although clearly moving away from the subjective isolation and grandiosity of Abstract Expressionism, the new work was equally clearly in its debt. Each of the artists came to figuration with a sympathetic understanding of abstraction and a deep enthusiasm for the Abstract Expressionists' achievements; all had themselves worked non-objectively, and several had received national recognition for their abstract work. Their mature post-abstract figurative paintings preserved a sophisticated dialogue between abstraction and representation—the image oscillating between a recognizable subject and a boldly colored, abstract arrangement of thick slabs of paint.

Why did these artists need the figure, the still life, or the landscape? As Park explained in 1952:

> I believe the best painting America has produced is in the current non-objective direction. However, I often miss the sting that I believe a more descriptive reference to some fixed subject can make. Quite often, even the

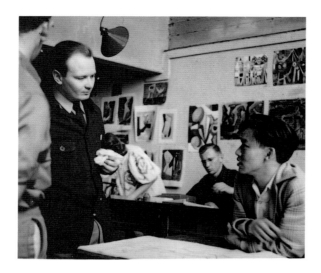

FIG. 1.1. Elmer Bischoff, California School of Fine Arts, ca. 1950. Courtesy San Francisco Art Institute.

very fine non-objective canvases seem to me to be so visually beautiful that I find them insufficiently troublesome, not personal enough.[3]

Park was not alone in finding that much non-objective painting was becoming as decorative and ineffectual as "apocalyptic wallpaper," in the words of one New York critic.[4] Following de Kooning's example, many younger artists on the East Coast were also turning to the figure, but the different context produced very different results. As I will discuss more fully in a later chapter, the New York figurative painters were able to present their work as an extension of Abstract Expressionism, while the San Francisco artists were forced to recognize that their new figurative works represented a decisive break.

For artists in the Bay Area, turning to the figure was not a matter of summoning figurative images from their subconscious (as might have been the case for Pollock or de Kooning); it meant turning out to the world, drawing from the model, and working from the motif. Despite their formal commitment to the lessons of abstraction, the San Franciscans knew that they could no longer call themselves Abstract Expressionists. Arguably, their need to make a clean break was one of the reasons for the vigor and coherence of their new style. Another reason may have been the small scale and general tolerance that characterized the San Francisco art world. Where New York artists felt compelled to achieve an unmistakably individual approach, an identifiable and potentially saleable "trademark" image, San Franciscans enjoyed a relaxed collegiality and openness to mutual influ-

ence. In contrast to the atomized, reactive quality of figurative painting in New York, the emerging work of the Bay Area artists had the stylistic unity and positive momentum of a movement.

But was it a movement? The goal of this book, and the exhibition it accompanies, is historical: to map the terrain of a fifteen-year development in figurative art in the San Francisco Bay Area. But the historical terrain resists, buckling and heaving during the cartographic attempt. Put simply, the artists who created what we now call Bay Area Figurative art resist labeling, resist inclusion, resist mapping. From the first exhibition that gave them their name, they have denied that their defection to figuration may have become a movement, leery of those who would try to subsume their individuality to a group. As Richard Diebenkorn (fig. 1.2) remarked in 1977:

I have always kind of cringed at the title "Bay Area Figurative." It was a tag I didn't want to have. I think there is considerable basis for the label, considerable truth in it. . . . [There] was certainly interaction, we affected one another, our work rubbed off and I suppose it was so for the Impressionists, Cubists, the Vorticists. . . . [But] I'm much more interested in the aspect of the artist which is unique and inside that person's head.[5]

Given such attitudes on the part of the participants, describing Bay Area Figurative art as a movement is problematic. Even when artists themselves proclaim a new art with eager manifestos, arguments and defections inevitably dissipate the intended impact, and the objects produced never fully correspond to the rhetoric. Far more common are the artistic developments defined from the outside, by contemporary critics or subsequent scholars; most of these were named not by supporters but by shocked opponents, such as Impressionism, Fauvism, and Cubism.

Defined externally and hotly debated at the time, Bay Area Figuration had all of the attributes commonly associated with movements: joint effort, mutual support, signal exhibitions, critical recognition, a shared stylistic and thematic vocabulary, and artistic followers. For all these reasons, I will argue that Bay Area Figuration *was* a movement—in the eyes of critics, other artists, and the general public. The point is far from moot, since contemporaneous New York figurative painters did not coalesce into a movement, and many scholars have routinely assumed the same incoherence for the Bay Area Figurative artists and their work. As I hope to demonstrate, the paintings and sculptures produced by the artists discussed in this book reveal a stylistic and thematic unity born of their frequent interaction and respect for each other's

work. Defining Bay Area Figuration as a movement is a product of that unity and interaction.

Bay Area Figuration gained its name and critical focus from an exhibition organized in 1957 by Paul Mills, at that time curator of the Oakland Art Museum. In his conclusion to the catalogue essay, Mills cautiously explained why he was not claiming to have recognized a new movement:

> [There] is nothing the principal artists involved in this want less than a new movement. What they are doing now they are doing partly because they got tired of the whole business of movements. . . . What they don't want is for their defection from The Cause to become itself just another Cause, another manifesto which too many artists might be persuaded to adopt.[6]

Although Mills was careful to stress that the exhibition was "a kind of introductory sampling rather than . . . a definitive survey," and warned his readers against rushing to label a new "ism," he recognized that the process was already under way: "it isn't clear whether it will be possible to keep this from becoming a movement here."[7] His exhibition was, of course, no small factor in the process. It traveled after its local showing, focusing the first national critical attention on the new figurative art.[8] Acknowledging its importance, most recent curators have taken the Oakland exhibition and catalogue as their primary source.[9]

Since Mills's survey, Bay Area Figuration has been portrayed as a return to the figure by artists previously involved with Abstract Expressionism, a dramatic break initiated by David Park and pursued by others in an individual fashion. A revisionist approach to this standard reading might claim a strong local tradition of modernist figuration, begun by the Society of Six. Dating to the early twentieth century, the Six pioneered Impressionist and Fauvist approaches to the area's rich potential for genre scenes and landscape views. Such a revision might argue that Bay Area Figuration of the mid-century represented only a continuation of a long-standing local commitment to figurative imagery.

Arguments supporting the revisionist approach are not persuasive, however. As Mills recognized, Bay Area Figuration was a new development responding to national issues in contemporary art; the artists involved were almost entirely ignorant of their local predecessors.[10] But pressured as he was by their active resistance, Mills was disposed to minimize the stylistic coherence of the works he selected, averring that "whatever these paintings may have in common, the different, individual personalities of the painters re-

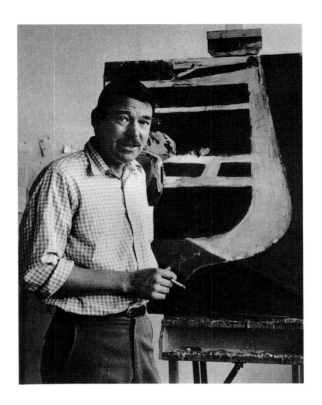

FIG. 1.2. Richard Diebenkorn, artist-in-residence, Stanford University, 1963. Courtesy Stanford University Museum of Art.

main the stronger factor."[11] This reading has remained largely intact, for no one has traced the complex interactions and alliances that lay beneath the appearance of the new work. Now, in the late 1980s, we are in a better position to construct the history of Bay Area Figuration, to discern the consistencies distinguishing it from postwar figurative developments elsewhere, and to recognize a movement where contemporaries may only have seen a trend.

Broadly speaking, Bay Area Figurative art had two general characteristics. First and foremost, it pursued a union of figurative subject matter (including all modern representational genres from the nude to still life to portraiture to landscape) with Abstract Expressionist paint handling and formal compositional concerns (such as non-perspectival space and an emphasis on process), combined with a conscious resistance to specific aspects of the Abstract Expressionist ethos (such as the requirement that the artist's personality or subconscious be the source for all imagery). Second, the work portrays physical attributes associated with California (such as deep, saturated colors and the play of strong sunlight) and often depicts pastoral or suburban subject matter. One of the most intriguing features of this latter aspect is the artists' treatment

of traditional themes, such as the nude, in a non-traditional way—the nude is male, or presented as an implied self-portrait.

As with any group, each of the ten artists discussed in this book departs in one way or another from these two general principles, and they exhibit strong generational differences. Those differences, masked initially by the strength of shared goals and concerns, became the opening wedges in the movement's eventual breakup. Although the directions taken in that breakup were individual, they were also characteristic of the general shift in American art of the mid-sixties toward flatness and "hard-edge" painting amidst a pluralism of styles. As in their move away from Abstract Expressionism, the Bay Area artists responded to national developments in their move toward minimalism, and did so from the strength of their regional identity.

As I hope to demonstrate, this regionalism was not provincial. Artists came to the Bay Area as they had come to New York, in search of a specific environment for their work. Far from representing a provincial backwater, the Bay Area Figurative artists participated fully in the broader context of American art, producing work of exceptional quality in response to the culture of their times.

In the chapters that follow, I will first establish the contexts for postwar figuration in the Bay Area and elsewhere. I will then examine the San Francisco School of Abstract Expressionism, which was the breeding ground for the Bay Area Figurative style. After constructing these contexts and sketching the broad historical outline of the first figurative "defections," I will turn to history on a smaller scale and follow the development of individual artists. By teasing out the important differences in the stages of Bay Area Figuration, identifying a first, bridge, and second generation, I hope to suggest a new and more nuanced periodization that goes beyond the common descriptions of a simplistic efflorescence and decline.

In my conclusion, I will examine the ways in which the Bay Area Figurative artists have been perceived over time, under various critical rubrics—with special attention to their usual grouping with the second generation of the New York School. At that juncture I will also address the regional characteristics of the movement, which is perhaps more deeply identified with place than any other since that of the Barbizon painters of the nineteenth century. Finally, I will review some of the changes contributing to the end of Bay Area Figuration and its endurance as a tradition in the area.

NATIONAL, INTERNATIONAL, AND LOCAL CONTEXTS

In 1948, the New York critic Clement Greenberg described American abstract painting as the only hope for the future of Western art, characterizing the abstract artists upon whom this future depended as deeply isolated, possessed by "the neurosis of alienation," with only "two or three fellow painters" supportive of their work.[12] This perceived tension between importance and invisibility was resolved by the mid-fifties. By that time American Abstract Expressionism had gained worldwide attention, owing in part to the growing influence of critics like Greenberg and in part to the economic and political shifts that made New York City the center of postwar capitalism.[13] The status of Abstract Expressionism as a national style was ensured when mass-market magazines such as *Life* published articles that explained how to appreciate paintings by Mark Rothko and Clyfford Still, or when canvases by Jackson Pollock appeared as backdrops behind fashion models in the pages of *Vogue*.[14] This media attention was in turn the result of earlier proselytizing efforts of the forties at progressive cultural institutions throughout the country. New York's Museum of Modern Art played an important role, particularly through its program of international exhibitions. Even more adventurous was the San Francisco Museum of Art (later renamed the San Francisco Museum of Modern Art) under the direction of Grace McCann Morley. Morley had shown and purchased works by Arshile Gorky, Pollock, and Rothko before these artists were shown in New York museums, and her commitment to international modernism resulted in an impressive series of exhibitions.[15]

One of Morley's most significant acts was to bring Douglas MacAgy with his wife, Jermayne, to San Francisco in 1941. The MacAgys became powerful advocates for the new abstract painting through their respective activities at the California School of Fine Arts, where Douglas was director beginning in 1945, and the California Palace of the Legion of Honor, where Jermayne prepared exhibitions. Their promotion of Abstract Expressionism, through both academy and museum, fostered a San Francisco School out of which the Bay Area Figuratives developed.

In San Francisco, as in the country as a whole, Abstract Expressionism functioned somewhat paradoxically as a national style, for it emphasized internationalism and opposed the more blatant chauvinism of the regionalist painters of the American scene. In the spring of 1945 Jermayne MacAgy mounted *Con-*

temporary American Painting at the California Palace of the Legion of Honor, an exhibition dedicated to the country's newly international national style. The catalogue stated:

A few years ago, not without embarrassment, the people of this country witnessed some of their artists kindling the primitive smoke signals of nationalism. High-pressure promotion of mannered representations of the "American Scene" publicized an artificial point of view and concealed its flimsy supports. Today there is no better reflection of America's international attitude than the dissolution of the nationalist art movement and the widespread evidence of a cosmopolitan vision among artists. In its way, contemporary painting in the United States is a recognition of the interdependent condition of all nations in a culture of the world.[16]

The rhetoric of the catalogue was more consistent than the selection of artists, which included Norman Rockwell and Andrew Wyeth as well as Gorky, Robert Motherwell, Pollock, and Rothko. Despite the seeming diversity, representation was not a neutral choice in the late forties. Figurative imagery was associated either with Regionalism, where it was politicized by association with the isolationists and "America Firsters" who had opposed entry into the war, or, increasingly, with Social Realism, which was linked with the Soviet-sponsored Communism of the Popular Front.[17] Some artists were capable of stylistic schizophrenia: one prominent San Francisco Abstract Expressionist detoured from his new style to contribute a stirring Social Realist illustration to a publication of *The Communist Manifesto*.[18] But with the escalation of the Cold War, abstraction provided the most powerful aesthetic position for left-liberal artists seeking the "Vital Center" of American cultural life.[19]

In San Francisco, the split between a neutral abstraction and a politically fraught representationalism had a specifically local character, centering on old allegiances dating from the depression and the WPA. The University of California at Berkeley had appointed Hans Hofmann to teach painting in 1930, the same year that Diego Rivera came to San Francisco to paint a mural in the Pacific Stock Exchange. Both stayed through 1931, Hofmann still teaching at Berkeley and Rivera painting a fresco in the social hall of the California School of Fine Arts. Although both Hofmann and Rivera had their roots in European modernism (Rivera having produced significant Cubist works while in Paris in the teens), Rivera had responded to the Mexican revolution by embracing a monumental Social Realist style. Hofmann, in

contrast, retained his aesthetic of "art for art's sake," which was formed during his years in early-twentieth-century Paris, augmenting his earlier theories of German and Russian expressionism.[20]

The appointments of Hofmann and Rivera both reflected and reinforced respective institutional preferences. Berkeley became the intellectual, theoretical center of a formalist modernism whose heroes were Cézanne, Picasso, and Mondrian, and the California School of Fine Arts emerged as the practical training ground for working artists and art teachers whose heroes were "artists of the people," the Mexican muralists. Glenn Wessels, an artist and teacher who had studied with Hofmann in Munich, became his course assistant at Berkeley and remained alienated from the San Francisco Art Association for decades "because of the way the old Art Association made fun of Hans Hofmann at the time . . . when Ralph Stackpole and Edgar Walter wanted to bring in the Mexican Gods."[21] This schism was an important factor in Bay Area artists' later resistance to enlisting in movements. Tellingly, in his 1957 catalogue essay on the Bay Area Figuratives, Paul Mills recounts another of Wessels's anecdotes about the fate of Mexican-style Social Realism during the heyday of San Francisco Abstract Expressionism, presenting it as a cautionary tale of the way in which "movements come and go around here." Mills continued:

We were on a jury together for a graphics show at the San Francisco Museum of Art. . . . Most of the entries were examples of current abstract styles. One of the others was a drawing entirely in the Mexican style introduced by Diego Rivera, . . . and it was rejected unanimously by the jury with hardly more than a glance. Slumped in his chair, speaking to no one in particular, Wessels said, "Hmmmph . . . you couldn't get *in* this place ten years ago unless you had big feet."[22]

By the MacAgy era, Hofmann's alternative of abstraction to Rivera's Social Realism was only a memory, and in no sense did it function as a stylistic influence. Whereas many of the East Coast Abstract Expressionists had met and studied at Hofmann's school in New York (as had the critic Clement Greenberg), there were only former students to keep Hofmann's influence alive on the West Coast, and their impact was primarily confined to Berkeley. Locally, the hatchet seemed to be buried between the Mexican god-worshipers and the Hofmann acolytes by the late forties, when MacAgy appointed Still and Rothko to teach at the California School of Fine Arts. Nonetheless, there were echoes of the old dispute in the split

between David Park and Still that accompanied the figurative painters' defection later on.

Clyfford Still had no brief for Hofmann; neither did he harbor any vestigial left-wing political sympathies.[23] His rhetoric shared much of the tone and vocabulary of the East Coast Abstract Expressionists, with its references to the "totalitarian hegemony of . . . tradition" and a sought-for "freedom and independence" from conformist pressures.[24] The political content of the Abstract Expressionists' manifestos was far from clear or explicit. As one scholar has commented, "[the] manifestos of the New York modernists constituted a kind of domesticated avant-gardism . . . which came to cherish . . . the liberal notion of individual freedom . . . and universal humanism. . . . [They] seemed to issue from the pulpit rather than from bohemia."[25] From this standpoint, Still's statements could be read as radical or reactionary, depending on the reader's own beliefs:

> The works must be kept together if their fundamental idea is to be made clear. As single spies they are complete, but in a group show the collectivist rationale is dominant with its psychological and political motivations. Thus my imagery and its powers become the tools of authority and exploitation.[26]

Using terms such as "political motivations," "the collectivist rationale," and "the tools of authority and exploitation," Still drew freely from opposing political vocabularies without clarifying their significance for his own views. His most famous statement, widely publicized in a 1959 issue of *Time* magazine, was politically ambiguous and reinforced his image as a powerful preacher of hellfire and damnation: "Let no man undervalue the implications of this work or its power for life, or for death, if it is misused."[27]

Still asserted the dignity of the priest-artist in everything he did. Dressed like a businessman in a pale gray suit, gray gloves, and a homburg hat, he entertained visitors only by appointment, when his painting tools would lie, immaculately clean, next to his glass palette.[28] Former students describe his classes as seminars that were not about painting per se but about life as an artist in a hostile, commercialistic world.[29] Whatever Still's actual political beliefs might have been, his uncompromising attitude attracted the young, idealistic, and largely left-wing students and faculty of the California School of Fine Arts. Soon he was the undisputed spiritual master of the California Abstract Expressionists—if not, in the eyes of participants, a leader of the San Francisco School.

THE DISPUTED EXISTENCE OF THE SAN FRANCISCO SCHOOL

When Douglas MacAgy became director of the somewhat sleepy California School of Fine Arts, he had won the approval of the trustees to reorganize the school's curriculum and to overhaul its faculty. Setting the tone immediately by hanging a curtain over the Rivera mural, MacAgy proceeded to fire many of the current faculty and to hire several new instructors, among them David Park and Hassel Smith (fig. 1.3), both of whom had been teaching part-time prior to MacAgy's arrival. Elmer Bischoff was hired in January 1946, initially as a replacement. That fall, MacAgy appointed the first non-local artist, Clyfford Still.[30]

Most scholars argue that it was Still who brought the energy of Abstract Expressionism to San Francisco and the school, but some former faculty members disagree. In the first year of MacAgy's tenure, before Still arrived, the student body had already begun to transform itself radically, creating within itself as powerful a sense of change as did any of the new faculty. Supported by the G.I. Bill, the new students were mature veterans, financially secure for the moment and eager to confront the most advanced pictorial ideas. John Grillo was an outstanding example of the new breed of students; he came from New York with an open, non-objective style closer to Motherwell's than to the expressionistic modernism of most of the faculty.

MacAgy's innovations, such as keeping the painting studios open all night and fostering the creation of the Studio 13 Jazz Band (in which Park, Bischoff, and occasionally MacAgy played), contributed further to the new spirit of experimentation and excitement. Bischoff states unequivocally that they "didn't have to wait for Still" to ignite the fires: "A lot of names were current—Baziotes, Gottlieb, Pollock. . . . These ideas were just there, they were in the air and they infiltrated and took hold."[31]

Whether or not Still's presence was required, there can be no doubt that it was catalytic. Still was a forceful, if enigmatic, presence at the school during 1946, but it was his July 1947 solo exhibition at the California Palace of the Legion of Honor (fig. 1.4), organized by Jermayne MacAgy, that galvanized opinion about his approach to art and life. In this exhibition Still showed some works dating from 1943 that still bore the vestiges of representation. Almost half of the paintings, however (six out of thirteen), were very recent, completely non-objective paintings, large in size and severe in color. Two students from the time

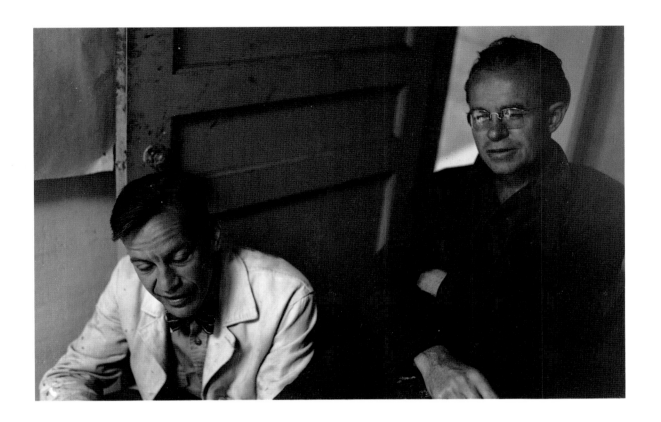

FIG. 1.3. David Park (left) and
Hassel Smith, 1949, in Park's studio
at California School of Fine Arts,
photographed by colleague George
Stillman. Courtesy George Stillman.

FIG. 1.4. Clyfford Still solo
exhibition at the California Palace
of the Legion of Honor, 1947.
Courtesy of The Fine Arts
Museums of San Francisco.

FIG. 1.5. *Paintings by Elmer Bischoff,
David Park, and Hassel Smith* at the San
Francisco Museum of Art, 21 May–
15 June 1948. Courtesy George Stillman.

later described the impact of these uncompromising
canvases with their dark earth colors and sooty, tarry
surfaces:

> Most of us . . . had stern convictions as to the nature of
> modern painting; it must be Mondrian, Miró, or Pi-
> casso. What we were confronted with on the walls of
> the Legion Museum was unrelated to these precon-
> ceptions—unrelated in the most upsetting fashion. . . .
> Still's works were marked by a violence, a rawness which
> few of us . . . were prepared to recognize as art.
>
> [The paintings had] a kind of relentless thing that was
> sort of anti-beauty in a sense, . . . a willingness to use
> something really raw and brutal.[32]

Instructors, too, were profoundly shaken. Hassel
Smith recalls that Still's exhibition prompted a
schism between him and his closest colleagues Park,
Bischoff, and Richard Diebenkorn, who had begun
teaching at the California School of Fine Arts that
year. This memory of a rupture may be Smith's pro-
jection from his later break with these artists over
their switch to figuration, since the evidence suggests
that their most successful Abstract Expressionist
paintings date from the years immediately following
Still's show. But Smith recalls that the three artists
began to distance themselves from the influence of
Still's work at a very early date:

> [When Still showed in 1947,] something very interest-
> ing happened! Almost immediately a kind of schism de-
> veloped around that situation, with Elmer Bischoff and
> David Park and Dick Diebenkorn taking a very adverse

attitude toward Clyff's painting. I had been very inti-
mate with them, but I disagreed with them about that.
And we . . . had a sort of falling out over that situation.
And I found myself, then, having much more in com-
mon with Frank Lobdell, Ernie Briggs, and some of the
students.[33]

Whatever they thought of Still's paintings ini-
tially, it seems clear that Bischoff, Park, Diebenkorn,
and Smith himself soon went much farther in the
direction of "action painting" than Still would ever
have countenanced. Still's craggy, flamelike images
were carefully crafted, the paint lovingly and labori-
ously applied with neat strokes of a small palette
knife. The improvisational flicks of the brush that an-
imated Bischoff's and Diebenkorn's abstract canvases
were not innovations of which Still would have ap-
proved. Similarly, Park's later non-objective works
(see fig. 2.7) were also more spontaneous than Still's,
showing Park's commitment to Abstract Expression-
ist notions of process and the idea that a painting
should be intuitive, freely painted and not precon-
ceived—ideas exemplified by the term *action painting*.

Still was vocal in his opposition to action painting,
or the "drip and drool school" as he called it,[34] and
even Hassel Smith, one of Still's closest colleagues,
acknowledges that Still's painting may not have been
as influential as many thought:

> The Action Painting idea was a critic's invention, [but as
> it happened,] this *idea* was *inherent* in the whole devel-
> opment [in San Francisco]. Whereas . . . most people
> would have said to themselves that Clyff was the major

influence, now looking back on it, his work affected other people in a rather minor way, because little of that [Action Painting] was in his own work. . . . His work was very intellectual, very elegant and constructed and not at all spontaneous, [yet] his followers were painting big, wild things with much freedom.[35]

Probably with the encouragement of MacAgy, whose interest in Dadaism led him to respond to any activity that seemed radical and experimental, the San Francisco Abstract Expressionists began to slather on paint with an excess that shocked contemporary observers. In an exhibition that would become pivotal for perceptions of a distinct San Francisco School, Park, Bischoff, and Smith were shown at the San Francisco Museum of Art in the spring of 1948, with great success (fig. 1.5).[36] It was an appropriate grouping, for the three artists had made a practice of meeting once a week in each others' studios for convivial critiques. Richard Diebenkorn often joined them, setting the stage for their later figurative interactions.

Park's paintings for the 1948 exhibition were large, and photographs show them to have been unusually geometric when compared to the surviving *Still Life Non-Objective*. Unlike Still's flamelike imagery, which seems based on forms from nature, Park's non-objective canvases of this period resemble the more ordered works of certain painters in New York. The boxy subdivisions and polarities of one untitled work from the exhibition (fig. 1.6) correspond to early Barnett Newman paintings or Adolph Gottlieb pictographs; the palette of blacks, browns, and mustards recalls works by Robert Motherwell.[37] Viewers remember Park's paintings from the exhibition as wild and expressionistic—a response that is difficult to comprehend until we recall the thick, turgid surface of *Still Life Non-Objective*. It was this side of Park's non-objective vision that had the greatest impact for visitors to the 1948 show.

Fred Martin, later director of the California School of Fine Arts, recalled the exhibition as "perhaps the most important" of the group shows during the period: "As I remember it, this was the first really major presentation of abstract expressionist work in the Bay Area, other than the Still one-man at the Legion."[38] Martin also described the Park works in the show as "the size of the whole wall, it seemed."[39] Writer Mark Schorer corroborates this, remembering "city blocks of canvas. . . . Freewheeling is hardly the word to describe these paintings, that were at least as bewildering as they were brilliant."[40] In a contemporary review, Berkeley professor Erle Loran wrote: "Noth-

FIG. 1.6. Park non-objective painting, photographed by colleague George Stillman in the artist's studio, California School of Fine Arts, ca. 1948. Courtesy George Stillman.

ing like this has been seen in such large amounts in one place. . . . It was the most complete release from restraints of all kinds that had ever occurred. . . . Clyfford Still . . . seemed composed and orderly by comparison."[41] And Diebenkorn, Park's former student and then a recent addition to the faculty, remembers the show as "expressionistic and pretty wild . . . freewheeling, wide-open, totally generous. . . . People were seriously shocked."[42]

At least one contemporary reviewer was shocked not by the paintings' size and excessive *matière* but by the artists' abandonment of the common people in favor of market-driven fashion. Here are perhaps the last echoes of a Social Realist, pro-Rivera criticism, which the Abstract Expressionist painters had rejected out of hand:

It is most unfortunate that artists such as Messrs. Bischoff, Park and Smith are unable to solve the contradiction which capitalism inevitably thrusts upon those engaged in cultural work—i.e., the contradiction between the demands of the market and the portrayal of objective reality. Artists, instead of enriching our cultural life with a humanist art, are driven by the demands of the market to paint anything but life.[43]

The participating artists would have found it ludicrous to impute marketing motives to their abstraction. In the debates over the "California School" in the mid-fifties, the one thing all could agree on was that there had never been anything like a market for painting in San Francisco. Unlike New York, where schools grew up around galleries (such as the Betty Parsons Gallery or Peggy Guggenheim's Art of This Century), clubs and bars (Cedar Tavern, the Eighth Street Club), or critics (Greenberg, Rosenberg, et al.), California's postwar schools were literally educational institutions where individual personalities held sway. Without teaching positions, none of the Bay Area Figurative artists could have supported themselves or their families.[44] Similarly, none of the successive styles—from the San Francisco School to Bay Area Figuration—would have developed without the close contact and collegial network fostered by the area's educational institutions.

New Yorkers have traditionally derided teaching in general and Bay Area schools in particular for their "hothouse" atmosphere, claiming that the schools foster derivative rather than independent artists; but one can make the opposite argument with equal force. Like the Bauhäusler of earlier decades, the painters at the California School of Fine Arts were free to pursue their own theoretical and aesthetic programs, fully independent of dealers and the market— which is not to say that either the Germans or the San Franciscans were indifferent to outside opinions or political pressures.

In the early fifties, a French critic named Michel Tapié, excited by the productions of San Francisco expatriates Sam Francis, Claire Falkenstein, and others, wrote enthusiastically of a new *Ecole du Pacifique*, a style he identified with artists from the West Coast. He placed particular emphasis on their relative proximity to Asia, seeing the influence of Oriental ideas of space in their work (irrespective of similar spatial devices in the paintings of artists of the New York School such as Kline, Pollock, and Rothko).

In a panel discussion on the subject, the artists named by Tapié largely rejected the notion of a shared style or set of beliefs. In the words of Sam Francis, whose most important teacher had been David Park:

> To speak of a school with regard to American painters and in particular those of the Pacific Coast is, more or less, to make an abstraction out of particulars in order to separate out common traits. This remains very arbitrary. In any case, the most important thing is the individual. Analysis limits precisely that which has no limits: an individual development, an interior feeling.[45]

Francis's emphasis on individuality and rejection of a school or movement parallel Bay Area artists' later hostility toward efforts to identify a local figurative style. Both positions stemmed from the Abstract Expressionists' belief in the inviolability of the individual's style and creative approach, a belief in constant tension with their simultaneous efforts to create a unified avant-garde.[46]

Despite the artists' rejection of the term, Tapié's declaration of a new school was apparently picked up by *Time* magazine and adopted by at least one New York curator.[47] Debate soon peaked in 1956 with Hubert Crehan's *Art News* article "Is There a California School?," which prompted the Oakland Art Museum to sponsor the panel discussion "California School— Yes or No?"[48] Crehan, who had studied briefly with Still at the California School of Fine Arts, argued that there was no Ecole du Pacifique or California School: "There is not enough formal or emotional significance common to it all."[49] More to the point, he argued, none of the painters involved in the "free and inspired spirit" that reigned from 1945 to 1952 painted anything like Clyfford Still—an artist he identified with the abstractionists of the New York School.

Defenders of a specifically Bay Area form of Abstract Expressionism agreed that it differed from Still's work. They too placed Still in the New York School, but argued that the local variant should then be known as the San Francisco School.[50] For our purposes, the most significant aspect of the defense lay with its examples. Hassel Smith, in a humorous mystery story constructed around the "search" for a California School, wrote: "I should think that Park and Bischoff were perfect examples [of the San Francisco School] until they fell back upon the pre-pared [sic] positions of representationalism."[51] Fred Martin echoes this judgment in a response to the panel discussion at the Oakland Art Museum, remarking that Park's Abstract Expressionist works were "some of the most influential ones being made. Their largeness, openess [sic] and simplicity . . . left a permanent mark upon the art of the Bay Area." Martin also observed that the panel assembled by the Oakland Art Museum to discuss the question of a California School contained two of its "killers"—Park and Diebenkorn, who had both by then defected to figurative painting.[52]

Non-objective works by Bischoff and Diebenkorn survive, and with their loopy calligraphy and fields of saturated color they share many of Smith's stylistic traits. Of David Park's seemingly influential Abstract

Expressionist works, only one exists with certainty (see fig. 2.7). According to legend, Park destroyed the rest in a dramatic visit to the Berkeley dump in 1949, thereby renouncing three years' worth of his abstract work and inaugurating Bay Area Figurative painting the following year (fig. 1.7).

CONCLUSION

The San Francisco School of Abstract Expressionism was the breeding ground for Bay Area Figurative painting. Its ostensible inspiration, Clyfford Still, was seen by some as a delegate from the New York School, more cerebral and deliberate than the San Francisco painters. Park, Bischoff, and Diebenkorn were regarded as the leading painters of the San Francisco School: sensual, emotionally supercharged, painterly in an intuitive way, and connected with nature.

Most artists agreed that there was a distinct San Francisco approach to Abstract Expressionism but were loathe to give it a label all its own. The debate over the existence of a San Francisco School mirrored other arguments regarding the coherence of a new style of "American-type painting," viewed until the fifties as a collection of individual approaches to abstraction and only later granted coherence as New York School painting or Abstract Expressionism. Artists on both coasts were anxious not to appear derivative and were worried about the flattening effects that a movement label threatened.

Arguments over the existence of a San Francisco School also foreshadowed artists' resistance to the Bay Area Figurative label, exacerbated by the fact that figuration itself was loaded with past associations and political significance. The hard-won hegemony of Abstract Expressionism as the first national style rendered any deviation from it doubly suspect: simultaneously a defection from progressive trends and a regression to dangerously politicized forms. The individuals who conducted the Bay Area Figurative "defection" perceived it quite differently, of course. Like others in New York and abroad, they viewed the dominance of Abstract Expressionism as a form of stultification. Figuration seemed to be a way of saving that which was still vital and dynamic in the Abstract Expressionist style, a way of moving forward, of encouraging a more generous personal vision. In their minds, and increasingly in those of others, they were not "the killers" of the San Francisco School so much as the liberators of its spirit.

FIG. 1.7. David Park, early 1950s. Courtesy of The Oakland Museum.

CHAPTER TWO

FIRST DEFECTIONS FROM THE
SAN FRANCISCO SCHOOL

*Art ought to be a troublesome thing, and one of my reasons for painting representationally
is that this makes for much more troublesome pictures.*

DAVID PARK (1957)[1]

THE FIRST OF THE KILLERS · Fred Martin had identified David Park and Richard Diebenkorn as the killers of the San Francisco School, and yet elsewhere he defended them for taking "the decision to do as one pleased rather than to try to participate from a distance in the New York scene."[2] This ambivalence about Park's rejection of abstraction—was it murder or euthanasia?—still characterizes discussions of the period. Moreover, ambivalence is embedded in the legend of the death itself, which has taken on mythic dimensions over the years. Rather than undergoing a slow transformation, Park's abstractions were said to have disappeared through a climactic act with religious or apocalyptic overtones: reputedly he drove them to the dump and released or ritually destroyed them.

Like many legends, this one is largely apocryphal. In Paul Mills's extensive interview notes, only Park's aunt mentions the trip to the dump, and Park's colleagues were seemingly unaware of the change until the following year.[3] Diebenkorn, who had been Park's student, colleague, and friend, recalls that nothing had changed by the time the Diebenkorns left for Albuquerque on New Year's Day, 1950.[4] It was not until he saw a reproduction of a figurative work by Park in the spring of 1951 that Diebenkorn knew of Park's changed style. He remembers reacting with great dismay: "My God, what's happened to David?"[5]

There are several indications that the change was not complete until the summer of 1950. Park's entry in the spring 1950 annual of the San Francisco Art Association, although unillustrated, is titled simply *Horizontal Painting*, suggesting a non-objective work,[6] yet Park submitted a figurative painting to another exhibition only a month later.[7] Complicating matters

further, an article in a local newspaper discussed the dominance of abstract work "at the Metart galleries and in all the large museum shows," and Park is quoted extensively, speaking in support of artists working in a non-objective style.[8] The article is subtitled "Leaders of New School, Variously Known as 'Spiritist' and 'Blob,' Tell Theories," and its topical pretext is an exhibition of work by Hassel Smith and Richard Diebenkorn at the Lucien Labaudt Gallery. Thus, although the evidence shows that Park was painting figuratively by the spring of 1950, he was still willing to defend non-objective painting to the curious press—and was still considered a leader of the "new school." The implication to be drawn is that the famous ritual dumping of abstraction was not as final as it was later portrayed; Park was juggling his new figurative interest and his non-objective reputation at the same time.

Park's defense of abstraction reads (with the acuity of hindsight) as a covert justification for his own stylistic leap. He begins by disparaging the average person's art education, which "rarely progresses beyond the two-year-old stage where a child identifies a dog, a duck or a rabbit in a picture book." Viewers, he suggests, need to discover composition, color relationships, and mood, for these qualities "are to be found in fine painting of any type." Going beyond these fairly mild defenses, in which abstraction is hardly given priority over any other type of painting, Park emphasizes the analogies between abstract and representational painting and points to artists' absolute freedom to move between them. His arguments in favor of abstraction are worth quoting at some length, for they would later echo in his comments about his own decision to return to figuration:

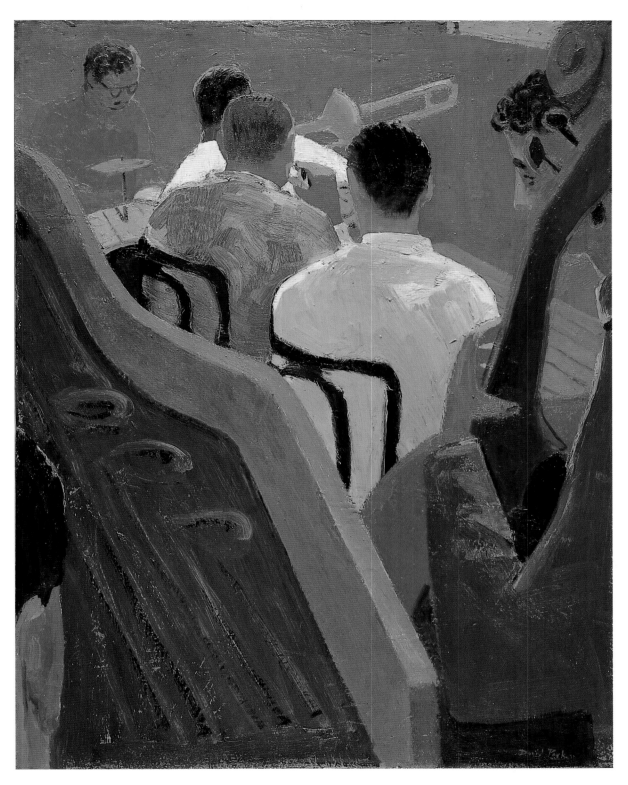

FIG. 2.1. David Park, *Rehearsal,*
1949–50. Oil on canvas, 46 × 35¼ in.
(116.8 × 90.8 cm). The Oakland Museum.

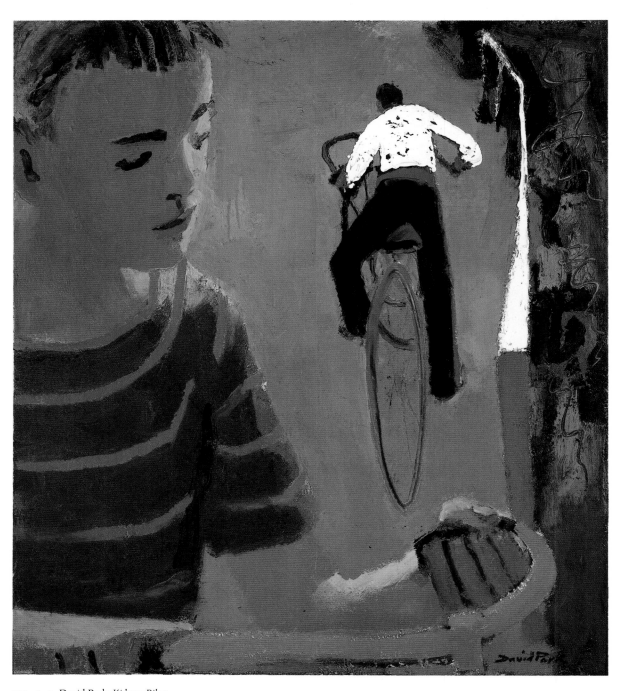

FIG. 2.2. David Park, *Kids on Bikes*, 1950. Oil on canvas, 48×42 in. (121.9×106.7 cm). The Regis Collection, Minneapolis.

Even though contemporary work such as Hassel's and Dick's is painted with larger brushes than is customary and with freer application of color, many of their concerns are not too different from the concerns of a good representational painter. . . . Attempting to get your ideas out may mean standing firmly on your own convictions regardless of how it offends the established tastes. . . . Hassel and Dick would be the first to say they have no idea how they are going to paint next year. They are not fixed to one idea. If this leads to a different way of painting that may have a richer personal significance to them, they are in no way bound to continue in their present direction. . . . Artists are people, and they are apt to be more willing to change and grow than is the more conservative layman. Maybe not all of these things being done now are good, but you don't know until you've tried. And if you feel strongly about them, you should try them.[9]

Park's try-it-and-see attitude is a fairly tame and tolerant approach to painting, suitable for the defense of either abstraction or representation. Its mild, non-combative stance must have contributed to the generally slow response to Park's new figurative work. Fred Martin is the only artist who recalls anyone seeing one of these early figurative works in Park's studio, but he also remembers that its significance was unclear at the time: "At this moment [during the peak of San Francisco Abstract Expressionism] someone saw David Park starting to paint a man looking out a window at a distant mountain. Though no one knew it, the San Francisco style was passing then its zenith."[10]

The painting mentioned in Martin's anecdote was either painted over or lost; the painting now identified as the first in Park's new figurative style is *Rehearsal* (fig. 2.1). *Kids on Bikes* (fig. 2.2) is sometimes given priority, but *Rehearsal* was the first to be exhibited in March 1950.[11] It seems to have made little or no impression on anyone at the time, as there are no comments in print or recorded in subsequent interviews. The full impact of Park's change was not felt until the following spring, when *Kids on Bikes* was shown at the San Francisco Art Association Annual and won a major award.[12] Documented by an illustration in the published catalogue, *Kids on Bikes* suddenly publicized Park's figurative defection, with dramatic results. The prior exhibition of *Rehearsal* had made no such impression.

This is only the first example of a dynamic that consistently characterized the Bay Area Figurative movement: its salience in the eyes of San Francisco artists was proportional to the recognition it received in the outside world (even if that world was the highly circumscribed one of the local art annuals). The Art Association award and published illustration gave *Kids on Bikes* an immediate fame and corresponding notoriety not given *Rehearsal*—yet in many ways, *Rehearsal* is the more provocative painting.

Unlike Park's earlier genre paintings of musicians (fig. 2.3), *Rehearsal* blatantly rejects harmonious composition and narrative in favor of abrupt juxtapositions more closely linked to the artist's Cubist-inspired puzzle paintings of interlocking profiles from the forties (fig. 2.4). Colleagues confirm that *Rehearsal* depicts the Studio 13 Jazz Band formed by MacAgy in the early years of his tenure as director of the California School of Fine Arts, and that the members are Park on piano, MacAgy on drums, Charlie Clark on clarinet, and John Schueler on bass (fig. 2.5).[13] But these are hardly portraits. With the exception of the percussionist and the bass player, the band members turn their backs on us—the ultimate in what art historian Michael Fried terms *absorption* in contrast to *theatricality*.[14] The composition reinforces the narrative closure: while the exaggerated diminution of the figures draws us into the picture, the open maw of the piano—taking up almost half of the painting—returns our gaze to the surface. Contradicting this modernist reinforcement of the picture plane, however, is the bracketing *repoussoir* made of the cropped bassist and the slice of Park's ear, which frames the view and suggests depth in the image. Other playful contradictions inhabit the background, where the bentwood chair backs terminate abruptly at the edge of the players' shirts, becoming patterns rather than objects in space.

By contrast, *Kids on Bikes* is a far less complex composition, although many of the same devices are at play. Here the flattening of the picture plane is initiated by the barely inflected ochre ground, the abstract olive vegetation, and the vertical leg of the background biker, limned with red as if in a sly reversal of Manet's *Fifer*. Once again this modernist flatness, so important to the Abstract Expressionists on both coasts, is contradicted—this time by the fence diminishing into the distance at the right, and the framing boy at the left.

Diebenkorn remembers that the juxtaposition of large foreground figures with a miniaturized background scene was Park's way of rebelling against the formalist belief in the sanctity of the picture plane. He recalls Park snorting, "Ridiculous! I'd like to break the damn picture plane!" in response to criticisms of his spatial devices from an abstract painter. Park also

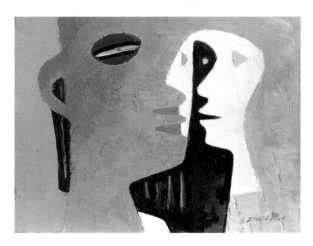

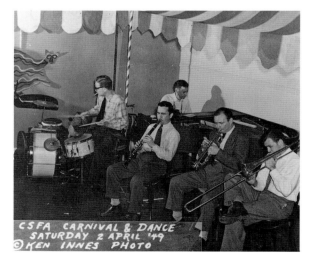

FIG. 2.3. David Park, *Untitled*, ca. 1930. Oil on canvas, 25¼×34 in. Collection of Mr. and Mrs. Roy Moore, Santa Barbara, California.

FIG. 2.4. David Park, *Encounter*, n.d. Oil on Masonite, 10×12 in. (25.4×30.5 cm). The Oakland Museum.

FIG. 2.5. Studio 13 Jazz Band, including David Park on piano and Douglas MacAgy on drums, playing for California School of Fine Arts Carnival and Dance, 1949. Courtesy Archives of California Art, The Oakland Museum.

teased Diebenkorn about the younger painter's observance of the formalist rules: "He would sort of get on me for respecting the picture plane . . . he would call me 'tasteful.'"[15]

In his rejection of the canons of formalist flatness, Park turned to earlier painting for inspiration. Friends recall that he loved the illusion of deep space found in works such as Diego Velázquez's great *Las Meninas*, as well as the shallower, rhythmically patterned space in the enigmatic frescoes of Piero della Francesca. But if these were Park's models, they were seldom apparent in the paintings. The space in *Rehearsal* and *Kids on Bikes* is disjunctive, cropped, and contradictory, closer to its treatment by Edgar Degas, Edouard Manet, or even Giorgio de Chirico than to the work of premodern painters. Thus even in these early, somewhat awkward figurative works, Park was striving for a union of traditional subject matter with selected modernist formal devices. That this did not at first appeal to his abstractionist colleagues was a result of their prejudice against any kind of recognizable subject matter. It also stemmed from the sheer awkwardness, corniness, and innocence of Park's early attempts.

LOCAL RESPONSES AND THEIR SOURCES

A few of Park's contemporaries thought that *Kids on Bikes* was a wonderful painting: "The whole picture just shone—it was the white on the shirt of the bicycle rider. . . ."[16] But even colleagues like Bischoff, who were not particularly surprised to see Park return to figurative subject matter, still found the work "a pretty flat-footed painting . . . a sort of outlandish, goofy thing."[17] Diebenkorn felt even more strongly: "I didn't like it then, and still don't like it as a painting—it contains some of the worst kinds of stylizations David Park would use."[18]

By far the strongest adverse reaction came from the supporters of Clyfford Still, who also set the terms by which Bay Area Figurative art would be judged on the East Coast. Frank Lobdell, Hubert Crehan, and others called Park's move a "failure of nerve"; Hassel Smith concurred: "I have thought it was [a failure of nerve] myself at one time or another."[19] Park, of course, had never been in Still's camp—he was seen instead as a leader of the San Francisco School in opposition to Still's New York School leanings. There was in fact a substantial schism between the two, an understanding of which is important for assessing the nature of the local response to Bay Area Figuration. Park's defection con-

stituted a direct threat to Still's legacy, and artists like Hassel Smith disparaged the new figurative painters as being entirely motivated by antagonism to Still—his painting, his personality, and his privileges at the school: "[Still] threatened their cozy bohemianism, made mincemeat of their post-cubist preoccupation with simultaneity and other 'space' problems. Some provincial jealousy may also have been involved."[20]

"Provincial jealousy" is a cruel way to put it, but there is no doubt that Park and others who had been at the California School of Fine Arts before Still felt that the locals were not being treated fairly. James McCray, a faculty member who had met MacAgy at the Barnes Foundation in Merion, Pennsylvania, before coming to California, recalled:

> Still was the little Tin God at the school and those other fellows felt left out—they felt that Douglas wasn't treating them that well. Plus he [MacAgy] got a big salary, [which] put MacAgy in another social class altogether. It was on the basis of this that [David] eventually revolted. [It was never] on the basis of personalities—it had to do with establishing rights for teachers. We wanted some guaranty against arbitrary dismissals—David led the fight for those things.[21]

Diebenkorn remembers that the conflict was not quite so independent of personalities: "David hated Still's guts. Before Still came—MacAgy's first year, when I came in '46—David was a respected painting teacher." Diebenkorn went on to describe the star system that MacAgy helped create, recalling that a gifted young student, Ernest Briggs, took his course the first semester, but was quickly siphoned away when MacAgy learned of his talent: "By the next semester [Briggs] was the star of Still's class."[22]

Given Park's reasons for opposing Still and what he stood for, it is perhaps surprising that Park had an Abstract Expressionist phase at all. Even when defending the experimental virtues of abstract painting in the article of 1950, Park ended on a note that could only have sprung from his exasperation at the cult of personality Still had fostered at the school: "'Artist' is a lousy word in our age. It has come to mean [someone] who sets himself up as a high priest, and the public expects him to produce a continuous flow of masterpieces."[23]

Even in 1947, at the fervent beginnings of his abstract period, Park's outlook differed radically from Still's, as indicated by their teaching. Here is Still's course description from that year, which contains a strong and didactic formalism within its rhetoric of imaginative and expressive discovery:

> *Drawing and Composition*: Problems of composition are suggested to acquant [sic] the student with the possibilities of the mediums of space, form and color. Drawing is emphasized as an expressive tool. Subject-matter is drawn from life-studies and the material of the imagination. The goal is to help the student to achieve a grasp of the fundamentals of composition.

Compare it with Park's description for a similar class:

> *Line Drawing*: The drawings in this class are made in thirty seconds or a minute. Subjects are called out by the instructor and the students are timed. Subjects include landscapes, figures, insects, architecture, illustration of poetry, myths, memory drawings from the model, etc. The emphasis is on the use of the imagination. Speed is used to combat hesitancy.[24]

Park's description for an advanced painting class sounds even more like an intentional counterpoint to Still's demands. He lists among his aims that "students should develop their originality and independence [and] try to make working habits as genuinely simple, unself-conscious and vital as any process of nature." He concludes: "The class aims to get the student launched in his life long undertakings as an artist. Problems of form, color, representation, composition, etc. have been presented in other classes."[25] By contrast, Still's class on space organization still emphasized that "Invention and the fundamentals of design become a process of discovery."[26]

But if Park wanted to counter Still's influence, it was not always by playing warm to Still's cool, or nature to his culture. Park was as passionate as Still about art, teaching, and the fate of his students, and similar phrases arise in discussions about both men. Hassel Smith recalls that "Dave felt rather strongly that the Still influence was a pernicious one," and began to promote a "counter-cult" among the students.[27] One reviewer, writing a few years after Park's death, noted "there is something of the cult of personality connected with him (there was even before his death). . . ."[28] And one of his closest friends and colleagues, Elmer Bischoff, recalled Park's response to Still with harsh, if insightful, words:

> David Park had, to a certain extent, authoritarian tendencies; he was a strong-willed person; he was, in the class room, that way; his students often spoke of him in those terms, they liked him immensely, but he had this kind of tendency and there could possibly have been some feeling on his part in regard to Still that would have been something less than warm and receptive and friendly.[29]

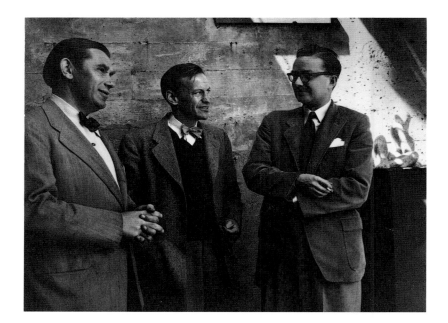

FIG. 2.6. Left to right: Ernest Mundt, new director of the California School of Fine Arts; David Park, Summer Session director; and Douglas MacAgy, outgoing director, 1950. Courtesy San Francisco Art Institute.

Park's antagonism toward Still was, in the end, overdetermined. Still, who once came to a school costume party dressed in a monk's cowl, was often described by students and colleagues in religious terms: "He was almost like a Calvinist who had to face the reality of the breakdown of materialism." "Somebody called him a Holy Roller, the Mid-West preacher." "Still works in terms of black and white, good and evil, and kind of the old sin concepts of life. . . . He is a puritanical personality."[30]

Park knew this austere and moralistic world. His father was a Unitarian minister against whom he had been gently rebelling for more than thirty years. Still was the educated verbalist, Park the self-taught, anti-intellectual intellectual. Still had been to college and had studied art history extensively—he had even obtained a master's degree. Park, by contrast, had only scraped through high school and a few classes at the Otis Art Institute and Berkeley Summer School. Although Still had once thrived in academia, now he despised it; Park cherished friendships with Berkeley novelists and scholars of rhetoric and music even before his appointment to the University of California faculty. Still recalled his young manhood as a time when "my arms have been bloody to the elbow shocking wheat,"[31] while Park wrote his mother proudly at age eighteen about how he had answered a question in a philosophy class, surprised that the professor was pleased at his "ignorant" response. Admitting that "What I know about Ethics is nothing but what I know about Metaphisics [sic] is one hundred percent less," he asked his mother to "be sure and tell . . .

Marion" (Park's younger sister) about the professor's approval, because "I've got to impress my family with the fact that I'm not as dumb as I look."[32]

Whether or not Still felt at all threatened by Park, for Park, Still came to be the hard, unforgiving "man who preached hatred" (in one older colleague's words).[33] Park's early conversion had soured, and he was as ready as anyone for a change at the California School of Fine Arts.

By the spring of 1950, with enrollment falling and money from the G.I. Bill drying up, the school was clearly returning to hard times. Trustee support for innovative programs was eroding, and MacAgy decided to leave the directorship to make documentary films in the Pacific Northwest. Now, for the first time in years, there was a power vacuum, and with it came the possibility of a direct challenge to the Abstract Expressionists' preeminence at the school. Park was in many ways an obvious leader for the opposition. He was a longtime member of the community, a senior teacher on the staff (appointed prior to Still), and a real presence at the school; along with Still, he was one of the few professors with a studio in the building. According to some, he had not supported MacAgy's efforts for some time and certainly had his own ideas about what was best for the students.[34] There must have been talk about who would be taking over, because Still apparently made it clear that "if either David Park or Ernest Mundt were made directors, he would leave."[35] Park was named acting director during the summer of 1950 (fig. 2.6), and Still left for New York soon thereafter.[36]

Of course there was more to Park's new figuration than the liberation of his political will. For one thing, his art had been figurative since childhood, through phases of American scene painting and Picassoesque portraits.[37] There is a general consensus that Park's short-lived essays in abstraction had been covertly figurative all along, and his surviving abstract work, *Still Life Non-Objective* (fig. 2.7), strongly suggests an arrangement of flowers.[38]

Despite the fame of his Abstract Expressionist work in some quarters, it is clear that it never satisfied Park. Although he could still say in 1952 that "I believe the best painting America has produced is in the current Non-objective direction," a year later he acknowledged somewhat ruefully that his own Abstract Expressionist paintings "never, even vaguely, approximated any achievement of my aims. . . . Other people's reactions seemed to vary . . . but none of them held a candle to the insistence of my own reactions."[39]

Park's statement in 1954 to the critic Alfred Frankenstein expanded upon what he had said the previous year, and it is worth quoting at some length for what it reveals of the issues at hand:

> During that time I was concerned with big abstract ideals like vitality, energy, profundity, warmth. They became my gods. They still are. . . . I still hold those ideals today, but I realize that . . . what the [abstract] paintings told me was that I was a hard-working guy who was trying to be important.
>
> Gradually it dawned on me that my attention was always being drawn away from the painting and directed to the painter. . . . Three years ago, [I] was too much concerned with the direction that art would or might take, too much with my thoughts on the future of painting and not enough on the present. I believe that we are living at a time that overemphasizes the need of newness, of furthering concepts.[40]

This concern about the "overemphasis on newness" is one reason why Park did not want to acknowledge that his figurative painting could be the start of a movement. Park, and those who joined him, presented the new figuration as an *escape* from self-consciousness, from ambition to join "art history," and from style itself. Significantly, Park felt that even his earlier figuration had been mannered, and only the new work was truly representational and free from affectation:

> I call [these new works] pictures. The work that I have been doing previously I call paintings. They were non-objective, before that abstract, and earlier still they were

FIG. 2.7. David Park, *Still Life Non-Objective*, 1949. Oil on canvas, 34 × 25 in. (86.3 × 63.5 cm). The Oakland Museum.

highly stylized compositions not directly concerned with representation. For more than twenty years I had preferred other qualities to those of representation.[41]

As Diebenkorn recalls, "it was a kind of anti-style thing—style was a threat to individuality. [Park had] utter disdain for the New York School; he felt that New York put style absolutely first. He was thrilled by going way out on a limb."[42]

That Park's new stance could not actually *be* so neutral, or so isolated, was due in part to the charged political environment: Park's figuration emerged simultaneously with the departure of Clyfford Still and the changing of the guard at the School of Fine Arts and was inevitably seen by Still-partisans as a reactionary turn. Once the movement was recognized by critics (after Mills's exhibition in 1957), it gained further prominence within the larger critical context, in which figuration seemed to be an antidote to the proliferation of Abstract Expressionist imitators in the United States and abroad.

But before Park's isolated defection could be considered a movement, it required the participation of talented colleagues such as Elmer Bischoff and Richard Diebenkorn. Their contributions brought coher-

FIG. 2.8. Elmer Bischoff, *Untitled*, 1946. Water-color, gouache, and ink on board, 14⅜ × 18¾ in. (36.5 × 47.6 cm). San Francisco Museum of Modern Art.

ence and identity to the development, and they challenged Park to give his figurative work an ambition and rigor it had not previously possessed. As the first to join Park in his dramatic shift, Elmer Bischoff played a particularly crucial role in the evolution of the Bay Area Figurative style.

ELMER BISCHOFF'S
TURN TO THE FIGURE

Like Park, Bischoff had a prolonged phase of what he later described as "Picassoesque mouthings" in the late thirties and early forties, but his subsequent Abstract Expressionist period was more complex and successful than was Park's.[43] Accordingly, it is more difficult to understand his eventual abandonment of the abstract style, which he seems to have taken far more seriously than Park ever did.

Returning from the war in 1945, Bischoff felt that all his previous assumptions about art and life had to be challenged. "Until then art had been an external acquisition; [now it] became more of a quest."[44] Hired as a short-term replacement at the School of Fine Arts in 1946, Bischoff was kept on by MacAgy and became an avid participant in the heady, experimental postwar scene:

> Never before and never since have I known an organized group of people to be so free-wheeling and yet purposeful, so warm, open and encouraging, and yet demanding. . . . The school was like a monastic brotherhood composed of members recently liberated from a world of semi-darkness. . . . In general, for the people at the school the aesthetic experience, at its most intense, was of the order of a religious illumination . . . but the voice emanated from the artist, not "beyond."[45]

Bischoff is adamant that the school "didn't have to wait for Still" to become Abstract Expressionist, and his own work suggests that he was acutely aware of what was already happening in New York.[46] An untitled watercolor from 1946 (fig. 2.8) shows him to be learning from early Rothko, whose *Slow Swirl by the Edge of the Sea* had been acquired by the San Francisco Museum after the large Rothko exhibition that same year.[47] Bischoff remembers the impact the painting had: "I thought [Rothko's] earlier style was absolutely tremendous . . . very present and very mysterious. [It was] loaded with overtones."[48]

Unlike Park, whose conversion to abstraction was apparently sudden, Bischoff went through an evolution similar to that of Arshile Gorky, in which he slowly worked through the styles of Picasso's Synthetic Cubism and Surrealism to attain his own approach to abstraction. He had earned both undergraduate and graduate degrees at Berkeley, studying with Margaret Peterson and Erle Loran, devotees of Picasso and Cézanne. In the Berkeley program, Picasso's Analytic and Synthetic Cubist works were emphasized at the expense of his Surrealist ones, and Cézanne was presented as the artist of cubes and cones and tight compositional structure. Bischoff thus experienced Abstract Expressionism as a liberation from his student values, which had tied the French painters to a formalist tradition. After he left school, Bischoff replaced Picasso with Kandinsky as his hero, and French rationalism gave way to an interest in Eastern European art and Surrealism. Significantly, for Bischoff Impressionism became the first bridge out of Cézanne and Cubism toward the immediate impact of Abstract Expressionism:

> It seems like [Impressionism is] so direct that everybody will be able to understand the generosity, the courage, the spiritedness, the immediacy, the candidness, the thereness, the images on that canvas, all these things. And you go up to an Impressionist painting and it's obviously pigment on a piece of cloth. You go up to an academic painting, and they don't want you to ever think this is pigment on a piece of cloth.[49]

Thus, although he valued the mystery and the overtones of early Rothko, Bischoff was soon drawn toward the promise of immediate communication that later gestural forms of Abstract Expressionism seemed to offer. Unlike Park, Bischoff readily accepted the utopian idealism that Still and others projected onto the new abstract language, reflecting the postwar optimism of a potentially peaceful and united world:

[When we were painting non-objectively,] when we were creating that, it had a timeless and universal feeling. It's as though you're talking to mankind over the face of the globe. . . . I think the forms that emerged on the canvas were looked upon as gestures that almost embodied a language . . . a sign language, potentially readable by anybody.

[There was] the trust that gestures in paint on canvas, gestures in welded metal and wood and plaster and stone could become a sort of visual Esperanto, liberating to all who had eyes.[50]

As to *what* was communicated or liberated, Bischoff's suggestion seems to be a combination of Still's iconoclasm and his own gentler, more idealistic aims:

[The artist] himself was seen as needing to stand as a fortress against the disuading [*sic*] and subverting forces of the outside. . . . I would say there were few at the school who did not have some underlying trust that their work might play a role in the forming of a better world—that it might assist toward a deeper understanding between people, even peoples, and aid in the bringing about of a true fellowship of man.[51]

Bischoff's abstract works have nothing of the turgid, palette-knifed surface of Park's surviving late non-objective canvas. Diebenkorn remembers that the main thing Abstract Expressionism showed Park was "how far he could go with paint": "He was in *love* with oil paint and its capacity to become *merde* which he manipulated with frank relish. . . ."[52] Bischoff remembers being affected by the physicality of Park's canvases, their "very powerful presence, very powerful material presence." And he recalls that the education at the School of Fine Arts "had to do with that switch from an emphasis on products to an emphasis on *process*."[53] But in his own work, by contrast, he maintained relatively mute surfaces (fig. 2.9). There are layers of paint, but each is scraped and smoothed so that it remains hidden under the new skin of pigment—the process is there, but it is effectively masked in the finished painting.

What Bischoff learned about process, then, was neither about action painting nor about using the canvas as an "arena" for uncompromising gestures. For Bischoff, process was about the image revealing itself during the act of painting; "preparatory sketches and studies preliminary to making a painting or sculpture," he felt, "were decidedly not part of the process."[54] The image would be discovered through painting, but for Bischoff all stages of that process were not revealed to the viewer.

During his Abstract Expressionist phase, Bischoff

FIG. 2.9. Elmer Bischoff, *Portrait with Red*, 1948. Oil on canvas, 41 × 33 in. (104.1 × 83.8 cm). The Oakland Museum.

also learned about color and about freeing line from its function as underlying armature so that it could float across the surface of the work. By the end of the forties his non-objective works came to include more specific forms, and color is contained and less atmospheric. As with his development into Abstract Expressionism, Bischoff's conversion to figuration was gradual and was a result of broader changes in his life rather than dissatisfaction with his past work. Where Park had moved swiftly into abstraction, and fairly swiftly into figuration, Bischoff approached each new step with deliberation.

Although they had visited each other's studios for years (together with Smith and Diebenkorn), Bischoff and Park moved away from abstraction at different times and seemingly for different reasons. Bischoff has acknowledged that Park's prior shift was important in pointing the way toward a possible new direction, but changes at the School of Fine Arts may have proved as influential in his decision as they had been for Park.[55] For Park, liberated by Still's and MacAgy's departure, the change was a wholly positive one toward a more personally satisfying way of working. Bischoff's move three years later had a more negative cast, however, for by then the situation at the school had deteriorated, forcing him to rethink his artistic career.

FIG. 2.10. Elmer Bischoff, *Blues Singer*, 1954. Oil on canvas, 55×72 in. (139.7×182.9 cm). The Oakland Museum.

In the fall of 1950, the board of the California School of Fine Arts appointed Ernest Mundt director, trying desperately to cut costs by using him "as the handy man for getting rid of some of the faculty they didn't want any more."[56] Mundt was "an old Bauhaus man. . . . They were trying to work the school into a kind of Bauhaus, all this form and function, design."[57] First Mundt fired Edward Corbett, and Park and Bischoff were "flabbergasted." Although they didn't always agree with Corbett's tight, Mondrian-esque style, they knew him to be a "first-rate teacher and artist." When rumors began to circulate in 1952 that Hassel Smith was to be next, the two men "went to Mundt and said 'if you fire Hassel, we quit.' So he fired Hassel and we quit."[58]

For both Park and Bischoff, the next few years were painfully isolating and gloriously productive at the same time. Park earned money by doing window displays in liquor stores, which he loathed and found so humiliating that his wife decided to go to work at the university library to support him and the family on what he gratefully called the "Lydia Park Fellowship." Bischoff, after looking for teaching jobs up and down the coast, worked for Railway Express loading and driving delivery trucks—a job so exhausting that all he could manage in the way of art were small drawings during lunch hours and breaks.

I found myself drawing figures at every opportunity. I parked my truck outside of Foster Cafeteria and . . . spent a lunchtime . . . drawing people through the

glass, drawing people sitting, having lunch, drinking coffee, chatting at the tables and so forth.[59]

The sense of pathos and loneliness that this description conveys may not be illusory. Bischoff consistently compared his disenchantment with abstraction to the end of a romantic attachment:

There was a definite cooling off. I can only compare it to the end of a love affair. When I was in the real grip of Abstract Expressionism, the marks and gestures had a hyper existence. But it was your own passion that inflamed these things, and there was just a gradual loss of this passion.

[It was] like falling out of love. Automatically this would bring a lot of these questions and doubts to mind. And then [it] seems inauthentic, it seems cooked up.[60]

For Bischoff, figurative work was a way of getting outside the "cooked-up" artificiality of abstraction, with its demands upon the self for invention. Paradoxically, figuration was also falling in love again, a return to feelings and a way of expressing them, perhaps in order to expel them:

In dealing with representational paintings, . . . you're starting with things that exist externally to oneself, and you're talking about these things in terms of your response to them. You're not pretending that you're creating them . . . out of your insides. [It's saying] "Here is something that exists out in the world that I think is worth dealing with, that I have certain responses to, that I have a certain love for, possibly, and I want to

show that in a canvas, I want to show my responses to this in the canvas, as opposed to inventing a brand new language."

Ideally, one would wish to do away with the tangible facts of things seen . . . and deal directly with the matter of feeling.

A "unity of feeling" is the principal end. . . . What is most desired in the final outcome is a condition of form which dissolves all tangible facts into intangibles of feeling.[61]

After a year and a half of underemployment, Bischoff became head of the art department at Yuba College in Marysville, California (about 100 miles northeast of San Francisco). He moved to Marysville with his new wife and small son in the fall of 1953, working feverishly, "determined to paint my way out."[62] For three years he pursued a new figurative style, painting all summer long and getting up at four in the morning during the school year to work before classes.

One of the earliest of these canvases is *Blues Singer* of 1954 (fig. 2.10), an enormous work with a bold composition that is not entirely successful. The right half of the painting is filled with the figure of a towering black singer, shown as she would appear to a spectator seated at the level of her hips. The left half is a vortex of paint, which attempts to describe the satin swags that decorate the ceiling but threatens to suck our gaze away from the singer into the knot at its center. The frieze of silhouetted musicians is reminiscent of Degas's café-concert paintings—but here, the singer is not menaced by aggressive cello necks; rather, she entirely dominates both the men at her side and the satin vacuum above her.

Despite its awkward composition, the painting is already accomplished in its virtuosic brushwork and its idiosyncratic use of color. The drapery is a violent mélange of reds, greens, and orange; the singer's skin is mauve with green highlights. The figures of the musicians are green and blue against chartreuse and peach; they are echoed in the singer's blue glove.

Orange Sweater (fig. 2.11), painted the following year, offers a striking contrast. Its palette is equally unusual but is comparable to the silvered greens of Corot rather than *Blues Singer*'s fin-de-siècle mauved aquas. The composition is also gentler and more balanced. The deep, receding space of the room is filled with incidental and reflected light and broken by columns, a mirror, and the barely converging planes of a two-tone panel on the right and a window grid on the left.

The figure wearing the sweater of the title is positioned just off center in the painting's lower third. It is small and marvelously understated, making clear as *Blues Singer* did not that Bischoff's interest is not in the character or personality of his figural subjects but in the concerted impact of the figure within a particular environment. The orange sweater is the heart of the painting but, like a heart, is sensed more than seen. The warm color pulses up the figure's left side and seeps under the cool green of the walls into the line bisecting the canvas. Edges of the same umbrous orange remain from the painting's earlier stages, bordering the open window and vibrating under the green wall. A second, even more anonymous figure (or mannequin?) is a pale ochre echo in the background. The wonderful greens—unnaturally monochromatic—become persuasive as representations of heavy plate glass, watery light through summer fog, peeling institutional paint, and leafy branches of an aggressive tree thrusting through the window.

Bischoff was highly successful with these early figurative works, winning first prize at the 1955 Richmond Art Center Annual[63] and receiving a solo show at the Paul Kantor Gallery in Los Angeles. The exhibition that had the most impact on his future career, however, was a one-person show of paintings and drawings installed in January 1956 at the California School of Fine Arts gallery. Bischoff believes that it was the evidence of this show that brought him a job as head of the new graduate program at the School of Fine Arts under its new director, Gurdon Woods.[64]

The overwhelming emphasis in Bischoff's lengthy statement that accompanied his exhibition was on *feeling* (the word occurs fourteen times in two pages). As suggested by his Abstract Expressionist works, Bischoff implied that the process of making the painting should be less important in the finished work than its overall emotional impact. He opened his statement with two carefully chosen epigrams, one from an aesthetician and the other from an artist:[65]

The artist shows us the appearance of feeling in a perceptible symbolic projection. . . . The effect of this symbolization is to offer the beholder a way of conceiving emotion. *Susanne Langer*

I want to get to the stage where nobody can tell how a picture of mine is done. What's the point of that? Simply that I want nothing but emotion to be given off. *Picasso*

Years later, Bischoff spoke of his shift from the formal issues that had been stressed during his training at Berkeley to the new values he found in figurative work. For him, the externally imposed intellectual values of design, order, and clarity (residing in line

FIG. 2.11. Elmer Bischoff, *Orange Sweater*, 1955. Oil on canvas, 48½ × 57 in. (123.2 × 144.8 cm). San Francisco Museum of Modern Art.

and composition) had become secondary to internally discovered emotional and expressive values (residing in color and light):

> Light and color were paramount as expressive content and also as organizational elements. . . . I guess this could represent some kind of rebellion against my early schooling where "organization" of a painting was always seen as an organization of contours, a continuity and relatedness of edges. But to me it was always painters like Rembrandt and Titian who exerted a positive attraction. In their work it doesn't matter where you place things in the picture. Color and light are the primary organization forces.[66]

In his 1956 statement he wrote poetically of the frustration that this search for non-intellectual values often entailed and expressed his hope that the "inexactness" of communication through color and shape would not prevent the viewer from understanding the feelings he was trying to convey:

> One dreams of moving free of the shapeliness of shapes and the colorfulness of colors only as one would wish the ability somehow to converse in silence and so avoid the inexactness of words. But in actuality the visible facts of the paint on the canvas clarify and refine the painter's feelings. . . . Without the repeated attempts to objectify his feelings in this concrete form these feelings would remain lodged inside him as vague and dis-

turbing promptings and, in the light of outside utilitarian demands, appear as mere foibles.[67]

Bischoff's statement can be read as a quiet manifesto for the type of figurative painting with which he wanted to be identified. He did not want to transcribe reality mechanically, as in a photograph. Like Park and, later, Diebenkorn, Bischoff never painted directly from a model but relied on visual memories and drawings to provide images for his work. Such memories had attributes for Bischoff suggesting the Jungian collective unconscious: a shared pool of archetypal images which would resonate for all human beings. Hassel Smith vividly remembers Park and Bischoff trying to get him to read Jung,[68] and the following passage from Bischoff's statement echoes certain Jungian ideas:

> It would seem that the mind, or some curious and secretive part of the mind, is given to an endless process of selecting out and hoarding memories of experience. These memories are not in the category of those that can be recalled at will. . . . Rather, they are of the order of formless but potent forces that persist apart from conscious memory. . . . From time to time some fragment of the every-day world will, of a moment, make connection with one or some of these forces, and for the moment the fragment and its surroundings will come alive with an arresting vitality.[69]

The goal of his new figurative painting, Bischoff suggested, was to raise such shadowy experiential memories "above the level of commonplaces" by tapping "the intensity of one's feeling about them translated into paint." Yet for all his intense feeling, Bischoff has always maintained that his images are not autobiographical—an idea not easily dispelled after looking at his work. Knowing that he painted his first figurative-style nudes by observing himself in a mirror, admitting, "That's why the women in some of the paintings are so chunky," we may well ask what he intends by the refutation of autobiography.[70] Perhaps the autobiography is intended to be on the unconscious, even subliminal level of feeling, rather than on the literal, but cooler, plane of Park's in *Rehearsal*.[71]

Park had himself moved away from the specificity of genre toward the classicism of the nude in landscape, probably influenced by his renewed contact with Bischoff after the latter had turned to the figure.[72] Earlier, the "Lydia Park Fellowship" had given Park his most productive year ever. But the resulting paintings, most of them caricatured portraits or sharply observed group scenes, preserved the narrative and pictorial values of *Rehearsal* and *Kids on Bikes*, although these values were leavened by the satire and irony of Park's cutting social observations. Park continued to use the expanding-space device, in which massive foreground figures are juxtaposed with smaller background ones, employing it to great graphic effect in works such as *Audience* (fig. 2.12). By 1954, however, a dramatic change occurred in his work, moving it in the direction of Bischoff's enigmatic, universalized feelings and away from mannered compositional form. By the time Park painted *Nudes by a River* (fig. 2.13), the last of the obvious spatial devices have vanished, as have the figures' towels and props. The nude figures inhabit a space that is at once open and intimate, flat and expansive.

Diebenkorn recalls this transition of Park's as very sudden, and significant. Where Park's previous bathers had been clothed and engaged in ball games or other activities, now they simply stand, with a slightly lost expression, like the poignant central figures in paintings by Watteau. "Before, [it was] kind of [an] extension of the American representational tradition—a kind of genre thing—there had to be a rationalization for the presence of the figure. . . . At one point he was able to throw this off, and figures began to simply exist—simply exist on the canvas."[73]

In *Nudes by a River*, the bathers do "simply exist," but they are much more the subject of the painting than figures in Bischoff's work of the same period.

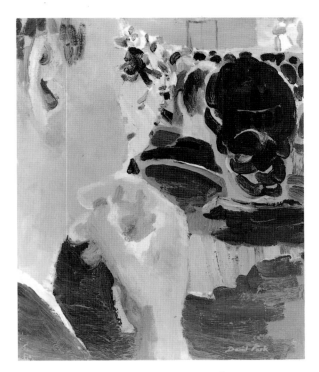

FIG. 2.12. David Park, *Audience*, ca. 1953. Oil on canvas, 20×16 in. (50.8×40.6 cm). The Oakland Museum.

Light serves the figures, suggesting psychological conditions rather than consistent properties of nature. Bischoff later explored this approach in all its nuances, but here Park is the pioneer. Thus the man turns his back to the light (*his* light—it has a different source than that illuminating the woman) and turns his head toward the receding dark blue center of the pool. The woman, as if in mirror image, turns her back on the water and plants her broad feet on the yellowed bank of the river. Her head inclines toward the light green corner of the canvas. Where the man's legs are shadowed, hers are bathed in pearly reflections from the water below.

These observations do not argue for some parable of enlightenment; it is more likely that Park was exploring an artist's version of the mathematician's "map problem"—exploring the exact number of colors required to differentiate adjacent areas. Here the light head is mapped against the dark pool, the dark head against the light, and so forth. But this formal game does not take away from the Bischoffian feelings evoked by the work, stirred particularly by the fact that the man is white and the woman black. Perhaps even this should not be made much of, since Park's favorite model, Flo Allen, was black (she was also the influential head of the Bay Area models' training program; see fig. 4.27). It is provocative, nonetheless, that in the year of the important civil

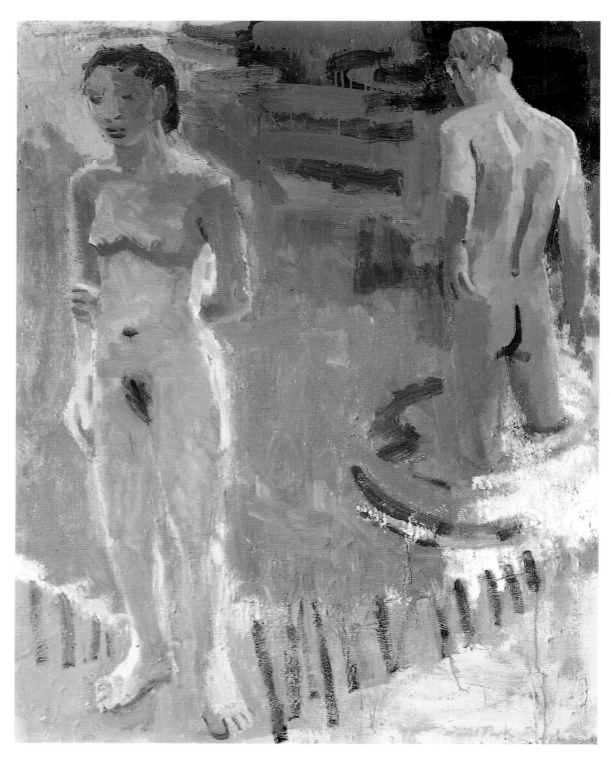

FIG. 2.13. David Park, *Nudes
by a River*, 1954. Oil on canvas,
59 ½ × 47 ¾ in. (151.1 × 121.3 cm).
The Chrysler Museum, Norfolk,
Virginia.

rights case refuting segregation in schools—*Brown vs. the Board of Education*—Park should paint a nude interracial couple, standing with their backs to each other like saddened lovers after a fight.[74]

Park's willingness to plumb personal memories and explore emotional issues is also suggested by the bold *Standing Male Nude in the Shower* of 1955 (fig. 2.14). The canvas shocks with its size, palette, and aggressive composition. The male figure is life-sized, deep red against yellow and cerulean blue; he meets our gaze with an unfathomable expression made more obscure by the shadow cast over his features. There is no effort at eroticism here, no coy avoidance of the viewer's gaze. The figure confronts us before we can gather our viewing apparatus; he ambushes us with his enigmatic stare and frank frontal pose. One critic wrote of Park's painting: "a nose, a chin, a breastbone, a patch of pubic hair—like biological chat"; another criticized the Bay Area Figurative painters in general for painting "Christian nudes": still hidden behind their fig leaves in shame.[75]

But the figure in *Standing Male Nude* is neither coolly biological nor ashamed. He is a hybrid of ages: his hairless torso and outsized hands and feet seem adolescent, while his head is that of an older man—possibly, as one critic has suggested, that of Park himself.[76] Diebenkorn's wife, Phyllis, has observed that Park's later nudes were always humans first, and males or females second.[77] It is in this spirit that *Standing Male Nude* seems to have been painted: part unabashed self-portrait, part generalized statement about corporeal, quotidian humankind.

The newly broadened vistas in Park's works (both literal and emotional) corresponded to the growing complexity of Bischoff's, and the two intensified their friendship when the Bischoffs moved back to the Bay Area in 1956. Diebenkorn, who had also returned to the area after working and studying in New Mexico, Illinois, and New York, must have found both artists' new paintings intriguing, for it was around this time that he turned toward the figure in his own work. For Diebenkorn as for Bischoff, Park was not the only source for his rejection of abstraction, but the charismatic older painter was a powerful and persuasive pioneer.

Diebenkorn Turns to the Figure

Diebenkorn took the largest risk of any of the artists by turning to figuration in the summer of 1955, for he had attracted considerable national recognition with his abstract work. The Solomon R. Guggenheim Museum had included one of his Berkeley abstractions in its *Younger American Painters* exhibition of 1954, and dealers in Los Angeles and Chicago had shown him extensively. In his first one-person show in New York, the abstractions were enthusiastically received by collectors, and one critic described the best works as "really splendid," hailing their artist as "a born painter": "His freedom, his unusual sensitivity to landscape and his undeniable daring in both color and form, mark him for important future achievements."[78]

Strengthening his ties to the New York art establishment, Diebenkorn had lived with his family in Woodstock for a year in 1946 and in Manhattan during the summer of 1953. He had met and become friends with some of the most important members of the art community, among them Franz Kline and the critic Clement Greenberg, and was sufficiently respected by Robert Motherwell and Ad Reinhardt to be included in their landmark publication *Modern Artists in America*.[79]

In addition to his growing national reputation, Diebenkorn enjoyed a strong local position as an abstractionist. In his first years as a teacher at the California School of Fine Arts, Diebenkorn had lived in Sausalito near the talented students John Hultberg and Frank Lobdell. The group became known as the Sausalito Abstract Expressionists, carving out their own identity within the San Francisco School.

Diebenkorn had even gained the respect of Clyfford Still and was certainly affected by the older artist's work.[80] Upon his return from New York to teach at the California School of Fine Arts in the fall of 1947, Diebenkorn saw Still's one-person exhibition. This experience, and the impact of the freewheeling paintings of student John Grillo, made Diebenkorn somewhat embarrassed by his own small, carefully composed works. Under Still's and Grillo's influence, he moved to larger canvases and tried to work free of contour line in favor of pure color areas. These more adventurous works became the nucleus of Diebenkorn's solo exhibition in 1948 at the California Palace of the Legion of Honor, organized by Jermayne MacAgy. By 1949, Still's influence on Diebenkorn's painting peaked. Heavy earth colors, impastoed surfaces, and jagged organic shapes predominated; what line there was survived only as an edge between competing colors. Soon, however, Diebenkorn was exploiting a new kind of line, responding to reproductions of the powerful, even violent, calligraphies of Willem de Kooning.[81]

Hassel Smith was an equally important source for the freeing of Diebenkorn's abstract line (fig. 2.15).

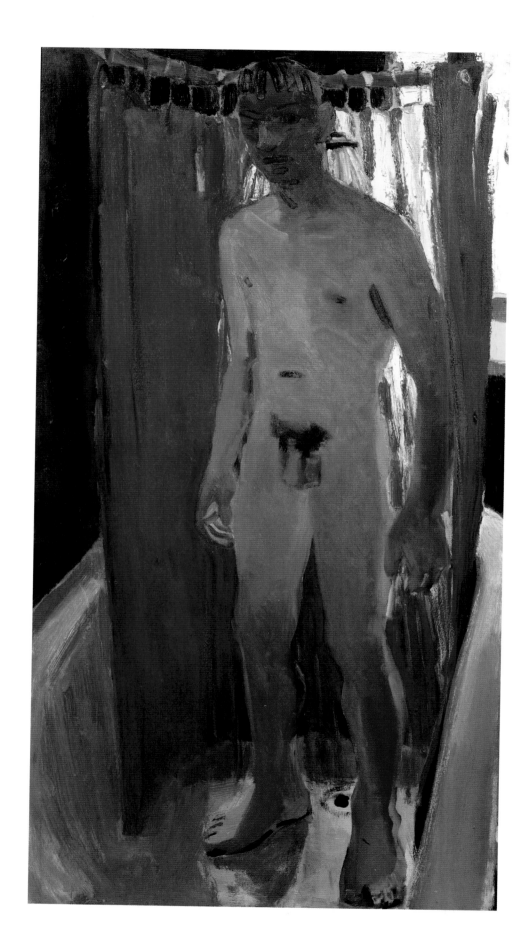

FIG. 2.14. David Park, *Standing Male Nude in the Shower*, 1955. Oil on canvas, 70¼×37¾ in. (178.4×95.9 cm). Private collection, Courtesy Salander-O'Reilly Galleries, New York.

The weekly studio visits among the four artists (Smith, Park, Bischoff, and Diebenkorn) had resumed upon Diebenkorn's return to the area, and Diebenkorn remembers that "I felt really influenced."[82] Bischoff identifies similarities in the two artists' work from that time: "One can see a kinship in their drawing. . . . Diebenkorn was keen about Krazy Kat cartoons, cultivating a deliberate awkwardness. Neither man was ever clumsy."[83] In fact, Diebenkorn and Smith felt so close in their aims that they tried collaborating on an untitled canvas of 1949–50 (see Gerald Nordland, *Richard Diebenkorn*, 1987, p.36). Each artist took turns working on it in Smith's studio when the other was teaching, but ultimately Diebenkorn acknowledged that the older painter had taken over. As he later wrote to Smith:

> I looked very hard at it—mainly trying to find some trace of my own hand. I thought I saw it momentarily in a couple of places, but . . . I would have to say that it was total H. W. Smith. I remember my chagrin on two occasions, alone in your studio in 1949, confronting that canvas in preparation to picking up on some of my previous work on it and finding that you'd completely wiped me out. *Very* unsportsmanlike![84]

Diebenkorn's abstractions reached maturity after he left his teaching position to take advantage of the G.I. Bill to study for a master's at the University of New Mexico at Albuquerque. Like others in 1950, he "could kind of see the handwriting on the wall" at the School of Fine Arts, and it said that he would be better off moving on.[85] Additionally, he was beginning to chafe under the strong influences of Park, Smith, and Still, and at the sense that "there was a kind of line to be toed" at the school.[86]

The works from Albuquerque, and from the subsequent period when Diebenkorn taught at Urbana, display an intriguing openness to representational references that he had previously denied. Earlier, as Diebenkorn recalled, "[I] thought I was being nonobjective—absolutely non-figurative—and I would spoil so many canvases, because I found a representational fragment, a Mickey Mouse. . . ."[87] In getting away from the Bay Area and the uncompromising atmosphere created by Still, Diebenkorn felt more open to such fragments entering his work from the outside world. Landscape began to exert a particularly strong pull at that time:

> Temperamentally, perhaps, I had always been a landscape painter, but I was fighting the landscape feeling. For years I didn't have the color blue on my palette because it reminded me too much of the spatial qualities

FIG. 2.15. Hassel Smith, *Brandenberg Barbecue*, 1952. Oil on canvas, 69¼ × 53⅞ in. (175.9 × 136.8 cm). San Francisco Museum of Modern Art.

in conventional landscape. But in Albuquerque I relaxed and began to think of natural forms in relation to my own feelings.[88]

Figurative references were also to appear during this period, as in the strange and amusing monochromatic work named *Disintegrating Pig* from 1950, or another titled *Urbana No. 2 (The Archer)* from 1953. But after moving back to the Bay Area and setting up a studio in Berkeley during the fall of 1953, Diebenkorn put aside these figural references and focused almost exclusively on complex, horizontally banded abstractions which evoked the colors and orientations of local landscape views.

At the time, Diebenkorn was unwilling to admit that the paintings were drawn from landscape experiences. In 1955 he would only acknowledge that they *looked* that way:

> What I paint seems to pertain to landscape but I try to avoid any rationalization of this either in my painting or in later thinking about it. I'm not a landscape painter (at this time, at any rate) or I would paint landscape directly.[89]

Berkeley No. 22 (1954; fig. 2.16) illustrates the brilliant brinksmanship of these paintings—the silvered slate color of fog abruptly juxtaposed to the dun

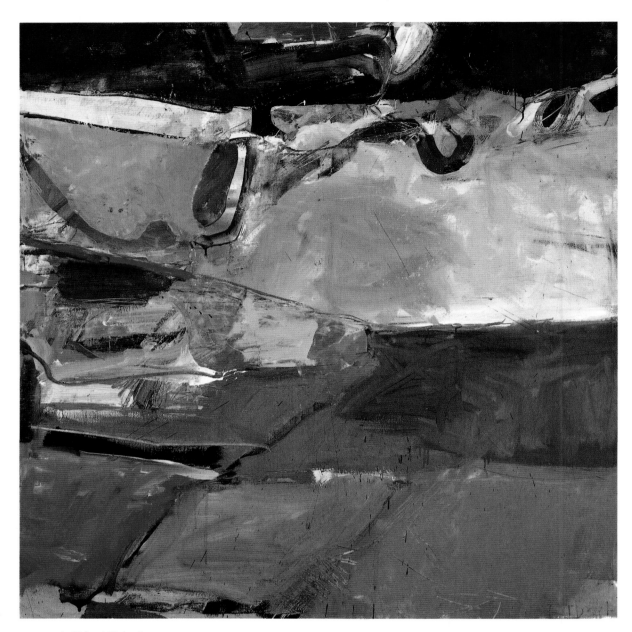

FIG. 2.16. Richard Diebenkorn,
Berkeley No. 22, 1954. Oil on canvas,
59×57 in. (149.8×144.8 cm).
Hirshhorn Museum and Sculpture
Garden, Smithsonian Institution.

of the summer hills, a band of deep ultramarine sky balanced by a pool of grayed cerulean, water reflecting the clouds above. Yet all of this is accomplished without the slightest indication of represented landscape, with its narrative incident and located light.

It is clear that Diebenkorn's skittishness at the time resulted from his recognition that painting so close to the motif had its price:

It was always a putdown for me in the '50s. . . . There were, one was told, all the New York artists doing strictly abstract painting; but according to *Art News* I was nothing but a landscapist. I resented being cut out from the rest, some of whom were as much or as little landscapists as myself.[90]

Perhaps here Diebenkorn was thinking of the floating aquatic landscapes of Baziotes, whose work he had earlier admired in a 1944 issue of *Dyn* magazine, and whom he had later met in New York. Rothko may also have been an example, for his work since the forties had come closer to landscape, using hovering horizontal fields of color that were compared to sunsets by the popular press. But it was de Kooning who would come closest in feeling to Diebenkorn's work, and he did not begin his true landscape paintings until after Diebenkorn had abandoned them.[91] Even then, the famous de Kooning line, which Diebenkorn had admired and used in his work, gave way to massive brushstrokes that came from de Kooning's close friend Franz Kline. As much as he may have wanted company, Diebenkorn seems to have been alone in his horizontally banded but nonspecific evocations of natural and urban spaces.

While in Urbana Diebenkorn had recognized his need for sympathetic professional and aesthetic surroundings. Already in his first semester there, he inquired about possible jobs at Berkeley, writing a former teacher there that "although I find teaching at the University interesting, the atmosphere here (I refer to the midwest) is extremely hard for me to take. I would like very much to return to the Bay Area which I know to be a most vigorous enviornment [*sic*] for painters."[92] Although he had left the Bay Area with some relief, fleeing in part the oppressive requirements to "toe" the abstract line, he still felt drawn by its physical and professional milieu.

When Diebenkorn returned to the Bay Area from Illinois and eventually began to teach at the California College of Arts and Crafts, however, much had changed. Few of the Abstract Expressionist painters were still around, and none was teaching at the California School of Fine Arts. Park was no longer there,

Bischoff was gone, and Hassel Smith was on his way out. Although there were still many good artists painting at both schools, and Diebenkorn had some good individual students at the College of Arts and Crafts, the situation was not comparable to the electrifying mood at the School of Fine Arts six years earlier.

In this uncertain atmosphere Diebenkorn began to question his abstract landscape work and thought increasingly about "coming clean" with his representational impulses—whatever New York might say. He had always maintained a figural option through the medium of drawing. First, he had been required to take a figure drawing class in Albuquerque (where his teacher was unimpressed with his work).[93] Then, in Urbana, he had joined a drawing group with a physicist, an English professor, and members of the art department. The English professor read poetry aloud, and the group drew images generated by the poetry. When asked what function drawing served during these years of largely abstract painting, Diebenkorn replied:

That's a very interesting question. I had always drawn Phyllis and the dogs. . . . [But] representational painting wasn't feasible, it was really a betrayal of what I was up to. I was an abstract painter. But with drawing, drawing allowed for anything. Drawing could be doodles, it could be a serious study from life. It was not a social thing.[94]

A year or so after returning to the Bay Area, in the thick of his questions about Abstract Expressionism, Diebenkorn *did* engage in drawing as "a social thing," by initiating a new drawing group with Park and Bischoff (fig. 2.17).[95] As he later remarked: "For someone who was intending to continue as an abstract painter I was clearly consorting with the wrong company."[96] But for someone with deep concerns about the old movement (it was gathering weak second-generation followers like moss on a static stone), Diebenkorn was obviously in the right company. His doubts about Abstract Expressionism were directed not only at others, but, increasingly, at himself:

I came to mistrust my desire to explode the picture and super-charge it in some way. At one time the common device of using the super-emotional to get "in gear" with a painting used to serve me for access to painting, too, but I mistrust that now. I think what is more important is a feeling of strength in reserve—tension beneath calm.[97]

Diebenkorn remembers making a group of drawings during this period that presented his feelings about

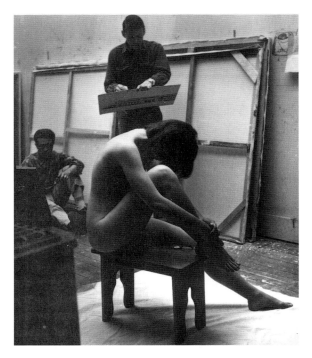

FIG. 2.17. Richard Diebenkorn and Nathan Oliveira (sitting) drawing a nude in Theophilus Brown and Paul Wonner's Berkeley studio, 1955. William T. Brown Papers. Courtesy Archives of American Art, Smithsonian Institution.

the last stirrings of Abstract Expressionism. They were satirical and explosive, showing a painter at his easel engaged in "the act," rendered so as to suggest a masturbatory activity.[98] He also recalled: "in the last of the abstract paintings . . . it was almost as though I could do too much, too easily. There was nothing hard to come up against."[99] Diebenkorn simultaneously sensed both onanistic indulgence and lack of real constraints in Abstract Expressionism, complaints echoed in Park's objections to the style; the two artists may well have discussed the problem.

As Diebenkorn remembers it, in 1955 he began to feel "a little resistance" to abstract work:

> Then, one day, I felt it was all done. There were things working on me . . . pressures causing me to change. . . . You see, I was trying to demonstrate something to myself—that I wasn't going to get stuck in any dumb rut. I felt I could move on to something else. I got kind of a thrill out of doing that. I said, "I can leave all this behind."[100]

Descriptions of Diebenkorn's first figurative efforts differ. Earlier he recalled doing a "messy still life" of objects he found in his studio; most recently he remembers taking a canvas and some paints out in his car in late 1955, driving around until he located a scene that looked promising, painting it directly,

without a sketch, on the spot. The resulting painting, identified by Gerald Nordland as *Chabot Valley* (1955; see Nordland, *Diebenkorn*, p. 87),[101] was barely more representational than the *Berkeley* paintings, but Diebenkorn included slanting rooftops, shrubbery, and a telephone pole to cue the viewer to the scene's scale and convey a general relationship to everyday reality.

These early figurative canvases were kept largely secret, although visitors to the studio sometimes saw them. The younger artist Bruce Conner recalls visiting Diebenkorn in 1955, specifically because he was interested in Diebenkorn's shockingly colored abstractions, which he had seen reproduced in *Art Digest*. "I asked him if he ever did any figurative work. He pulled out this one painting with a really grotesque female figure. He said, 'Well, I try to do at least one figurative painting a year.'"[102] Diebenkorn was clearly not yet sure that the figurative paintings would "stick": "I had all sorts of moments and days and works when I would go back to abstract painting."[103] He took time out during the summer of 1956 to build a studio and contemplate the new direction of his work. His thoughts were complicated by the success earlier that year of his New York show of abstractions, and by pressure from collectors and his Los Angeles dealer to cease his disastrous figurative experiments.[104] Eventually his determination to avoid being locked into a single style prevailed, and later he recalled: "I wasn't going to let considerations about career influence me as to whether I continued the figurative painting or not."[105]

This determination did not go unchallenged. A "distinguished critic" in New York (probably Clement Greenberg) had told Diebenkorn that if he wanted his paintings to attain the highest quality "he would have to switch to the staining method and move East, 'to take your New York knocks.'"[106] A few months after Diebenkorn's figurative defection, Greenberg had sent a few of his artist friends to visit the painter in his Berkeley studio, fully expecting them to see abstract work. In Diebenkorn's recollection, the first was Kenneth Noland.

> [He] as much as told me, "What the *hell* have you done?" . . . He was really very disappointed. Then Tony Caro came and visited, and he was also disappointed. He was telling me about the wonderful things he was getting into. He was showing me photographs of his work before and after, and I remember the marvelous heads in clay that he did, and also the new metal stuff. But this clay work I liked a great deal, and I told him so. Well, that didn't go over too well . . . that I was liking something he was leaving in disgust.[107]

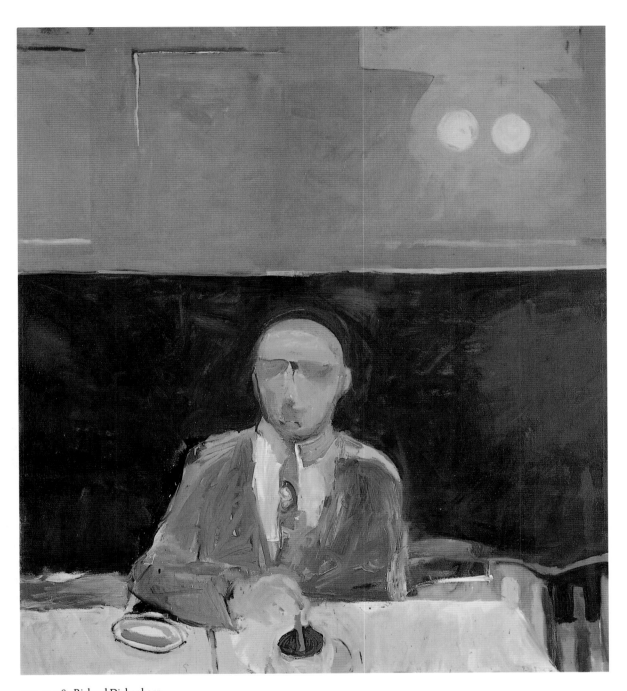

FIG. 2.18. Richard Diebenkorn,
Coffee, 1956. Oil on canvas, 67 × 58
in. (170.2 × 147.3 cm). The Chrysler
Museum, Norfolk, Virginia.

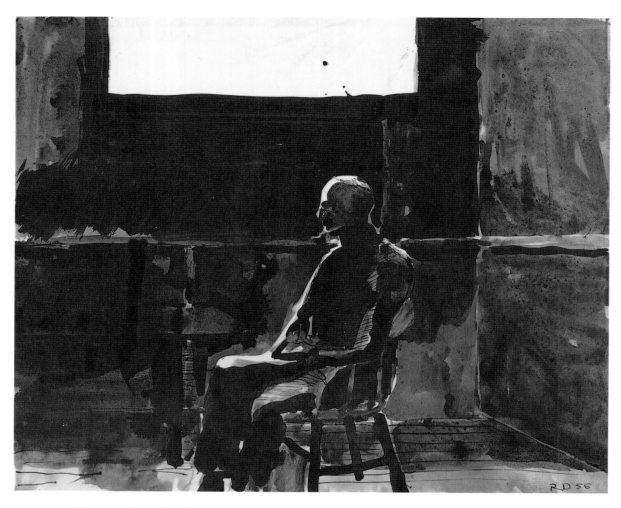

FIG. 2.19. Richard Diebenkorn, *Seated Man under a Window*, 1956. Graphite, pen and ink, ink wash, and watercolor on paper, 14×17 in. (35.6×43.2 cm). The Michael and Dorothy Blankfort Collection.

By the end of 1956, Diebenkorn had resolved his remaining doubts and began to attempt complex figurative paintings. The earliest of these seem to be loosely based on self-portraits, as Herschel Chipp records in his essay of 1957, "Diebenkorn Paints a Picture."[108] But if such works began as self-portraits, they were much altered in the course of making the painting. As Chipp reported, the canvas he witnessed initially depicted a male figure out-of-doors at a beach. The figure was then moved forward and the landscape changed to a field, and then to a simplified, non-specific outdoor scene. The figure became a woman and was moved to the side; the landscape became a view from a porch, and the painting was finally declared complete and titled *Woman by the Ocean*, 1956.

This kind of experimentation may have resulted from the special circumstances of having an art historian literally looking over Diebenkorn's shoulder, magnifying whatever criticisms the artist may have felt. Other paintings of the period seem more direct and are less laden with pentimenti; they also have a certain consistency of subject. Seated men turn their faces toward the viewer (as to a mirror), their eyes heavily shaded. They may purposely stir a cup of coffee (*Coffee*, fig. 2.18); sometimes they watch us passively with veiled eyes. *Seated Man under a Window* (fig. 2.19) is related to these early paintings of men in interiors. The deep chiaroscuro with light just edging the figure, the high window, and the shadowy furniture all contribute to an enigmatic stillness that characterizes many of these works.

Coffee, however, offers a dramatic narrative contrast to the stillness of *Seated Man*. The space here is shallow and further compressed by the dark palette of red, black, and blue, so that the man seems somehow crowded by his environment. The only clue to perspective is offered by the edge of the table, at right; this is tilted forward so dramatically that it disorients us even more.

The artistic parallels to *Coffee* are tantalizing, but possibly unintended. Narratively, comparisons with paintings by Edward Hopper such as *Nighthawks* (New York, Whitney Museum of American Art) seem inescapable—the harsh, shadowing light of an all-night diner, the lonely customer lost in thought. One thinks also of T. S. Eliot's J. Alfred Prufrock, measuring his life out in coffee spoons.[109] The absentminded absorption of the figure brings Degas's painting *Absinthe* (Paris, Musée d'Orsay) to mind as well, although the drug is American and the figure solitary. Without beginning to exhaust the associations we could even see one of Gauguin's leering idols in the strange twinned lights over the man's shoulder.

The painting may also have a basis in literal observation. As Diebenkorn describes his first Berkeley studio: "It was a triangular room at the back of a tavern; I could open a door and look right down the bar at all the regulars."[110] Whether the man in *Coffee* was a barroom regular or not, Diebenkorn had found in such paintings both the constraints and the complexities he sought in leaving Abstract Expressionism. In treating the figures and objects of the real world, painting had become a dialogue again: "The figure . . . takes over and rules the canvas."[111] With this dialogue, one of the most important aspects of Abstract Expressionism had been reclaimed: the engagement of the painter with the visible process of making the painting. The new challenges of figuration helped Diebenkorn to rediscover that process, enacted on the canvas itself.

> [You] have to make compromises. That is something that is not necessary in abstract painting and I wish that it were. The conflict between the conception and how to realize it helps to keep the ball rolling, it creates a struggle that is important to painting. That can fall away in abstract painting.[112]

CONCLUSION

For Park, Bischoff, and Diebenkorn, the end of Abstract Expressionism was a highly personal event that seemed to each an entirely internal development. Yet each painter was responding also to larger events and to each other, and their reasons for leaving Abstract Expressionism inevitably share some similarities. Each felt that he had exhausted the capacities of Abstract Expressionism: Park, its capacity to sustain belief; Bischoff, its capacity to communicate feeling; Diebenkorn, its capacity to provide resistance. Each also responded to the collapse of a community that had long sustained those capacities through shared faith, shared communication, and shared criticism. Moreover, their shifts echoed the dissatisfactions of artists across the United States and abroad, who had felt the heady promise of Abstract Expressionism become dissipated among numberless acolytes and adherents.

Even their friend Hassel Smith, who continued with Abstract Expressionism until the mid-sixties, expressed the pervasive sense of frustration in a letter to friends in 1957:

> When we first moved to the ranch [in Sebastopol around 1955, it] seemed to me then that painting, non-objective painting . . . all the stuff that had gone on in San Francisco and New York and elsewhere—had reached a dead end, a quitting place. Quite a few of the painters were going back to representationalism, some snide, some forthright, and for a year or more I contemplated doing likewise, but couldn't get with it. . . .

For Smith the choice was a difficult one, for as he noted: "After all, I painted representationally for quite a spell and going back would be for me *really* going back. . . ."[113] In addition to the feeling that the best artists were slowing down or losing faith (as was said of de Kooning), with lesser followers gaining the upper hand, there was a growing sense that what had originated as a rebellious and liberating movement was now as dead and flaccid as that which it had replaced.

The dogmatization that so dismayed Park, Bischoff, and Diebenkorn began with some of the first-generation painters but only crystallized with successive followers, whose zeal to understand converted intuition into formula. One such follower, the young artist and critic Hubert Crehan (who had studied with Still and Rothko at the California School of Fine Arts), turned on de Kooning with vicious fury when the latter first showed a group of his *Woman* paintings. De Kooning, who had painted figures more or less covertly throughout the forties, was described as "lonely," "hysterical," yearning for "smug and familiar surroundings." This was not just disappointment with a set of paintings, or even a single great painter. Crehan perceived it as a danger for all art:

> Does de Kooning, *or any painter today*, especially an artist who has previously jetisoned [*sic*] so many of the ba-

nalities of the associative encumbrances of the subject, does such an artist need an image to express an emotion in his work, even an emotion about Woman? Are we on the scene of a reaction? *Is our revolution in painting imperiled so soon?*[114]

De Kooning made the rather reasonable response that a painted figure was hardly less abstract than a "non-objective" landscape: "That word 'figure' becomes such a ridiculous omen—if you pick up some paint with your brush and make somebody's nose with it, this is rather ridiculous when you think of it, theoretically or philosophically."[115] But the purists were not satisfied.

Formal criticism, brilliantly practiced by Clement Greenberg, played perhaps the most powerful role in converting intuitive Abstract Expressionist faith to non-objective dogma. Artists were charted on a scale of art-historical progress and found wanting if their works seemed to be backsliding into "literary" rather than "purely pictorial" values.[116] Part of formalism's power was that it could be easily taught, but as teaching replaced the more spiritual "preaching" of the earlier generations, something was lost.

Toward the end of the fifties, critics and scholars wrote increasingly of the bankruptcy of "the cult-wagon of abstract expressionism."[117] In one critic's jeremiad, the call for more formalist values is clear and strong:

> More and more, month by month, abstract expressionism reveals itself to be more fraud than Freud. The movement is based on the proposition that you can't kid the id, but each succeeding dredging of the unconscious proves anew that the spectator/purchaser has a right to the ego and occasionally the superego, not to mention some mastery of the sheer craft of painting and the assurance that the thing'll hold together till he gets it home.[118]

Such concerns had affected Park and other artists much earlier, and they had been disillusioned by the perceived failure of Abstract Expressionism to constitute a new universal language. This loss of faith in abstraction's universality was directly tied to the turn to the figure and to the sustaining belief in figuration's capacity to communicate directly with a broad public.

In the following quotation, Bischoff makes an interesting rhetorical shift from "one's" disillusionment to "no one's" belief. To the individual *and thus* to the community, it seemed clear that the emperor had been exposed:

> If one has cooled off with the Abstract Expressionist idea, meaning that one no longer believes in it as a language, then no one any longer believes in its communicative potential—then it seems like it's pretentious, then it seems like it's very elitist, then it seems like it's very esoteric and very unapproachable by anybody but the initiated.[119]

For Bischoff, Diebenkorn, and Park, the turn to the figure was thus a contemplated decision, leveraged by the pervasive disillusionment with the more grandiose claims of Abstract Expressionism. Supported by their collective independence, the three Bay Area artists "returned" to the figure paradoxically to save what was salvageable in abstraction. They strove to preserve not only the technical achievements of "action painting," with its sensuously loaded brush and sumptuous color, but its idealistic aims and convictions as well. For these first figurative "defectors," their shift was not so much a change in style as an attempt to resuscitate it. In place of the deflated "individualized universalism" of non-objective form, they sought the less personal universalism of the figure. Bischoff put it best in a later meditation:

> I never did figurative painting where the personages were identified or repeated. Figurative painting was not regional. [I] did want to take on some of the universality that was felt to be the realm of the abstract expressionists' work. . . . [There] was this desire . . . to create a world and to create people in that world which [sic] were more timeless . . . were not dated in time.[120]

Whether or not Bay Area Figuration achieved the universalism Bischoff sought, it did create a powerful, persuasive world that appealed strongly to painters and to the public of the period. Well before Mills's show in 1957, the still unnamed development had gathered adherents and supporters—not by the dramatic, hortative methods of the Abstract Expressionists, but by slow, osmotic accretion. Park would live just long enough to see his "failure of nerve" celebrated as the motivating act for a major regional movement. He would not survive to see it cited as part of the pedigree for new national styles.

CHAPTER THREE

GROWTH AND MATURITY OF THE RELUCTANT MOVEMENT

Historical development is really a hindsight thing. I think they're really interesting intellectual games, but the critic who steps into the breach and selects somebody who is the logical next step, well it's really ludicrous because the next step might be some kind of crazy throwback into left field— which then in hindsight becomes the perfect next step.

RICHARD DIEBENKORN (1977)[1]

INTRODUCTION · Although the "Triumph of the Figure in Bay Area Art" (as one gallery celebrated it in 1987) was consolidated by Paul Mills's 1957 survey exhibition at the Oakland Art Museum, expressionistic figurative painting had earlier made inroads in the local art world.[2] As was the case with the San Francisco School of Abstract Expressionism, the growth of the figurative movement in Bay Area art had an institutional base. When Gurdon Woods replaced Ernest Mundt as head of the California School of Fine Arts in 1956, he moved quickly to give the former bastion of Abstract Expressionism a new, dynamic, and largely figurative direction.

During the Mundt years (1950–56), the school had been plagued with funding and enrollment problems, and the students provided the only signs of life. As one recalled, "that Clyfford Still syndrome of . . . what we called the creepy-crawlies [Abstract Expressionists], and the Figs [Figuratives] . . . their fighting didn't matter any more. The battle had ceased to exist."[3] When Woods took over, he sought to recapture the energy of the late 1940s by hiring some of the former stars of the faculty who had been fired or had resigned under Mundt.

As if in recognition of the decline of Abstract Expressionism in the Bay Area, Woods chose to concentrate his recruiting efforts on the figurative painters. He first tried to hire David Park, but Park had already accepted an offer from Berkeley—a job his colleagues knew to be a plum.[4] Woods then hired young Nathan Oliveira in 1956 to revive the moribund printmaking department and asked Bischoff to return, this time as head of a new graduate program.[5] At Bischoff's urging, Diebenkorn and James Weeks were hired, together with the abstract painter Frank Lobdell and the mystical landscapist William Morehouse.

Despite this array of painters, most of whom are now clearly associated with the figurative movement, it is not quite accurate to say that Bay Area Figurative painting became the new official style of the California School of Fine Arts. What most faculty and students observed instead was the growth of a united front, led by Bischoff and Lobdell (described by one student as "surrogate fathers" taking the place of Park and Still).[6] This group supported an Abstract-Expressionist approach to the *process of painting*, be it figurative or non-objective. Students were free to paint anything they chose, since it was understood that subject matter was entirely subordinate to the values of process, paint, and significant form.

Despite his commitment to both Abstract Expressionism and figuration, Nathan Oliveira was one faculty member who felt alienated from the leading group. He disapproved of efforts to reclaim the glorious MacAgy years, since such efforts placed a premium on those who had actually been there. He saw younger abstract artists such as Sonia Gechtoff fired and replaced by "early Abstract Expressionist or Bay Area Figurative painters. . . . There seemed to be a political move stirring to create a core of similar thinking individuals."[7] Chief among their emphases, in Oliveira's opinion, was a shared conviction in the supremacy of formal issues over content.[8] Painterly values reigned supreme; in Fred Martin's recollection, "all other styles were either not moral or not

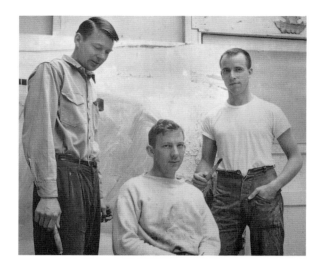

FIG. 3.1. Left to right: Diebenkorn, Wonner, and Brown in Shattuck Avenue studio, Berkeley, 1955. Courtesy Archives of American Art, Smithsonian Institution.

painting."[9] When Oliveira was told he would be teaching basic design instead of figure drawing, he felt justified in his unease, and submitted his resignation. Woods negotiated to keep him on, but Oliveira eventually resigned in 1960 when "the political thing [was at its] zenith."[10]

Even if the school were more than a Bay Area Figurative bastion before the term was coined, the bringing together of Bischoff, Diebenkorn, and Weeks created a powerful figurative constellation on the faculty. David Park's presence on the Berkeley faculty provided a strong figurative influence on students there, and annuals and other exhibitions began to reflect the growing eminence of figurative painters in the area.

The 1949 Art Association Annual had been entirely non-objective. By the end of 1956, it was dominated by figurative paintings, when Diebenkorn received first prize for a small still life, *Flowers and Cigar Box*, Park was awarded third prize for *Balcony*, and Theophilus Brown won a prize for a painting from his football series.[11] In August 1957 the Richmond Art Center presented *Directions: Bay Area Painting, 1957*. This exhibition was an important indicator of the changing status of figurative painters, for the works were chosen by Bay Area artists who were asked to name their most important colleagues. Of the eleven most frequently named, four were solidly figurative: Bischoff, Diebenkorn, Park, and Oliveira.[12]

Thus Paul Mills, coming to the area in 1953, would have been well aware of the important local painters. As the ambitious new curator of the Oakland Art Gallery (whose name he helped change in 1954 to the

Oakland Art Museum), Mills wanted to make his institution more than a warehouse for municipal art shows. He decided to focus on the art of his adopted state and organized the Archives of California Art in 1955. Glen Wessels urged Mills to recognize David Park, whose charisma and leadership he knew firsthand. In addition, Mills had been advised by Fred Martin, then the museum's registrar, to build the museum's reputation in contemporary art by "hitch[ing] yourself on to a group of strong artists." The artists Martin recommended were, not surprisingly, Park, Bischoff, and Diebenkorn; they became the focus of Mills's first effort to raise the Oakland museum to national importance.[13]

THE *CONTEMPORARY BAY AREA FIGURATIVE PAINTING* SHOW

Having conceived the idea of an exhibition featuring three local leaders of figurative painting, Mills began with the ambitious working title *New Realism*, a label that aspired to national or even international scope. He arranged to meet Park, Bischoff, and Diebenkorn at Park's home in Berkeley to discuss his concept; from this point the stories as to exactly what happened some thirty years ago diverge.

Mills reports that Park spoke for Bischoff and Diebenkorn in objecting to the "New Realism" rubric:

[They] did not want this promoted as a new movement. They objected, not because they felt there was no justification for it, but because they disliked the whole business of "movements" in art. Park himself suggested the title *Contemporary Bay Area Figurative Painting*. He felt it was a descriptive title for an exhibition, and would not be interpreted as the name of a movement. To him, "figurative" was an artist's word, clarifying what was meant without added associations.[14]

Diebenkorn recalls it very differently:

We didn't know we were forming a school. Not until Paul Mills came around and told us we were a movement—the California Figurative Painters! Well, I just hated this thing of getting people together and forming a school. I remember feeling wildly threatened by that. We had a meeting at David's house—there was Elmer Bischoff, Paul Mills, and myself—and I remember raising my voice and saying "This should not happen." Well, David was for it because he was going to be the grandaddy of it all. Elmer was sort of on the fence. But I hated being labeled. . . . I didn't go for that at all.[15]

And, more succinctly: "[During the meeting] at Park's house, I hit the ceiling and was irrational. I wasn't going to cooperate."[16] Bischoff remembers

FIG. 3.2. Theophilus Brown, *Football Painting #2*, 1956. Oil on board, 34¾×62 in. (88.3×157.5 cm). Santa Barbara Museum of Art, California.

feeling that it was all right with him to have the exhibition, so long as no movement was implied. He has no recollection of Diebenkorn's being so adamantly opposed.[17]

There is similar disagreement about which artists were to constitute the final list for the show. Paul Mills remembers that Park, Bischoff, and Diebenkorn urged him to include more painters, in the hope of democratizing the exhibition, and suggested several names. Diebenkorn remembers that Park and Mills chose the participants, and is especially sensitive about this aspect of the narrative since many of those included in the exhibition were his own students or former students:

> It's gotten around that David, Elmer, and I selected people for the show, and people have gotten annoyed about that. It's not true, certainly of me. . . . I wasn't in on the selection process, but I was pleased that so many of the painters in the show were my students.[18]

Clearly, Diebenkorn's memories of opposition to the exhibition reflect his subsequent anxieties about being perceived as the leader of a movement. He is correct in remembering that the participants in the exhibition were not determined at that first meeting. After agreeing that the show should include more artists, Mills generated a much longer list. This was subsequently reduced to the final group, which consisted

of Joseph Brooks, Theophilus Brown, Richard Diebenkorn, Robert Downs, Bruce McGaw, David Park, Robert Qualters, Walter Snelgrove, Henry Villierme, James Weeks, and Paul Wonner. All of the exhibitors knew at least one of the three initial artists. Downs, McGaw, Qualters, and Villierme were all Diebenkorn's students at the time the exhibition was being planned; Wonner and Brown had met Diebenkorn around 1955 when they rented a studio in the same Berkeley building and had briefly joined the group drawing sessions Diebenkorn had organized with Park and Bischoff (fig. 3.1); Weeks had known Diebenkorn in high school, and the two had been delighted to meet again in Park's class at the California School of Fine Arts in the late forties. Joseph Brooks had also studied at the school during those years, but he and Walter Snelgrove were perhaps the least intimate with the initial three.

Mills's second list was not only larger but also more eclectic than the final selection; it included three women whose paintings were largely nonobjective at the time. Advance publicity for the exhibition referred to it as *The Next Direction* and, in addition to the artists above, it listed Fred Martin, Louise Smith, Joan Waite, and Nori Yamamoto. The article enthusiastically proclaimed that the exhibition "promises to attract national attention" and, "accord-

FIG. 3.3. Theophilus Brown, *Still Life*, 1958. Oil on cardboard, 10×14 in. (25.4×35.4 cm). The Oakland Museum.

ing to the curator Paul Mills, will include work of painters with a background in Abstract Expressionism who have extended this movement beyond forms existing in painting to include the spirit as well as the form in the world around us."[19]

While he recalls that Martin declined participation in the exhibition, Mills seems not to have pursued the three other painters, perhaps because the stylistic focus of the exhibition had once again tightened, and their work no longer seemed relevant. Mills also remembers considering Nathan Oliveira, but did not include him for a variety of reasons.[20] Diebenkorn's students remained, however, adding stylistic coherence to the exhibition. Although Villierme's work was rawer, McGaw's moodier, Downs's less polished, and Qualters's more atmospheric, each of these young painters was unmistakably a student of Diebenkorn. Downs and Qualters each depicted a figure of indeterminate gender, standing to one side of a bifurcated interior; Villierme produced a small landscape and McGaw a close-up torso of a figure with upraised arms. Qualters scrubbed his pigment into the ground, while Downs, McGaw, and Villierme used thick, buttery paint laid on with a large brush.[21]

Not surprisingly, the senior artists in the exhibition showed more stylistic diversity. Snelgrove and Brooks were the farthest from what might be called the core style; Brown's work also maintained a distinctly individual cast. Snelgrove, primarily a landscape painter, showed a shadowy, softly brushed *Interior with Figures*, dominated by a chandelier in which elegantly applied paint reads as glittering crystal. Brooks's single work, intriguingly titled *The Beast in the Garden*, was not illustrated in the catalogue. A painting from the same period in the Oakland Museum collection, much more reticently titled *Studio*,

is a small, tautly painted, nearly monochromatic interior. Both Brooks and Snelgrove seem to have very different formal aims from those of the original three.

Theophilus Brown contributed *Football, No. 33*, a large mixed-media work from his brushy, de Kooningesque series based on photographs from *Sports Illustrated. Football Painting #2* (fig. 3.2), also from this series, betrays the strong links Brown maintained with the New York School; despite his move to the Bay Area, he remained relatively independent of the San Francisco Abstract Expressionists.[22] Brown emphasized to Mills that he had been to Europe five times by 1957, and had studied with Amédée Ozenfant and Fernand Léger.[23] Despite his strong links to Cubism, interest in Surrealism, and friendship with Willem and Elaine de Kooning, which mark his works from this period, his painting changed dramatically after Mills's exhibition. Perhaps in response to Diebenkorn's deft still life and Park's tawny palette, Brown began to paint small studies of objects, remarkable for their comprehension of the emerging Bay Area Figurative style. The cut fruit, water glass, and open boxes of his 1958 *Still Life* (fig. 3.3) could have come out of a Diebenkorn canvas, but the idiosyncratic palette seems to draw on that of both Park and André Derain.

Wonner and Weeks, although strongly individual painters, shared enough traits with Park, Bischoff, or Diebenkorn to reinforce the internal coherence of the exhibition. Wonner, Brown's close friend and companion, was represented by *The Glider* (fig. 3.4), a daringly cropped composition, lush with loose paint but tightly structured by verticals and diagonals. The composition, with the ostensible figural subject of the work aggressively halved by the canvas edge, is reminiscent of both Degas (as in his *Place de la Concorde*, destroyed) and David Park; the linear structure and color wedges are devices Diebenkorn brought to figure painting from his abstract landscapes at around this same time.

Wonner's boldest departure in these early works was the arbitrarily thick paint layered on the canvas. As the scholar John Ward notes, this thick brushwork is an almost mannerist quotation of Abstract Expressionist facture, which the younger generation of painters felt free to adopt independently of any investment with the *process* that was its usual justification.[24] Unlike Diebenkorn or Park, Ward argues, Wonner worked out his compositions before approaching the canvas, and the brushwork is thus a stylistic device rather than a painterly by-product.

FIG. 3.4. Paul Wonner, *The Glider*, 1957. Oil on canvas,
58×38 in. (147.3×96.5 cm). Collection of Adolph Mueller.

FIG. 3.5.
James Weeks,
Jazz Band,
ca. 1957. Oil
on canvas,
72×96 in.
(182.9×243.8
cm). Destroyed.

FIG. 3.6. Hassel Smith exhibition
at the Iron Pot Restaurant, San
Francisco, 1946. Hassel Smith Papers.
Courtesy Archives of American
Art, Smithsonian Institution.

FIG. 3.7. James Weeks, *Untitled*, 1953. Oil on canvas, 78 × 96 ½ in. (198.2 × 245.1 cm). San Francisco Museum of Modern Art.

Wonner's dripping paint created the reputation for painterly bravura in the Bay Area Figurative style, before that bravura became characteristic of the other artists in the exhibition. His confidence in wielding the loaded brush of Abstract Expressionism may well have proved instructive to much more experienced artists, such as Park and Weeks, as both moved farther in the painterly direction following the 1957 show.

Perhaps confirming that he was dissatisfied by comparisons of his works with those of the other painters, Weeks destroyed his paintings from the Oakland exhibition. Some scholars have argued that this purgative act was in response to his "ambivalence about identity with this group," but this seems absurd given the local popularity of the figurative work and the newness of the rubric.[25] The Oakland catalogue documents that he exhibited *Figures in an Interior* (unfortunately not illustrated) as well as an enormous canvas (the largest in the show at 72 × 96 inches) depicting a jazz band (fig. 3.5). Weeks's *Jazz Band* brings Bischoff's *Blues Singer* to mind with its tentlike setting and disparities of scale among the figures. Park's *Rehearsal* is an even more likely model and not merely because of its subject matter (the subject dates back at least to the forties in Hassel Smith's paintings of jazz musicians, fig. 3.6). The primary comparison with Park lies in the composition. Park's head, a slice of which appears at the lower left of *Rehearsal*, is echoed

in the lower left of Weeks's canvas where a similar slice appears. Because the musicians are shown frontally in Weeks's work, the comparison breaks down, but not before revealing some telling similarities between the two paintings.

Musicians are a constant theme in Weeks's work, reflecting both his adult interests and childhood environment as the son of successful bandleader Anson Weeks and classical pianist Ruth Daly. As early as 1953, when he was working as a billboard painter and struggling to maintain his life as a professional artist, he produced another scene of jazz musicians (fig. 3.7), even larger than the work exhibited in 1957. In this untitled early painting, the composition is more obviously Cubist in inspiration, with added debts to Matisse in the tilted planes and faceless, bisected background figures. Like Diebenkorn and others, Weeks had visited the collection of Sarah and Michael Stein in Palo Alto, where his interest in Matisse was well rewarded. As in *Jazz Band*, there are Parkian notes in the frieze of figures, the scale disparity introduced by the cropped figure on the left, and the almost repellent palette of yellow, orange, and chartreuse.

Weeks suggests that his dissatisfaction with his contributions to the 1957 exhibition resulted from his "reservations . . . about my painting at the time. It was difficult for me because of the sign painting [I was doing]. I was very impressed with what other paint-

FIG. 3.8. James Weeks, *Woman Singing*, 1957. Oil on canvas, 65 ³⁄₁₆×41⁵⁄₁₆ in. (165.5×105 cm). Private collection, Phoenix, Arizona.

ers did."[26] Perhaps feeling that his billboard work was contaminating his large-scale, multifigural paintings, the first canvas he completed after destroying the others was a smaller oil of a single figure, *Woman Singing* (fig. 3.8). As one scholar observes:

> The picture works as a retrenchment. . . . The single figure on a two-color ground . . . , the generalization of features . . . , the dragged strokes of color around the periphery of the figure, and the sense of spaceless, airless surface in tension with the summarized volume of the figure are all familiar from . . . earlier work.[27]

The retrenchment was a necessary one, probably instigated by the 1957 exhibition. After finally quitting his billboard job, Weeks experienced a burst of productivity in the early 1960s. This period would result in his finest paintings: monolithic figure compositions that consolidated the maturity of the first generation's Bay Area Figurative style.

Park, Bischoff, and Diebenkorn, whose total of sixteen works constituted almost half of the exhibition, showed complex and ambitious paintings that fully displayed their mature styles. In works such as *Interior* (fig. 3.9), Park had become more relaxed since painting formalized compositions such as *Rehearsal* and the caustic caricatures of the early fifties. The process that began around 1954 with paintings such as *Nudes by a River* seems to have been accelerated by Park's participation in the group life-drawing classes initiated by Diebenkorn in 1955 where Park produced such lucid, elegant drawings as *Nude with Hand on Hip* (fig. 3.10). In addition to these free studies of the nude, there are also line drawings that are deliberate studies for *Interior* (fig. 3.11). Lydia Park (now Lydia Moore) recalls that she and Elmer Bischoff were the models in Park's in-house studio in Berkeley.[28] As Lydia Moore recalls, Park tried different floor and ceiling perspectives in the work, finally settling for the vaporous, atmospheric interior found in the finished painting. The result is contemplative, with an open indeterminacy of space reminiscent of Spanish baroque painting. The soft intensity of the pooled light at the upper left of the painting also recalls the fogbound light of Bischoff's *Orange Sweater*, but unlike Bischoff, Park has consciously pursued the empty center characteristic of so much Abstract Expressionist painting. In *Interior*, Park had not yet invested in color as an indicator of light and shadow, confining his muted palette to the hues offered by the depicted objects. It would take the examples of Bischoff and Diebenkorn to liberate Park the colorist from Park the realist.

From the same year, but not in the exhibition, the remarkable *Bather with Knee Up* (fig. 3.12) utilizes bolder color. In this painting there is further evidence of an opening up in Park's work: the brushstrokes are thick and loose, colors are applied freely with single bold swipes of the brush. The orange edging the boy's buttock, a device which also appears in Bischoff's work of the same period, was added late in the painting's evolution and is echoed in the figure's ear, profile, and elbow. Although based on a drawing from the group sketching sessions (fig. 3.13), the painting has been substantially reworked, particularly the area of the young boy's thighs, and underlying strokes of paint curve across the canvas from the figure's right hand to just below his buttock. The watery setting suggests that this curving form could have been the edge of a rowboat, and in fact there is a drawing in one of Park's earliest surviving sketchbooks of a figure standing up in a canoe (fig. 3.14), going under a railroad trestle similar to the structure in the background of *Bather with Knee Up*.[29]

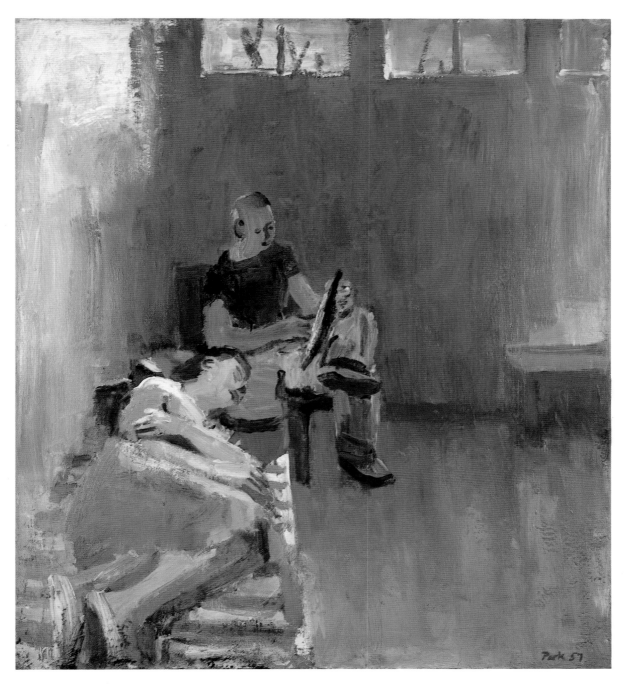

FIG. 3.9. David Park, *Interior*, 1957. Oil on canvas, 54 × 48 in. (137.2 × 121.9 cm). The Lobell Family Collection, New York.

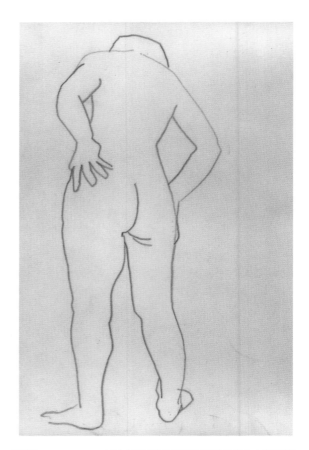

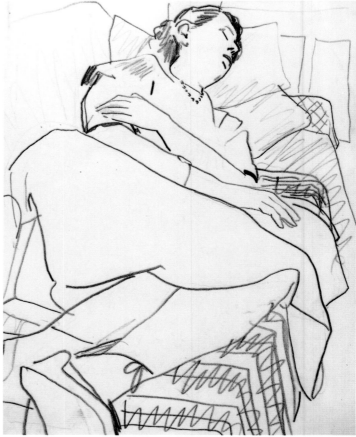

FIG. 3.10. David Park, *Nude with Hand on Hip*, ca. 1955–58. Graphite on paper, 12×7½ in. (30.5×19.1 cm). Collection of Mr. and Mrs. Roy Moore, Santa Barbara, California.

FIG. 3.11. David Park, *Sketch of Lydia Sleeping* (Study for *Interior*), ca. 1957. Graphite on paper, 11×8½ in. (27.9×21.6 cm). David Park Papers. Archives of American Art, Smithsonian Institution.

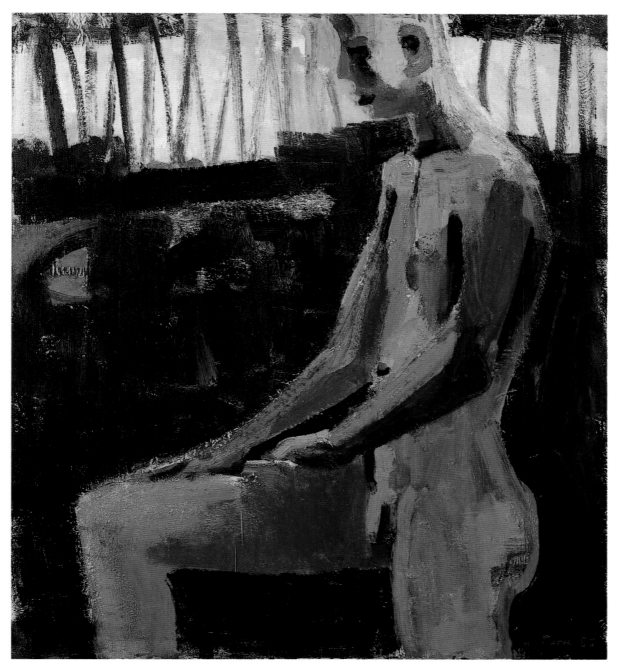

FIG. 3.12. David Park, *Bather with Knee Up*, 1957. Oil on canvas, 56 × 50 in. (142.2 × 127 cm). Collection Newport Harbor Art Museum.

FIG. 3.13. David Park, *Male with Raised Knee*, 1957. Graphite on paper, 19 × 12 in. (48.3 × 30.5 cm). Collection Newport Harbor Art Museum.

FIG. 3.14. David Park, *Sketch of Canoeist*, 1920s. Graphite on paper, 6½ × 6 in. (16.5 × 15.2 cm). David Park Papers. Archives of American Art, Smithsonian Institution.

There is a general consensus that, particularly in the later years of his life, Park worked almost exclusively from memory, building up images directly on the canvas in a slow process of accretion. This theory is supported by the layered paint and pentimenti of *Bather with Knee Up*. But the presence of drawings that clearly served as sources for the painting's imagery suggests that Park trained his memory through sketching, fixing both motif and stroke sequence in his mind. His painting method seems to have been open but not spontaneous, and he would freely use past sketches if they promised to resolve a pictorial problem, even if he had to jettison the original image in the process.

There are equally tantalizing questions regarding Park's openness to art-historical sources. Unlike Bischoff and Diebenkorn, Park mentioned only a few artists of the past whom he held to be significant for his work. Picasso is the most obvious example, but Park also cited Piero della Francesca, influential for his complex compositions juxtaposing faces and figures in a crowd.[30] Park must also have admired the preternatural stillness and dignity of Piero's carefully posed figures, elements echoed in Park's own late work.

Striking, though unacknowledged, parallels can also be found in the work of the German Expressionists, whose romantic involvement with themes of the nude in nature seems linked with certain aspects of Park's imagery. *Bather with Knee Up*, in particular, calls to mind sculptures such as Wilhelm Lehmbruck's *Rising Youth* or the Belgian George Minne's elongated adolescent nudes. Like the Germans and their colleagues in other countries, Park sought in his late work a universal statement rather than a portrait of a particular individual; the still, contemplative cast of his *Bather* gives it a far more generalized presence than any of his earlier figures possess. But if Park was aware of parallels to German art, he never mentioned them. However, exhibitions of the Galka Scheyer collection had earlier given German art a high profile in the Bay Area, and both Diebenkorn and Bischoff would have been well-informed sources for discussions of earlier modernism.

Bischoff was represented in the exhibition by six canvases, more than any other artist, and his masterful *Figure in Landscape* (fig. 3.15) illustrates the cover of the catalogue (this pride of place undoubtedly accorded because the painting had been bought by the Oakland Art Museum earlier that year). *Figure in Landscape* shows the generalized influence of Edvard Munch, whose 1951 San Francisco exhibition had

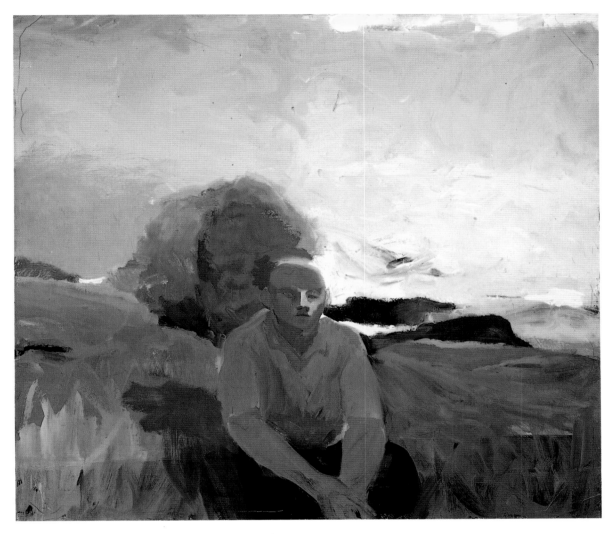

FIG. 3.15. Elmer Bischoff, *Figure in Landscape*, ca. 1957. Oil on canvas, 52 × 57 ½ in. (132.1 × 146.1 cm). The Oakland Museum.

deeply influenced a number of the Bay Area Figurative painters.[31] In Bischoff's work, a man sits just below the center of the canvas, eyes seemingly downcast and hands clasped thoughtfully in his lap. He is seated on the edge of a meadow or on a low wall that borders it. Beside and behind him, the landscape flickers and undulates in a Munchian palette of muted greens, mauves, and whites, with touches of red hinting at a setting sun. As in Munch's powerful image *Puberty* (fig. 3.16), which evokes the internal turmoil of personal change with a looming, sexualized shadow, Bischoff has extended the dark area behind the central figure. The shadow, which contradicts the apparent light source, is further extended by being linked in color and value to the large bush on the horizon. The bush becomes thought or emotion, emanating from the seated man like steam from a kettle.

Landscape paintings in general, and *Figure in Landscape* in particular, seem to have sprung full-blown from Bischoff's accumulated pictorial energies. Unlike Diebenkorn or Park, Bischoff had never before admitted landscape as a presence in his work, beyond the Surrealistic, Rothko-inspired watercolor of 1946. Yet in several paintings from the 1957 exhibition (*Houses and Hills*, *Three Graces*, and *Two Figures at the Seashore*, in addition to *Figure in Landscape*), Bischoff presented polished compositions in which landscape played an important role.

Although the specific part played by landscape changes in each of Bischoff's paintings, in general its role is much more charged and symbolic than in either Park's or Diebenkorn's work. Bischoff is not eager to discuss the symbolic or autobiographic aspects of his art, reflecting the deep formalist bias of his col-

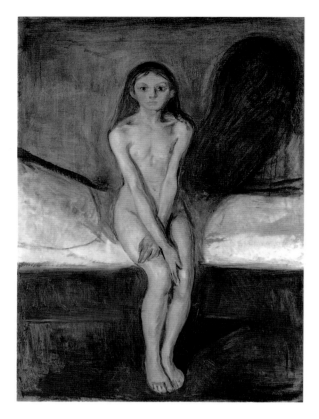

FIG. 3.16. Edvard Munch,
Puberty, 1895. Oil on canvas,
59⅝ × 43⁵⁄₁₆ in. (151.5 × 110 cm).
Nasjonalgalleriet, Oslo.

leagues, his training at Berkeley, and his subsequent experiences as a painter at the California School of Fine Arts. Yet although discussions in the halls of the school and in group drawing sessions seem to have emphasized strictly formal issues, Bischoff is perfectly open about his interest in painters such as Goya, Munch, Titian, and Rembrandt—painters praised in our culture more for their humanism and deep psychological values than for their substantial formal accomplishments.

Younger colleagues more open to questions of symbolic content than Park and Diebenkorn confirm that during his figurative period Bischoff was attempting to deal with strong personal challenges and was sometimes conscious of their impact on his work. As Joan Brown commented, "Elmer paints so much from his heart, he's incapable of keeping it out."[32] Certainly paintings such as *Figure in Landscape* and *Two Figures at the Seashore* suggest the presence of deeper meanings than mere description or color harmony; one recalls with interest Bischoff's earlier discussion of feeling in conjunction with his figurative work.

In *Two Figures at the Seashore* (fig. 3.17), the landscape is a far more torrid component of the scene. The figures are now two, and they are nude. If we compare Bischoff's painting to Park's *Nudes by a River*, we can see how much more charged Bischoff's encounter is. The Bischoff nudes confront each other directly, if ambivalently. The woman, whose body is bisected by an engulfing black shadow, stands visually above the man in the center of the composition. Her beautiful three-quarters profile, painted wet-in-wet, seems to glance away from the man, who presents his back to us as he stares at the hot orange underside of her jutting forearm. He is a spectator of the scene, a figure for the external world, while she is identified with nature, inhabiting another sphere entirely. A different sun strikes her shoulders and fires the clouds and sand with red. Red and white water pools under her legs, and her projecting abdomen catches reflections of the strong ambient light.

With *Two Figures* Bischoff began to explore the strong, even dissonant colors that would prove so inspiring to Park and others. The brilliant red edging the woman's thigh and the man's back, although it has its analogue in the red ears of Hassel Smith's self-portraits or the scarlet stripe of Park's bicyclist, is here more powerfully disjunctive than in either of those earlier paintings; it is closer in spirit to the red that limns Park's *Bather with Knee Up* of the same year. Bischoff's success in making such colors read as light was one of his strongest contributions to the group, and Park and Diebenkorn must have learned much from their shared studio visits.

Diebenkorn's use of color was equally well developed in the 1957 exhibition. He had already established a palette of brilliantly clear, biting hues in the Berkeley landscapes, and he continued to use them in the sun-drenched figurative paintings of the late fifties. But at the same time, he maintained his capacity to switch from hot, saturated colors to cool ones, in the manner of his admired master, Matisse. Given his tendency to work on several canvases at once, these alterations do not seem to have had any developmental significance. Diebenkorn used color to strengthen selected areas within each composition and, depending on the exigencies of the specific painting situation, the resulting palette could be cool, as in *Interior with View of the Ocean*, or searingly hot, as in the witty painting *July*.

Like Bischoff, Diebenkorn showed both pure landscapes and landscapes with figures in the 1957 exhibition, extending his earlier work in which windows frame and contain the outdoor view. Unlike Bischoff,

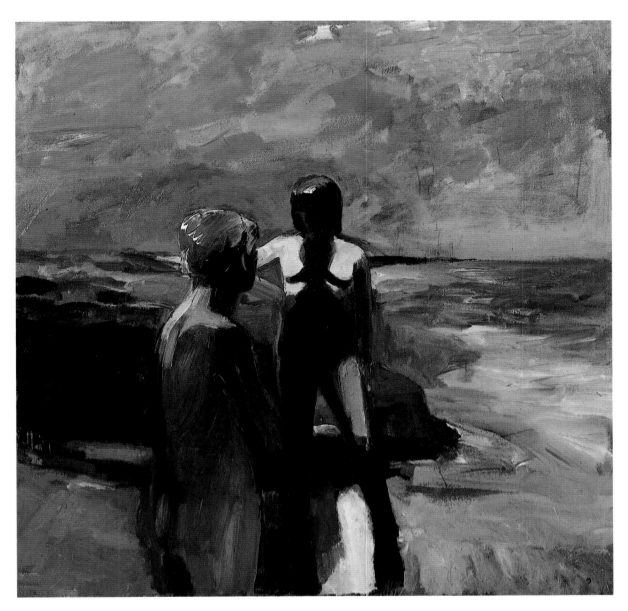

FIG. 3.17. Elmer Bischoff, *Two Figures at the Seashore*, 1957. Oil on canvas, 56×56¾ in. (142.2×144.1 cm). Newport Harbor Art Museum.

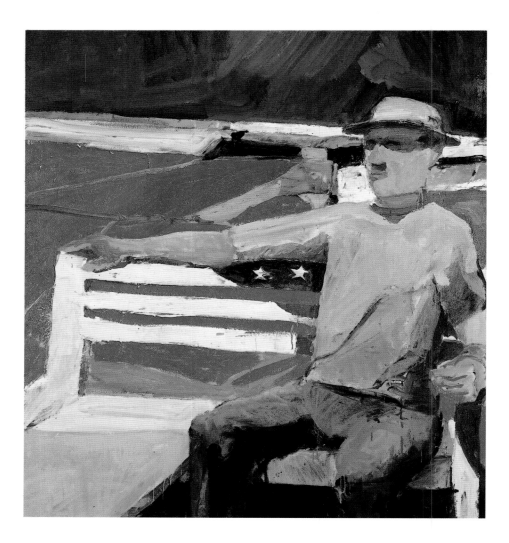

FIG. 3.18. Richard Diebenkorn, *July*, 1957. Oil on canvas, 59 × 54 in. (149.8 × 137.1 cm). Private collection.

FIG. 3.19. Richard Diebenkorn, *Interior with View of the Ocean*, 1957. Oil on canvas, 49 ½ × 57 ¼ in. (125.7 × 145.4 cm). The Phillips Collection.

Park, or other Bay Area Figurative painters, however, Diebenkorn never explored the essentially romantic tradition of nudes in nature; in fact, he has never painted the male nude, and female nudes appear only in interiors. In *July* (fig. 3.18), his male subject is a stocky, middle-aged suburbanite, dressed in nondescript hat and T-shirt and seated on a bench as if stolidly waiting for the Independence Day parade to pass by. One senses that the wit of the painting was discovered in the course of making it. The red-white-and-blue flag that appears in reverse under the man's arm is a colorful illusion: its stripes are created from the juxtaposition of the red background and the white bench, and the stars are reserved out of the blue shadow as if in a last-minute decision to make a pun on the existing stripes.

What is the significance of this Pop image, painted before Jasper Johns's encaustic flags had ever been shown? It is likely that for Diebenkorn the cultural comment was intended lightly, if at all. More to the point is Diebenkorn's lifelong interest in the symbols of heraldry: Maltese crosses, pennants, and flags had animated his imagination ever since his maternal grandmother gave him a set of postcard reproductions of the Bayeux tapestry. Crosses, hearts, clubs, and spades appear in many of his abstract Urbana and Berkeley landscapes, as well as in one of his first figurative canvases (*Landscape with Figure*, 1956). For Diebenkorn, these heraldic devices played a role similar to the arabesques in the Moorish furnishings Matisse included in his paintings; they set a decorative mood without fully determining the painting's content. The choice of decorative motif is significant, however, for if Matisse's flowery arabesques enhance a sensuous, interior, female world, Diebenkorn's flags and Maltese crosses imply a masculine, military presence. Perhaps, as in Marsden Hartley's work, they are codes for the male nude, otherwise absent from Diebenkorn's work.[33]

A subtle heraldic device appears, for example, in the chair to the right of *Interior with View of the Ocean* (fig. 3.19), one of the more stunning of Diebenkorn's

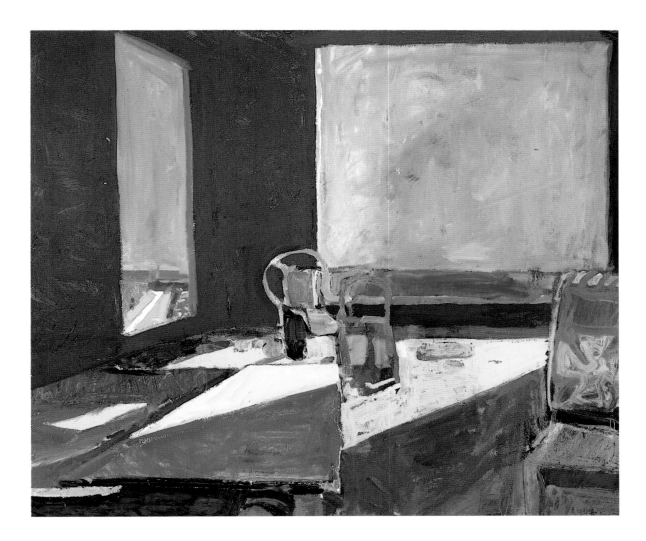

paintings from this period. In a yawning interior, the chair functions as a figural surprise, the Maltese cross on the chair back standing with its arms outstretched. The other chairs echo the planes of the windows, with the left one paralleling the slant of the left opening and the central chair as resolutely frontal as the window behind it.

Dated 1957, *Interior with View of the Ocean* may have been produced very early in the year, for it was painted on top of a Berkeley abstraction before that painting was fully dry.[34] It is certainly one of the first of Diebenkorn's paintings to be deeply (and obviously) indebted to Matisse. As Maurice Tuchman relates, Diebenkorn had visited The Phillips Collection in Washington, D.C., during the war, when he was stationed at a military base in nearby Quantico, Virginia. "No painting had a greater impact upon Diebenkorn in this period than Matisse's *The Studio, Quai St. Michel.*"[35] Tuchman correctly notes the salient aspects of the Matisse for Diebenkorn: the revealing way in which the artist left areas in the canvas

unfinished, conveying a sense of process; the contrast between interior and exterior space; the model's representation both by the rendering on the foreshortened canvas at left and by sign in the glass and tray at right; the play of parallels with the canvas edge in the window, table legs, chairs; the chairs themselves as tokens of the artist's presence in the scene.

Diebenkorn pursued his interest in Matisse at the Philadelphia Museum of Art, where he saw *Interior at Nice* in the Gallatin collection. His abiding interest in the French artist was further reinforced by the Matisse retrospective held in 1952 at the Los Angeles County Museum, which Diebenkorn had seen that summer en route to the Bay Area from Albuquerque. Diebenkorn's deep debt to Matisse reached a peak in 1957, with canvases such as *Interior with View of the Ocean*, *Man and Woman in Large Room* (fig. 3.20), and *Girl on the Beach* (fig. 3.21).

Man and Woman in Large Room recalls Matisse's *Studio, Quai St. Michel* (fig. 3.22) with its three high rectangles, although in Diebenkorn's painting they

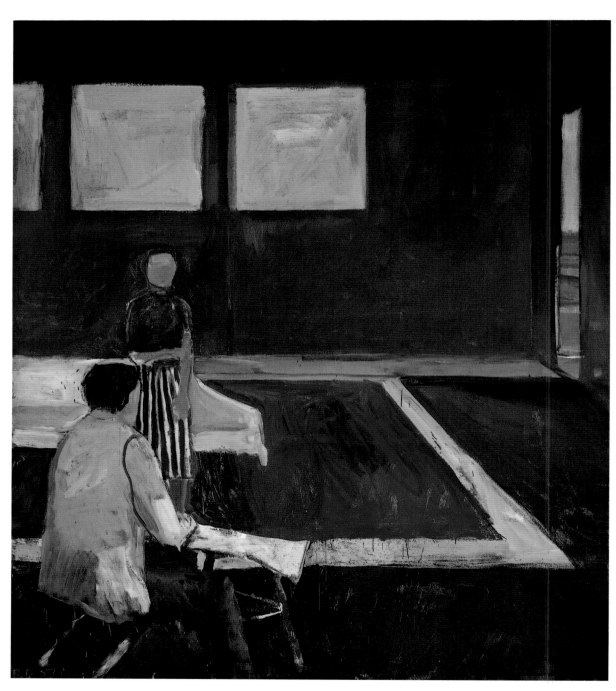

FIG. 3.20. Richard Diebenkorn,
Man and Woman in Large Room,
1957. Oil on canvas, 71⅛ × 62½ in.
(180.7 × 158.8 cm). Hirshhorn
Museum and Sculpture Garden,
Smithsonian Institution.

are regularized and one is occluded. The cropped window seems to wrap around and recur on the right in the open door that shows a flattened and frontal slice of landscape. Diebenkorn's canvas went through many changes, which are perceptible under the thin layers of paint, just as Matisse reveals his experiments in the *Studio*. Diebenkorn originally extended the artist's sketchpad much farther into the background, which at one time was a landscape (preserved now only in the layered wedge through the door). The plein-air scene became a somber, backlit interior; the silent confrontation between artist and model evokes Matisse's *Conversation* in the same subtle way that the woman's bold facelessness brings to mind the French artist's later blank-faced, egg-headed women. Both elements underscore that these figures are meant to function as forms, not personalities; yet we cannot fail to be intrigued by the absorbed, sketching artist in this painting (self-portrait or homage to Matisse?), and the woman who grows like Galatea from his working hand.

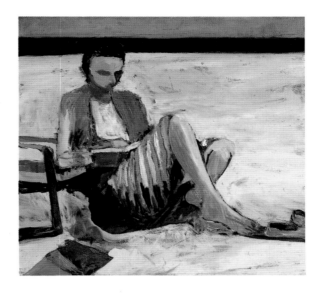

A final example of Diebenkorn's thoughtful use of lessons from Matisse, with a dash of Delacroix, occurs in the 1957 painting *Girl on the Beach*. The orientalizing odalisque, in her shimmering striped pantaloons and short jacket, lies behind Diebenkorn's seemingly prosaic image of a woman reading in the sun.[36] In images such as these, rather than in his drawings or paintings of nudes, Diebenkorn's gentle, sometimes humorous, erotic impulses are revealed. The iridescent garment of the odalisque may distract the eye, but subliminally we sense that her parted thighs offer and reveal access—albeit purely visual access—to the darkened area within.[37]

MATURITY OF PARK AND THE
FIRST GENERATION

Park's maturity was enforced, in a manner both tragic and tantalizing, by his death of cancer in 1960 at the age of forty-nine. We are obliged to label as late a group of works which could have signaled a new beginning; certainly they were the boldest and most successful paintings of his figurative career and served as the capstone to the mature achievements of the first generation.

There is little doubt that the supportive exchanges between Park and his colleagues encouraged him to take greater risks in his work. Even before moving beyond genre subjects, Park's work showed the effects of his interaction with Diebenkorn, as in the humble still life *Cup and Saucer* from 1957 (fig. 3.23). Diebenkorn had begun painting still lifes at the earliest

FIG. 3.21. Richard Diebenkorn, *Girl on the Beach*, 1957. Oil on canvas, 52⅛ × 57¼ in. (132.3 × 145.4 cm). Collection of Mr. and Mrs. Harry W. Anderson.

FIG. 3.22. Henri Matisse, *Studio, Quai St. Michel*, 1916. Oil on canvas, 58¼ × 46 in. (147.9 × 116.8 cm). The Phillips Collection.

FIG. 3.23. David Park, *Cup and Saucer*, 1957. Oil on canvas, 8¼ × 11¼ in. (20.9 × 28.6 cm). Collection of Mr. and Mrs. Roy Moore, Santa Barbara, California.

FIG. 3.24. David Park, *Nude— Green*, 1957. Oil on canvas, 68 × 56⅜ in. (172.5 × 143.1 cm). Hirshhorn Museum and Sculpture Garden, Smithsonian Institution.

stages of his figurative period (by one account a still life was his first post-abstract figurative canvas) with great success; one critic found a still life "the single most impressive painting" in Diebenkorn's 1963 Poindexter Gallery show.[38] Park was inspired by these small canvases, with their bravura paint handling and intimate emotional effects, and was soon attempting his own.

In part because of their small size and unambitious format, Park's still lifes liberated his painterly sensibilities. Park has initialed *Cup and Saucer* on the spoon (which the saucer widens to accommodate), humorously carving a family monogram in the thick, viscous paint. The sensuous pleasures of pure, buttery paint are celebrated, as are the joys of color. Color is perhaps the primary subject of an isolated experiment Park undertook in the same year as *Cup and Saucer* and *Interior*—the monumental *Nude—Green* (fig. 3.24). Unlike *Interior*, whose space is filled with a Bischoffian atmosphere, *Nude—Green* presents a woman standing before a flat curtain of dramatic yellow-green. The precedent for her slate-colored, marble-cold flesh lies not with Diebenkorn or Bischoff (although Diebenkorn may have inspired the subject of an interior nude), but with Picasso's classical women of the twenties. The painting is anomalous within Park's work, and his figures of the subsequent year are set outdoors, their backgrounds full of brushy incident.

Park's major painting of 1958, and perhaps one of the finest of his late period, is the large-scale canvas *Four Men* (fig. 3.25). The painting reads like a frieze whose meaning remains more mysterious than that of any of the Pieros that Park admired. Three men face us; one turns his back to row toward shore. Only one figure is not cropped; he stands as an eerie projection or prototype of the other two, one arm bent and the other hanging stiffly at his side in a variation of the others' positions. Light bathes this standing figure, seemingly penetrating his skin from behind, in the manner of a child's hand held over a flashlight.[39] With his bare, smooth chest and spindly legs he seems the youngest of the four figures. Indeed, one might project an allegory of the ages of man onto the cryptic narrative (and perhaps the rower plies the river Styx).

Strengthened by the armature of reality, Park painted *Four Men* with a freedom of color and a lush abandon that was unavailable to him during his nonobjective phase, self-consciously concerned as he was with "making a painting" rather than painting a picture. No doubt learning from Bischoff's palette and

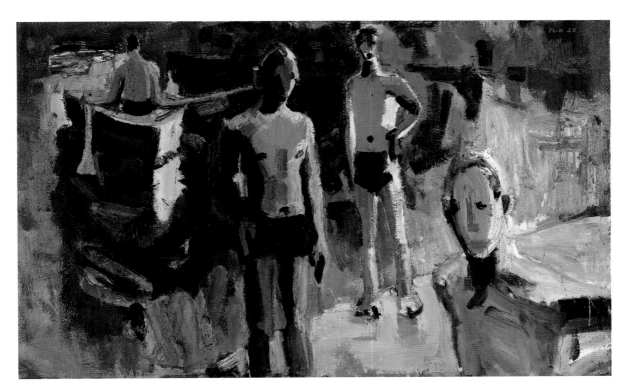

FIG. 3.25. David Park, *Four Men*, 1958. Oil on canvas,
57×92 in. (144.8×233.7 cm). Whitney Museum of American Art.

painterliness, Park had his own approach to the Abstract Expressionist notion of process. Unlike the others, he scraped down very little, painting wet-in-wet and obsessively layering on pigment until the image met his approval.[40] Interestingly, the figures in *Four Men* lie at a level lower than the background, indicating that Park found his greatest challenge in creating the men's environment. The chartreuse scoop of riverbank remains unconvincing as representation, although it satisfies a formal need to create a frontal plane.

Perhaps the most startling innovation in *Four Men* occurs in the head of the foreground figure. Using a hybrid language combining verism and schematization, Park created here the poetry that would animate his late oils and gouaches—particularly the haunting series of Crowds and Heads he painted at the very end of his life. For verism, Park used the powerfully persuasive tool of light to model the basic forms of the face. Although the palette may be unrealistic, with Prussian blue shadows and chalk white highlights, the system of values in *Four Men* is consistent: the light comes from the right, outlining the figures and casting their left sides in shadow. Onto this convincing base of modeled form, Park places his schematized facial features: blue squirts of paint for eyes, a red

slash for a mouth, and a corresponding vertical stroke for a nose. The result of this hybrid combination is both unsettling and deeply satisfying. Perhaps drawing upon Matisse's (and Diebenkorn's) empty ovoid faces, and Alexej Jawlensky's wonderfully symbolic series of schematized heads, Park created a personage that was everyman and no-man, a charged image oscillating between representational content and abstract form.[41]

Couple (fig. 3.26) exemplifies Park's recurring interest in these strange personages. Although not clearly identified, the figures seem to be male on the left, female on the right. Their boldly brushed faces are roughly constructed from thick slabs and swipes of paint; nonetheless they convey a deep sense of human emotion. Particularly in the case of the female figure at right, Park has allowed an expression of pain, even anguish, to develop. The red background and elegiac, raking light lend credence to one collector's feeling that the painting speaks of dramatic endings: bombs, wars, and other human tragedies.[42]

The composition of Park's later paintings becomes tighter and tighter, with the figures brought together and the surrounding landscape reduced to a minimum of sketchy lines. In *Ethiopia* from 1959 (fig. 3.27) this development reaches a climax in which two

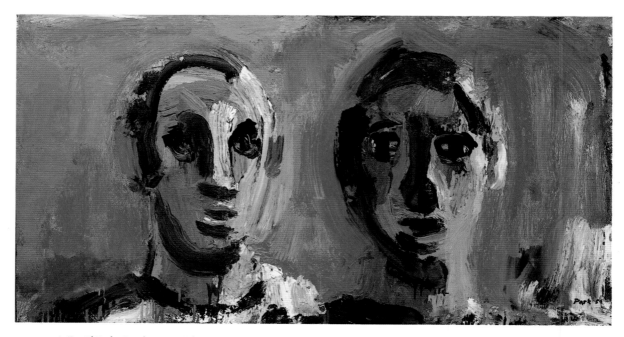

FIG. 3.26. David Park, *Couple*, 1959. Oil on canvas, 25½×47 in. (64.8×119.4 cm). Flagg Family Foundation, Monterey, California.

men and two women are pressed in on one another in an ambiguous confrontation. In part these tight compositions seem to recapitulate the Cubist-inspired puzzle friezes of faces that Park did in the mid-forties (see fig. 2.4), in part they look to the "fabric of persons" Park admired in Piero.[43] With delight in his own version of the map problem, Park has painted each figure with a different color scheme. Only the color orange seems to be common to the four figures, although it is minimal in the black woman in profile. She seems to have been completed at an early stage of the painting, as was the green sketchy background. The other figures show thicker, more heavily worked paint and fewer late drips.

As in *Four Men*, the painting's title and subject are mysterious. The beautiful black model from *Nudes by a River*, probably Flo Allen, is here caricatured, her lips thrust out like an African mask (via Picasso's *Demoiselles*). She is placed lower on the canvas than the other figures, is cropped more radically, and is positioned in the foreground as if she is an emissary to the others. These factors and the overall friezelike composition attest that Park's interest in Piero della Francesca is here more than general. In the Renaissance painter's fresco of the Queen of Sheba's meeting with King Solomon, among the queen's court is a small Ethiopian girl, shown in profile, standing slightly apart from the queen's other attendants. Whatever her significance for Park, she seems the likely source (if not the inspiration) for *Ethiopia*.[44]

Cellist (fig. 3.28) is generally thought to be Park's last finished oil painting; in it he returns to one of the genre subjects he depicted often in his youth. The grace and delicacy of the earlier paintings has here been converted to heft and power. The cellist saws at her instrument with deep concentration and intensity; she is oblivious to the audience as she stares down at her hand, willing it to perform as desired. Park, his back pain worsening, here created an image of the artist alone with her instrument, intent on control.

After an unsuccessful vertebral disc operation in November 1959, Park was diagnosed the following spring as having terminal cancer. He was physically unable to stand or paint in oils, so friends and family helped rig up an easel at a reclining chair where he could paint in gouache. These gouaches, of which Park produced some one hundred in ten weeks, were his self-conscious final statements.[45] Their brilliance, luminosity, and assurance belie the fact that for Park gouache was a relatively new medium that, unlike oils, did not allow for constant reworking.

The themes of these gouaches are consistent with the late work. Genre subjects are more in evidence: musicians, women with babies. But the dominant images are nude figures in a landscape, as in *Standing Nude Couple* (fig. 3.29), and heads, either singly or in groups, as in *Crowd of Ten* (fig. 3.30). *Standing Nude Couple* relates to Park's earlier works, but its narrative is more explicit. The woman, rendered in bluish

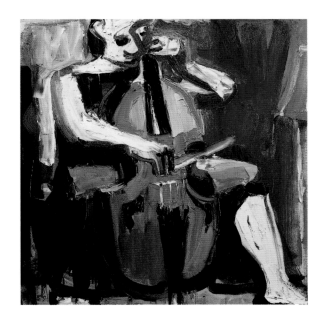

FIG. 3.28. David Park, *Cellist*, 1959. Oil on canvas, 56 × 56 in. (142.2 × 142.2 cm). Collection, Portland Art Museum, Oregon Art Institute.

FIG. 3.27. David Park, *Ethiopia*, 1959. Oil on canvas, 52 × 60 in. (131.1 × 152.4 cm). Lowe Art Museum, University of Miami, Coral Gables, Florida.

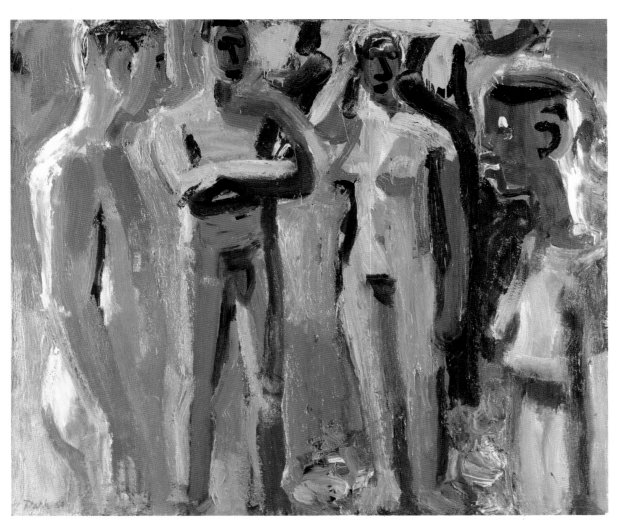

FIG. 3.29. David Park, *Standing Nude Couple*, 1960. Gouache on paper, 15½ × 13¼ in. (39.4 × 33.6 cm). The Oakland Museum.

FIG. 3.30. David Park, *Crowd of Ten*, 1960. Gouache on paper, 13¼ × 19¼ in. (33.6 × 50.2 cm). Collection of Mr. and Mrs. Harry W. Anderson.

white, stands next to a striding man, painted in ruddy umbers. Beside them both, perched on a long dark branch which runs behind them, is a bird with a long tail, its beak seemingly open in song. The overwhelming suggestion is of Adam and Eve, before tasting the Tree of Knowledge, their innocence—and ignorance—intact.

Crowd of Ten returns to the enigmatic status more characteristic of the late work. A striped blue awning and mustard yellow background offer tentative clues to a beach or similar outdoor scene. But the crowd, pressing toward us, reveals nothing other than demographic diversity—the black man, the ochre man, the orange man, diminishing in the shallow space to a field of yellow where the faces dissolve into ciphers and ghosts. In this distant corner, Park reduces his hybrid approach to pure schematization. Light here does not illuminate solid forms, it burns through evanescent spirit, leaving only the symbols of human faces behind.

Park's death in September 1960 was not a surprise to his closest friends. The day after, Diebenkorn and Bischoff joined Park's widow, Lydia, and his dealer, George Staempfli, to make an inventory of all the paintings at the house.[46] Diebenkorn must have been hit particularly hard; in addition to being an old and devoted friend, he had spent a great deal of time with Park at the end, making countless portrait sketches and paintings of his ailing colleague (which, to date, have never been shown). It was a difficult year for Diebenkorn in other respects as well. A major exhibition at the Pasadena Museum brought the inevitable reconsideration of the previous decade's work, and Diebenkorn's painting suffered amid the distractions. His works of 1960 and 1961 were turbulent and even muddy, paint-laden and compositionally crowded by cropped formats and awkward figural poses. He may have been experimenting with Park's use of paint as *merde*, or he may have lost touch with his customary clarity of vision; whatever the cause, he soon returned to the classically poised and balanced works that characterize his mature period.

DIEBENKORN'S MATURE FIGURATIVE WORKS

Before Park's death, and resuming a year or so later, Diebenkorn was productive and successful, achieving such accomplished paintings as *Woman on Porch* (fig. 3.31), *Interior with Book* (fig. 3.32), and *Interior with Doorway* (fig. 3.33). Of similar size, these paintings are almost square in format and about the height of a person; in them Diebenkorn synthesized

FIG. 3.31. Richard Diebenkorn, *Woman on Porch*, 1958. Oil on canvas, 72 × 72 in. (182.9 × 182.9 cm). New Orleans Museum of Art.

his previous experiences to achieve a classically balanced representationalism purged of detail or specificity.

In *Woman on Porch* Diebenkorn has given the figure a face (which had been missing in *Man and Woman in Large Room*), but only barely. He did not return to the purplish shadows of his earliest figures; rather, he barely indicated the woman's features within the burning orange of the hot Pacific shade. Dwarfed trees hover along the horizon, mirrored (in a heat mirage?) on the roof of a nearby building. The hot, saturated palette and the outdoor setting of such paintings led some to criticize Diebenkorn, Bischoff, and the figurative movement in general for celebrating "the domestic and mundane values of the Western way of living. [There] is no harsh or jarring disturbance; life is very beautiful and the only pit is for barbecues. [The paintings] have the beauty of a ripe California navel orange. . . . But like the orange, they are often bland; they look delicious but there isn't much juice."[47] Diebenkorn himself once said, "I would prefer Doomsday in the bright sun."[48] But if his paintings are less emotionally suggestive than Park's or Bischoff's, neither are they bland affirmations of easy living. It has already been suggested that Diebenkorn's mute still lifes and interiors have strong erotic overtones, often embedded in symbols and signs that he "prefers to keep . . . private."[49] One scholar has noted the "frank sexual symbolism" in his still lifes (as in, for example, the pieces of fruit shown with a knife between two split halves), although this

FIG. 3.32. Richard Diebenkorn, *Interior with Book*, 1959. Oil on canvas, 70 × 64 in. (177.8 × 162.6 cm). The Nelson-Atkins Museum of Art, Kansas City, Missouri.

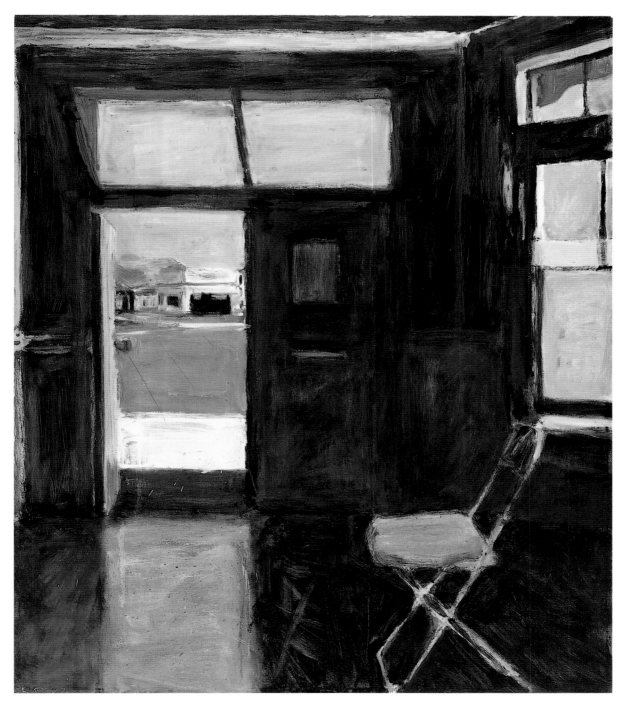

FIG. 3.33. Richard Diebenkorn,
Interior with Doorway, 1962.
Oil on canvas, 70¼×59½ in.
(178.1×152.2 cm). Pennsylvania
Academy of the Fine Arts,
Philadelphia.

FIG. 3.34. Richard Diebenkorn, *Cityscape I* (formerly *Landscape I*), 1963. Oil on canvas, 60 ¼ × 50 ½ in. (153.1 × 128.3 cm). San Francisco Museum of Modern Art.

FIG. 3.35. Richard Diebenkorn, *Cityscape (Landscape No. 2)*, 1963. Oil on canvas, 47 × 50 ¼ in. (119.4 × 127.6 cm). Collection of Mr. and Mrs. Richard McDonough, Berkeley.

attribute is characterized as "atypical of the artist's work."[50] In fact, it is less atypical than often thought.

Interior with Book may be less explicit than Diebenkorn's still lifes, but the welcoming armchair contains powerful suggestions of the human presence, with a "head" formed from an outdoor shrub, and an open book standing in slyly for a lap.[51] As in *Interior with View of the Ocean*, Diebenkorn does away with the figure entirely, while retaining all of its affect. The individuation characteristic of portraiture is enforced by color, whether the saturated blues of *Interior with Book* or the moody, Rothko-esque maroon of *Interior with Doorway*.

In *Interior with Book*, the windows are flattened by the abstract banding of the landscape in conjunction with the window panes, which parallel the canvas edges for "the integration of a two-dimensional scaffold as relentless as any of those of Piet Mondrian."[52] *Interior with Doorway*, inspired by Diebenkorn's Hillcrest Road studio in Berkeley,[53] accomplishes the same effect through even more relentless distortion. The right-hand window, which is the only one to intersect with the canvas edge, is skewed so that its bottom sill

and central molding are parallel to the bottom frame, and not to the floor.

The two versions of *Cityscape* (figs. 3.34, 3.35) executed in 1963 allow us to compare early and later stages in Diebenkorn's development of a pictorial idea. In the first painting, the artist is more faithful to the motif. Odd rooflines, gaps in the shadows, trees and telephone poles all recall that first, fresh attempt at representation in *Chabot Valley*. Diebenkorn's signature process, with its searching and scraping, is also evident, although, fascinatingly, some of the same "pentimenti" are now consciously evoked in the later *Cityscape (Landscape No. 2)*. As in the earlier painting, the same light green is brushed over ochre, dark green over light, and even a similar bit of ochre intrudes on the gray shadow in the painting's center. The composition has changed markedly, however. The canvas is slightly smaller, and horizontal rather than vertical in its orientation; the horizon line is gone, and all incidental details have been suppressed or eliminated. Comprehensible areas have become abstract form, with the result that the second painting connects both with the Berkeley series of abstract land-

scapes, and with Diebenkorn's non-objective Ocean Park paintings to come.

A similarly revealing comparison can be made between two tiny still lifes of scissors dating from 1959 and 1963 (figs. 3.36, 3.37). The earlier painting, of the type that inspired David Park, features shadows and foreshortening, so that the scissors lie in a receding, representationally three-dimensional space. In the 1963 version, Diebenkorn eliminated such spatial devices. The simple tool is painted more lushly, but less realistically, forced to the surface of the canvas like a butterfly under glass.

One of the most rewarding paintings among Diebenkorn's many masterful still lifes is the nearly monochromatic *Still Life with Letter* (fig. 3.38). It shows the intimate objects that live in Diebenkorn's studio and appear often in his work: the French match-striker, with its air of Montmartre and the Cubist still life; the coffee mug, migrated from its saucer; the artist's spiral-bound sketchbook, propped up and opened to a dark, heavily worked image; and the letter of the title, its edge barely visible, a blurred stamp at its corner providing the only color in the scene.

With small masterpieces such as these, and a New York audience already familiar with his work, Diebenkorn was promoted by critics to the head of Bay Area Figurative painting after Park's death. Nothing was quite so onerous to Diebenkorn as the thought that he was surrounded by eager followers, imitators, buyers, and thieves, but for at least a few more years he was content to remain in the area, teaching at the San Francisco Art Institute (its name was changed from the California School of Fine Arts in 1961) and exploring with Bischoff and Weeks the mature first-generation style.[54]

James Weeks's Contribution to the First-generation Style

Both Weeks and Bischoff, colleagues of Diebenkorn at the Institute, participated in the consolidation of the Bay Area Figurative movement. Since destroying his figurative works in 1957 and beginning over with *Woman Singing*, Weeks had obtained a part-time teaching appointment that allowed him to quit his billboard job (fig. 3.39). He returned to earlier

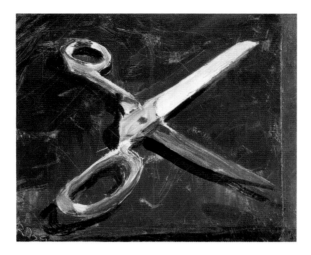

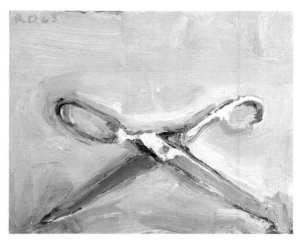

FIG. 3.36. Richard Diebenkorn, *Scissors*,
1959. Oil on canvas, 10¾ × 13¼ in.
(27.3 × 33.7 cm). Private collection.

FIG. 3.37. Richard Diebenkorn, *Scissors*,
1963. Oil on canvas, 10 × 12⅝ in.
(25.4 × 32.1 cm). Private collection.

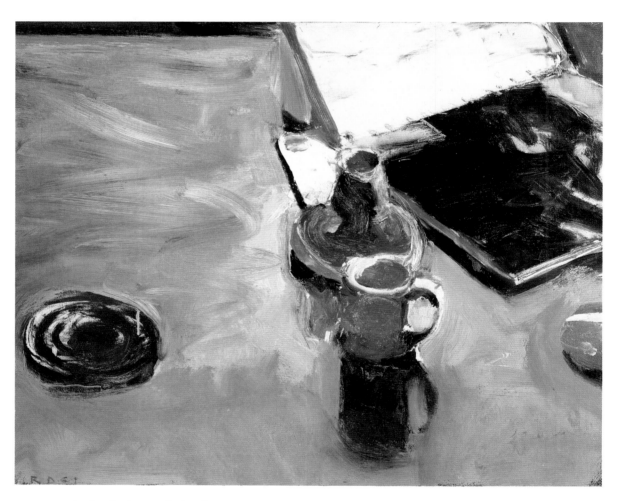

FIG. 3.38. Richard Diebenkorn, *Still Life with Letter*,
1961. Oil on canvas, 20⅝ × 25⅝ in. (52.4 × 65.1 cm).
Collection City and County San Francisco.

themes, but the new treatments had a sophistication and formal clarity missing from his earlier work. The monumentality he had previously sought in sheer size was now achieved through purified geometry and composition alone.

By 1960 Weeks had hit his stride as a figurative painter, and the canvases of this year are among the finest of his career. Eschewing his colleagues' predilection for the figure in the out-of-doors, Weeks painted the indoor world of the jazz club and the sports arena. The men in *Two Musicians* (fig. 3.40) and *Fighter with Manager* (fig. 3.41) are not even as active as *Woman Singing*—rather, they are posed in relaxed grandeur, looking out and slightly down at the viewer as if from a stage. The occupation of the *Man in a Blue Suit* (fig. 3.42) is unclear, but he shares their poise and authority.

These men are tough, potentially violent characters, but they are not demonic. In *Two Musicians* we sense the raw power held by the kings of bebop in the Bay Area. The utter security of being cool, of living at the cutting edge of underground culture, is projected by both the shadowy standing man, with his phallic saxophone, and his seated companion, haloed with blues.[55] In *Fighter with Manager* the petty threat of the fighter, thighs tensed and fist clenched, pales beside the brute authority of the faceless manager. This is not the Parkian search for everyman, or even Bischoff's personalized psychological projections. These are characters from Damon Runyon, Upton Sinclair, or Weeks's admired Orozco: trenchant commentary on the darker side of American culture.

Probably in response to the other Bay Area Figurative painters, Weeks softened his imagery in these works through open brushwork and a rich, varied palette. Colors slide in and out of existence, and feet are merely outlined (as if to reassure us that these tough characters are only paint). The background panels curve in to embrace the musician's calf and the fighter's knee, and the shimmering paint on the boxer's satin trunks is as lush as that in any French boudoir painting.

These sensual details hint at another side of Weeks's artistic persona, exemplified by the delicacy and sureness of line in his pencil drawings. Weeks had participated irregularly in the drawing sessions with Park, Diebenkorn, Bischoff, and others, but his best and most characteristic drawings were made on his own. The portraits of his friend Hayward King and his own son Benjamin (figs. 3.43, 3.44) are models of incision. The taut, Ingres-like line spares nothing, yet adds no unnecessary information; here Weeks re-

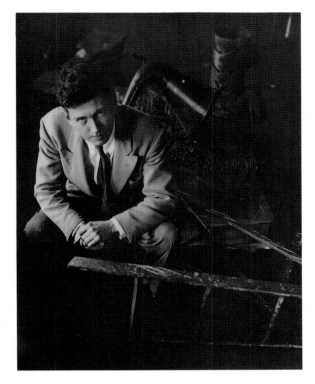

FIG. 3.39. James Weeks, 1949. Courtesy James Weeks.

veals his enduring commitment to the figurative tradition in its most classical form.

Possibly in response to the work of Theophilus Brown, and the life-drawing sessions they shared, Weeks began "acting on the delayed impetus to explore atmospheric light and space," producing his first landscape paintings.[56] One of the smallest yet most successful of these is *Pacific Ocean—Rocks and Surf* (fig. 3.45), where creamy paint effectively renders the froth of surf against the dark brown grit of sand. As one writer has noted, most of Weeks's other landscapes are studio composites, and the paint is manipulated so assertively as to "stand out more insistently as material than as the cliffside and water they are meant to depict."[57] For Weeks, the tension between pigment and image in his landscapes is not always in balance, and the crusty orange of a distant bank can thrust itself into view more demandingly than the image warrants. With its fresh intimacy, however, *Pacific Ocean—Rocks and Surf* fully succeeds.

Weeks found his work flattening out and becoming more formalized as the decade progressed. A comparison between the 1964 and 1966 versions of his Embarcadero studio (figs. 3.46, 3.47) readily illustrates the subtle shift in emphasis. The earlier painting is austere, reflecting Weeks's long-standing interest in Vermeer. Cool gray and cream canvases

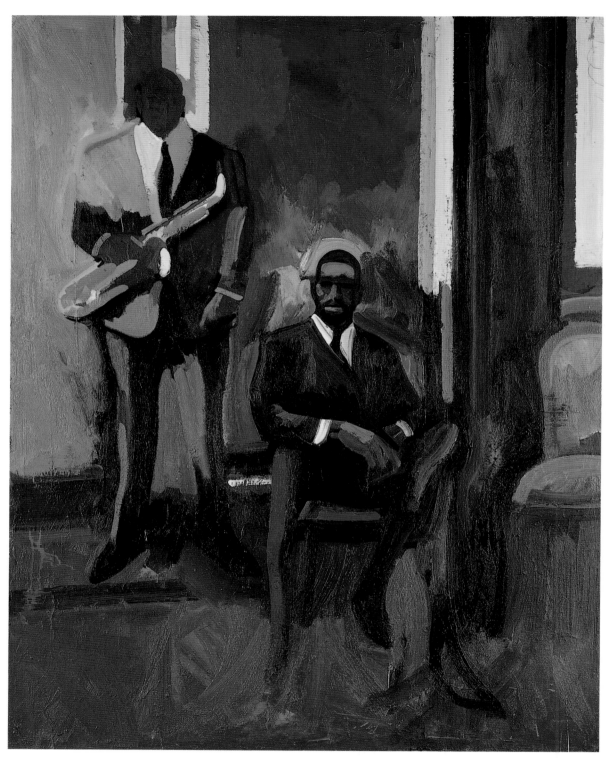

FIG. 3.40. James Weeks, *Two Musicians*, 1960. Oil on canvas, 84 × 66⅛ in. (212.3 × 168 cm). San Francisco Museum of Modern Art.

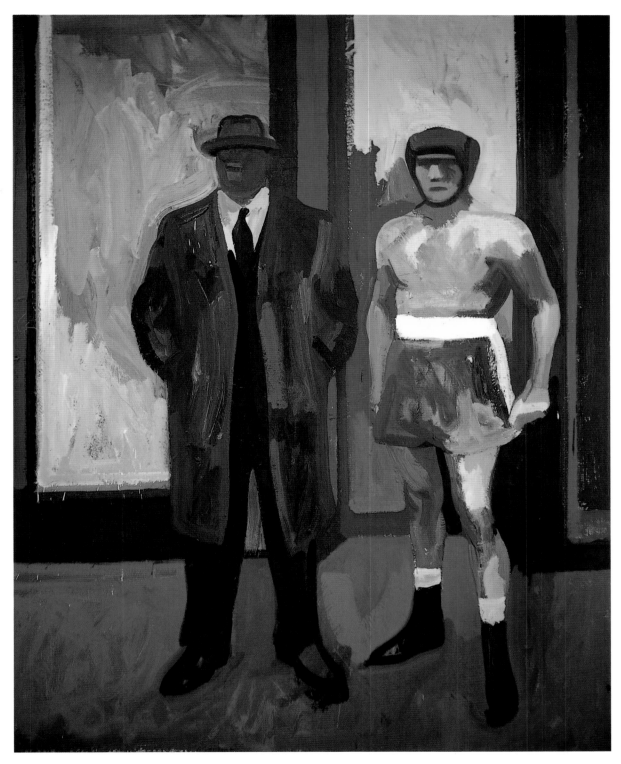

FIG. 3.41. James Weeks, *Fighter with Manager*, 1960. Oil on canvas, 84¼ × 66⅛ in. (214 × 168 cm). Private collection, Phoenix, Arizona.

FIG. 3.43. James Weeks, *Portrait of Hayward King*, 1961. Graphite on paper, 26×17⁵⁄₁₆ in. (66×44 cm). Collection of Hayward King, San Francisco.

FIG. 3.42. James Weeks, *Portrait of a Man in a Blue Suit*, 1962. Polymer-tempera on board, 11×7¾ in. (27.9×19.7 cm). The Oakland Museum.

FIG. 3.44. James Weeks, *Benjamin in a Chair*, 1961. Graphite on paper, 15×10 in. (38.1×25.4 cm). Collection of Theophilus Brown, San Francisco.

are stacked up against the wall, their surfaces inflected only by the slight shadow of a counter. Above the counter a nearly abstract painting hangs on an angled wall. Light pours in from the right-hand side of the composition, animating the curving chair back and picking out the bright colors of objects on the counter surface.

By contrast, the 1966 canvas has been purged of all highlights, the palette reduced further to buff and putty colors (with the exception of the canvas backs, which are now red and blue). The painting above the counter is eliminated, its companion to the left drained of all brushy incident so that it hovers, depthlessly parallel to the picture plane. The angled wall has likewise been rendered parallel to the picture plane, its outline trued to the canvas edge. The earlier view's austerity has here become almost clinically exact.

Critics often distinguished Weeks from the other Bay Area Figurative painters by what one writer called his "plain style." Connecting him to Thomas Eakins and Winslow Homer, Anita Ventura wrote:

> There is a repression, one might say even a suspicion, of elegance—a turn, at times, even to awkwardness, or at least to stiffness—[producing] a sense of contemplativeness [and a sense of] painting itself once again a *medium*, but not for expression so much as for comprehension. This determination, of stance and intent, differentiates Weeks's paintings from those of, say, Diebenkorn, Park and Bischoff, and makes of him a most singular figure on the local scene.[58]

But despite this singularity, Weeks's work of the early sixties fits well into the range of individual approaches pursued by the Bay Area Figurative painters, toward the axis of Diebenkornian classicism rather than Bischoffian lyricism. Perhaps the most salient difference between Weeks and his contemporaries is that he was never known for a non-objective style, although there is some evidence he may have privately tried one.[59] Although his public work was never non-objective, he was always involved with what he terms "the abstract *ideas* of painting," which he found "very real . . . realler [*sic*] than figuration in many ways."[60] Dominated by the formal and abstract ideas he wanted to achieve in his work, but unwilling to give up a recognizable subject, Weeks risked a cerebral dryness in his realism. He was never fully able to pursue the purely plastic qualities of paint while still controlling the tension between paint and image, as Bischoff, Park, or Diebenkorn had learned to do in their abstract work. Weeks himself

recognized that he may have missed something: "I've always been impressed by Elmer and Dick, how their abstract enthusiasms were very impressive in the kind of command they got from doing it . . . rather than what I did, the opposite."[61]

Weeks's major contribution to the development of Bay Area Figuration lay in his very constancy, as a strong and solid painter who built on the foundations of the Mexican muralists to bring an aspect of social concern to the movement. Although somewhat shy and reticent, Weeks was active as a teacher at both the California School of Fine Arts/San Francisco Art Institute and the California College of Arts and Crafts, where he influenced many younger painters to pursue the figurative legacy. Like Diebenkorn and Bischoff, and before them Park, he proved to be a steadfast beacon of the local figurative tradition.

BISCHOFF'S MATURE FIGURATIVE PAINTINGS

As did Weeks, Bischoff fully developed his figurative style in the early sixties (fig. 3.48). His work became more varied and complex as the decade progressed, but as others suffered stylistic crises or left figurative painting altogether, he painted what are arguably some of the finest paintings of his career.

Perhaps inspired by the direction Park's work was taking, perhaps liberated by a year's leave in 1959 (made possible by a generous grant from the Ford Foundation), Bischoff's use of color and brushwork are freer in work done after 1958, as canvases such as *Woman with Dark Blue Sky* (fig. 3.49) and *Girl Wading* (fig. 3.50) attest. The themes of these two paintings are similar: a woman stands immersed in a light-filled space, contemplating nature with indeterminate emotion.

Mystery is palpable in these paintings. Color plays a major role, because Bischoff deploys it in a way that contradicts one's standard experience of nature (and the traditional formulae of landscape painting).[62] For example, the sky in *Woman with Dark Blue Sky* grows slightly paler as it moves away from the horizon, while in fact the opposite obtains on a clear day, when the horizon is the palest part of the sky. Similarly, the lurid red and chartreuse of what we presume to be fall foliage in *Girl Wading* are not reflected in the pool below, although the scale of the foliage leads us to believe that it is visually quite close to us. Amazingly, Bischoff employs these almost Surrealist devices (compare, for example, René Magritte's townscapes in which the sky is shown at midday, the street in dusky silhouette) in a fully convincing way. As Park

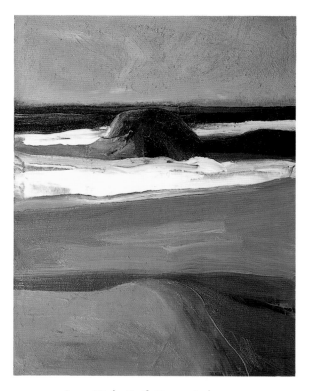

FIG. 3.45. James Weeks, *Pacific Ocean—Rocks and Surf*, 1962. Oil on canvas, 24½ × 18½ in. (62.2 × 47 cm). The Lobell Family Collection, New York.

maintained visual tension through a hybrid of realistic modeling and schematized features, so Bischoff persuades us through his use of consistent light sources on the figures themselves. The water in *Girl Wading* seems to reflect a scene entirely different from the pool's surroundings—tranquil blues and silvery whites rather than turbulent, churning crimson—but we accept the landscape's reality because the central figure is coherently lit and persuasively modeled. Leavening the figure's realism, however, Bischoff has contrived the shadow that falls on the wading girl's upper torso to line up with the distant bank, rendering the girl a translucent wood nymph. The significance of her gesture is unclear—is she merely pushing the dampened hair from her face, or is she in pain? Bischoff suggests that for him the scene is peaceful, even Edenic, and he notes his source in a seventeenth-century painting:

[*Girl Wading*] was inspired, in part, by Rembrandt's painting *A Woman Bathing* and was done under the spell of a host of romantic sentiments about the figure and about nature. The human figure linked with nature, as is the case here, might suggest to some viewers an earlier day of happy accord before the Fall. And I wouldn't object to such a reading.[63]

In a series of outdoor bathers and women holding flowers that paralleled Park's earlier canvases of the same subjects, Bischoff explored such themes further, courting comparisons to other artists in the grand history of figure and landscape paintings. The ample proportions of the women in *Girl with Towel* (fig. 3.51) and other works link them with Gustave Courbet's massive outdoor nudes, and with the even longer tradition of the surprised bather that links paintings of Susanna and the Elders with sculptures of the Venus Pudenda. In Bischoff's case these references are subtle inflections rather than outright quotations, for his women's gestures are more functional than classical. The artist views the figure and landscape as integrally related, a single subject generated (in the best Abstract Expressionist fashion) during the act of painting itself:

I have often thought that the pictures of this period of my work should not be considered "figure in landscape" but "landscape with figure"—ocean, sky, rocks with figure. Obviously, there's an emotional involvement with the figure, but right away I'd have to say also with the trees, the sky, the rocks, the water, the interior scene. . . . But while there's this emotional involvement with these things, it's as if they arise naturally, so to speak, as a kind of gift—in the act of painting. My desire is to make a *painting*, without being trapped in some kind of psychological movement. . . . Whatever there was in the way of a mood in the end result was always a by-product—an aspect of . . . trying to get the painting to work and to feel right. . . . The process is one of finding a painting through painting.[64]

Girl with Towel is an interesting example of how Bischoff "found his paintings" in the year that Park died. Park's death had "a profoundly disturbing impact" on him, and some have suggested that it motivated him to adopt more of Park's techniques in his work.[65] The face of the bather in *Girl with Towel* is pure Park—two blue swirls for eyes, a horizontal stroke for a mouth, and a wet-in-wet calligraphic squiggle for the nose. The paint is looser than previously, and there is evidence that Bischoff worked on the canvas over a long period of time—the white cloud above her left shoulder and the blue sky above her right were painted over cracks which had already formed in the drying paint. Since oil paint takes several months to set (and years to dry fully), it seems that Bischoff came back to *Girl with Towel* after a gap of some months, to continue working on the blustery background in search of the finished painting.

Girl with Mirror (fig. 3.52), finished in January 1961, has the torrid palette of Park's *Couple*, although

FIG. 3.46. James Weeks,
Large Studio, Embarcadero,
1964. Oil and acrylic
on canvas, 79½×65 in.
(201.9×165.1 cm).
The Oakland Museum.

FIG. 3.47. James Weeks, *San
Francisco Studio Interior,* 1966.
Acrylic on canvas, 50×40½
in. (127×103.6 cm). Collec-
tion unknown.

FIG. 3.48. Elmer Bischoff, 1959. © 1959 San Francisco Chronicle.

the mood is more sensual than apocalyptic. Because of the smaller scale, the paint appears to be even more turbulent than in *Girl with Towel*—the brush drags out thick, linear shadows, scrubs buttery curlicues into the mirror frame, and dances through a boiling cauldron of fiery paint in the background.

As with Bischoff's earlier figurative work, questions arise as to the autobiographical basis for the strong emotions embedded in such warm interior scenes. In 1962 Bischoff embarked on his third marriage, to a painter and former student, Adelie Landis. Collectors who know the artist have long felt that the paintings from around this period portray Addie, particularly a series from 1960 depicting couples—the man in a suit, the woman in a pale dress.[66]

If these intimate interiors could be tied to Bischoff's domestic happiness, others, such as *Lavender Curtain* (fig. 3.53), evoke more general art-historical parallels—in this case, Edward Hopper. Bischoff denies any interest in Hopper: "I respect his paintings but was never especially attracted to them."[67] But the thematic and stylistic correspondences are strong, if unacknowledged. The nude woman pulling a curtain back from a balcony or window has its echo in Hopper's etching of his wife, Jo, sitting up in bed as the wind blows the curtain into the room (fig. 3.54). The curtain in Bischoff's painting (which appears again in *Cityscape*, fig. 3.55, and other works) has a sexual charge also found in the Hopper etching—except that in Bischoff's case it is not a threatening presence but

a seductive, tender one. The paint forming the curtain is the barest veil of color, a translucent skin behind which the landscape shimmers like a paradise of natural fulfillment. In *Cityscape*, we see the curtain from the other side; its shimmering, flesh-colored expanse masks the invisible interior. Although the woman in *Lavender Curtain* is no longer visible, the curtain suggests her presence.

The woman's attitude as she peers into the landscape beyond the lavender curtain—tentative, cautious, even awed—is mirrored by the figure in *Breakers* (fig. 3.56), a more romantic work of near-Wagnerian intensity. While nature in the earlier painting is framed, curtained, and contained, here it is raw and overwhelming. The sky is stormy and turbulent, and the waves tower over the woman's head. This is not Diebenkorn's California of sun-drenched porches and ordered fields and roadways; in his landscapes Bischoff reveals himself to be a very different painter from his colleagues. Although he continued to draw with Diebenkorn (the group included Frank Lobdell after Park's death), Bischoff's paintings bear little relation to his drawings done with the other artists. Bischoff's from the period (figs. 3.57, 3.58) are not unlike Diebenkorn's (fig. 3.59)—more tonal and involved with environment, but dealing with the same images of seated women and erotic nudes.

The images in Bischoff's paintings, by contrast, were found largely during the painting process itself. In the case of *Yellow Sky* (fig. 3.60), for example, Bischoff recalls that the image came very directly from a Munchian motif of trees silhouetted against a luminous sky. "It was one of those rare cases—I don't trust [such speed] ordinarily."[68] Similar to the effect Park had achieved in his late paintings of heads (and in Bischoff's own *Girl Wading*), in *Yellow Sky* the viewer's disbelief is suspended in the face of a powerful visual conviction—even if the image is laden with internal contradictions. The blue-black lines forming the trees' shadows, for example, move toward the luminous sky, although the rock and island shadows move away from it. And is the island in the background spouting smoke, or is that an intersecting branch which seems to issue from it?

Toward the end of the 1960s, Bischoff moved away from pure landscapes and landscapes with figures to concentrate on a series of urban interiors. In these images Bischoff departed from the Park influence, and his work moved in a new direction, again evoking Edward Hopper; Bischoff has acknowledged that at least one of these canvases, *Interior with Two Figures* (see frontispiece), is "Hopperesque, although I'm not a

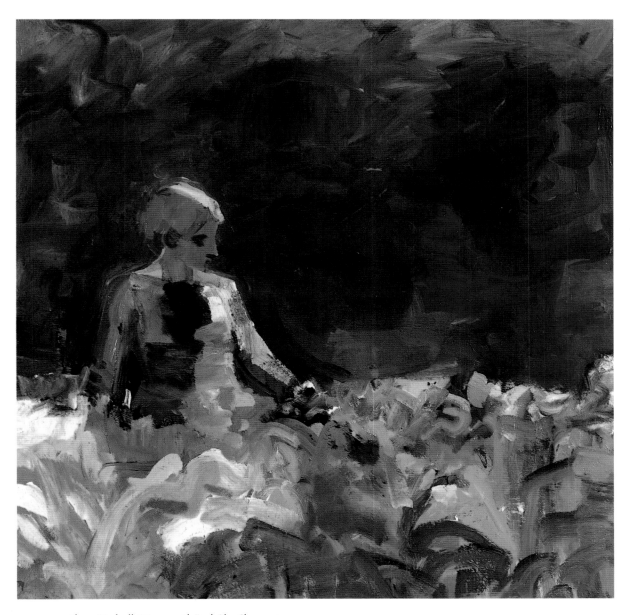

FIG. 3.49. Elmer Bischoff, *Woman with Dark Blue Sky*, 1959. Oil on canvas, 67⅞ × 67⅞ in. (172.4 × 172.4 cm). Hirshhorn Museum and Sculpture Garden, Smithsonian Institution.

great Hopper fan."[69] Additionally, motifs suggesting Hopper's work recur from earlier Bischoff paintings—such as the sensuous, translucent drapery from *Lavender Curtain* and *Cityscape*.

Interior with Two Figures stays well within the figurative style Bischoff had established, although the artist here painted more thinly than previously, modeling his figures in a more solid fashion, with less Parkian brushwork and suggestion. The painting's atmosphere is brooding—outdoors, the buildings stand in silhouette, and indoors a late afternoon sun illuminates only the curtains and a bright yellow wedge of wall at the far left. The man and woman in the room are visually coupled but psychologically divorced; he looks vaguely into the foreground space, his face shadowed; she stares in the opposite direction at the windowsill or perhaps out the window. The flesh-colored curtain billows above the man's left shoulder like a dream or a figure of temptation. It is the only clue of movement in the room—even its partner is sashed so that it cannot catch the breeze.

The strong psychological overtones of alienation and ennui in *Interior with Two Figures* and other works of the series are, according to Bischoff, unintentional. Writing of another canvas in the group of urban interiors depicting a couple, Bischoff noted:

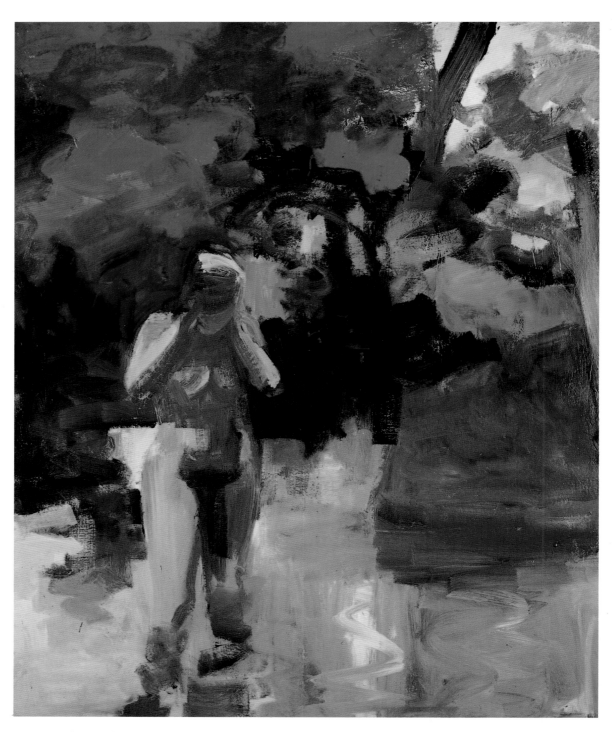

FIG. 3.50. Elmer Bischoff, *Girl Wading*, 1959.
Oil on canvas, 82⅝ × 67¾ in. (209.9 × 172.1 cm).
Collection, The Museum of Modern Art, New York.

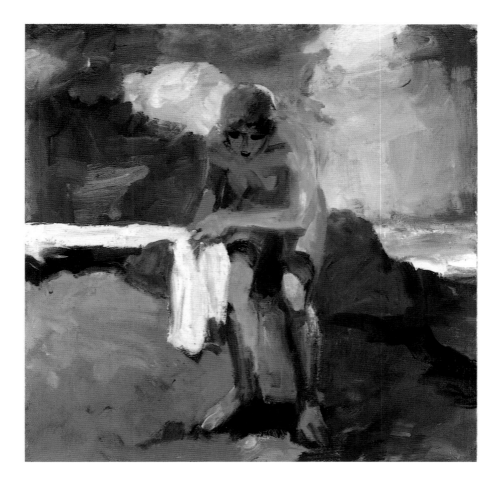

FIG. 3.51. Elmer
Bischoff, *Girl with Towel*,
1960. Oil on canvas,
59¾ × 59⅝ in.
(151.8 × 151.5 cm).
The Morgan Flagg
Family Collection,
Monterey, California.

The woman appears at ease. . . . And the man might be seen as tense, immobilized by uncertainty. But none of this was directly intended. When I did the painting the woman's fluid pose seemed to correspond to her immediate surroundings—and similarly for the man and his rigid stance.

Bischoff also commented: "As with most of my figurative painting, this is as much about space—two- and three-dimensional—as it is about anything else."[70]

BISCHOFF AND DIEBENKORN: LATE FIGURATION

While Weeks's style became taut and smooth in his late works, Bischoff's paintings soon departed from even the Hopperesque solidity of *Interior with Two Figures*. In his final figurative paintings, Bischoff's paint became thin and liquid, brushed and scraped on in impressionistic flickers and small, nervous daubs. Diebenkorn, by contrast, like Weeks, shifted toward a flattened, planar imagery in which color is applied in fields rather than strokes. With hindsight, one can see that both Bischoff and Diebenkorn were moving back—and forward—to the characteristic form of their abstractions. Diebenkorn increasingly thinned his paint and trued his forms to the canvas edge, so that the austere, geometric composition dominated, while Bischoff sought a scintillating, allover brushwork that brought the painting to the surface in an abstract play of shapes and color.

In Diebenkorn's late figurative canvases such as *Seated Figure with Hat* (fig. 3.61), the figure is enlarged well above life size. Features and modeling are kept to a minimum, so that elements of the woman's clothes and body read as jigsawed shapes pressed into a flat composition. *Seated Figure with Hat* is explicit about its abstract intentions: the background is contained within an interior strutwork of horizontal and vertical lines, with no pretense to any real-life environment.

Window (fig. 3.62) is one of Diebenkorn's last representational works before his committed leap back into non-objective painting, to which he returned late in 1967 after his move to Santa Monica.[71] Fresh impetus had been given to his long interest in Matisse by a visit to the museums of the Soviet Union in 1964,

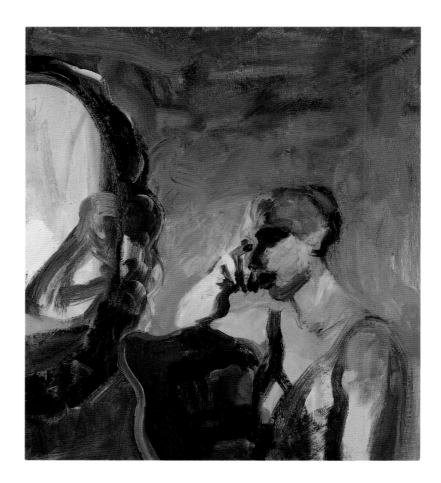

FIG. 3.52. Elmer Bischoff, *Girl with Mirror*, 1961. Oil on canvas, 37¼ × 33¼ in. (95.9 × 85.7 cm). Collection of Mr. and Mrs. David Lloyd Kreeger.

and again by a large exhibition at the University of California, Los Angeles, in 1966. Matisse's austerity (in paintings such as *Open Window, Collioure* [Paris, Musée National d'Art Moderne], where wooden shutters open onto a black void) is at the root of Diebenkorn's *Window*. With the exception of the Parisian window grille at left, *Window* is pure linear geometry. Buildings are leveled off, and the lone chair is lined up with the diagonal green shadow so that nothing protrudes beyond its allotted space. As the Diebenkorn scholar Gerald Nordland notes, "The sense of deep space in the vista is contradicted by the strong orange-ochre coloration of the yard"; the uninflected blue of the sky and the green of the foreground contribute to the overall flatness.[72] Only the strange, oval shadow to the left of the right-hand column gives the work its requisite note of Diebenkornian mystery. This headlike shadow, which has no apparent source, is the last remnant of the figure to appear in Diebenkorn's work to date.

The move to abstraction by Bischoff and Diebenkorn in the late sixties signaled the demise of the original Bay Area Figurative movement, but not before it had generated interest and gathered momentum

among artists of a transitional bridge generation—Nathan Oliveira, Paul Wonner, and Theophilus Brown—as well as a dynamic second generation that included Bruce McGaw, Manuel Neri, and Joan Brown. As with the first-generation painters, these artists did not conceive of themselves as joiners of a movement. Many painted figuratively before becoming aware of Bay Area Figuration. Some, like Oliveira, remain fiercely ambivalent about the connection of their work to the styles now identified as Bay Area Figurative. Others, such as McGaw, accept the idea of their own participation but feel that some of the other artists diverged from the essence of the movement.

A coherent notion of Bay Area Figuration was constructed not by the artists but by the critics and curators who identified shared stylistic traits and the beliefs that they implied, either celebrating or rejecting those implications. Centered in New York, the critics of the movement based their judgments primarily on the work of the first-generation artists; later artists were perceived through the filter established by this response to the first generation. Before proceeding with a discussion of the bridge and second-generation artists, we should understand the

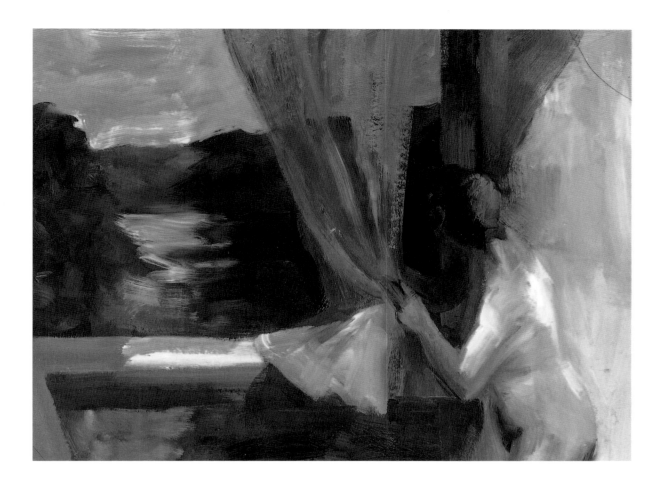

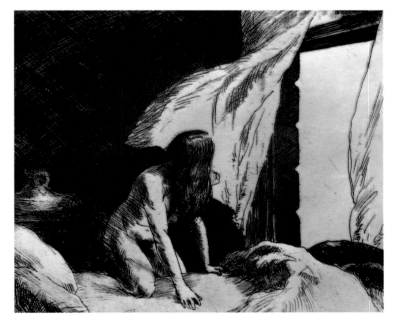

FIG. 3.53. Elmer Bischoff, *Lavender Curtain*, 1962. Oil on canvas, 54×72 in. (137.1×182.9 cm). Rose Art Museum, Brandeis University, Waltham, Massachusetts.

FIG. 3.54. Edward Hopper, *The Evening Wind*, 1921. Etching, printed in black. Plate, 6^{15}/$_{16}$×8^5/$_{16}$ in. (17.6×21.1 cm). Collection, The Museum of Modern Art, New York.

FIG. 3.55. Elmer Bischoff, *Cityscape*, 1965. Oil on canvas, 80×80 in. (203.2×203.2 cm). Yale University Art Gallery, New Haven, Connecticut.

FIG. 3.56. Elmer Bischoff, *Breakers*, 1963. Oil on canvas, 61×70 in. (154.9×177.8 cm). Archer M. Huntington Art Gallery, The University of Texas at Austin.

first phase of the critical response; it is to this criticism that we now turn.

CRITICAL RECEPTION OF THE FIGURATIVE STYLE

Reflecting later on the fortunes of the Bay Area Figurative painters, Paul Mills bemoaned the fact that their work had been viewed by East Coast critics as a challenge to the Abstract Expressionist avant-garde rather than "an apostasy of avant gardism, an abandonment not so much of abstraction in particular as of the whole power politics of style." Mills reveals once more the tension between the artists' stated goals of independence and his own role as curator (and, inevitably, popularizer) of the style, stating:

> It is truly possible to wonder if [the artists] and their West Coast enthusiasts did not sully the style's independent status by accepting the benefits of this "challenger" image instead of denying it more firmly. Applying hindsight to the situation, to have preferred to see them recognized somewhat erroneously over being ignored equally erroneously, is perhaps a pardonable sin.

In his article, Mills refers to "the groundswell of the avant garde, which . . . carried [the style] to the crest of international art consciousness."[73] In fact, critical response to the movement was rather less volcanic than this metaphor suggests, consisting of a few influential articles and reviews written by critics in New York after 1960 about gallery exhibitions of work by Park, Bischoff, and Diebenkorn.

The sole reference in a national art magazine to the 1957 Oakland show was a four-paragraph, illustrated notice in *Arts* magazine. The skeptical author notes:

> Audiences in other areas of the country—and above all in New York—may have some difficulty in distinguishing the specifically "California" elements in this new work, or indeed, in distinguishing it from similar efforts which they may have noted among artists in their own home ground. The audience for this new painting will also want to determine whether, as Mr. Mills . . . implicitly claims, it represents a new pictorial strength or, as its adversaries have argued, it is merely a new failure of nerve in the face of the challenge which the so-called "heroic" period of American abstract painting laid before a younger generation.[74]

It is no surprise that the figurative movement and its exhibition were seen from the very outset as part of the larger challenge to Abstract Expressionism. Despite the artists' desires to be seen as independent (and Mills's respect for those sentiments), Park, Diebenkorn, and Bischoff had openly acknowledged that

FIG. 3.57. Elmer Bischoff, *Girl Looking in Mirror*, 1962. Ink on paper, 14¾ × 17⅞ in. (37.5 × 45.4 cm). San Francisco Museum of Modern Art.

FIG. 3.58. Elmer Bischoff, *Untitled (Woman Seated on a Couch)*, 1963. Pen and ink, and ink wash on paper, 26½ × 11½ in. (67.3 × 29.2 cm). Collection of Byron R. Meyer, San Francisco.

FIG. 3.59. Richard Diebenkorn, *Untitled (For Gilda)*, 1964. Ink on paper, 17 × 14 in. (43.2 × 35.6 cm). Collection of Mr. and Mrs. Charles Campbell, San Francisco.

their turn to the figure was in response to a loss of belief in Abstract Expressionism *as a movement* (if not as a style). Diebenkorn was perhaps most open in identifying what for him had become the empty rigidities of late Abstract Expressionism, which he described in 1960 as "reduced to a book of rules."[75] And the critics in New York, whether pro- or antifiguration, were forced to admit that the movement had become moribund and academic. Thus it was inevitable and appropriate that Bay Area Figuration was seen as a response to Abstract Expressionism. It was also desirable; first, because the movement *was* such a response, and second, because it was this very responsiveness that distinguished the Bay Area painters from countless other individual figurative artists emerging in the years following Abstract Expressionism's decline.

Although he did not yet distinguish Diebenkorn's figurative work as participating in a separate movement, Sidney Tillim (himself a figurative painter) gave it a glowing early review. A colleague and contemporary of Clement Greenberg who was less than comfortable with that critic's single-minded celebration of non-objective painting, Tillim opened his re-

view with a general statement of support for the different irruptions of figurative painting: "From exhibition to exhibition, the tremors in the crust of modern style are growing. . . . Representational art is the mountain thrusting through the plain. For my part, it is the painting I am now most interested in." Tillim found Diebenkorn one of the most promising of the younger figurative painters, among whom he included Alex Katz and Philip Pearlstein, but he warned that representation might disappear again "if it does not disprove the allegation that it is old-hat or if it does not fulfill the needs which shaped and inspired its reemergence."[76]

If Tillim and other critics acknowledged that Abstract Expressionism had passed its prime and recognized Bay Area Figurative art as a potential challenger, they were still not ready to accept it as a viable replacement for the earlier style. After all, Abstract Expressionism had given the country its first international success. Obviously, those critics who had played the largest role in the triumph of American abstract art had the hardest time shifting from its automatic defense.

Dore Ashton was an unusually sympathetic observer who often wrote about West Coast art, but she also held a strong allegiance to the New York School. She published the important article "The San Francisco School" in 1957, a time when the West Coast Abstract Expressionist development was already waning. Although she did not exactly celebrate the local non-objective painters, neither did she praise the figuratives, whom she largely dismissed as cramped and inhibited by their efforts at portrayal. Tellingly, she quoted at length from a letter written by Hubert Crehan, the former student of Clyfford Still with whose partisan support of late Abstract Expressionism she seemed to agree:

There has been in San Francisco, as in New York, a movement . . . back to figurative representation. Led by David Park, the ideological leader . . . , it superficially appears to have won the day, but that's only because people are inclined to accept the honors handed out by juries without really looking at the work or inquiring into the motives of jurors. Elmer Bischoff is a cohort of Park; they have recently taken Richard Diebenkorn into camp as well as Paul Wonner and several others. These older painters are all teachers and wield influence at the grass roots as well as through their tactics of awarding each other top prizes as they take turns on juries. . . . I should mention . . . the second generation . . . of the original San Francisco nonobjective movement. . . . It counteracts the Park ideology and carries on the spirit of Clyfford Still.[77]

FIG. 3.60. Elmer Bischoff, *Yellow Sky*, 1967.
Oil on canvas, 79⅝ × 92⅛ in. (202.2 × 233.9 cm).
San Francisco Museum of Modern Art.

Ashton was slightly more sympathetic by 1960, when the Staempfli Gallery in New York began to mount the first New York exhibitions of Park and Bischoff (among other Bay Area Figurative painters).[78] By this time she held no torch for Abstract Expressionism and did not fault the figurative painters for their so-called failure of nerve. Yet while she rightly perceives the style's tension between figural content and Abstract Expressionist paint handling, she finds it a liability rather than the works' strongest asset. "While they have restored the human figure nominally," she writes, "they do not seem to believe in its singular efficacy." Although Bischoff "comes closest to a happy resolution of the inherent contradictions in the current figurative style . . . the disparity between his expressionist style and realist subject-matter must be regarded as a conceptual flaw."[79] Such phrases as "inherent contradictions," "must be regarded," and "conceptual flaw" smack of formalist dogmatism, and those critics (like Greenberg) who searched for the current of historical ne-

cessity that determined the mainstream found Bay Area Figurative painting deeply lacking.

Hilton Kramer was arguably the most mordant and influential critic among the post-Greenberg formalists. When he first discussed Bay Area Figurative painting in 1960, it was in the context of an essay on the loss of contact Abstract Expressionism suffered from its vital, historically necessary roots. Reviewing Park, Bischoff, and Diebenkorn in a single essay, he opens by bemoaning "the deadening of useful traditions, and its accompanying loss of excellence" in the new figurative painting. "At first glance all three painters have made their way out of the impasse of current abstract painting with some vigor—but at first glance only." Like Ashton, he argues that the three figurative painters have "taken up the painting of the figure in a serious way without any real decision about its meaning." Tellingly, he finds that their figures "lack necessity" and are therefore "decadent"—in other words, they fail somehow to propel painting *as a whole* along the Hegelian path of histor-

FIG. 3.61. Richard Diebenkorn, *Seated Figure with Hat*, 1967. Oil on canvas, 60×60 in. (152.4×152.4 cm). Collection of Mr. and Mrs. Lawrence Rubin, New York.

ical development. In a final, damning paragraph, Kramer concludes:

> Far from constituting a "way out" of the current impasse in abstract painting, the figurative work of these three painters is actually a chapter in the crisis of abstract painting at the present moment. These painters leave painting in exactly the same state of exhaustion in which they found it. They refuse to bring any ideas to their work which might violate the painting method they favor, a method they have inherited but not enlarged, and this refusal insulates the method against having to expand under the pressure of a new experience. It is in this refusal that one feels the profound consequence of the . . . version of modern painting which is now so widespread. Here, indeed, . . . the individual voice is silent.[80]

Kramer's yearning for the individual voice, his desire to reconnect with the "native, existential impetus in modern painting," and his irritation with the persistence of a seemingly emptied Abstract Expressionist style redeem his otherwise peevish review with a certain prophetic accuracy. Two solutions were suggested by his critique of an emptied Abstract Expressionist stroke and a loss of emotion, and both assumed increasing importance as the decade unfolded. First, as demonstrated in the work of the Bay Area Figuratives themselves, the adherence to the loaded brush of the fifties would gradually give way to a taut, flat surface which came to exemplify the styles of the sixties (in Pop, Minimalism, and, later, Photorealism). Second, the emotional reticence of the first-

generation Bay Area Figurative artists (which was itself, as we have seen, a response to the perceived excesses of Abstract Expressionism) was slowly transformed by succeeding generations. Autobiographical narrative, images from popular culture, and personal dreams would infuse the work of younger artists in the Bay Area Figurative style as well as other movements on both coasts.

In the case of the Bay Area Figurative painters, the transformation to a more personal subject matter was encouraged by the bridge generation. This generation, most of whom Paul Mills had included in his 1957 exhibition, were less interested in Diebenkorn's cool classicism, Bischoff's denial of autobiography, and the ambiguous anonymity of Park's figures; instead, they opened their work to autobiography, symbolism, and explicit eroticism. Their work, though occasionally less accomplished or assured than that of the first generation of figurative painters, had powerful implications for the art of the second. Some of those implications would contribute to the end of the Bay Area Figurative movement itself, while suggesting fruitful new directions for the individual artists.

That Bay Area Figurative art was to end as it began—with a rash of individual stylistic decisions that gradually coalesced into a trend—is not surprising. But that it generated the momentum for a movement before declining, with a proliferation of talented artists joining the stylistic ranks, is the more remarkable legacy.

FIG. 3.62. Richard Diebenkorn,
Window, 1967. Oil on canvas,
92 × 80 in. (233.7 × 203.2 cm). Stan-
ford University Museum of Art.

BAY AREA FIGURATIVE ART
EXTENDED AND EXPLORED

INTRODUCTION · When Paul Mills selected the artists for his 1957 exhibition, he began the process of codifying the movement, albeit against his stated intentions and the wishes of the principal artists involved. Within three years of the Oakland exhibition, the figurative works of Park, Bischoff, and Diebenkorn had been shown in galleries in New York. This crucial exposure consolidated critical perceptions that they were the leading painters of the group.

Had he lived, Park might well have relished this leadership role by helping the careers of younger painters as he had always done in the Bay Area through his service on various prize committees and fellowship boards. With his death, the mantle of leadership fell to Diebenkorn as the most visible survivor—but Diebenkorn was the last man to seek identification with a movement by promoting a type of painting or group of painters. As a result, Bay Area Figuration remained vague and ill-defined in the eyes of East Coast critics, a movement sensed but not known.

Critics on the East Coast perceived a principled opposition to Abstract Expressionism as a motivating force behind the Bay Area Figurative movement. While this was true of Park, Bischoff, and Diebenkorn, it was far less important for Weeks or members of the bridge generation, Paul Wonner, Theophilus Brown, and Nathan Oliveira. Although each of these painters had worked within a non-objective or Abstract Expressionist style for a time, none but Oliveira had ever fully abandoned recognizable subjects. Even during his brief flirtation with abstract painting, Oliveira was simultaneously painting the figure, as is evident in an early studio photograph (fig. 4.1). In any case, none of his abstract work survives.

Of equal significance, unlike Park and his colleagues, none of the bridge generation had become particularly well known, even locally, as abstract painters. Brown had received a boost in the popular press for his de Kooningesque football paintings when *Life* magazine featured them in "Camera Kick-off for Art" (fig. 4.2), and one of Wonner's allover landscapes had been included in the exhibition *Younger American Painters* at the Solomon R. Guggenheim Museum in 1954 (fig. 4.3).[1] But both artists moved smoothly from these works into their own interpretations of the Bay Area Figurative style (as did Oliveira) and there was no sense that a major transition had occurred.

As for painters of the second-generation New York School, for this bridge generation Abstract Expressionism had become a style to be exploited rather than a life choice to be made.[2] Although Mills relates that Wonner "does not feel very involved in non-objective action painting, and that, if anything, he is 'against it a little,'"[3] the artist's own written statement a year earlier suggested that the need to choose between figurative and abstract painting had not been a pressing issue. Rather, the two poles were merely options:

> There seems to be a good deal of feeling at present about the lack of cohesive values, aesthetic absolutes, etc. . . . If the disparity of values in art today creates a storm of insecurity in which to work, it has also given us certain advantages. Practically all of art is opened up to the painter, so that any form, from primitive sculpture to Bouguereau, may be approached without the prejudicial blinders of a particular school. . . . Also, when [a painter] selects a manner in which to work, there is no longer an "either/or" compulsion about following the choice forever. . . . For the reasons given above, I do not feel strongly about either the issues surrounding non-objective painting or the platform of more representational painting. The arguments seem to me, at the moment, to be without vitality or meaning.[4]

Similarly, Theophilus Brown told Mills that "he doesn't worry too much about fighting for a conscious

FIG. 4.1. Nathan Oliveira with abstract painting in North Oakland studio, 1955. Courtesy Nathan Oliveira.

individuality of style."[5] Oliveira was certainly different in this respect, seeing himself more consciously poised between American Abstract Expressionism and the great tradition of European figure painting. Nonetheless, they all felt free to utilize the expressionistic style while dipping into sources (from Bouguereau to sports photography) that would have made most of the New York School painters blanch.

Thus, although they were less visible to the New York critics than were the first generation of Bay Area Figurative painters, the members of the bridge generation were liberating forces locally. Their omnivorous appetite for art of the past and their greater openness to themes and images drawn from autobiographical sources set important precedents for younger painters and influenced the course of the Bay Area Figurative style.

THE BRIDGE GENERATION: WONNER, BROWN, AND OLIVEIRA

If reviewed at all by the New York critics, artists of the bridge generation were likely to be criticized as derivative of the more established figurative painters, when in fact their styles had been largely coeval with, and occasionally influential upon, the work of the first generation. Park, Bischoff, and Weeks had been teachers and independent artists for many years, but they were unlikely to look upon the work of the less established artists as deriving from their own. And

Diebenkorn, because of his own precocious youth, probably looked on Wonner, Brown, and Oliveira as colleagues rather than as potential recipients of his mentorship. Indeed, both Wonner and Brown are actually older than Diebenkorn by a few years.[6]

Generational identity, however, has less to do with age than it does with shared formative experiences. Since Brown, Wonner, and Oliveira were not at the California School of Fine Arts during the "heroic years," they could not be seen as members of that famous club; Oliveira in particular had felt actively excluded.[7] Oliveira had been in the army and both Wonner and Brown had been students at Berkeley when Diebenkorn was teaching at the California College of Arts and Crafts and exhibiting his landscape abstractions. At least initially, they would have identified with younger painters.

Brown and Wonner themselves felt strongly influenced by the more established artists' work (as did Oliveira, to some degree). In 1955 Brown and Wonner rented studio space in the same building on Shattuck Avenue in Berkeley where Diebenkorn worked. Here, the expanded group held life-drawing sessions; Diebenkorn, Bischoff, and Park were joined by Wonner, Brown, and occasionally Weeks and Oliveira (see fig. 2.17). Together, the weekly drawing sessions and the experience of seeing the others' work as it developed made a powerful impact. As Brown later commented, "I think that both Diebenkorn and David in their various ways were a big influence on the rest of

FIG. 4.2. Theophilus Brown
in Berkeley studio with sports
magazine football pictures,
1956. © 1956 Time, Inc.

FIG. 4.3. Paul Wonner, ca. 1956.
Courtesy San Francisco Art
Institute.

us." Brown temporarily gave up figurative subjects, swayed by Diebenkorn's Berkeley paintings.[8] Wonner, influenced by Weeks, moved in the opposite direction toward figuration, away from his earlier all-over, nearly abstract landscape paintings:

> One of the first things that made me consider subject matter again was seeing Weeks's things. He was very important to me. I think I got a lot of Romanticism from Elmer. But I was immensely influenced by all of them, I think, in one way or another.[9]

An exhibition of Wonner's early figurative works was held at the California School of Fine Arts gallery late in 1956, and the works illustrated show little of Weeks's tight control of the canvas surface. Compared to Wonner's previous abstract landscapes, however, they are more controlled, their compositions more focused and less "allover." Working away from what he described as "the permissive standards of Abstract Expressionism," Wonner had achieved a style that was still looser and more painterly than it would be in *Glider* the following year.[10] His line at this stage was liquid, calligraphic, and close to abstract—but there is less independence between line and contour than in Diebenkorn's abstractions of the same period. Already Wonner had committed himself to conventions of representation, and line was firmly identified with descriptive boundary and edge.

In these 1956 paintings, Wonner's figures are cropped horizontally and thus more aggressively than in *Glider* (in which the figure was vertically cropped). Heads and legs are cut off by the canvas edge, in a willful assertion of the fact that the figure is merely a compositional unit like any other. Wonner's self-described progression through "Pure Plastic Art and . . . Cubism" to Abstract Expressionism and, finally, figuration, is palpably evident. As Wonner noted at the time:

> From Cubism, there is a hangover of the conviction that somehow, whatever the three-dimensional space, the two-dimensional surface ought to be recognized, not necessarily as an intimate relationship, but rather as a speaking acquaintance.[11]

The "speaking acquaintance" with formal concerns continued to be an important influence until 1957 and after, when it began to give way to narrative in Wonner's work.

Wonner moved to Davis in 1956, Brown followed in 1957. Wonner worked as a librarian at the University of California there, and Brown joined the teaching faculty in 1958. Both worked hard to maintain

FIG. 4.4. Paul Wonner, *Standing Figure #2*, 1959. Oil on canvas, 48½ × 47 in. (123.2 × 119.4 cm). Private collection.

their ties to the Bay Area, commuting to Berkeley regularly to keep up with the group and the studio. The effort had an effect, for despite their move to Davis, both artists' work began to change in the direction of the more established Bay Area Figurative painters. Brown, following Park's example, transformed his slashing Abstract Expressionist brushstrokes into the carefully placed slabs of color that delineate his 1958 *Still Life*. And as was already noticeable in *Glider*, Wonner's use of figures as compositional units began to give way to their deployment as narrative presences. By 1957 he would tell Paul Mills, "I think a painting has to be some kind of translation of psychological experience."[12]

In 1959 Wonner began a series of male bathers and boys with bouquets that seemed to offer, if not explain, some such "translation of psychological experience." *Standing Figure #2* (fig. 4.4) has approximately the same color scheme as *Glider*, but it is far more brooding in its final effect. The acid greens, blues, and creams are here unleavened by the peaches and reds of *Glider*, and the result is nocturnal and moonlit. Unlike Park's *Standing Male Nude*, Wonner's figure does not meet our gaze—his shadowed eyes look down and to the side. The circle of cream behind him evokes a plastic swimming pool, and with his vaguely defined but seemingly aroused genitals, the

scene foreshadows Eric Fischl's paintings of the 1980s depicting sexual undercurrents in suburban backyards.

Although very few of Brown's paintings from this period survive, scholars note that his work remained linked to that of the other Bay Area Figurative painters, fairly constant in subject and style until he visited Europe in 1959.[13] In *Still Life* of 1958, his response to Park and Diebenkorn is obvious in his choice of palette, subject, and paint handling; after seeing works by the Italian Metaphysical painters in Europe (such as Giorgio de Chirico), he would be much more open to the kind of mysterious narratives which Wonner had already been exploring. *Sun and Moon* (fig. 4.5) was painted after Brown's return from Europe, and although it is much smaller in scale than the Italian paintings, it conveys a similar dreamlike, melancholic sensibility. The impossibility of seeing the sun and moon's conjunction, depicted low on the horizon, underscores the painting's roots in Surrealism; the emerging differences between Brown and his more established figurative colleagues are clear.

At this point, Wonner seems to have been more interested than Brown in maintaining stylistic links with the Bay Area Figurative style, although Brown would continue to produce drawings (such as *Male Nude Seated*, fig. 4.6) that relate to works on paper by

FIG. 4.5. Theophilus Brown, *Sun and Moon*, 1960. Oil on plywood panel, 9×12 in. (22.8×30.5 cm). Collection of Mr. and Mrs. Charles Campbell, San Francisco.

FIG. 4.6. Theophilus Brown, *Male Nude Seated*, 1960. Pen and ink wash on paper, 8½×11 in. (21.6 ×27.9 cm). Collection of the artist.

Bischoff and, of course, Wonner. Wonner's oil painting *Untitled (Two Men at the Shore)* (fig. 4.7) depicts an essentially Diebenkornian theme, although it is more overtly autobiographical than Diebenkorn's work. With the strong central figure in the foreground and the more retiring figure behind, the painting seems to be based on the relationship between Brown and Wonner, which by 1960 was a stable and committed one. Photographs from Brown's collection show the two at Davis in a similar pose, though in a different locale; charcoal underdrawing on the canvas evinces that Wonner carefully sketched out the full composition before applying any oil paint, changing little when making the painting. This predetermination, so different from the aggressive, searching process of the first-generation painters,

was characteristic of the bridge generation as a whole. As Brown said to Mills, "I usually stick with the original image and if it doesn't work, I abandon the whole thing and start something else."[14]

Wonner balanced straightforward, brilliantly observed works of neutral subjects, in watercolors such as *Man Seated against the Light* (fig. 4.8), with more charged compositions which openly invited interpretation, through quotations of such time-honored themes as *vanitas*. Wonner had told Mills in 1957 that he did not want to depart from such classical genres as landscape, still life, and figure groups, for fear that his work would become "too journalistic, too much like illustration."[15] The lure of illustration must have been a temptation he was already having difficulty resisting, for by 1961 he was sketching and painting a series of works in which a human skull provides an unavoidable link with the iconography of *memento mori*.

Woman with a Mirror and Skull (fig. 4.9), although superficially a simple life study, draws upon two symbols from the vanitas tradition for its image and title. The woman's reflection grins at us from the mirror. We see her, and thus, following the laws of reflection, she sees us—the true objects of the moral lesson being taught. Her leering figure is absent from the roughly contemporaneous *California Landscape (Mirror, Skull, and Chair)* (fig. 4.10), and the half-open door suggests that the figural subject has already left. The chair is the figure's surrogate, shadowed by the mirror, which is here positioned to reflect the death's head itself.

Wonner's focus on mortality and vanity begins, suggestively, immediately after Park's death. Although he was closer to Diebenkorn stylistically, Wonner had earlier shown evidence of Parkian sympathies, if only in his choice of subjects (such as nude male bathers and figures holding flowers). And Park was clearly encouraged to increase both the liquidity and thickness of his paint through the example of Wonner's (and others') somewhat freer Abstract Expressionist *maniera*. Doubtless the death of the charismatic practitioner of the figurative style and the resulting breakup of the group drawing sessions contributed to Wonner's interest in the vanitas theme. But stylistic evidence suggests that he was simultaneously moving away from the core Bay Area Figurative style on his own.

The scumbled and encrusted surface in Wonner's *California Landscape* first appeared around 1960 and suggests that the artist was turning to sources outside the figurative group—in this case, to the French art-

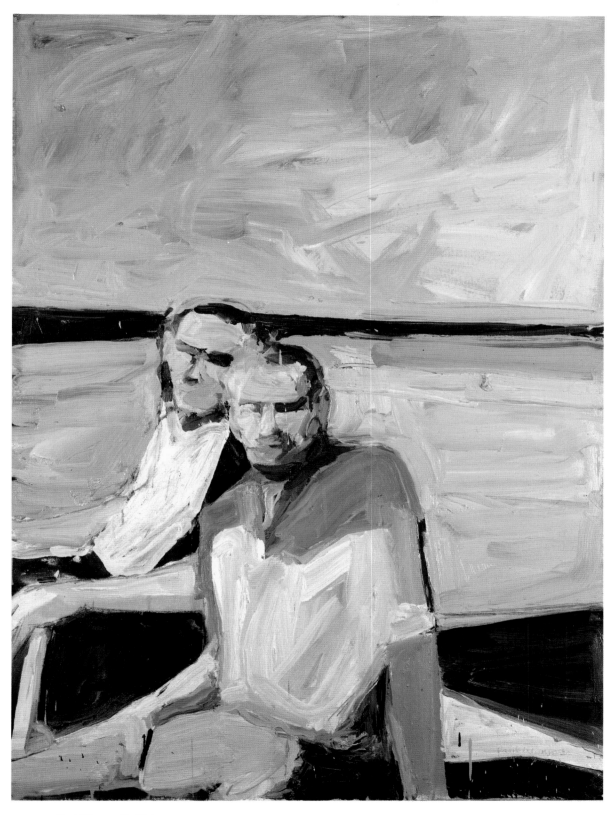

FIG. 4.7. Paul Wonner, *Untitled
(Two Men at the Shore)*, ca. 1960. Oil
and charcoal on canvas, 50×40 in.
(127×101.6 cm). The Lobell Family
Collection, New York.

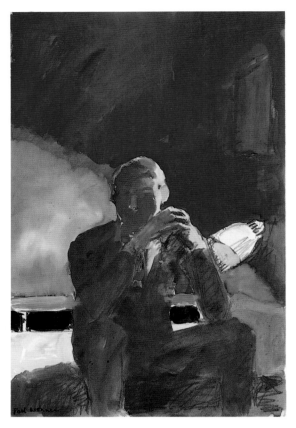

FIG. 4.8. Paul Wonner, *Man Seated against the Light*, 1961. Acrylic and pencil on paper, 18 × 11⅞ in., irregular. Hirshhorn Museum and Sculpture Garden, Smithsonian Institution.

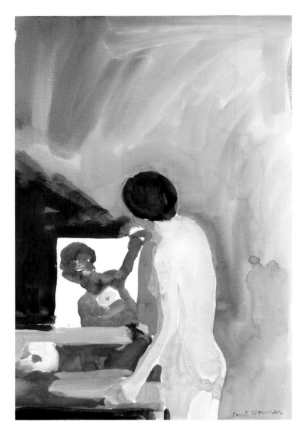

FIG. 4.9. Paul Wonner, *Woman with a Mirror and Skull*, 1961. Watercolor on paper, 17⅞ × 11⅞ in. (45.5 × 30.3 cm). Hirshhorn Museum and Sculpture Garden, Smithsonian Institution.

ists Pierre Bonnard and Edouard Vuillard. *Figure by Window* (fig. 4.11) from 1962 shares much with Diebenkorn's women in interiors, but the close-valued tonalities of woman, plant, and sun-dappled couch are more reminiscent of the Intimist painters' densely patterned interiors in which figure and ground become nearly indistinguishable. The contemporaneous *Kitchen (Breakfast)* (fig. 4.12) also shows signs of this conscious realignment. The careful study for the painting (fig. 4.13) already presents the dramatic horizontal composition favored by Bonnard (so different from the largely square Bay Area format), drawn in feathery pencil strokes that mimic the surface of a richly textured tonalist painting. In the finished canvas, the window has become a strong figural shadow (found in Munch and Vuillard alike), the round table has become rectangular, and the bentwood chair, angled out in the study, has been made parallel to the picture plane. The areas of close-valued texture in the pencil sketch have been trans-

formed into the painting's glowing colors, intensified through canny juxtapositions of complementary hues.

The color-filled interiors of *Figure by Window* and *The Kitchen* stand in dramatic contrast to *Nude and Indian Rug* (fig. 4.14). In the late summer of 1961, Wonner and Brown moved to Santa Monica, then to Malibu in October 1962, when Wonner began a two-year teaching stint at the University of California, Los Angeles. The crowded, light-filled interiors and brightly colored outdoor scenes of Wonner's Northern California paintings began to disappear even before the move, to be replaced by austere, nearly monochromatic works that marked an experimental phase in Wonner's career.

Nude and Indian Rug is not an ingratiating work. The figure is isolated across a vast expanse of palette-knifed pale blue floor, rendered in loose, fluid paint closer to that of *Glider* than the later *Kitchen*. The corner of patterned carpet edging in from the left warms

the scene slightly, but the plants provide the only other warming tone. These seem to grow from the shadow looming behind the nude, and their green hue is echoed in her pubic triangle. Wonner retreated from the sober palette and emptied composition of *Nude and Indian Rug*, returning to a more typical Bay Area Figurative theme in the masterful *Model Drinking Coffee* of 1964 (fig. 4.15). Sharing *Breakfast's* intimist overtones, *Model Drinking Coffee* abounds in luscious passages of paint, especially in the small still life on the table. Like certain Diebenkorn paintings, the figure is almost incidental to the composition, which is dominated by clean planar divisions in the room and playful squares of landscape framed by the window. It has been observed that the model sits in a pose perfect for self-portraiture, drawn easily from a mirror reflection;[16] but noting the empty chair at the table and the second coffee cup, it seems more likely that these items stand in for the absent artist, and the model is just that—possibly sketched at one of the drawing sessions Wonner attended.

Wonner, and Brown, continued to draw avidly after moving to Malibu, often at the homes of friends such as Christopher Isherwood. *Living Room at I's* (fig. 4.16) documents one of these occasions and confirms Wonner's superlative skills as a draftsman. Our eyes follow the perspective lines of the coffee table and couch from left to right as they converge on the two figures in the middle of the complex composition. Here our gaze is abruptly halted by the frontal blue plane of the window shutter, which injects a startlingly abstract note into the scene. The two figures are far from absorbed in their activities or diffident in our presence—they stare out at us with preternatural intensity, waiting for us to complete the story.

The narrative richness, psychological nuances, and sheer ambiguity of Wonner's figurative works were unmatched by any of the first-generation Bay Area Figurative artists, with the possible exception of Bischoff, whose late, Hopperesque interiors are prefigured in works such as *Living Room at I's*. Wonner's personal reticence may have contributed to his shift away from such autobiographical nuances, or perhaps it was attributable to the move to Los Angeles, where a developing aesthetic of hard-edged, technologistic productions must have made Bay Area Figuration appear hopelessly anachronistic. For whatever reason, by the end of the sixties, Wonner's break with Bay Area Figurative painting was complete.

Oscillating between the austerity of paintings such as *Nude and Indian Rug* and the complexity of works such as *Living Room at I's*, Wonner ultimately

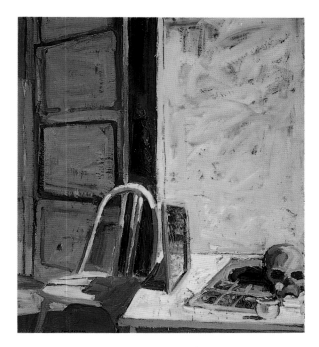

FIG. 4.10. Paul Wonner, *California Landscape (Mirror, Skull, and Chair)*, ca. 1960–62. Oil on canvas, 50×48 in. (127×121.9 cm). Stanford University Museum of Art.

created a hybrid style in paintings such as *Jar, Glass, Narcissus* (fig. 4.17): the austere complexity of the photo-realist "Dutch still lifes." These inventory paintings of domestic objects, art postcards, and circumscribed vistas were immediately popular, but struck some reviewers as either banal or revelations of "bourgeois capitalism" in America.[17] Leading up to them, Wonner had created several suites of drawings and watercolors dominated by explicitly Surrealistic and religious imagery. The symbolic systems embedded in the "Dutch still lifes" were undoubtedly heartfelt and personal, but they were personal in a professional way. This was art about art, where his previous figurative paintings had been art about life (his and potentially ours), or art about the visual experience of living.[18] Although still working figuratively, Wonner had moved in both style and substance as far from his earlier work as had Diebenkorn and Bischoff in their post-figurative abstractions.

Theophilus Brown's work evolved far more gradually, remaining loosely linked to Bay Area Figuration at least until the late 1980s. At the same time, his paintings were never as close to the core Bay Area Figurative style as were Wonner's; this was partly because Brown was never as interested as Wonner was in purely formal problems. Despite the fact that both artists had attended Berkeley, which at the time was

FIG. 4.11. Paul Wonner, *Figure by Window*, 1962.
Oil on canvas, 60×46½ in. (152.4×118.1 cm).
Collection of Mr. and Mrs. Harry W. Anderson.

a bastion of formalism, Brown always retained an involvement with subject matter and its symbolic potential. Indeed, for Brown subject matter seemed to dictate his stylistic approach: "I'm very attached to subject matter and this determines to a large extent what happens in my paintings, much more than the formal concept, perhaps."[19]

Thus Brown felt no compunction to work within a single style at any given period; within certain broad limitations the appropriate style would be determined by the image depicted. In 1958, through the evidence of *Still Life*, we know that Brown worked briefly under Park and Diebenkorn's influence, but by 1961, in quick oil and casein sketches of Beat figures Allen Ginsberg and Jack Kerouac (figs. 4.18, 4.19), he returned to the Abstract Expressionist calligraphy of his earlier football series. Executed that same year, *Male Models* (fig. 4.20) lies somewhere in between the Abstract Expressionist stroke and the broader, more planar Bay Area Figurative style.

By nature a small-scale, intimate painter, Brown works best in the close range and hand-to-eye relationship of the cabinet picture. In *Male Models*, as in *Portrait of D. K.* (fig. 4.21) from a few years later, swift brushstrokes are married to specific manipulations of light and color. *Portrait of D. K.*, which depicts Brown's friend Don Knutson, holds closest to the Bay Area Figurative style. Its wonderful sense of light, glimmering in a dark interior, is unlike the work of any other painter; it stands as a small monument to Brown's individual mastery of the style.

Unusual for Brown, and probably related to Wonner's work, is an untitled interior of 1963 (fig. 4.22). The cropped frontal figure in particular evokes Wonner's early figure works, although Brown maintained it as a device for a longer period (using it in *Male Models* from two years earlier, for example). Less familiar in Brown's work is the crowded, close-up composition, packed with strong color and incident. It connects with the 1958 *Still Life* and drawings such as *Figure Reading* (fig. 4.23) more readily than with his later figure paintings, which are characterized by broad color areas, fairly open spatial arrangements, and odd poses which seem pregnant with meaning. As one reviewer noted early on, "Brown . . . seems to be the most symbolist and allegorical-minded of the [Bay Area] group."[20]

Bathers at Dawn (fig. 4.24) is typical of Brown's idiosyncratic figurative style. Probably based on photographs from nudist magazines,[21] the male and female figures are shown in arrested poses, slightly cropped, and seemingly defiant of gravity. The male

may be simply standing and raising his arms to keep them out of cold water; the female, who stands higher in the water, seems to have been caught in mid-plunge. The figures are awkward and mysterious; their eyes are closed, like sleepwalkers. Brown does not attempt the characteristic Bay Area Figurative depersonalization of facial features, but neither does he open his figures to characterization. The harsh, opaque light carves masks from their cheeks and noses, and their closed eyes deny our gaze.

As in other paintings from this period, which depict male bathers, nudes in gardens, and boys wrestling, Brown does not court the aesthetic tradition in which the figure is softened and made universal. Instead, his nudes are naked, corpulent, and disquietingly erotic. He has said that the figures of young men at the beach are fantasies of a beautiful, harmonious world, and one reviewer reflected this assessment: "In fact, Brown's paintings are Expressionist idealizations. He presents a better, more desirable world, a paradise cut again and again by a sharp green, or lighted by a blue which seems to warm the room in which the pictures hang."[22] Another spoke of "the reality of harmony and oneness" in his work, as contrasted with the "shock, sensation, repulsion . . . chaos" of contemporary aesthetics.[23] But in many ways Brown's works are more disturbing than the more aggressively painted canvases of Park, Bischoff, or Diebenkorn. In paintings such as *The Swing* or *Pedestrian Crossing* (figs. 4.25, 4.26), both from 1966, lust and alienation erupt into the artist's dreams of paradise.

Brown reworks paintings that have remained in his studio over the years; *The Swing* is no exception. Early reproductions of it show the same composition, but the rough, brushy paint handling has since been smoothed, and the shadows on the man's body have been rationalized and reduced.[24] Pentimenti and comparisons with earlier illustrations also show that the small bather in the background has been made smaller still, and the value contrasts on her body reduced.

The female nude in the foreground has been changed least of all. She still has the same odd posture, supported by the bearded, grinning man and a rope leading out of the painting to an unseen anchoring point. Swinging, in the sense suggested by the rope, is here impossible: given the rope's present angle and the arc of its trajectory, the woman would crash into the ground if the man released her. Perhaps another type of swinging is implied; the leering, faintly Mephistophelian air of the man, the wom-

an's visual blindfold and her nakedness, the strange voyeur in the distant water—all evoke the nudist photograph rather than the classical tradition, the "swinging" hipster rather than the bounding nymph.[25]

Brown insists on the corporeal reality of his figures, their activity and vivid presence (although they may be a dream). As with Wonner's *Standing Figure #2* from almost a decade earlier, Brown's *Swing* suggests the sexual dramas of Eric Fischl. Brown's characters are similarly knowing and suggestive in their paradisiacal encounters, disturbing the cool classicism of the Bay Area Figurative style.

Brown's *Pedestrian Crossing* presents a far less loaded image, if an equally enigmatic one. Purchased in 1968, the work has been changed but little since it was ostensibly "finished" in July 1966. Early reproductions show that a portion of the footbridge was painted out at the left, and the lone figure may have been slightly altered. Smaller than *The Swing*, this canvas conveys a very different mood. Painted in blues and purples over aquamarine, ochre, and pink, it feels nocturnal, an impression reinforced by the full moon hovering above the far hill. The moon is not the primary light source in the image, however—the bridge and figure are lit from the right, as if by the setting sun, its rays cooled by dusk. An enormous, inexplicable shadow falls on the hill behind the small figure. Close in value to the farther hill, it dwarfs the figure and creates a yawning space behind him, intensifying the melancholic, de Chirico–like mood.

The dreamlike mystery of these images links them to the deepening interest in symbols and allegory in Wonner's (and Oliveira's) canvases from the same date. The flat, laconic way in which they are painted, facilitated by Brown's new use of acrylic paint, also relates them to the flattening of Diebenkorn's contemporaneous work.

Diebenkorn had also moved to Santa Monica by this time and was living and working not far from Brown and Wonner in Malibu. There was a growing sense that the momentum of Bay Area Figurative painting was dissipating, and that artistic energies in general were shifting to Southern California, codified in 1964 when *Artforum* magazine, founded in San Francisco, moved its editorial offices to Los Angeles. Oliveira had come down in 1963 for a one-year teaching job. Although he had been friends with Brown and Wonner in San Francisco and drew with them occasionally in Los Angeles (once at Isherwood's), he found himself resisting the renewal of their acquaintance, avoiding past allegiances and stylistic commit-

ments: "[Paul and Theophilus] had to be down there, but we were not close at that time. It had something to do with the hangover, I think, of Bay Area Figurative art. . . . We were not as close as we are now or were before."[26]

Oliveira had always been ambivalent about the Bay Area Figurative movement. His feelings went beyond the others' opposition to any movement, their certainty that stylistic choices were purely individual. Oliveira saw that the Bay Area Figurative artists indeed had much in common but felt that their commonalities excluded him in important respects. Paul Mills's decision not to include him in the 1957 Oakland exhibition further exacerbated Oliveira's sense of exclusion. As he wrote Charles Alan, his New York dealer at the time:

> That particular show created quite a stir among the artists in the area because it only represented one side in relation to figurative painting being done here. Most of the artists represented in the show were students of Richard Diebenkorn, Elmer Bischoff and David Park. These three are mature painters and leaders of the particular concept in that show. I admire Diebenkorn's work a great deal but my objectives in painting are quite different.[27]

Oliveira's objectives, as he saw them, were closer to contemporary European painters of the figure such as Alberto Giacometti and Francis Bacon, artists he admired greatly. He had decided in the joint drawing sessions that the Bay Area Figurative artists were too willing to sacrifice the figure's intrinsic significance, using it, in his view, as "simply an element that was among other elements . . . used as a device to make pictures." Their discussions of the way light hit the model's shoulder or moved through the space of the room struck Oliveira as boring. "But it certainly meant a great deal to Dick, Paul, Bill, and Elmer and this was the line. It had been established and so I just simply went on my own."[28]

Oliveira's alienation from the group possibly had more to do with his resistance to rhetoric—the formalist line that had been established without him—than it did with any actual artistic differences. Wonner's and Brown's work was never purely formalist in its treatment of the figure, nor was Bischoff's (or, for that matter, Park's or Diebenkorn's). The other figurative painters clearly felt some affinity with Oliveira's work or they would not have invited him to the drawing sessions. Doubtless Oliveira would have felt more a part of the group himself had he shared more with them personally—but by age, background, and artistic training, he came from a different world.

FIG. 4.12. Paul Wonner, *The Kitchen (Breakfast)*, 1962. Oil on canvas,
30¼×70 in. (76.8×177.8 cm). Collection of Byron R. Meyer, San Francisco.

FIG. 4.13. Paul Wonner, Study for *The Kitchen*,
1962. Pencil on paper, 8×12 in. (20.3×30.5 cm).
Collection of Byron R. Meyer, San Francisco.

With hindsight, however, it becomes clear that Oliveira was engaged in much the same endeavor as the "official" Bay Area Figurative group, responding to many of the same irritants and inspirations. As he later mused: "Under any circumstance from 1957 on 'Bay Area Figurative Painting' included me, like it or not."[29] His ambivalence should be seen for what it is—an emotional involvement oscillating between admiration and aversion, but no less of an involvement for that.

In the continuum that emerged between the cool classicism of Diebenkorn and the loaded imagery of Brown, Oliveira filled a specific and important niche within the bridge generation. Although his models were very different, his works, like Diebenkorn's, dealt with the lessons of past and present art. Their emotional affect, however, was hot and personal where the first generation's had aimed at the cool and universal. Again, the source for these differences lay in Oliveira's past, which guided his choice of role models and created his fierce sense of solitary struggle.

OLIVEIRA: EXISTENTIALIST MEN, EROTIC WOMEN

Nathan Oliveira was born Nathan Joseph Mendonca Roderick (anglicized from the Portuguese *Rodrigues* by his father at Ellis Island) in Oakland, six years after Diebenkorn and Weeks, the youngest of the first generation of Bay Area Figurative painters. Although the depression never really enters the narratives of Park, Bischoff, Diebenkorn, and the others, it had a dramatic impact on Oliveira as a child.

The depression hit the Portuguese community hard, and Oliveira's maternal grandfather Joseph Furtado was bankrupted. The two-generation family dissolved, and when Nathan was barely three, the Furtado women—his grandmother, mother, and aunt—moved with him to San Francisco, where they lived in a small flat on Haight Street. Oliveira remembers the loneliness and isolation he felt as a child in the Haight Street house: "My grandmother had failing sight. The day would go and, San Francisco being quite foggy, it would get darker and darker and the next thing I'd know, it would be practically pitch

FIG. 4.14. Paul Wonner, *Nude and Indian Rug*, 1961. Oil on canvas, 48×60 in. (121.9×152.4 cm). Collection of Mr. and Mrs. Charles Campbell, San Francisco.

FIG. 4.15. Paul Wonner, *Model Drinking Coffee*, 1964. Oil on canvas, 49½×45⅞ in. (125.7×116.5 cm). National Museum of American Art, Smithsonian Institution.

dark in the flat, and it was really a traumatic experience for me."[30]

After two years in San Francisco, Elvera Furtado married George Oliveira, who adopted Nathan as his son. The new family moved to Niles (now Fremont) in the East Bay, a rural enclave Oliveira describes as "arcadian," despite the inevitable tensions in a community where the Portuguese were firmly sandwiched in the social hierarchy between the Mexicans below and the Protestants above.[31] His mother, ambitious for a better life for her son, enrolled him in art classes taught by the town doctor's wife; later he took cornet lessons. Because he was dyslexic and had difficulty with the standard curriculum, art and music were Oliveira's principal pleasures in school. He played in a jazz band, and for many years his career goal was to be a musician.

After the war the family moved again to San Francisco, where Oliveira completed high school. He found that he had lost interest in music; he studied painting briefly with a local landscapist and went to the M. H. de Young Memorial Museum in search of

motifs. Here he was floored by a Rembrandt portrait and on the spot decided to become a portrait painter. But after four weeks studying commercial art at City College, he became discouraged and left, working first for a commercial printer and then as an apprentice bookbinder. Oliveira feels he might have drifted for years had it not been for a chance encounter on the street with his former high school principal, who encouraged him to enroll in the program at the California College of Arts and Crafts. With his family's grudging support, he began studying advertising design there in 1947.

Oliveira soon shifted into painting and printmaking, finding support at the college for his developing ideas about portraiture and figurative art. Although unfamiliar with much contemporary painting, Oliveira knew the work of Clyfford Still, whom he found "a complete mystery." Likewise, Pollock's work seemed to him "nonsense." Without understanding Abstract Expressionism, the young painter already felt a need to confront and counteract it, partly at the urging of his teacher Otis Oldfield, a figurative

FIG. 4.16. Paul Wonner, *Living Room at I's*, ca. 1964. Gouache on paper, 12 × 18 in. (30.5 × 45.6 cm). San Francisco Museum of Modern Art.

FIG. 4.17. Paul Wonner, *Jar, Glass, Narcissus*, 1968. Oil on canvas, 48 × 48 in. (122 × 122 cm). The Oakland Museum.

painter who had studied in Paris, since searching for "seven young men" to start a new figurative movement: "because at this time the Abstract Expressionists were painting at the Art Institute, and he thought that was a bunch of malarky; I did too." At one point a group from the California School of Fine Arts came to the College of Arts and Crafts to lecture and put up an exhibition of their work; Oliveira recalls that the Oakland group thought the others were crazy: "they were talking about green for green and paint for paint's sake and red in visual relationships and realities of color."[32]

Doubtless Oliveira's response to all of this would have remained fairly conventional and naive were it not for the experience of four exhibitions, which "patterned my life . . . and supported the continuation of the figure."[33] In quick succession from 1948 to 1951, the de Young Museum presented retrospectives of the work of Max Beckmann, Oskar Kokoschka, Edvard Munch, and Hyman Bloom. These exhibitions had a profound impact on the young painter, and when Beckmann taught at Mills College in the summer of 1950, Oliveira seized the opportunity to study with the great German Expressionist, who found Abstract Expressionism "amoosing" and whose primary word of advice was always "more bleck." Beckmann became most enthusiastic when the class had a model, preferably Flo Allen, whom he would pose on a red velvet Victorian settee with a cigarette, red scarf, and fuchsia high heels (fig. 4.27). These sessions with the model were also the occasions when Beckmann's encouragement of the young painter was most forthcoming:

When I painted the model I forgot about inventing a powerful statement, German expressionist statement—figures with masks. When one dealt with reality, that's when he [Beckmann] became enthused. . . . But when I found myself getting more subjective and inventing a world purely from my imagination that interested him much less.

Oliveira recalls going through an exhibition of Beckmann's prints which had been put up at Mills that summer and asking Beckmann what makes art. "He ran his hands down his face and said 'sweat, much sweat.' . . . I couldn't wait to work."[34]

Another formative influence was Leon Goldin, who became an instructor at the college during Oliveira's last year. Goldin emphasized the importance of abstraction in figuration and confirmed Oliveira's twin passions for German Expressionism and printmaking. Oliveira received his M.F.A. in printmaking in 1952.

Oliveira was granted a draft deferment after graduation to take over Goldin's printmaking class briefly when the older artist went to Europe on a Fulbright fellowship. But after only a semester, Oliveira was drafted in 1953; happily for him, after demonstrating his artistic skills, he was assigned to the local topographic division in San Francisco. He was able to see his new wife fairly often; their first child was born in 1954.

During his years in the army, Oliveira painted and kept up with the art scene. He vividly remembers lying on his bunk and looking at a 1953 issue of *Time* magazine, which had an article on Willem de Kooning's new Woman paintings. The reproduction of the semi-abstract *Woman I* made a great impression on him: "I was familiar with de Kooning before as an abstract artist only. But here this man was really trying something."[35] The following year, Oliveira saw Diebenkorn's retrospective at the San Francisco Museum of Art, and he was similarly affected. He had met Diebenkorn briefly before going into the army but found the new Albuquerque and Berkeley paintings far more exciting than his earlier, more completely abstract works:

That was the first time I was ever really impressed by Abstract Expressionism. Those paintings had such a profound effect on me, pretty much like de Kooning's women in that they were not purely visual paintings. They were of Berkeley. They were vistas. They were reality, there was a sense of reality about them.[36]

After his discharge from the army in January 1955, Oliveira moved to Oakland and struggled to find work. He left a job at Doggie Diner after deciding he "couldn't take slicing the onions."[37] He taught part-time both at the California College of Arts and Crafts and the School of Fine Arts and finally was asked to become head of the newly rejuvenated graphics department at the School of Fine Arts in 1956. Under Gurdon Woods's leadership, Oliveira was soon joined by Bischoff, Brown, Weeks, and eventually Diebenkorn; it was a dynamic time.

During his military service, Oliveira had painted works that resembled the landscapelike abstractions of local painter Lundy Siegriest more than the grandly national style of Still. He returned to this style after his discharge and later recalled his trajectory as somewhat anachronistic: "while the abstraction was going on in San Francisco, I was studying this kind of academic figurative painting, changing to abstract expressionism around 1953, just as the others were abandoning it for the figure."[38] As an early

FIG. 4.18. Theophilus Brown, *Portrait of Allen Ginsberg*, 1961. Oil and casein on paper, 10⅞ × 8½ in. Hirshhorn Museum and Sculpture Garden, Smithsonian Institution.

FIG. 4.19. Theophilus Brown, *Portrait of Jack Kerouac*, 1961. Oil and casein on paper, 10⅞ × 8½ in. Hirshhorn Museum and Sculpture Garden, Smithsonian Institution.

photograph shows, however, Oliveira was simultaneously exploring the figure in drawings, prints, and some large-scale studies, one of which is visible on the wall behind the easel in his Oakland studio (see fig. 4.1). Perhaps teaching at the School of Fine Arts, where the ghosts of the San Francisco School were everywhere, forced Oliveira to choose between abstraction and figuration—or to work actively on their synthesis.[39]

"It was like the aftermath of a great party," Oliveira recalled of the first years of Woods's directorship, "and we had to clean up." There was a "spirit of resurrection" in the air following the heyday of the Abstract Expressionists, when "Still's great legacy [had been that] art started with them . . . they were destroying the past."[40] Oliveira clearly saw himself and the other new appointees as constructive antidotes to the Abstract Expressionists' chaotic catharsis. But in his efforts to construct a style for himself without destroying the past, he learned a great deal from the attitudes of the former Abstract Expressionists with whom he was now associating and from the new figurative artists in the group drawing sessions he had joined. As he later recalled, he honed his sense of direction and decided what kind of figurative painter he would be primarily through arguments with the older painters:

> I think I was probably more influenced by a person like Bischoff through these arguments than by an environment that was really conducive and agreeing with me. In other words, Bischoff, Park, Diebenkorn, all these people are true painters and very high quality painters and not kids that are going off with a fragment of an idea. So that the arguments that we had . . . I being considerably younger were more impressive to me and more influential. . . . [The] influence that came out of that particular situation, the influence that the group had on me was on this basis, as working against something, against something that was pretty darn good, even though at times I didn't agree with it.[41]

Oliveira's description of his struggle at the time sounds eerily like Bischoff describing his own loss of faith in Abstract Expressionism. The young painter was searching for the universal language that the older artist had lost:

> Some of us became very independent and moved into our own situation of trying to . . . discover a language that dealt with the figure and also recognizing the contemporary concerns about Abstract Expressionism— somehow trying to develop a language that embodied all of these characteristics. . . . An awareness of contemporary painting language, a recognition of paint for

FIG. 4.20. Theophilus Brown, *Male Models*, 1961. Gouache on board, 8½ × 11¼ in. (21.6 × 28.6 cm). Collection of Mr. and Mrs. Charles Campbell, San Francisco.

paint's sake, action painting, recognizing a certain obligation that I had to fulfill according to my own needs as a painter, interpreting a form of reality, somehow trying to combine all of these aspects into a language that would represent a modern figure painting.[42]

In pursuing this language, Oliveira revealed his belief that the artist's gesture was the primary means of communicating. In this he bridged both traditional figure painting and Abstract Expressionism, seeing in Rembrandt the vital gesture of contemporary art: "The 'presence' of Rembrandt's portraits was, in part, in the very act of moving his hand and conveying his energy to bring these figures to life. These figures were [both] personage and paint. Rembrandt transmits his own energy, his own life, in the act of making a brushstroke."[43]

Rather than painting the figure because it seemed more fruitful or sympathetic, Oliveira saw himself as having "a responsibility to those traditional aspects of painting that dealt with an image."[44] This sense of responsibility may have come from his difficult childhood; it explains in part his tropism for the German Expressionists, Giacometti, Bacon, and other artists reaching for content beyond form. Suggesting a possible direction for that content without expanding on

his politics, Oliveira remarked, "I guess I was concerned . . . with social predicaments and with my associations with the socialists. . . ."[45] Oliveira recalls a "Marxist aesthetician" teaching during his student days at the California College of Arts and Crafts who was responsible for the political slant given much of the figurative work there, but this was not the thrust of his own paintings (despite his memory of "associations with the socialists").[46] Oliveira wrote to his dealer in New York, Charles Alan, that the "HORROR [and] deep human experiences" of World War II "cannot be painted,"[47] and his *Seated Man with Dog* (1957; fig. 4.28) is concerned not with the social or political concerns of humanity but the individual's existential position.

In this painting, the signature style of Oliveira's figurative work is set forth: a single figure is portrayed, here in profile, within an indeterminate space activated by brushstrokes. The color is monochromatic in *Seated Man with Dog*; in other paintings it is employed largely as an accent rather than a field or area. Impasto is not so much an indication of process as it is a sign of depth, projection, or visual focal point in the figure.

Seated Man with Dog is in some ways atypical of

FIG. 4.21. Theophilus Brown, *Portrait of D.K. (Don Knutson)*, 1964. Oil on canvasboard, 11½ × 9¼ in. (29.2 × 24.8 cm). Collection of the artist.

Oliveira's early figurative works, which tend to have more detail and color. Oliveira himself felt at the time of its completion that it was "the largest and I feel the strongest, of my new work."[48] In the manner of Giacometti, Oliveira has swathed the figure in linear brushstrokes that connect it to the ambiguous environment and convey a sense of agitated flux and temporal instability. But where Giacometti's lines strive to map and define the figure (however much this remains a painful impossibility), Oliveira's lines appear to dissolve it. The gestural force lines emanate *from* the figure, like an explosion of existential anguish from which the dog runs, head raised in a howl.

The wedge of black at the top left of *Seated Man with Dog* mitigates the heat and pain of the figure. This incursion reinforces the idea that the picture space is an illusion, a shifting plane of paint parallel to the canvas. Such formalist games seem strange in light of Oliveira's later claim that he could not relate to the other Bay Area Figurative painters' more formal concerns. But during the 1960s, Oliveira was not only open to discussions of formal issues, he positioned them at the center of his work: "My concern for the figure is primarily a formal one, growing out of the problems of painting itself. The implications are unconscious, for I have no desire to illustrate stories."[49] Perhaps this comment has more to do with the art-historical context of the time (in which Greenbergian critics were foregrounding "the problems of painting") than it does with Oliveira's own motivations. Certainly his ability to "talk form" was reinforced by his continuing association with the other figurative painters; it was later undercut by his own obvious inclination toward content of a non-narrative kind, through his focus on the solitary situation of existential man.

Although one reviewer described it as "a Frankenstein," *Man Walking* (fig. 4.29) suggests the potential of this non-narrative content.[50] It is redolent of earlier works in the history of art, calling to mind sculptures such as Auguste Rodin's *St. John the Baptist* or Giacometti's attenuated walking figures. Oliveira's painting shares the sense of frozen movement in these works, their description of a figure that tries to move, but is frozen as if in a dream. His face and body a shadowed void, only the walking man's arm and thigh are illuminated as, Lazarus-like, he staggers toward us.

Lightening these somber overtones, a playful treatment of the ground performs the same function as the contrasting wedge in previous paintings. Red on the left, blue on the right, the two bands of color

FIG. 4.22. Theophilus Brown, *Untitled (Interior)*, 1963. Oil on canvas, 46¼ × 48 in. (117.3 × 121.9 cm). Hirshhorn Museum and Sculpture Garden, Smithsonian Institution.

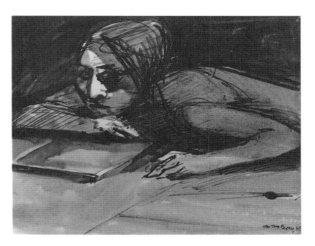

FIG. 4.23. Theophilus Brown, *Figure Reading*, 1965. Pen and ink on paper, 7¼ × 9¼ in. (18.4 × 23.5 cm). Collection of the artist.

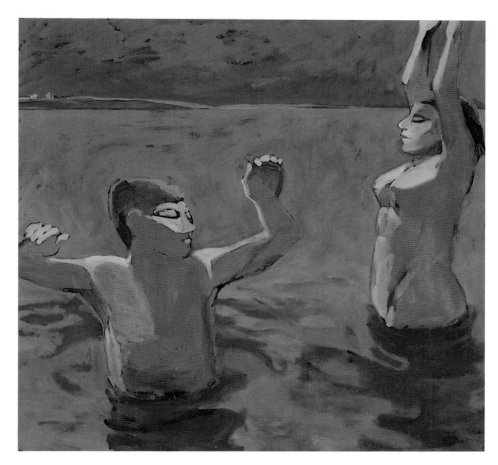

FIG. 4.24. Theophilus Brown, *Bathers at Dawn*, 1964. Acrylic on canvas, 48×48 in. (121.9×121.9 cm). Stanford University Museum of Art.

immediately contradict the illusion of receding space. They press up against the surface of the canvas, flattening the figure against the white ground like a playing card. Force lines are now largely absent, although Oliveira's nervous sgraffiti adumbrate the moving arm. The impasto of previous works has also been withdrawn, and there is evidence of more deliberate calculations during the evolution of the painting. The red ground was reserved early on, and the beautiful shadowed flesh tone of the left arm is simply the worn remnant of an area that was scraped, and scraped again, at an earlier stage of the painting's existence.

The year 1958, in which Oliveira completed *Man Walking*, was heady and successful. After feeling depressed and threatened in his position at the California School of Fine Arts, excluded from the club of former Abstract Expressionists (see the discussion in chapter 3), he had found a New York dealer, scheduled his first solo New York show, and won a Guggenheim fellowship to study printmaking in Europe. He ar-

ranged to leave in September 1958, so that he could visit New York and help with the preparations for his exhibition. New York held almost as much interest for him as Europe did at this point. As he wrote his dealer, Charles Alan: "I am developing a great deal of anxiety as to New York and what is there in fact I would like to live there if there were any possibilities of obtaining a teaching position."[51] Alan discouraged him, and Oliveira confined his ambitions to England, Paris, and Rome, planning to spend the year abroad with his wife and children.

The loneliness and complexity of life in Europe persuaded the Oliveiras to travel during their sojourn rather than settle in any one community. They visited museums in Italy, Germany, and the Netherlands, returning in December to San Leandro, where Oliveira's parents-in-law gave him their empty garage to use as a studio.

The European trip proved crucial for Oliveira's developing approach to figure painting:

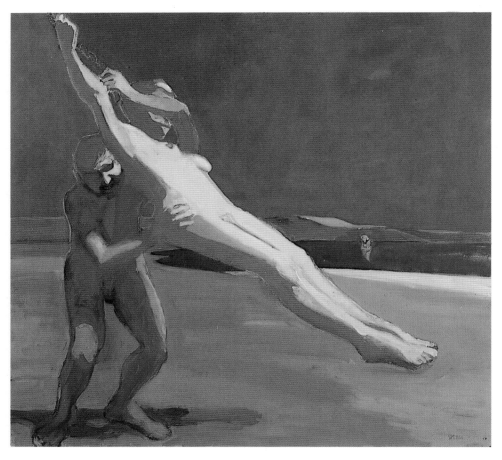

FIG. 4.25. Theophilus Brown, *The Swing*, 1966.
Acrylic on canvas, 52×56 in. (132.1×142.4 cm).
Collection of Daniel and Virginia Mardesich.

It . . . supported the position that I had taken in the Bay Area as a figurative painter [in relation to] the Bay Area Figurative people—it supported my concept . . . about making figures out of paint, it represented that language that I seemed to be seeking earlier, in 1956, and certainly the enforcement of seeing all the figurative painting in Europe, the historical painting, was so important to me. . . . I didn't see a damned abstraction in all those historical museums.

The works he completed in the San Leandro studio in 1959 "became the very foundation of my whole identity as a painter in this country."[52] Working through the concept of "making figures out of paint," Oliveira arrived at a leaner style in which the figure's environment played a new and important role. Despite his feeling that the new painting distinguished itself more clearly from the established Bay Area Figurative artists, it was in fact both closer to historical traditions and more comfortably linked with the Bay Area Figurative style.

Adolescent by the Bed (fig. 4.30) represented a kind of homage to Edvard Munch's *Puberty*, which connected it to some of Bischoff's paintings of the period as well as to the late-nineteenth-century Norwegian. The new theme clearly excited Oliveira, for as he wrote to his dealer: "the *Adolescent Girl by a Bed* is an idea that I want to carry out again or a number of times."[53] The image is arresting: a youthful girl stands beside a bare-looking bed, one arm resting on its metal frame and the other gesturing toward it. Unlike Munch's thin and anxious adolescent, who crosses her hands tensely over her groin, Oliveira's is voluptuous and welcoming. She stands confidently and virtually beckons the viewer to bed. The dark shadow under Munch's bed has become a warm and vivid red under Oliveira's; the swelling black shadow that threatens Munch's girl has been compressed into a rectangular void behind the bed in Oliveira's canvas.

The dramatic shift in the depicted attitude toward sexuality reflects the moment in the late fifties when

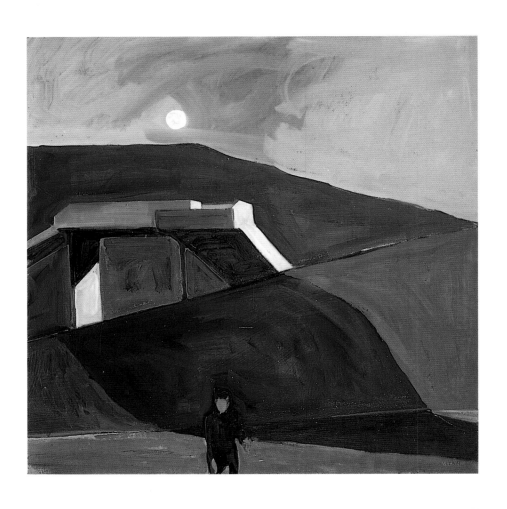

FIG. 4.26. Theophilus Brown, *Pedestrian Crossing*, 1966. Acrylic on canvas, 48 × 47⅞ in. (121.9 × 121.6 cm). Hirshhorn Museum and Sculpture Garden, Smithsonian Institution.

FIG. 4.27. Flo Allen modeling for class at California School of Fine Arts, 1948. Harry Bowden Papers. Courtesy Archives of American Art, Smithsonian Institution.

FIG. 4.28. Nathan Oliveira, *Seated Man with Dog*, 1957. Oil on canvas, 58⅜ × 49½ in. (148.2 × 125.7 cm). Hirshhorn Museum and Sculpture Garden, Smithsonian Institution.

Oliveira's version sprang to life. In the controversy over Vladimir Nabokov's book *Lolita*, which was first published in 1955 (first United States publication, 1958), some readers felt that the seduction of the young "nymphet" was a depraved act, while others found it liberating. Oliveira's adolescent seems to encompass both possibilities. The dark paint dripping between her legs and spattered on the bed behind implies that Lolita's "liberation" has already occurred; the girl's sober expression, combined with her proprietary grasp on the bedframe, suggests a complex mixture of resignation and pride.

Some of the same devices that appeared in *Man Walking* and other earlier works recur here—the wedge at the upper left and the different color areas between the figure's legs, beneath the bed, and to her left all function to flatten the image as did the wedges and split grounds of the earlier paintings. But beyond these similarities, most compelling are the differences in *Adolescent by the Bed*. The possibilities for narrative, the overt homage, and the complicated pictorial space are all new for Oliveira; the implications

of such changes were pursued only occasionally over the next few years.

Seated Figure with Pink Background (fig. 4.31), for example, explores a new lushness of color without invoking any of the environmental complexities of *Adolescent by the Bed*. The painting was completed by August 1960, and the small moths embedded in the background paint layer suggest that it was painted at night under artificial light.[54] A sumptuous peach color, painted late in the work's history, surrounds and delineates the woman and her exaggerated breast. Bands of blue and red zip in from the right, and a dark blue line is reserved at the top edge of the canvas. These flattening elements are balanced by large, atmospheric color areas of ocherous olive and brownish black.

Earlier, Oliveira had gouged force lines or auras trailing from the heads of his figures; here they are converted into hair, linear scrapings covered with thick maroon paint to create a mass that whips out behind the seated woman. Her face is nearly invisible, and frightening. Park-like daubs of paint make

FIG. 4.29. Nathan Oliveira, *Man Walking*, 1958. Oil on canvas, 60⅛ × 48⅛ in. (152.7 × 122.1 cm). Hirshhorn Museum and Sculpture Garden, Smithsonian Institution.

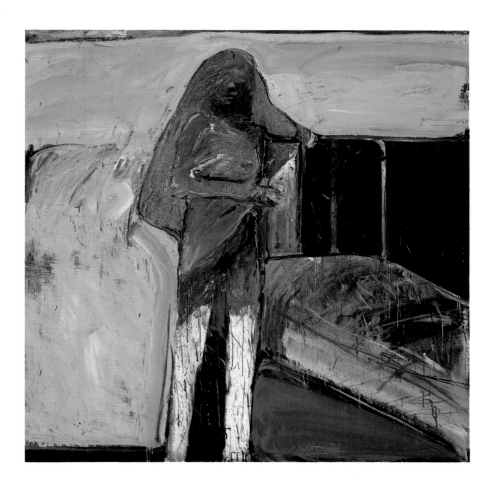

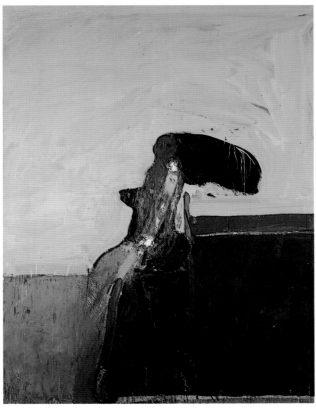

FIG. 4.30. Nathan Oliveira, *Adolescent by the Bed*, 1959. Oil on canvas, 60¼ × 60⅛ in. (153.1 × 152.7 cm). San Francisco Museum of Modern Art.

FIG. 4.31. Nathan Oliveira, *Seated Figure with Pink Background*, 1960. Oil on canvas, 82 × 62 in. (208.3 × 157.5 cm). Collection of Thomas W. Weisel, San Francisco.

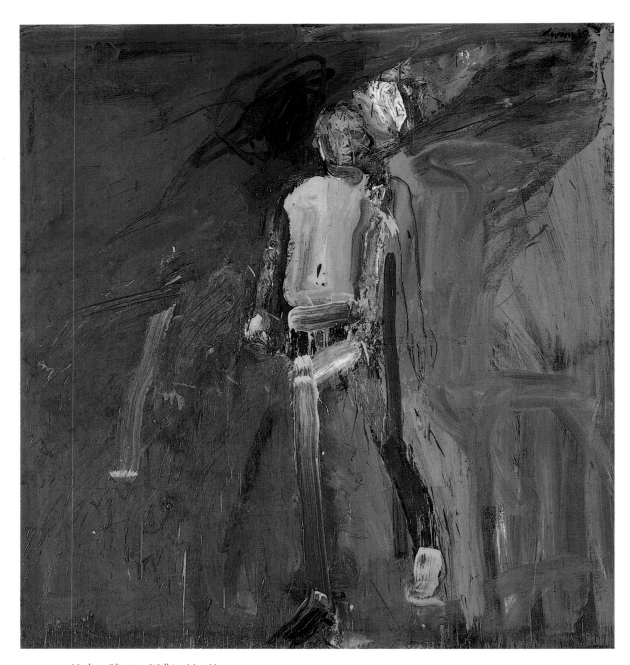

FIG. 4.32. Nathan Oliveira, *Walking Man No. 3*,
1960. Oil on canvas, 77¼ × 71¾ in. (196.2 × 182.3 cm).
Private collection.

up her shadowy features, but they are as void and insensate as a doll's or skull's. This empty gaze, together with the provocative thrust of her stocking-clad leg, gives her a haunting, harpylike presence—part sex, part death.

The death mask also appears in the face of *Walking Man No. 3* (fig. 4.32), which constitutes Oliveira's return to the theme he had first addressed in *Man Walking* two years earlier. Since painting *Adolescent* Oliveira had explored more expressive faces in the place of the blank visages and features sculpted out of thick impasto in his previous works. This *Walking Man* seems to have two faces—a partial profile looking to the left, and a skull-like gaze aiming front.

Color is the most spectacular development in *Walking Man No. 3*. The ground is a piercing blue, enlivened by an ochre trail issuing from the figure's head to the right, and a bold, totally abstract gesture in black to the left. This gesture, together with the blue and ochre colors, connects the work immediately to the landscapes of de Kooning, which first appeared in 1957, and the late color paintings of Franz Kline, which began around 1955.

Oliveira met de Kooning in 1959, when both were included in the prestigious but highly controversial *New Images of Man* show at The Museum of Modern Art in New York.[55] Oliveira found him "a marvelous, fantastic man," friendly and open to the younger artist, and he recalled how de Kooning "complained bitterly how everyone thought he was brutalizing . . . the female figure."[56] The two spent more time together when de Kooning visited San Francisco to be with his daughter and her mother. Oliveira tried to contain his enthusiasm about their meetings; as he wrote Charles Alan:

> I was very excited about meeting de Kooning, he was the last of the school boy influences, and I have little opportunity of meeting people like him. I may of exagerated [sic] his importance when he was here . . . however [I] very consciously did not put him above me, nor did I truly take my own enthusiasm too seriously.[57]

Apart from de Kooning's visit, the fall of 1960 was not a happy time for Oliveira. After the heady successes of his first solo show in New York (which sold out), the Guggenheim award, and purchases by The Museum of Modern Art and other major collectors, he was unprepared for the cool response to his second solo exhibition in October 1960. Sales were few and reviews were mixed; he was compared not always favorably to Diebenkorn, Bacon, de Kooning, Dubuffet, and French existentialist writers.[58] Tensions had arisen between his New York dealer, Charles Alan, and the Los Angeles gallery owner Paul Kantor, who had been showing Oliveira's work since 1958. In his efforts to control the supply of Oliveira's work, Alan sent decidedly mixed signals. "Desperate" for new paintings, he simultaneously urged Oliveira not to spread himself too thin:

> Since [the solo show] you have not even started any new canvases. . . . It is a continuing battle to maintain collectors' interest in an artist; they are an exceedingly fickle group. Just now, when we need paintings so badly . . . in order to fan waning interest, we have nothing to show.
>
> You don't see de Kooning or Levine or Diebenkorn or Kline or Tobey showing as much as you are planning to this season. Watch out, Nate, a public is awfully quickly surfeited.[59]

Oliveira, however, was unmotivated by these entreaties and remained despondent and unproductive: "At the moment, I am rather tired of my painting image and its repetition." He had been concerned about his imagery as early as January 1960, when he wrote Alan:

> I try so hard to change my painting, but no matter how much I try the symbol of the single figure remains. The change I think comes in how the image is painted, these new paintings are much more painted, and on this basis, I feel they are better than the ones in the past. They are becoming more difficult, and certainly take longer to realize. I don't think the paintings will change until my environment changes as well.[60]

The following year, Oliveira was able to change his environment, when the University of Illinois at Urbana asked him to be artist-in-residence. He found the large academic department and midwestern surroundings no more congenial than had Diebenkorn, but he took advantage of Chicago's proximity to develop new friendships with the group of figurative artists working in that city, among them George Cohen, Richard Hunt, and Ivan Albright. The stimulation of these new contacts helped him to resume painting and revive his flagging interest in the single figure.

At Urbana, Oliveira continued to develop some of his past themes, including a series of women in costumes from the 1930s which he had first explored around 1959. He wrote Alan at that time that he was "very interested in the '30s, there is something about the flavor, attitudes etc. that I like."[61] He returned to the theme in the spring of 1961, when he made a number of gouaches and oil paintings of women in

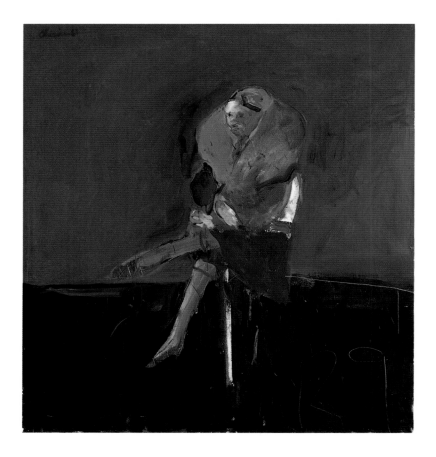

FIG. 4.33. Nathan Oliveira, *Nineteen Twenty-Nine*, 1961. Oil on canvas, 54⅛ × 50⅛ in. (137.9 × 127.3 cm). National Museum of American Art, Smithsonian Institution.

fur collars. The image reached an epiphany in the painting *Nineteen Twenty-Nine* (fig. 4.33), in which a seated woman, swathed in an enormous fur collar, sits with gartered legs crossed on a single-legged stool. The different areas of the figure are painted in paired but contrasting colors: one green leg and one green collar with one mauve leg and one mauve collar; one gray hand, one flesh hand, one red eye, one green eye. The colors are somber, the image disturbing. The single stool leg is painful, like an entomologist's mounting pin. The date of *1929* is scratched in large numbers at the lower left, and red slashes of paint spill from the figure's skirt across her legs.

The many variations of this image evoke family photographs, their hand-tinted colors fading into disparate hues. The year is also suggestive—the year after Oliveira's birth, the year of the great crash, the year the family was destroyed. In fact, the woman in *Nineteen Twenty-nine* is the central protagonist from that stage of Oliveira's life. As Thomas Garver writes:

Oliveira regards this image as being a portrait of his mother from memory—a memory tinged with the child's edgy awareness of "mother" as a person who offered protection but a protection compounded with an element of physical allure. It was not necessarily a happy memory, but one which had to be painted.[62]

Increasingly, Oliveira painted women. The existential implications of his standing male figures gave way to an astonishing sensuality, an involvement with the female nude as erotic Other. In the works on paper particularly—such as the 1961 *Studies of Nudes* and *Nude with Raised Leg* (figs. 4.34 a, b, 4.35)—he freed himself from growing concerns about his imagery to explore, on an intimate scale, the classic genre of the female nude. In the watercolor *Studies of Nudes*, typical of many such sheets from this period, Oliveira took as a model one of the greatest explorers of the female landscape: Auguste Rodin. As in Rodin's masterful late watercolors, Oliveira's pale, quick pen lines sketch the body's contours, while rich, translucent colors wash and pool within the created boundaries. The expressive poses and colors are invented: green hair, blue leg, pink clouds haloing the face. The impression of spontaneity is overwhelming, belied only by the touches of colored pencil that carefully delineate the nipple of the profiled nude.

While Oliveira had echoed Rodin's poses in his male figures (such as *Man Walking*), with his depic-

FIG. 4.34 a, b. Nathan Oliveira, *Studies of Nudes*, 1961. Watercolor and pencil on paper: left sheet, 11⅝ × 8¹³⁄₁₆ in. (29.8 × 22.2 cm); right sheet, 9⁹⁄₁₆ × 7¹³⁄₁₆ in. (24.4 × 18.7 cm). Los Angeles County Museum of Art.

tions of females he turned to Rodin's *method* of fluid watercolor sketches. Oliveira's color choice is less naturalistic than Rodin's, however, and becomes almost Fauvist: the darker hues do not necessarily correspond to areas of shadow within a rational lighting scheme. As Oliveira said of his oils: "Figures must have their own light. It wasn't light that struck the figure in a certain way—the light, the luminosity of white, was in the figure. It emanated from the paint itself."[63] In the case of watercolor, of course, the light emanates from the paper, glimmering from beneath the filmy color wash.

In his gouaches Oliveira worked more with darkness than with light. The colors are rich, umbrous, and deliquescent, mixed with oil or lacquered inks to create areas of gloss and depth. The pose of *Nude with Leg Raised* is less abandoned than in *Studies of Nudes*; it is the pose of a coquette, the wanton cousin of the woman in the fur collar. *Seated Woman* (fig. 4.36) shows yet another cousin, suggestively holding her pet in her lap and promising love with an outline heart that floats below. Although he believed that the figure in general represented "a universal symbol, it's timeless," Oliveira also recognized that for him the female was an intoxicating, unknowable Other.

Raised in the matriarchal culture of Latin Catholicism and surrounded by women as a child, it is not surprising that Oliveira found in females his most enduring and complex subject:

> I normally paint the female, simply because she's my opposite. I love to look at females. It's an incredible thing. I never tire of it. She becomes my wife, she becomes my mistress, she becomes my fantasies of all the women I've ever known and dreamed about. . . . [It] becomes a symbol of so many things that make me up psychologically and make me male.[64]

In the difficult years when Oliveira was struggling to confront dealers' pressures and the loss of faith in his signature style, the woman became an important anchoring motif. She was a character in the experimental, theatricalized works he would begin in Urbana around 1962. In these works, sgraffiti (like the heart in *Seated Woman*) proliferate and swirl around the woman like a comic-strip nightmare. Oliveira left such imagery, and increasingly, women became archetypal, even mythical figures in his last Bay Area Figurative canvases, exemplified by *Spring Nude* (fig. 4.37).

The palette in *Spring Nude*, developed at Urbana,

builds upon the Fauvist colors of the watercolors and theatrical oils: a saturated sunset peach, acid yellow, and spring green are the dominant hues. The scale is massive, making it one of the largest paintings Oliveira had ever made. Except for her nipples, which are sculpted in paint (like the touches of colored pencil in the *Studies of Nudes*), there are almost no sgraffiti or linear strokes, and the woman sinks, softened, into the landscape. Her head, a darker green than her body, seems to meld like an apparition into the slightly bluish distant hills. Her body seems more corporeal, with a golden outline highlighting the volume of her arm and leg—but a flattening wedge of ochre at left returns us, as always, to the canvas surface.

Spring Nude was followed by *Winter Nude* and other less massive canvases, but the rest of the year was a frustrating one. After leaving Urbana, the Oliveiras moved to a new home in Piedmont, where the earlier depression and malaise lingered. Complaining that Diebenkorn and others were continuing to command high prices for their figurative work, Oliveira was not comforted by his dealer's response that Diebenkorn was older and his works overpriced.[65]

"My ego has been wounded, and somewhat dented this past year. . . . The takeoff was great however I am beginning to get banged up and dented and a bit tarnished in flight. . . . It is amazing to think that after *all* this, that I still must rely on the Art School here. . . ."[66]

In the fall of 1963, Oliveira again sought a change, taking a year's lectureship at the University of California, Los Angeles. The new environment did not help, for he found that he "could not paint a picture to save my soul."[67]

> I was getting pretty anxious to change this image that had been attached to me. . . . The climate in terms of the fashion of art was moving away from figurative painting, the Bay Area Figurative people, my dealer in New York was insisting that I change my images . . . [while] Paul Kantor from Beverly Hills . . . was saying, "Don't change, paint the same painting, not too big, not too small, not dark. If you do this you'll never have to worry."[68]

Having always been the ambivalent loner in the context of the Bay Area Figurative movement, Oliveira could not rely on the support of others who were

FIG. 4.35. Nathan Oliveira, *Nude with Raised Leg*, 1961. Gouache and oil over graphite on paper, 20 ½ × 25 ½ in. (52 × 64.8 cm). Collection of Mr. and Mrs. Charles Campbell, San Francisco.

FIG. 4.36. Nathan Oliveira, *Seated Woman*, 1961. Gouache on paper, 25 ½ × 20 ½ in. (64.8 × 52.1 cm). Private collection, Phoenix, Arizona.

continuing to find viability in the style. He watched Wayne Thiebaud, who appeared to San Franciscans as a latter-day Bay Area Figurative painter, go to New York with his unsold canvases and get swept into the feverish explosion of the Pop Art market. The New York collectors of sober, humanistic figurative painting—which had seemed the dernier cri as recently as the *Images of Man* show in 1959—seemed to have disappeared overnight. Oliveira, still pegged by reviewers as having "[the] hand [of] Dubuffet Et Cie, but the voice [of] Francis Bacon," felt, as he said, "the forgotten man."[69]

Oliveira was unable to escape the impasse, which was perhaps exacerbated by the demand for his services as a teacher and the academic accolade of a retrospective at the Art Gallery of the University of California, Los Angeles. Offered a permanent teaching position at three different institutions, he finally accepted a post at Stanford, where he was given a studio in the former lodge hall of the Native Sons of the Golden West. Slowly, the mysterious performing arena of the lodge hall, with its distancing proscenium arch, began to inspire him. By 1966 the desire to paint returned, and he began to produce the Stage series, which constituted his decisive break with the Bay Area Figurative style (fig. 4.38).

After the long hiatus in production, Oliveira's painting style had changed dramatically, becoming tight and polished, with no stray brushstrokes or evidence of process to be found. Diebenkorn, Weeks, Wonner, and Brown were all responding in their painting styles to the hard-edged mood in American art of the period, and Oliveira was no exception. Unlike Diebenkorn and Wonner, however, whose shifts were far more drastic, Oliveira retained much of the thematic essence of his previous work. The lone figure still evoked existential angst. No longer dissolved in febrile brushstrokes, it is instead distanced and remote: born, and dying, alone.

CONCLUSION

Oliveira, Wonner, and Brown were not the cohesive group that Park, Bischoff, and Diebenkorn had been. Like Weeks, they were more aloof and less involved with the community of students, teachers, and artists that had always constituted the Bay Area's artistic scene. Their role as a bridge generation was never consciously sought and certainly not acknowledged

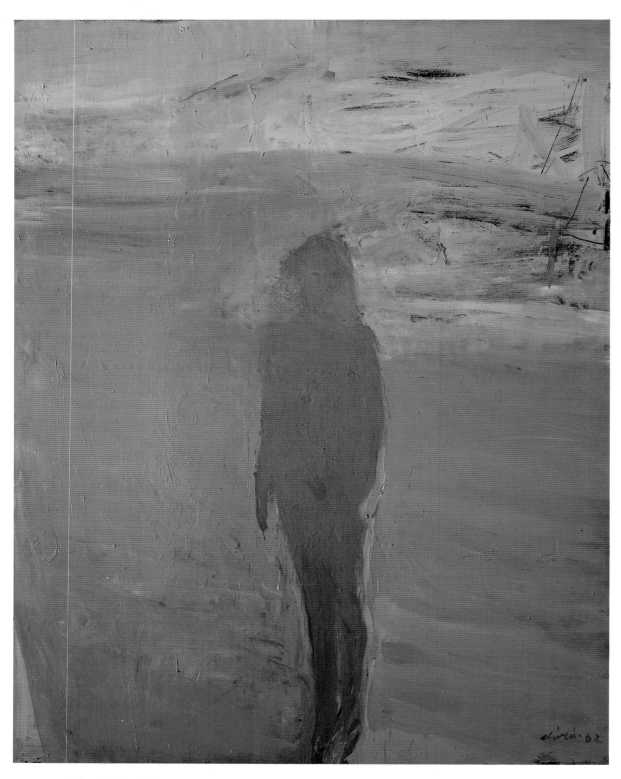

FIG. 4.37. Nathan Oliveira, *Spring Nude*, 1962. Oil on canvas, 96×76 in. (243.8×193 cm). The Oakland Museum.

FIG. 4.38. Nathan Oliveira, *Stage #2 with Bed*, 1967. Oil on canvas, 66 × 67 in. (167.6 × 170.2 cm). Collection of Mr. and Mrs. Harry W. Anderson.

by them; they were as leery of movements as their older colleagues had been, and had far less cause to band together.

But to the still younger artists whom they taught and interacted with at the California College of Arts and Crafts and the California School of Fine Arts, they represented important options within the spectrum of Bay Area Figurative styles. Wonner, the coolest and closest to Diebenkornian formalism, was not a teacher. But the works he showed at local annuals demonstrated the heat that could be generated by realist subjects, particularly when those subjects were drawn from lived experience and not canonical genres of the figure.

Brown, who taught at both Berkeley and the School of Fine Arts, revealed the power of a Surrealistic approach to Bay Area Figuration. This Surrealism was always more personal than literary, functioning as fantasy autobiography with just enough of an erotic edge to be disturbing. With his manipulation of styles, which seemed to appear or disappear with a given subject category, his work also condoned a mannerist approach to the brushwork, composition, and palette of previous artists. Seen as decadent by some, this mannerism signaled freedom to others.

In terms of Bay Area Figurative art, Oliveira's legacy was in many respects the most complex, because it was most consciously dissociated from the normative style. The autobiographical suggestions in Wonner's paintings, and the symbolist fantasies in

Brown's, were not readily available in Oliveira's work. Instead, he represented in some respects a stronger link with Abstract Expressionism, seeking universality in the existential isolation of the human figure. But his openness to emotion—particularly dark emotion—was his most salient gift to his fellow artists.

As a teacher, Oliveira often took students to the San Francisco Zoo. In a work that must be based on such a trip, Oliveira portrayed a baboon, face clenched in anger with a very male, human aspect.[70] Whether or not it is a self-portrait, the baboon demonstrates that Oliveira's motives were never strictly realist. He recognized himself that this made him atypical: "I do believe I am too romantically involved in what I do, this is not only in relation to the gallery, but also in the act of painting. I am sure that I belong to another century. . . . I have to become more conscious of reality. . . ."[71]

His insistence that the subject communicates individual emotional truth instead of reality was indeed different from the expressed goals of the first generation (although it is echoed in Bischoff's emphasis on "feelings"). The earlier Bay Area Figurative painters' denial of autobiography, narrative, and personal emotion threw into high relief the individual approaches of the bridge generation. The second generation would be drawn to both alternatives, but for various reasons, the choices of the bridge generation would prove most prophetic.

CHAPTER FIVE

THE SECOND GENERATION

INTRODUCTION · The bridge generation painters showed a greater openness to autobiographical subject matter than the generation that had defined the Bay Area Figurative norm. This was combined with a stronger interest in erotic, psychological, and Surrealist imagery. The paintings of Paul Wonner and Nathan Oliveira also diverged from the early Bay Area Figurative style, indebted as it was to Abstract Expressionism. Wonner in particular presented an almost mannerist interpretation of earlier nonobjective painting: the thick pigment in his work is a product of his conscious application rather than the result of his search for an image. Similarly, although Oliveira was involved in process to the extent that he wanted to find the figure through the act of painting, he used impasto consciously. Rather than being merely a layered by-product of the painting process, Oliveira's thickest paint was both a modeling device and a sign for pictorial intensity. Thus impasto was no longer only the trophy of a moral victory, won in the act of painting—it was also a mannerism that could be adopted without allegiance to Abstract Expressionism itself.

In part these shifts were the result of the bridge painters' lack of involvement with the initial phase of Abstract Expressionism. In its incarnation as the San Francisco School, the movement had called for a deep commitment of physical and emotional resources, a belief in a shared ethos of paint—as process, as universal language, as individual act. For painters who had not witnessed or participated in the blossoming of the San Francisco School, there was both less to rebel against and less to inherit.

The first generation of figurative painters came to distrust the emotional, relentlessly individual intensity of the Abstract Expressionist mode. They sought in figuration, in part, a greater personal distance from the subject. Never having been burned (or bored) by

this intensity, the bridge generation was less leery of it. Oliveira could mold his figures with as much existential angst as Pollock had poured into his skein paintings; both maintained full belief in their fusion of form with emotional content. But if they were less rebellious against the emotional excesses of Abstract Expressionism, the bridge generation had also inherited less of its formal rigor. The subject of a painting became necessarily more important without the lesson of pure painting to draw upon, and the painting's message to the viewer became that much more accessible and clear.

To the second generation of Bay Area Figurative artists emerging in the late fifties, represented here by Bruce McGaw, Manuel Neri, and Joan Brown, the legacy was mixed. The bridge generation offered the freedom to choose among previous styles and attitudes—from Bouguereau to Abstract Expressionism—as well as a greater openness to emotion and autobiography. But with the exception of Park, the first generation was still very much alive, vividly demonstrating the viability of the Abstract Expressionist ethos in a figurative mode. In many ways, these more established painters were the dominant figures in the lives of young artists studying Bay Area Figurative art. Diebenkorn was the charismatic teacher at the California College of Arts and Crafts, Bischoff at the California School of Fine Arts; their impact on younger artists was avowedly significant. Yet the second generation consistently employed the bridge generation's more aggressive manipulation of medium and their more personal subjects—in part through emulation of the other artists and in part through their own response to the changing culture.

The first generation had participated in World War II ("the just war"), whose soldiers had been welcomed home to the resurgent economic and cultural strength of peacetime America. The bridge genera-

tion was divided: Wonner and Brown shared the cathartic experience of World War II, but Oliveira participated in the second generation's war, the mortifying·and inconclusive Korean conflict. Unlike the triumphs of World War II, which were celebrated and ceaselessly revisited, the experiences of war in Korea were forcibly forgotten by Americans.

This effort at amnesia was only partly successful, however. Among the younger artists of the second generation especially, there was a growing sentiment that beneath the rosy, Eisenhower-era image of tract homes and the two-car garage there were "a lot of things brewing."[1] These artists felt a sense of hypocrisy and unease in American culture, which could be only partially redeemed by the honesty of jazz, underground films, and Beat poetry. Their art grew angrier, funnier, and more confrontational; they began to call it *funky*—an idiom borrowed from jazz to describe a soulful, even corny art of demolished perfection, rough edges, and self-consciously outsider status.[2]

This funky attitude did not appear suddenly with the second generation; the seeds for its raw energy had been planted with the first abstractions of the San Francisco School. Artists at the California School of Fine Arts during MacAgy's tenure remember the director's enthusiasm for the Dada movement, with its celebration of art at the edge of aesthetics; students of former School of Fine Arts faculty revived the Dadaist notion that technique could be a constraint, and permanence a liability.[3] Joan Brown, describing one source of her own feeling for Funk art, located it in her viewing of a Berkeley abstraction by Diebenkorn:

> Just out of high school, I saw a show at the San Francisco Museum—one painting turned me off and infuriated me. It was an abstract Diebenkorn in '54 or '55, in green and orange. I was so upset I went back again and again. I finally got turned on by being turned off. It was so hideous, and so gritty, and I really dug this feeling. [It's] sort of perverse, [but] I really wanted to reproduce this feeling.[4]

Brown's view of the Diebenkorn abstraction is colored by her needs and subsequent experiences. Other students of Diebenkorn, notably Bruce McGaw, valued precisely opposite tendencies in Diebenkorn's work: his classicism and restraint. But whatever their individual approaches, which were at least as diverse as those of the preceding generations, Brown, McGaw, and Neri extended Bay Area Figurative art in rich, new directions. They also participated in its eventual demise.

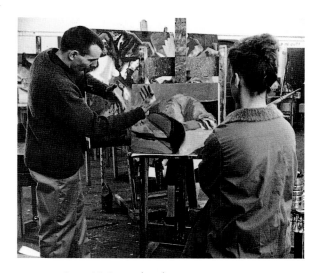

FIG. 5.1. Bruce McGaw and student in painting class, San Francisco Art Institute, ca. 1962. Courtesy San Francisco Art Institute.

One recent judgment holds that "around 1960, Bay Area Figuration was degenerating into diverse academic styles united only by a common use of impasto and gesturalism."[5] But it was not until 1965 that Bay Area Figurative art degenerated—and it did so then not out of decadence or exhaustion, but in conscious response to broader currents in the evolution of American art. Until that time, the movement showed no signs of slackening, in part because of the achievements of the second generation. When these younger artists chose to move on, momentum truly ceased—but while they were players, the game continued with fresh spirit.

BRUCE McGAW: GOING UPSTREAM

Although not the oldest of the second generation, Bruce McGaw was the only one to be included in the 1957 *Contemporary Bay Area Figurative Painting* exhibition (fig. 5.1). Born in 1935, he was in fact the youngest artist in the show, and recalls that "I got in on Diebenkorn's coattails . . . whether he suggested it or it seemed to fit. . . . I didn't even meet Park until virtually the night of the opening."[6]

Of all the students at the California College of Arts and Crafts, McGaw was perhaps closest to Diebenkorn (Henry Villierme was the only other contender for the post). He recalls being in Diebenkorn's class in 1955, the first Diebenkorn taught after returning from the East Coast in 1953. McGaw views their relationship at the time as similar to Matisse's with Derain. Matisse had visited Derain's family to persuade

FIG. 5.2. Bruce McGaw, *Abstraction*, 1955. Oil on canvas, 19⅞ × 26 in. (50.5 × 66 cm). Collection of the artist.

them to allow the young painter to pursue his career; similarly, Diebenkorn met McGaw's parents and impressed them with his great seriousness and support of their son's efforts.

McGaw's family had never been opposed to their son's choice of career, since art and geometry were the only subjects he had taken seriously in high school. He did not have sufficiently high grades to go to college, and the McGaws were pleased when he won a scholarship to study at the California College of Arts and Crafts. His commitment to fine rather than commercial art must have been encouraged by Diebenkorn, and possibly the professor's imprimatur made McGaw's choice more acceptable to his parents.

Before Diebenkorn, McGaw had studied with Leon Goldin, but found him less inspiring. McGaw had initially been drawn to abstraction, and Diebenkorn's work seemed immediately more appealing and less decorative than Goldin's: "[Diebenkorn] seemed to have an earthiness—like building things out of rock. They didn't have to be beautiful, just right in the space. His paintings were really rugged, with the sense of having been worked on."[7]

One of McGaw's surviving abstractions (fig. 5.2), probably painted in Diebenkorn's class, shows a clear debt to the older artist—although it is closer to Diebenkorn's earlier, nearly figurative Urbana paintings than to the more contemporaneous Berkeley works. McGaw retrieved an already-painted canvas from another student, and fragments of the earlier painting are visible where they have been purposefully reserved. The palette is teal, pink, and ochre, and lines function as contour, much as they do in Diebenkorn's pre-Berkeley abstractions. Further, there are inti-

mations of a profile in the right half of the image, recalling Diebenkorn's protofigural *Urbana No. 2 (The Archer)*.

Figuration for McGaw was not a furtive process, nor was it particularly incremental in his work. Like other second-generation artists, he was plagued neither by notions of linearity in art history nor by the compunction to work through one style before moving to another: "I got that very early on from Diebenkorn as a teacher. He didn't say it, but he demonstrated it. He'd show you a de Kooning or a Rothko, then the next thing a Daumier or Matisse. It wasn't a linear progression." Contributing to the breakdown of the lineage beloved by formalists was McGaw's own interest in Dada. Knowledge of that irreverent movement gave him the sense that "anything goes" and confirmed his feeling that "the lineage is, if anything, to be *destroyed*, because there's something more fundamental. . . ."[8]

During this period of experimentation as a student, McGaw invited children to draw at his parents' house so that he could observe their untutored approach to image making. In this, he was exploring an interest in the *art brut* of Jean Dubuffet (whom Diebenkorn had recommended), as well as pursuing an admiration for the consciously childlike inventiveness of Picasso. Mythological subjects and Zen calligraphy (which was taught by Sabro Hasegawa) completed the stew of figurative influences:

I just felt that anything was possible. And that was certainly Diebenkorn's attitude at that point: "this is a more interesting way to approach art than to try to subscribe to some formal dogma." So I was playing with a lot of stuff, and what was really in the world gradually began to be as interesting to me as anything else.[9]

McGaw's first mature figurative paintings were still indebted to Diebenkorn, but they also had a raw intensity of their own. Often working on a very small scale, he broke up the body into standard torso views (such as *Figure*, fig. 5.3) or odd, synecdochal parts (such as *Pat's Feet*, fig. 5.4). As Paul Mills wrote of these works in 1957:

[These] small paintings [are] quite different in character from the rest of the paintings in the show. These are very direct, literal observations. . . . There has been no attempt to alter the forms, the space or the degree of likeness; however the subject has been transmuted into high-keyed color which removes it from older traditions of figurative painting. Somehow, even though these paintings are sometimes hardly eight inches square, he manages to maintain a kind of paint quality in miniature.[10]

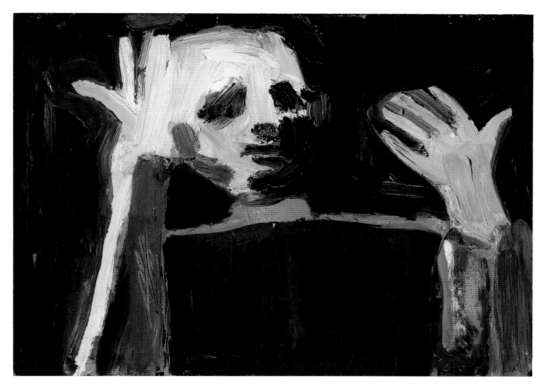

FIG. 5.3. Bruce McGaw, *Figure*,
1957. Oil on canvas, 13¼ × 18¼ in.
(33.6 × 46.4 cm). The Oakland Museum.

FIG. 5.4. Bruce McGaw, *Pat's Feet*,
1957. Oil on canvas, 10⅝ × 11½ in.
(27 × 29.2 cm). Collection of the artist.

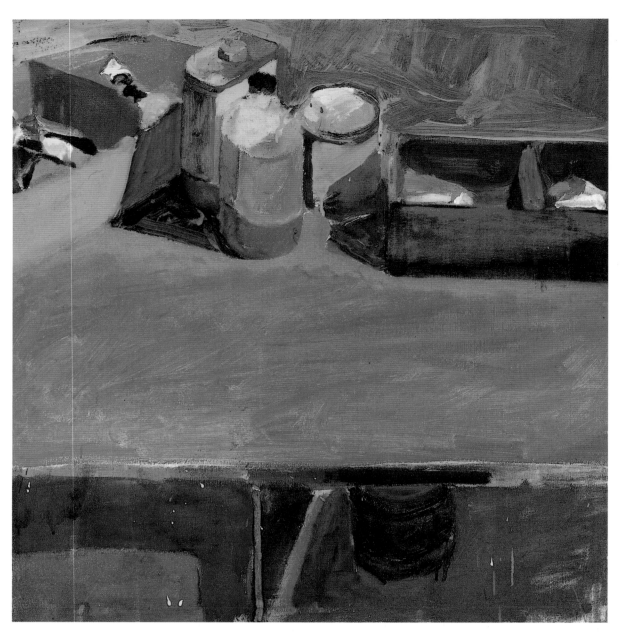

FIG. 5.5. Bruce McGaw, *Palette Table Top*, 1958. Oil on canvas, 25 × 24¾ in. (63.5 × 62.8 cm). Collection of the artist.

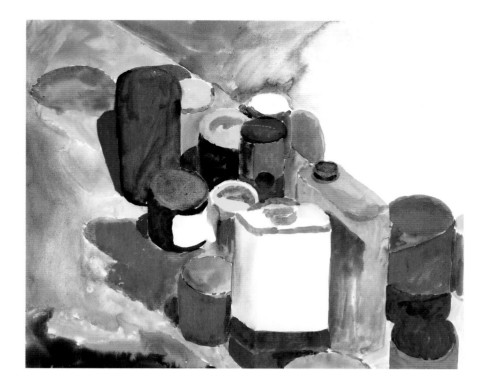

FIG. 5.6. Bruce McGaw, *Paint Cans*, ca. 1958–59. Watercolor on paper, 13¾×17 in. (34.9×43.2 cm). Collection of the artist.

Although one need not agree with Mills that Mc-Gaw's palette is removed from older traditions (there are links to German Expressionism as well as to the Fauves), it is certainly distinctive compared to those of the other Bay Area Figurative painters. The green shadows and mustard yellow highlights of *Pat's Feet* and the sepulchral coloring of *Figure* remove both from easy categorization. In revealing that the subject for *Figure* was the pope, McGaw also distinguished himself from his reticent elders, who were still more comfortable with anonymous genre scenes.

As McGaw told Mills, *Figure* was "a savage and sarcastic stab" at the pontiff. Mills seemed bemused by this report, which prompted him to ruminate on the subject of rebels and to comment on McGaw's unfashionable personality, "with [its] spontaneous aptitude for going upstream. . . ."[11] As McGaw now recalls, *Figure* was based on newspaper photographs of Pope Pius XII with arms raised commandingly above the mass below. The image annoyed McGaw, and he associated it with all of the socially regressive things that authority in general, and the church specifically, represented in the 1950s. It was his only attempt at social commentary (and was far from overt), but it suggests the non-conformist, Beat-generation impulses behind much of his work.

McGaw's life entered a new phase in 1957. In addition to the Oakland exhibition, which must have

been a heady initiation into the local art community, he and his wife had their first child and moved into a house behind his parents' home in Albany. Freshly graduated from the California College of Arts and Crafts, he began teaching at the California School of Fine Arts, somehow finding time to paint a series of studio interiors and commuting paintings, which were sketched furtively from the car window with one hand, while driving to San Francisco with the other. Despite the distractions, it was one of the most productive periods of his career.

The studio scenes began as moderately scaled still lifes (see *Palette Table Top* [fig. 5.5] and *Paint Cans* [fig. 5.6], both from around 1958). McGaw's color retained its high-keyed intensity, although it shifted from the darker tonalities of *Figure* toward a brighter palette of primaries and warm secondary hues. The watercolor *Paint Cans* shows an exaggerated, tilted-up perspective—found in Diebenkorn as well as Cézanne—but the various containers are lined up loosely rather than rigorously conforming to the picture plane. The hues mutate from very intense reds and blues near the containers to pale pinks and greens in the background. By comparison, the colors of *Palette Table Top* are more radical. There is no diminution in the intensity of the burnt orange of the table surface or the teal blue of the wall/floor. The strength and close values of the hues in the larger oil make them press forward and flatten—so much so that the

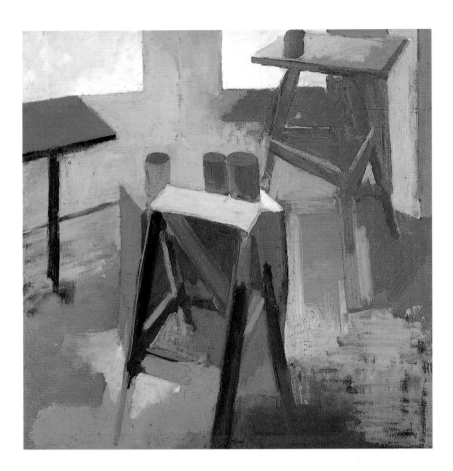

FIG. 5.7. Bruce McGaw, *Studio Interior*, 1960–61. Oil on canvas, 28 × 26½ in. (71.2 × 67.3 cm). Collection of the artist.

bottles and cans threaten to slide down the canvas and out of the frame.

McGaw recalls attempting to achieve "light out of darkness" in these works, "a kind of coloristic Rembrandt." This interest prevailed as he broadened his compositions to include more of the studio, as in *Studio Interior* from 1960–61 (fig. 5.7): "Before, I couldn't take my eye off the palette—now I'm finally looking somewhere else."[12] This roughly painted work dramatically complicates the space and light being depicted. Juxtaposing patches of intense color (in a manner somewhat similar to Weeks's figure paintings from the same period, which he admired), McGaw plays teasing games with perspective. The blue "shadow" in the lower left creeps over the bottom rung of the stepladder, and then disappears; the slate gray of the far right corner wall becomes the front leg of the easel-table, although it seems to come from behind. Three cans sit on a small table behind the stepladder, but they hover uneasily because the blue wall continues onto the table's surface.

Studio Interior is not an altogether successful painting, but it illustrates the formal aspects of McGaw's painterly investigations. In watercolors and gouaches such as *Figure* (fig. 5.8) and *Chair* (fig. 5.9) he pursued these further, but in *Books* (fig. 5.10) one can discern the non-painterly interests that were increasingly important to his work. As with the painting of the pope, the subtext of this canvas is accessible only to the initiated. Visually, all we are given is a pleasingly abstract composition of approximately six books and a drawing tablet, arranged haphazardly on a tiled table or floor. Once we learn the models for the composition, however, the work becomes an essay in autobiography—albeit of a peculiarly reticent sort.

The uppermost book is a copy of *Evergreen Review*, the nascent countercultural journal that began publication in 1957. Its second issue, the one depicted here, focused on the San Francisco scene, with an article by Dore Ashton on the San Francisco School painters (and a postscript on the Figurative artists by Hubert Crehan). The issue also contained a large selection of Beat poetry by friends or acquaintances of McGaw, among them Michael McClure, Philip Whalen, and Lawrence Ferlinghetti. Allen Ginsberg's *Howl*, which McGaw had heard recited in 1955 with Manuel Neri, was also published in full. At the bottom of the pile of books is a slim pamphlet ranging

in color from blue to peach to dark green, bordered by white. This conforms exactly to the Oakland Art Museum catalogue from 1957, which reproduced Bischoff's *Figure in Landscape* on its cover. Between this significant catalogue and the *Evergreen Review* are Ferlinghetti's *Pictures of the Gone World* (the slim black volume), a Thomas Mann novel (the striped paperback), and a book on the Italian still-life painter Giorgio Morandi (the dull brown folio). Here, then, are summarized the significant influences in McGaw's life in the early sixties—the growing figurative movement, the sobering rigor of the history of art, and the liberating atmosphere of the Beats.

Despite his feeling that "anything goes," it must have been difficult for McGaw to bridge the distance between Morandi, with his obsessive concentration on an extremely limited palette and motif, and the Beats, who celebrated grit, found imagery, and vernacular excess. Manuel Neri and Joan Brown were deeply involved with the Beat aesthetic and felt few constraints on their enthusiasm (fig. 5.11). Brown lived downstairs from the Beat poet Michael McClure, and was briefly involved with him; Neri had helped organize Ginsberg's first full reading of *Howl* at the cooperative "6" Gallery.[13] As much as he must have admired the young poets, McGaw was still strongly attracted to classicism. As he saw it, a central appeal of Bay Area Figurative art was "the classicism of Elmer Bischoff, Richard Diebenkorn, and Park . . . a kind of austerity where exactly the right note is hit."[14]

McGaw was also leading a very different life from his colleagues. Like Weeks, he worked at two jobs to support his growing family (a second daughter was born in 1961), while Brown and Neri were both in the process of finishing their degrees and separating from their respective spouses. Paul Mills, who described McGaw's interiors as "conformist" (albeit also "individual and distinctive"), quoted the painter as saying, "Rebellion is good, but I'm not for rebellion, I guess —at least I guess I don't want people to think so."[15]

McGaw's personality thus held his figurative work back from what he perceived as the excesses of the second generation. He speaks now of "that God-awful reverence for thick paint," and the "mannerism" of the later followers of Bay Area Figuration:

> With Park, the image and the forms don't break apart, where with . . . others it breaks apart. There isn't that reciprocity; the color's . . . too bright, so that it becomes a color experience which you have a hard time integrating. [True Bay Area Figurative] wasn't an either/or thing—it was absolutely a marriage.[16]

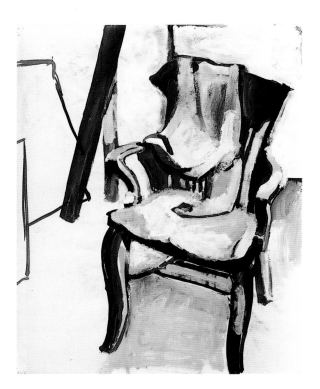

FIG. 5.8. Bruce McGaw, *Figure*, ca. 1958–59. Watercolor on paper, 13¾ × 16¾ in. (34.9 × 42.5 cm). Collection of the artist.

FIG. 5.9. Bruce McGaw, *Chair*, ca. 1961. Ink and gouache on paper, 24 × 19 in. (61 × 48.2 cm). Collection of the artist.

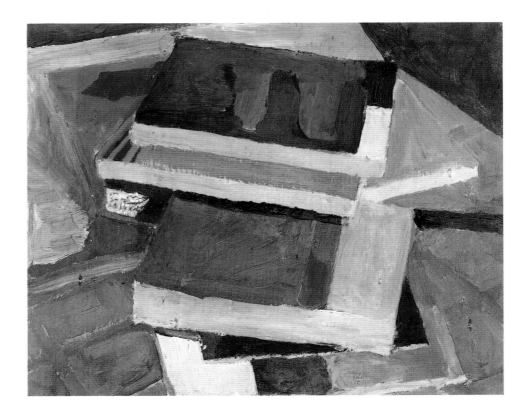

FIG. 5.10. Bruce McGaw, *Books*, ca. 1958–59. Oil on canvas, 11¹/₁₆×13⁵/₈ in. (28.1×34.6 cm). Collection of the artist.

In paintings such as *Chemical Plant by Freeway, Emeryville* (fig. 5.12), McGaw sought to define this aesthetic, in which color, form, and image would be strong but integrated. Here he depicts the barren landscape and "folk architecture, folk sculpture" of the chemical works next to the freeway in Emeryville, which he passed often on his commute to the renamed San Francisco Art Institute (formerly the California School of Fine Arts).[17] Anticipating the flattening out of Diebenkorn's, Wonner's, and others' work, McGaw's canvas explores a larger scale in which brushwork is severely restrained. Only the cloud of chemical effluent exhibits life, its brushy pink form like a breath against the icy blue sky.

Despite his classicism and restraint, McGaw was still of a distinctly different generation from his mentor Diebenkorn, as evinced by a searching series of self-portraits executed around 1964–65. *Self-portrait (First Version)* (fig. 5.13) and *Self-portrait (Second Version)* (fig. 5.14) are but two from the group, but they represent well the wide stylistic and emotional range McGaw explored. The first image is open, seemingly unfinished, and elegantly raw. The paint is thinly scrubbed, and a Matissean line predominates; color is subdued and restricted to a range of cool blues, greens, and browns. The composition is similarly restrained, the background split neatly over the figure's

head, the torso framed by a tilted blank canvas. McGaw depicts himself with a wary, masklike face, drawing back from the viewer into an enigmatic animal self.

By contrast, in the second self-portrait the wariness has become aggressive, as the figure lunges forward and fixes his yellow eyes on us. Paint is thicker, more worked. The figure takes up more of the surface area, and the background canvas is made parallel to the picture plane (although it takes an intriguing dip behind his head). The most curious effect, and the nearly maniacal intensity, results from McGaw's decision to paint the whites of his eyes the same mustard yellow as the background. A device familiar from paintings by Vincent van Gogh, it still has the power to call up a fiery madness behind the eyes.

Although it may have been painted before the other self-portraits, McGaw's *Self-portrait* (fig. 5.15) with Miró has the power of a resolved statement. The forms are simplified, and the Matissean line has been wedded to a more rational structure of light and dark. As in the studio interiors, McGaw has blended portions of the background color with foreground elements, integrating the two planes. The black-and-taupe pattern of the Miró reproduction (a reflected, mirror image of that artist's *Portrait #1* from 1938) feeds into McGaw's hair, ear, and the side of his head.

Other balances are achieved by the blue circle at the painting's upper right (perhaps a second mirror), which echoes McGaw's shirt and the bluish border of the Miró.

While painting this self-portrait McGaw was thinking both of Miró's *Portrait #1*, which had been recently illustrated in a Museum of Modern Art catalogue, and of a self-portrait by Rembrandt which had also just appeared in a new publication.[18] Once again, his openness to all of art history manifests itself, with dual implications of freedom and tradition. In these self-portraits we also sense the young artists's ambition, as well as a confessional self-examination not shared by the older Bay Area Figurative painters.

Unaccountably, given the talent evinced by these early canvases, McGaw never achieved the commercial success or critical exposure his colleagues enjoyed. In part it was a prideful, Clyfford Still–like stance inherited from his teachers, veterans of the San Francisco School, for whom commercialism was an unmitigated evil (albeit for most of them a necessary one). In part perhaps it was also McGaw's growing distance from his cohorts, who were forming communal galleries and providing each other with at least moral support in a city that had no discernible private collectors. Whatever the ultimate reason, McGaw was never caught up in the flurry of excitement that brought New York gallery owners to the studios of other Bay Area Figurative artists. Instead, he has continued to teach at the Art Institute (where he was appointed acting director in 1988), painting largely for himself in a steady and unassuming fashion. His current works are more fantastical than earlier ones, and more smoothly painted, but they are still the idiosyncratic paintings of "someone . . . with a spontaneous aptitude for going upstream," a trait paradoxically characteristic of the second-generation "followers" of the Bay Area Figurative movement.

MANUEL NERI, BAY AREA FIGURATIVE SCULPTOR

Sculpture is often considered to have its own history, separate from developments in painting, and until the modern period this seemed justified by artists' own distinctions. But beginning perhaps with Degas, more certainly with Matisse and Picasso, the interactions between painting and sculpture became increasingly intense. It was no longer possible to say with certainty where innovations first occurred, or in what direction influences flowed.

FIG. 5.11. Joan Brown modeling, California School of Fine Arts, ca. 1958. Courtesy San Francisco Art Institute.

Still, with a movement such as Bay Area Figuration—characterized so strongly by its relationship to paint—sculpture becomes a controversial inclusion. And while one might think of other painters who could be discussed under the broad rubric of figurative painting in the Bay Area, the number of sculptors is limited to one: Manuel Neri.

Yet despite this unique status, Neri's work must be included in any treatment of the movement. Although deeply involved with the Beat poets and Funk art of the late fifties, his first influences as a student came from Diebenkorn, Bischoff, Weeks, Oliveira, and the late work of David Park, which dictated an involvement with process, color, and the human form:

> It doesn't bother me at all [to be grouped with the Bay Area Figuratives]. I'm sure we were all influenced at one time by each other and still are very much so when we think of figurative painters. I was working with a figure at the same time that, let's say, Diebenkorn started with a figure and Elmer Bischoff and even David Park—when he finally got into working with a figure in that very heavy sort of impossible pushing of heavy paint around. . . . Everybody was more or less like that, was dealing with a figure at that time—except for Jim Weeks who had been working with it all along.[19]

Like all of the younger Bay Area Figurative artists, Neri explored abstraction at the beginning of his career (and has returned to it on occasion as "an interruption, to clear my head").[20] The figure became his

FIG. 5.12. Bruce McGaw, *Chemical Plant by Freeway, Emeryville*, ca. 1961. Oil on canvas, 73½ × 66½ in. (186.7 × 168.9 cm). Collection of the artist.

FIG. 5.13. Bruce McGaw, *Self-portrait (First Version),* ca. 1964–65. Oil on canvas, 22 × 23½ in. (55.9 × 59.7 cm). Collection of the artist.

FIG. 5.14. Bruce McGaw, *Self-portrait (Second Version),* ca. 1964–65. Oil on canvas, 22 × 23½ in. (55.9 × 59.7 cm). Collection of the artist.

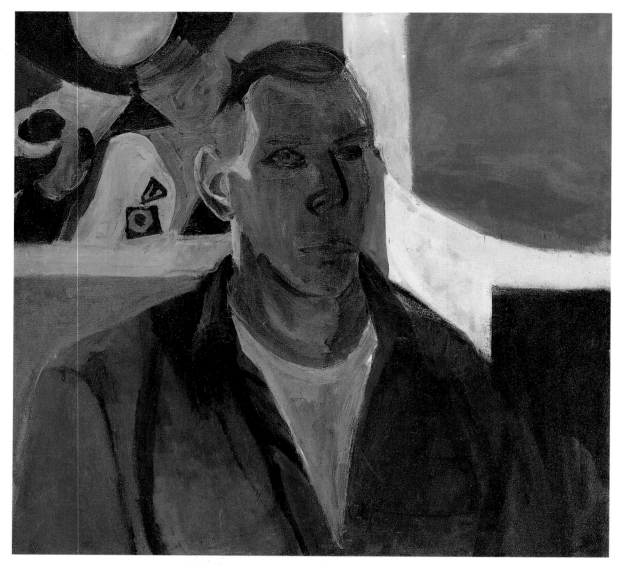

FIG. 5.15. Bruce McGaw,
Self-portrait, ca. 1962–64.
Oil on canvas, 24¼ × 25¾ in.
(61.6×65.4 cm). Collection of the artist.

primary vehicle after he left school in 1959; it allowed
him to synthesize his interests in color and form and
to play with the ambiguities of content that imbued
other figurative work of the period. The moments
during which he could not work with the figure
emerged as times of crisis and searching; he himself
describes them as "doldrums."[21] And yet the non-
specificity of his figures, their abstract qualities of
color, surface, and form, are what gives them their
power—and what renders them part of the Bay Area
Figurative movement rather than just another facet
of contemporary figurative sculpture in America.

Only two years younger than Oliveira, Neri faced
similar circumstances in his childhood. Like Oliveira,

he was raised largely by women in a Catholic,
Hispanic-American community. His parents had
come from Mexico during the depression; they
worked as farm laborers in the irrigated Central Val-
ley. After the death of his father and older brother,
Neri moved with his mother and two sisters to Oak-
land; his mother worked in cabarets to support the
family.

Neri showed no interest in art as a youth, but there
was little opportunity to do so. As a high school stu-
dent in Oakland, he became interested in radio and
telegraphy. Engineering seemed the logical career
choice, but while taking science classes to complete
his high school requirements Neri took a course in

ceramics to lighten his load: "it was just going to be an easy B, you know." To his surprise, "that class . . . opened up a whole new world for me and I just never walked out."[22]

Roy Walker was the extraordinary teacher of that 1950 course, and he was in touch with innovative art throughout the whole Bay Area. He encouraged Neri both to audit classes at the California School of Fine Arts (which Neri found bewildering) and to consider further study in the arts.

Neri soon dropped his engineering program, and in 1951 he began to attend classes at the California College of Arts and Crafts, enrolling officially in 1952. It was there that he first met the innovative young ceramicist Peter Voulkos, who was then a graduate student at the school. Neri found the dynamic Voulkos an extraordinarily galvanizing force, and his work a revelation: "It really knocked me out. It was like being hit over the head with what art was all about. After that, I began to realize that art was a strong, powerful thing and not this bullshit decorative stuff."[23] Voulkos was not yet making the "useless" slashed pots which would bring him fame as the ceramicist-inheritor of Abstract Expressionism, but he was already very different from the cautious technicians who then dominated the medium with their efforts to duplicate antique glazes. As Neri recalls, "he was doing . . . things like Greek pots, except instead of being a foot high they'd be four feet high." What most impressed the young student about "this big, hairy Greek" was his approach to the medium: "he forced himself onto the material, completely imposed himself onto it, instead of taking that kind of sacred approach toward ceramics that most people did. It was just clay."[24]

Neri soon began working with Voulkos as his principal teacher. Significantly, although Voulkos's work was entirely non-representational and vessel-oriented, Neri's primary project was a group of life-sized clay figures, none of which now survive.

Neri was drafted in the spring of 1953, but before he was assigned a post he took the summer to help Voulkos set up a ceramics workshop for the Archie Bray Foundation in Montana. By winter, he was in Korea, sending photographs of "Gung-Ho Neri" to his pregnant young wife.[25] The Neris' first child was born the following spring.

As he saw no fighting, Neri's service in Korea was uneventful, although he remembers attending an art class at the University of Seoul, taught by a fellow soldier. Neri returned in 1955, eager to take full advantage of his G.I. Bill tuition funds but unsure

where he wanted to study. His first thought was Mexico, where Weeks had gone in 1951, and for three months Neri traveled throughout the country with a former classmate, Billy Al Bengston. He was also tempted by another classmate, Mark di Suvero, to come to New York, and visited for a few days before deciding he did not belong there:

In '55, I was twenty-five years old, not a young artist. I had pretty well established what direction I wanted to take—di Suvero went to New York and it changed him for the better, annealed him. He needed that. I didn't want that—I'm not sorry. I took a good hard look at the situation and realized that as a figurative artist New York was not the place for me.[26]

This memory is clearly colored by subsequent reflection, for Neri would not settle on his figurative style until 1957 or so. Doubtless the situation of his young family also played a part (a second child was born in 1955), but whatever the reason, he decided to return to the College of Arts and Crafts to study with Diebenkorn and Oliveira.

Seeing Diebenkorn's work, together with poor reproductions of Abstract Expressionist painting, gave Neri an enthusiastic and exaggerated notion of the importance of color and *paint* in contemporary art:

I remember seeing a show Dick had. . . . They were those wild, crazy landscapes he brought back with him from New Mexico. The color just wiped us out. It was terrific! We knew about de Kooning and all the other people, sort of. . . . Somebody would bring back some little black and white snapshots and we'd say, "That looks pretty wild." We'd see these very forceful paintings and the color Diebenkorn was using and we started doing paintings that were two inches thick.[27]

Neri's experience was thus totally unlike that of McGaw, who sought out information about new painting and recalls that he had "been looking at de Kooning before I'd been looking at Diebenkorn."[28] McGaw now believes that one could have been confused about the actual thickness of a de Kooning painting only if one had been exposed to Still and his reverence for thick paint. Although Neri never officially took a class from Still, he remembers well the lessons Still taught, in person and through his show at the Metart Galleries in 1950:

Still was an impossible shit, but he taught me a few very important things—he was a complete romantic, but noncompromising: "What I do is important." He taught you to have respect for yourself, and held you responsible for what you did. I'm a true romantic and wanted to hear those words.[29]

With his romantic misapprehensions about contemporary painting, Neri's first works upon returning to the College of Arts and Crafts were large-scale abstract paintings, thick with paint and Diebenkornian color. He also produced a group of brightly painted non-figurative sculptures made from manzanita sticks clumped together with magnesite. He continued his prior work with clay, but magnesite, a war surplus material resembling both cement and plaster, came to replace it. Clay was "so goddam limiting. Too much of the process is out of your hands. . . . And it takes so much time. I didn't have the patience to wait around."[30]

Neri recalls that the inspiration for the color in his early sculptures came not from Diebenkorn but from European sources: Marino Marini and Picasso, the latter of whom was making colored ceramic sculptures at the time. Neri's interest in ceramics was important for his understanding of sculptural color, since both body color and glaze are part of the finished ceramic piece. But somehow his student sculptures seemed unrelated to his canvases, and Neri wanted to find a way to integrate painterly color with sculptural color: depicted color with literal surface hues.[31] Additionally, Diebenkorn was not encouraging about Neri's painting: "He said I should stick to sculpture. He thought I was a lousy painter, but he really liked the sculpture and the way it was combined with color."[32] Neri decided to concentrate on sculpture from that point on.

At the end of the school year in 1957, Neri decided to leave the College of Arts and Crafts and transfer to the School of Fine Arts. His decision was partly based on the lack of support he felt at the more conservative Oakland school: "They told me I couldn't continue doing those crazy sculptures if I wanted to stay in school."[33] Also, he was eager to work with Elmer Bischoff, about whom Neri had heard from both Diebenkorn and other students.

After Neri moved to San Francisco he more or less abandoned painting and began to make small figurative sculptures out of wire, cardboard, cloth, string, and other miscellaneous materials he found around the studio. Some were made without pedestals, to be hung like fetishes or crucifixes on the wall. Others were more elegant, such as a red-stained, cloth-covered striding figure; still others were pure Funk, such as a cardboard, wire, and plaid fabric figure with outstretched arms (figs. 5.16, 5.17).

Joan Brown has commented that the striding figure, despite its rough materials (paint rags and scrap wood), displays the inherent elegance and virtuosic ability that Neri possessed from the very beginning.[34] Seen in profile, the small work has the poise and humor of a wood sculpture by Elie Nadelman (who himself looked to painted American folk sculpture as a model). The flirtatious curve of the chest, the cock of the rear leg, and the bun tied onto the head are nuances that breathe life into the piece and dissolve its crudeness into grace; they are also devices that appear and reappear in Neri's figurative work over the decades.

Whereas the folk elegance of the cloth-covered sculpture mitigates its Funk aspects, these are dominant in the figure with outstretched arms. Neri has made no attempt to disguise the wire armature, or to mask the newspaper, dirty rags, bits of wood, and corrugated cardboard that make up the figure's body. Although neither outrageous nor horrific, the work anticipates the nylon-shrouded figures assembled by Bruce Conner a few years later—such as the corpse-like *Child* which would give Funk a visual equivalent to the Beats' protest poem, Allen Ginsberg's *Howl*.

Neri recalls when he first heard the word *funky*, and why it seemed so appropriate for what he and his friends were doing:

I remember listening to a group at the Jazz Cellar one night and hearing a guy say to one of the musicians, "Hey, that's really funky, I don't want to hear that." I liked the term because it was a put-down term—it meant something that was old-fashioned and corny. It fit with what we were doing—re-examining old ideas, throwing out new ideas, getting back to basics. . . . We treated everything equally—painting, drawing, sculpture, everything was important. The same thing with junk. . . . No one worried much if some of it fell off. A lot of the assemblages and paintings are still falling apart.[35]

Funk, like Beat, was uncentered, but to the extent that it had a headquarters, that place was the cooperative "6" Gallery. Neri had joined the gallery while still a student at the College of Arts and Crafts, but his living in San Francisco made it central to his existence (in the late fifties he became the gallery's director). The "6" had been founded in an old garage around 1954 by Wally Hedrick, Deborah Remington, and others, and came to involve Jay De Feo, Fred Martin, Bruce Conner, Joan Brown, Hayward King, and David Simpson. In addition to art exhibitions, most of which opened with a big party and effectively closed the following day (no one had the time or inclination to reopen the exhibition space), the gallery held poetry readings, jazz sessions, and sound-light-performance events that would come to be called Happenings.

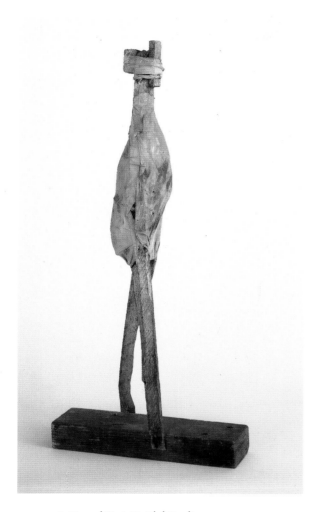

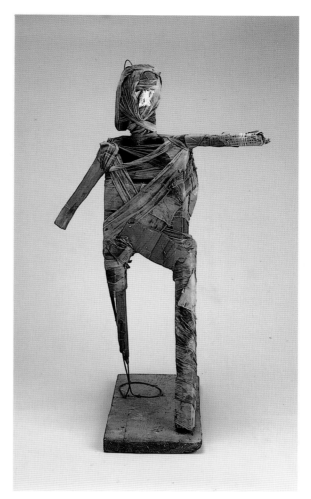

FIG. 5.16. Manuel Neri, *Untitled Standing Figure*, ca. 1956–57. Wood, cloth, and paint, approx. 20 × 5 × 10 in. (50.8 × 12.7 × 25.4 cm). Collection of Joan Brown, San Francisco.

FIG. 5.17. Manuel Neri, *Untitled*, ca. 1957. Wood, cardboard, newspaper, cloth, wire, plaster, and paint, 35 3/8 × 20 3/4 × 18 3/4 in. 89.9 × 52.7 × 47.6 cm). Courtesy of the artist and John Berggruen Gallery, San Francisco/Charles Cowles Gallery, New York.

Perhaps the most famous event occurred on the evening of 13 October 1955, when Allen Ginsberg came at the invitation of Neri and another artist to read *Howl* in full for the first time. Now recognized as "the official debut of the San Francisco Poetry Renaissance and the Beat era," the evening felt like "a religious experience" to the artists and other poets in attendance. "People just went wild . . . drinking cheap wine."[36] Ginsberg's elegiac ode to "the best minds of my generation . . . / who poverty and tatters and hollow-eyed and high sat up smoking in the supernatural darkness of cold-water flats floating across the tops of cities contemplating jazz," was censored even in its publication in the progressive *Evergreen Review*, primarily for its homosexual references. For artists who listened in the post–Korean

War era of 1955, its Whitmanesque incantations against mainstream America struck deep chords: "Moloch! Moloch! Robot apartments! invisible suburbs! . . . demonic industries! spectral nations! invincible madhouses! granite cocks! monstrous bombs!"[37]

Although events surrounding Funk art determined his social life, Neri was not as involved in the aesthetics of Funk art and assemblage or their musical-poetic correspondences as were some of his colleagues. For artists such as Wallace Berman, Wally Hedrick, and others, Beat and jazz were lifesaving outlets for their sense of alienation from society.[38] For Neri, the freedom and violent release of these other media were analogues to his own experience, but were not deep influences:

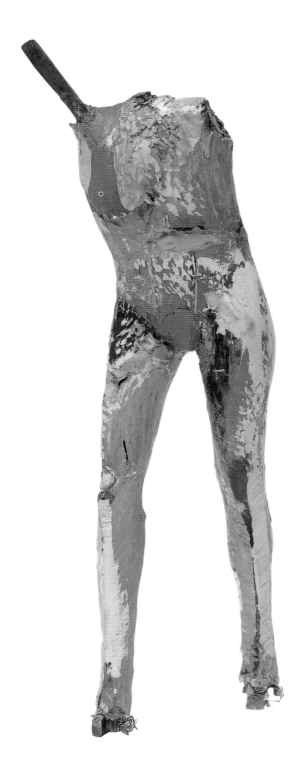

FIG. 5.18. Manuel Neri, *Untitled Standing Figure*, 1957–58. Plaster with enamel on wood and wire armature, 61 × 22 × 16½ in. (154.9 × 55.9 × 41.9 cm). Private collection, San Francisco.

As far as I could see, none of these ideas really mixed. The music didn't go into the art, and neither did the poetry. Everybody looked at what everybody did, but they were not directly influenced by each other. The excitement was in having all these ideas coming at you at once from all directions.[39]

Assemblage for Neri was more a matter of necessity, utilizing what was available in the studio—although he also valued the surprising ability of junk materials "to catch the gesture that I wanted to see in the figure."[40] The unfinished quality of his small figures and the extraordinarily evocative presence of their limited gestures carried directly into the life-sized plaster works that he began shortly thereafter.

Neri had been exposed to the medium of plaster by the artist Jay De Feo, into whose former home he had moved. De Feo had left behind a group of her large-scale, sculptural plaster crosses; Neri found them intriguingly fresh in their use of "low-class" plaster for fine art purposes. The cheapness and immediacy of the medium, its malleability and capacity to take paint, were clear advantages. Additionally, unlike clay, plaster presented no "personality" problems for Neri: "[it's] a mere blob. You can do anything with it, at anytime. And it's cheap. If you want to you can just throw it away."[41]

These early figurative works, such as the *Untitled Standing Figure* of 1957–58 (fig. 5.18),[42] or the *Untitled Standing Figure* from 1959 (fig. 5.19), were built on armatures of wood, wire, and burlap. Joan Brown, who was becoming close friends with Neri around this time, recalls the speed with which these pieces were made: "Manuel would put on a plaster real fast, take a hatchet real fast, cut that arm off, throw it away and twenty minutes later, he's got a new arm on there." Connecting this speed with the Funk aesthetic, Brown recalls the rebellion against "Brancusi slickness and polish" (referring to Brancusi's polished bronzes rather than his cracked wood carvings) that motivated this "electric . . . terrible hurry."[43]

The effect of Neri's early standing figures is astonishingly raw and immediate, a personal, funky approach to the Bay Area Figurative aesthetic. The 1957–58 standing figure is painted with juicy enamels in red, orange, and slate blue. Its "skin" is smooth integument in some places, rough viscera in others. Although the musculature is youthful, the body has experienced great stress: color has been applied, then rasped off; plaster is added, then removed. In a shocking gesture, the proper right arm is but a painted stick, a stumpy bone protruding from the carefully modeled torso.

Neri was moved by the fragmentary aspect of classical Greek sculpture:

> When I began to really look at all that early Greek sculpture, not just the forms involved, but what happened to the pieces with time—the missing heads and arms—the figure was often brought down to just the bare essentials in terms of structure. I love that look! That's why I went back to a lot of figures and started tearing off the heads and arms—because I could see that in some cases they got in the way. Often the figure had too much character to it.[44]

Michelangelo had buried his earliest marble sculpture to render it *all'antica*, and foundry technicians for generations had been aping time's slow patination. But with Neri's sculptures, the slow process of time was compressed into a violent encounter—some called it "action sculpture."[45] In the 1959 untitled figure, the violence of the encounter is subdued by the closure of the form—no limbs protrude and there are fewer eviscerated surfaces. But still visible are the marks of the rasp, the slathered strokes of plaster, the unsmoothed planes where the torso has been quickly roughed out. Adjacent to these rough areas are surfaces that have been lovingly smoothed—the shoulder, the hips, the chest. In this, Neri's violence is more like de Kooning's than Dubuffet's. Where Dubuffet thoroughly flays his victims—they are skinned and spread flat on the canvas with a seasoning of sand, mud, and humorous affection—de Kooning is more equivocal: his figures are caressed with one brushstroke and slashed with another; smooth lips are juxtaposed with maniacal eyes.

Like de Kooning, Neri does not see his figures as violent or disturbed. Of a later series he commented:

> No, I don't see them as tortured figures, really. A lot of people say that—that they're frightened by them, that they're Pompeiian mummies or what have you. . . . I've really wanted . . . intensity with a varied, strong, active surface but as minimal as possible. I was after that.[46]

In the early figures, color played an important role in the mood of the piece. Just as the glossy red stick protruding from the figure of 1957–58 could evoke amputation or blood, the cool silver thighs of the 1959 figure suggest a mechanistic surface. This silver, which may have been a kind of wishful substitution for expensive metal casting, plays oddly against the other color areas of red and ochre (it is complemented by the green). The earth colors render the surface visually more porous, while the silver actively repels light and vision. Importantly, Neri is not portraying

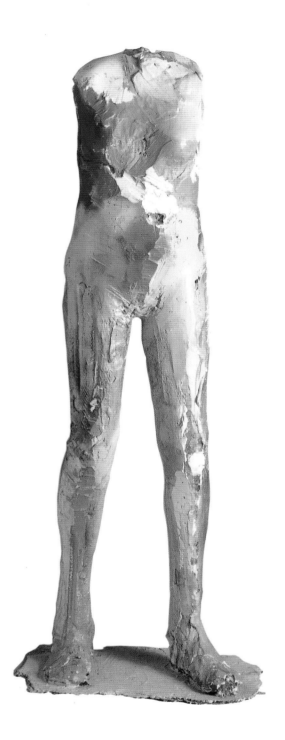

FIG. 5.19. Manuel Neri, *Untitled (Standing Figure)*, 1959. Plaster with enamel, 60 × 22 × 13½ in. (152.4 × 56 × 34.3 cm). San Francisco Museum of Modern Art.

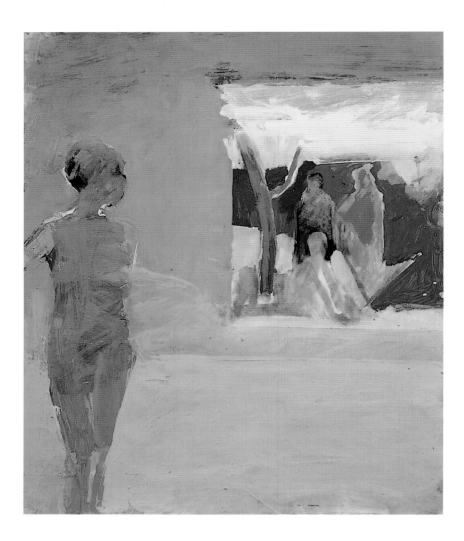

FIG. 5.20. Manuel Neri, *Untitled (Nude Model with Bischoff Painting)*, ca. 1958. Tempera, charcoal, and pastel on paper, 30⅝×25½ in. (77.8×64.8 cm). Collection of William and Penny True, Seattle.

some rationalized scheme of light and dark values. Taking a lesson from Park's and Bischoff's paintings at their most radical, he is using color as if it were emanating from the body itself, rather than a property of reflected light.

Neri worked from drawings rather than from a hired model when making his sculptures, primarily for financial reasons but also because he "[didn't want] the reality of the particular model to dictate the form. . . ."[47] Yet the drawings of this period explore only the forms of the sculpture. They treat color indifferently—or at least the color is explored in a manner completely different from its use in the sculptures. In gouaches and drawings from Bischoff's class, there is little hint of Neri's approach to color in his sculptures. *Untitled (Nude Model with Bischoff Painting)* (fig. 5.20) shows the figure in Oliveira-like isolation. Monochromatic and expressionless, it merges with the background in a manner faintly presaging Oliveira's later *Spring Nude*. By contrast, color takes

on a more powerful role in Neri's sculpture—akin to Oliveira's use of it in his earliest works, in which a red forearm or a streak of blue in the face provides emotional intensity rather than clues to an observed reality.

Neri also drew on Park's use of color in sculptures such as the 1959–60 *Chula* (fig. 5.21). As Thomas Albright observed in 1976:

[The early figures] could almost have stepped out of a mid-'50s canvas by the "cofounder" of Bay Region Figurative painting, David Park: The ruggedly chiseled plaster surface planes are smeared with vivid pigments that sometimes accentuate, sometimes obliterate the sculpted bulges and hollows, and the stances loosely suggest an ambiguous narrative.[48]

Neri remarks that *chula* is a Mexican-American word for "beautiful," an attribute that here challenges societal definitions.[49] The female figure is short, armless, and fleshy, but her flesh has none of the fantastic

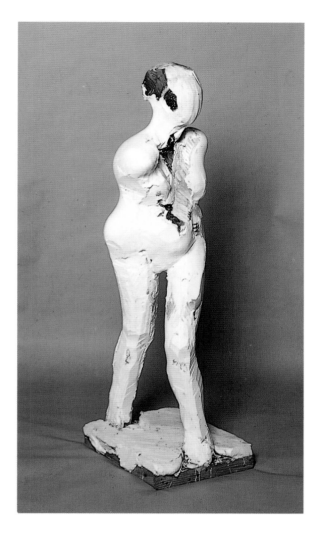

FIG. 5.21. Manuel Neri,
Chula, ca. 1958–60. Plaster
and pigment over wood,
46 × 14 × 16 ½ in. (116.8 × 35.6
× 41.9 cm). San Francisco
Museum of Modern Art.

FIG. 5.22. Manuel Neri,
Untitled Kneeling Figure No. 1,
1962. Plaster and enamel over
steel armature, 28 ¼ × 18 ¼ × 20 in.
(71.8 × 46.4 × 50.8 cm).
Courtesy of the artist and
John Berggruen Gallery, San
Francisco/Charles Cowles
Gallery, New York.

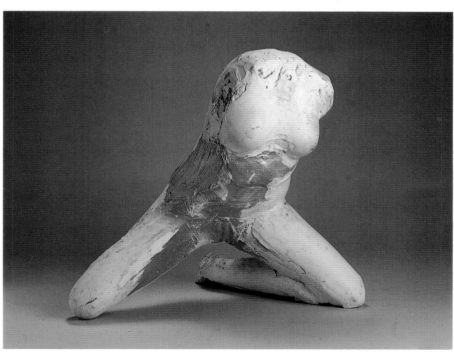

voluptuousness of a late marble by Nadelman or a Gaston Lachaise sculpture. Rather, her form suggests a deliquescent voluptuousness just this side of decay—slightly sagging potbelly, knock-knees, and twisting torso. Neri's view of this figure is loving, not caricatural, and her armless torso evokes an experienced, even archetypal maternal state rather than an erotic one.

In *Untitled Kneeling Figure No. 1* (fig. 5.22) Neri's response to the female form is less positive, calling forth questions about meaning and the role of color in his "ambiguous narratives." Part of a series inspired by the truncated pedimental sculptures of classical Greece (specifically, those at Aegina),[50] *Kneeling Figure* is headless and nearly limbless, reduced to a minimum that still conveys an upright reaching gesture. It is not the smoothed amputations or the gesture which disturbs us, however, but the red enamel, which spreads from the figure's pubic lips to her belly and thigh. Bracketed though it may be by a pale sea-green on one side and a cool silver on the other, the red reads as blood, either menstrual (hence natural), or violent.

The possibility of both readings is typical of the very richness and ambiguity of Neri's work, although in this case it provokes anxiety in the viewer. Neri's figures are rarely specific individuals; in fact, "[I] cut off the hands and feet and heads of the figures because I didn't want to deal with the personalities . . . I wanted the figure only as a vehicle of these other ideas."[51] The female figure, by its very nature as Other in a patriarchal context, becomes the most powerful vehicle for such "other ideas." As Marina Warner has pointed out, when we see a male figure on a pedestal, we ask Who is it? while a female prompts the question What does it *represent*?[52]

Neri's representations are archetypal rather than allegorical. Although influenced by pedimental Greek sculpture, he is not seeking to portray Athena/ Athens, wisdom, or victory. Rather he courts primeval Woman, and he argues that, for him, she embodies all of humankind:

> [My use of female figures] has to do with the role art is playing in society—it deals with everything, our fears, etc. I wanted an image that represented all of mankind, and for me the female does that. Maybe it's that old earth goddess thing of Europe, where the female represents magic—not sleight of hand, the real thing.[53]

Like Oliveira, Neri connects his figural work with images that resonate both individually, on a psychological level, and archetypally, in broader cultural and historical terms. *Chula* and *Kneeling Figure* represent

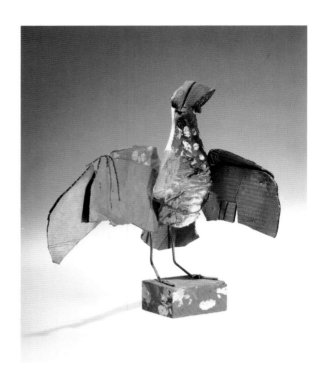

FIG. 5.23. Manuel Neri, *Untitled*, 1961–62. Wood, cardboard, paint, wire, string, and staples, 15¾ × 15 × 9½ in. (40 × 38.1 × 24.1 cm). Private collection, San Francisco.

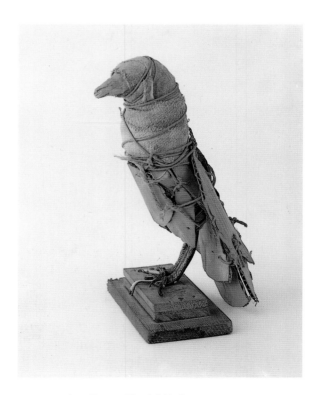

FIG. 5.24. Joan Brown, *Untitled (Bird)*, ca. 1957–60. Cardboard, twine, gauze, wood, and electrical wire, 12 × 6 × 8 in. (30.5 × 15.2 × 20.3 cm). Collection of the artist.

opposite poles in his oscillating investigations of Woman, the one comforting and even nurturant, the other powerful and disturbing. In part they can be seen as figures for the artist's personal struggles with women (as opposed to Woman) as the primary sources of love in his life.

By the end of the fifties, Neri was estranged from his wife and spending more and more time with the painter Joan Brown. Theirs was a volatile but extremely productive relationship, at times almost symbiotic in its intensity. As Brown recalls, "Manuel and I always influenced each other a great deal, way before we were ever together."[54] Neri recalls their collaboration as "a great period; there was a certain innocence we don't have now."[55] Brown was brash and adventurous, almost a decade younger than Neri, and her gifts were those of energy and courage rather than innate skill: "Neri had basic, classic talent—I didn't have it, mine was raw."[56] She made small string sculptures in response to his elegant stick and cloth figures, and when she wanted to paint birds in the early sixties, he made some for her.

Like Neri's earlier standing and striding figures, the birds have great wit and presence, created from the barest minimum of materials. An untitled figure of a bird with a green-spotted throat (fig. 5.23) is made of wire, wood, and cardboard, one ungainly wing hinged with string and the other stapled on at a cocked angle, serrated "feathers" spreading from its lower edge. Other surviving members of the aviary are an austere, unpainted hawk, and the largely preposterous *Ring Necker Night Cutter* and *Pink Spooned Snap*. Brown herself made a bird around the same time (fig. 5.24), and the contrast is illuminating. Where Neri's birds are simultaneously goofy and elegant, Brown's is funky, and as mysterious and fetishistic as a mummy. Perhaps her long-standing interest in Egyptian mummies manifested itself in this blind, gauze-wrapped creature. The wings are laced together so that they cannot move (unlike Neri's, which are hinged to flap freely), and the excessive quantity of string makes the bird seem bound. Brown's sense of the wit in Egyptian mummies also manifests itself in the reptilian legs made of electrical wire and the belly flap which opens like a canopic jar to reveal a cardboard heart within.[57]

At the invitation of Brown's dealer, George Staempfli (who had also given Neri an exhibition), Neri and Brown went to Europe for the first time in 1961 (fig. 5.25). After spending three weeks in New York, they took a ship across the Atlantic. The harmony of their trip was mitigated by Brown's reckless

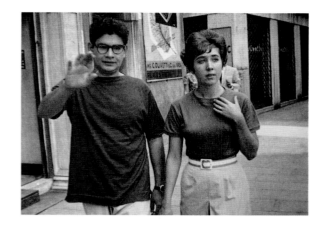

FIG. 5.25. Manuel Neri and Joan Brown in Venice, August 1961. Courtesy Joan Brown.

high spirits: "I had a wild romance on the boat, and was absolutely obnoxious. I won a dance contest and stuff like that."[58] But once they got to Staempfli's house in Spain and continued their trip through Italy, France, and England, they had a wonderful time visiting museums. Each was inspired by different experiences: Brown was overwhelmed by Goya, Velázquez, and Rembrandt; Neri was struck by Picabia's fertile imagination and the Elgin marbles, the dramatic sculptures from the Athenian Parthenon installed in the British Museum.

Until the trip to Europe, Neri had been "in the doldrums" with his full-size figurative work. After *Chula* and similar figures, he had been at a loss for ideas and inspiration, and had temporarily returned to ceramics with some abstractions he called *Loops*. In Europe he was exposed to "the real tradition that art has behind it" and the experience "changed my whole attitude."

One of the things that impressed me most was looking at Picabia's work. He was a tremendously influential artist, he really had more ideas than Duchamp, but most of his work looks like shit. He never put it together; he just threw out raw ideas. I wanted to reinvestigate all the raw ideas that I'd thrown out over the past five years, to get something more than just immediacy. So all that junk I turned out during the funk period I carefully reexamined and reworked.[59]

The *Untitled Kneeling Figure No. 1* of 1962 shows the evidence of this effort and of Neri's experience of classical Greek sculptures weathered by time and environmental exposure. "That's what turned me on about the Greek things—what nature brought, what man brought. They've been taken down to an essence. We'd hate it if it was new."[60]

FIG. 5.26. Manuel Neri, *Moon*, ca. 1960–63.
Wood, cardboard, plaster, and enamel, H. approx.
72 in. (182.9 cm). Private collection, San Francisco.

FIG. 5.27 a, b, c. Joan Brown, *Dogs Dreaming of Things
and Images*, 1960. Oil and enamel on canvas, three
panels, each 72 × 69 in. (182.9 × 175.2 cm). Collection
of Barbara and Ron Kaufman, San Francisco.

Neri's reevaluation of his work also stemmed from
his exposure to European attitudes about artists, so
much more respectful than in the United States.
"Here you're always a bastard—you have only
money to measure yourself against." Whereas in Eu-
rope, "artists are artists and don't have to do a damn
thing."[61] This new perspective encouraged Neri to
take a longer view of his career: "I realized that you
are an artist all your life—not just when you're pre-
paring for the next show. I slowed everything down,
began to think in terms of a life's career, rather than
just next year or the year after."[62] Despite this mem-
ory of a deep and dramatic change, there was no im-
mediate shift in the appearance of Neri's work. It still
bore strong connections to Funk, perhaps strength-
ened by his continuing involvement with Joan

Brown. The two were living together on Saturn
Street, more or less peaceably. Brown was pregnant
with her and Neri's child when her marriage to Bill
Brown was annulled; she and Neri were married in
1962 shortly before Noel Elmer Neri was born in
the fall.

Some of the first works Neri completed after the
European trip were, curiously, non-figurative. A se-
ries of beautiful studies of brightly colored crescent
moons culminated in the construction of several
large-scale *Moons* of plaster, cardboard, and wood
(fig. 5.26). Neri is reticent on the significance of or
inspiration for these works, but it is likely that he
began working on them before leaving for Europe—
a painting of Brown's from 1960, *Dog Dreaming of
Things and Images* (figs. 5.27 a, b, c), incorporates a

large crescent moon in its middle panel. Neri recalls that he made the moons when he was living alone, but a number of drawings by Brown suggest that the two artists were at least in close contact when the moons were made. Brown's drawing of *Rats Laughing at Manuel's Sculpture* (fig. 5.28) may not be the most supportive response to the *Moons*, but there is no doubt that it is a response.

The links between the two artists' work were often stronger than mere representations of each other's images. Neri occasionally painted areas of Brown's canvases, and in one Neri sculpture, *Seated Girl (Bather)* (fig. 5.29), Brown's hand is evident in the face, with the Krazy-Kat features she loved. There also exists a drawing by Neri, dated 11 August 1963, inscribed *Joan Brown working on sculpture*, and the sculpture depicted is unmistakably *Seated Girl*.

In its rounded absence of one arm and crouching, twisting posture, *Seated Girl* relates in part to the earlier *Untitled Kneeling Figure* from the previous year. But in all other ways it marks a departure for Neri— a personalized figure given its own prop, in the form of a rough-hewn wooden rail to sit on. Apparently Neri produced several of these figures, which were arranged in an informal group in the studio. Around the same time, Brown was painting a series of bathers—for example, *Girls in the Surf with Moon Casting a Shadow* (see fig. 5.39).

Whether Neri's sculptures served as models for the paintings, or Brown's paintings inspired the sculpted bathers, it is clear that the interaction between the two artists was extremely fruitful. Neri gave Brown a sense of the possibilities of color, dissociated from description and freed to serve emotion; Brown gave Neri the courage to be raw, direct, and even a little corny. Together they extended the compass of the Bay Area Figurative style; as they began to grow apart emotionally their commitment to the style also waned.

Neri's career gained stability after he was appointed to the faculty at the University of California, Davis. Before his move, he and Brown spent a summer together as visiting artists at the University of Colorado at Denver, where both did innovative works on paper (in addition to work in their primary media). Brown did enormous, roughly executed collages, only fragments of which survive today (see *Portrait of Nude Woman*, fig. 5.35, and Brown's self-portrait, visible behind her in fig. 5.30). Neri perfected his own collage technique in which torsos and body parts were cut from a template and glued to the sheet with a mixture of glue and india ink (fig. 5.31). The black

FIG. 5.28. Joan Brown, *Rats Laughing at Manuel's Sculpture*, 1960. Pencil on paper, 10×8 in. (25.4×20.3 cm). Collection of the artist.

mixture oozed out around the edges, giving a marvelously irregular line and an elegant tactility reminiscent of the paintings of the American Conrad Marca-Relli.

Despite the productive summer in Denver and his new circumstances at Davis, Neri stopped doing figurative work around 1965 and began, once again, to explore abstract imagery. As was the case with others working in the Bay Area Figurative milieu, he began to lose interest in figuration and experienced a decreased sense of the possibilities of expressionistic figural art. By the late sixties he was responding to both Minimalism and his own cultural roots in a series of sculptures based on the spaces and steep steps of pre-Columbian pyramids. He would not return to the figure until the 1970s.

Neri's contribution to the Bay Area Figurative style is difficult to assess, for few sculptors emerged to follow his lead.[63] From a purely aesthetic perspective, his work of the fifties and early sixties provides a provocative blend of the raw and the cooked, the primitive and the classical, the emotional and the restrained. It mixes funky directness with the span of art history—from Greek pedimental sculpture to Rodin, Giacometti, Fritz Wotruba, Marini, Picabia,

FIG. 5.29. Manuel Neri, *Seated Girl (Bather)*, ca. 1964.
Plaster and enamel on wood and burlap armature,
44 × 29 ½ × 27 ½ in. (111.8 × 74.9 × 69.8 cm).
Collection of Norma H. Schlesinger.

and Voulkos—with results both human and epic. Although he explored abstraction intermittently throughout his career, he has remained more constant in his recurring devotion to the expressionistic figure than any other Bay Area Figurative artist. The approach and media have become more sophisticated, the models more exclusively female, but Neri still uses the figure as a vehicle for his most ambitious formal and symbolic goals.

JOAN BROWN: KEEPING A DIARY

Unlike Neri, Joan Brown has changed so radically in her style and approach to the figure through the years that she can be described as a Bay Area Figurative artist only from approximately 1955 to 1965. She was a student for half of that time, and thus her mature Bay Area Figurative work spans only four or five years—one of the briefest periods of any of the artists under consideration. This brief moment was intense and productive, however, resulting in some of the boldest figurative works the movement could claim.

The artist was born Joan Vivien Beatty and raised in San Francisco, where her father worked at a bank. Although the family was solidly middle-class, Brown remembers a great deal of emotional stress and deprivation as a child. They were able to afford a house, but the Beatties lived in a cramped three-room apartment where Brown shared a room with her grandmother. The dark and claustrophobic environment was exacerbated by her mother's epilepsy and her father's drinking, although Brown now forgives him his bad habits: "He was weak in many ways, but who isn't? What the hell." The sad home environment encouraged her independence: "It was tense, and I had made up my mind very early that as soon as I got the opportunity I was going to get the hell out of there."[64]

Raised in Catholic schools, Brown had an adolescence that was, paradoxically, both rigidly supervised and totally free. After school she would escape to the beach for a swim or stay out with friends until two or three in the morning. She claims she graduated from high school "a con artist," adept at simultaneously indulging and concealing her rebellion. The crucial moment came in her senior year, when her parents wanted her to enroll in Lone Mountain College, a single-sex Catholic institution. Looking for any alternative, she flipped through a newspaper and saw an advertisement for the California School of Fine Arts. With no real experience or exposure to art, she stopped by the building and immediately loved the environment. She applied a week before she would

FIG. 5.30. Joan Brown with self-portrait, Denver, 1964. Courtesy Joan Brown.

FIG. 5.31. Manuel Neri, *Untitled*, n.d. Collage, 31½ × 25½ in. (80 × 64.7 cm). San Francisco Museum of Modern Art.

FIG. 5.32. Joan Brown, *Pinning*, 1959. Oil on canvas, 72 × 72 in. (182 × 182 cm). Neuberger Museum, State University of New York at Purchase.

have gone to Lone Mountain and was admitted on the strength of some teenage drawings of movie stars on typing paper. Her parents accepted her fait accompli and paid for her first year of course work at the art school.

That first year was difficult, and things did not go well. She was contemplating leaving when she met Bill Brown, a twenty-four-year-old student who seemed immensely sophisticated to the seventeen-year-old Joan Beatty. He had studied at the Art Students' League in New York, had fought in Korea, and had seen the world. He encouraged her to stay through the summer session for a landscape class taught by a new professor, Elmer Bischoff. The experience turned her around, and that August she and Bill Brown were married.[65]

In addition to Bischoff's class, in which "Elmer talked my language, although I hadn't heard it before," she made her first contact with art history when Bill Brown gave her a number of art books. The reproductions of Goya, Velázquez, Rembrandt, and the Impressionists hit her hard: "I was just knocked out. I'd never seen any of this stuff, and I felt this

tremendous surge of energy. And I said to myself, 'Damn it, when I'm an old person, I would love to feel the way these guys must feel.'"[66] This inspiration, together with Bischoff's open encouragement, gave her the courage to consider herself a painter for the first time.[67]

During her second year, a number of other students (including Neri) crossed the bay from the California College of Arts and Crafts to study with Bischoff. The atmosphere at the School of Fine Arts began to quicken. Although there was a great deal of painting in the Bay Area Figurative style, Brown remembers that the main emphasis was on a kind of violent expressionism, the focus of which could be either figurative or abstract. Confirming Oliveira's memory that there was a kind of "party line" dating back to the heroic days of the San Francisco School, Brown recalls that "there had to be one way of working, that was it."[68]

Frank Lobdell, a largely abstract painter who had been deeply influenced by Clyfford Still, was one of the major forces in this development and had a strong impact on Brown's work. She recalls that Lobdell

brought his colleague, Abstract Expressionist painter Jack Jefferson, to Studio 15, where she and a group of students had their work space. He pointed to her work and said, "What's good about her paintings is, it's such a struggle for her to get there."[69] As much as she admired Lobdell, Brown was bothered by the existential assumption that art had to be belabored and difficult (or if it was not, one had to pretend). While her own paintings were achieved with a struggle, she knew that some of the artists she most admired—Picasso and Matisse—had celebrated facility, ease, and joyousness in their work. In her student paintings, Brown had not yet achieved this ease, but she held it as a goal. She oscillated between Lobdellian "abstractions" (which she later realized were never truly abstract) and figurative imagery that echoed the work of Bischoff and, oddly, David Park.

Although he was teaching at Berkeley, Park often visited the School of Fine Arts to give guest lectures. Brown recalls a formative experience with Park during her last year at the school, when she was among the first group of students to get a master's degree in the new graduate program. Park came to Bischoff's class, where Brown's paintings were the subject of the weekly critique:

> And David said, "I just love these paintings." And Elmer said, "I can't stand them." . . . Although Elmer wasn't that up front, [he said] "They don't work, because of such and such." . . . And here were these two guys just at odds, these friends that have the same attitude. . . . We were absolutely shocked, very angry, very disappointed, and very depressed. Because where do you go now? . . . After that I thought "Well, damn it!" . . . You make your own choices. And that was a very good experience.[70]

The late student paintings to which Park was responding were thickly painted figural works with mysterious narratives and loaded themes, such as *Pinning* of 1959 (fig. 5.32). The palette is Parkian, with mustards and oranges predominating, and the knifed slabs of paint recall Park's evolving late style, but the composition is uniquely Brown's. Several figures sit or stand in the background, seeming to revolve around a central seated woman who stares out at the viewer. Behind her stands a dark, brooding male figure leaning on his elbows as he stares down at her, "pinning" her with a look.

Pinning is slang, probably picked up from the same jazz milieu that generated *funky*. Once a month, Brown and other students, usually Neri or Bill Brown, would cart their paintings to a jazz club called The Cellar at Columbus and Green in San Francisco.

They would mount their works in the window, have an opening and a drink, and hang out with the musicians and poets. But Brown also found other venues for exhibitions, one of which garnered her a lengthy review for being a teenager who was "early learning the value of promotion."[71] She and a fellow student had invited critics to their exhibition at the "6" Gallery—an action far removed from the Abstract Expressionists' disdain for the commercial world. At this point in her career, Brown was eager to cooperate with critics and dealers.

This openness proved immediately useful when Park's New York dealer, George Staempfli, came to Brown's studio, somewhat by accident, in 1959. The Browns were living next to Wally Hedrick and Jay De Feo at 2322 Fillmore Street, and Staempfli had come to see De Feo at the suggestion of his friend Nell Sinton. He came through the door that separated the two studios, and after looking around, gave Brown a check for $300 for two of her paintings. Brown was so convinced the check was a fake that she took it to her father at the bank. Only when it proved to be real did she take Staempfli seriously, eagerly responding to his offer to give her a solo exhibition the following year.

Staempfli's advocacy proved as important for Brown as Charles Alan's had for Oliveira. It was probably Staempfli who suggested to the organizers of the exhibition *Young America 1960* at the Whitney Museum that Brown's work be included. She was the youngest artist represented in the show. Additionally, Staempfli put her on a stipend, in return for which she gave him exclusive access to all of her work. Supplementing this income with a teaching job at a local private school, Brown saved enough for the trip to Europe with Neri in the summer of 1961. The experience had as dramatic an impact on Brown as it had on Neri, and her mature work truly began in that year.

"Knocked out" by the Louvre in Paris, by the Goya and Velázquez paintings at the Prado in Madrid, and by the experience of a major Rembrandt exhibition at the National Gallery in London, Brown returned to work in the fall of 1961 with a renewed commitment to "never [play] it safe."[72] Perhaps affected by the paintings she had seen of Rembrandt dressed in various costumes from his studio—or by the fact that she was now pregnant—she began to produce a number of canvases depicting her own experiences and surroundings. One was a painting titled *Flora* (location unknown), based on Rembrandt's painting of the same name. In Brown's version the figure is a young

FIG. 5.33. Joan Brown, *Models with Manuel's Sculpture*, 1961. Oil on canvas: left panel, 72¾ × 36 in. (184.8 × 91.4 cm); right panel, 72 × 120 in. (182.7 × 304.8 cm). The Oakland Museum.

girl, and the artist recalls that Flora was the name that she had intended for her child, had it been a girl.

Another ambitious painting from this period is a diptych, *Models with Manuel's Sculpture* (fig. 5.33); the two halves of this work were only recently reunited after having been sold separately.[73] The space is wonderfully complex across the two canvases, shutting down and opening up like a filmmaker's panning shot. Two of Neri's sculptures are included, together with a model in high heels and a new addition to the Brown-Neri household—a bull terrier known to all as Bob the Dog. Bridging the two canvases in back of the figures is the back side of a painting, stretcher bars and plywood corners clearly visible. A second canvas in the background of the right-hand painting is animated by a profusion of abstract-looking brushstrokes covering its right half. Throughout both paintings, the pigment is troweled, knifed, and (rarely) brushed on, the colors lush and abundant in orange, pink, red, green, blue, and brown.

Brown's drive toward impasto did not stop with her use of a trowel to layer on the viscous enamel. In some paintings, strips of fabric were crumpled into the paint, creating a lively surface. Even in gouaches and collages, such as *Figure with Manuel's Sculpture* and *Portrait of Nude Woman* (figs. 5.34, 5.35), Brown has added strips of fake fur, torn paper, thick glue, and

other elements to create depth in the drawing while asserting its actual surface.

The fetishism of fur, and its psychological function as a symbol of sexual power, reach their ultimate articulation in Brown's most funky sculpture, the 1961 *Fur Rat* (fig. 5.36). Large for a rat, the creature is over a yard long, made of plaster and chicken wire molded over a wood armature, its fur the decrepit remnants of an old raccoon coat. Although she would not consciously employ personal symbolism in her work until much later, Brown acknowledges that the disquieting creature is based on a dream in which it appeared to her on the kitchen sink, its luxurious pelt extending to a long, bushy tail. Only when she stroked the tail in the dream did she discover the sharp nails concealed within the soft fur.[74]

The suggestion of ambivalence toward sex and its possible price seems consistent with an untitled pen and ink drawing dealing with pregnancy from the same year (fig. 5.37). Detailed and tightly controlled, the image evokes Frida Kahlo's introspections on the physical pain accompanying the birth of even the most deeply desired child. The body parts, X-ray imagery, flayed musculature, and floating, defenseless fetuses all contribute to the sense of the body's vulnerable, inhabited state—as well as the miraculous genesis of a new being. What is extraordinary, given the realities of pregnancy, is that Brown remained as

productive as ever throughout the year. And whatever ambivalencies seem to be expressed in the drawing, Brown found the birth to be ultimately joyous and pain-free, describing it as "an awesome experience," among the most powerful and positive of her life.[75]

Girl Sitting (fig. 5.38), from the year of her child's birth, is one of the masterpieces of Brown's Bay Area Figurative period, a culmination of her aggressive use of color and impasto. Drawing on the examples of Park, Bischoff, and also de Kooning, Brown trowels and knifes the paint on with disarming frankness, admitting from the outset that this is willful representation, not mimetic reproduction. Unlike her models and mentors, Brown does not retain any aspects of the modeling abilities of light. Where we assume light to be absent, as under the figure's chin, an appropriate dark blue appears—but the same color is slathered on the woman's chest where light would normally be strongest. Similarly, the yellow arm and thigh, the pink hair, the olive face, and above all the broad strokes of maroon in the background, all read as brave and joyous explorations of paint: its abstraction as well as its material capacity to represent.

Given the previous year's *Flora* and the various portrayals of Manuel's studio, it is tempting to read *Girl Sitting* as a self-portrait. If it is one, it is only partially so, a projection of Brown's own diminutive frame onto an impressive image of monumentality and stolid strength. The other contribution to the image is likely to have been Patty Jordan, the wife of a filmmaker and School of Fine Arts instructor and the favorite model for many of the second-generation Bay Area Figurative artists. According to the late artist Gordon Cook, Brown's husband during the seventies, Patty became the quintessential Bay Area Figurative type:

> [She had a] Big Armenian face, kind of a severe overbite, not that much of a chin, . . . if the work that was done in the Bay Area through the fifties is ever really given serious attention, the type that Patty was, big schnoz, receding chin, big, full face, that type appears . . . in Manuel's work, Joan's work . . . somewhat heavy lids, prominent eyes.[76]

The Patty Jordan type appears in a lengthy series of paintings Brown completed in 1962–63 of female figures in the surf, exemplified by *Girls in the Surf with Moon Casting a Shadow* (fig. 5.39). "Some of the series stemmed from seeing the moon hit the water in the bay. I thought I'd combine that with the women in the water, so the series became somewhat graphic,

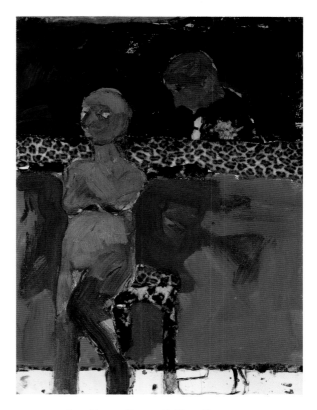

FIG. 5.34. Joan Brown, *Figure with Manuel's Sculpture*, 1961. Gouache, charcoal, fake fur, and collage on paper, 40×30 in. (101.6×76.2 cm). La Jolla Museum of Contemporary Art, California.

FIG. 5.35. Joan Brown, *Portrait of Nude Woman*, ca. 1964. Watercolor, gouache, and collage, 28¼×25¼ in. (71.7×64.2 cm). The Oakland Museum.

FIG. 5.36. Joan Brown, *Fur Rat*, 1962. Wood, chicken
wire, plaster, and raccoon fur, 20½ × 54 in. (52 × 137. 1 cm).
University Art Museum, University of California at Berkeley.

FIG. 5.37. Joan Brown, *Untitled*, 1962. Pencil on
paper, 26 × 40 in. (66 × 101.6 cm). Collection of the artist.

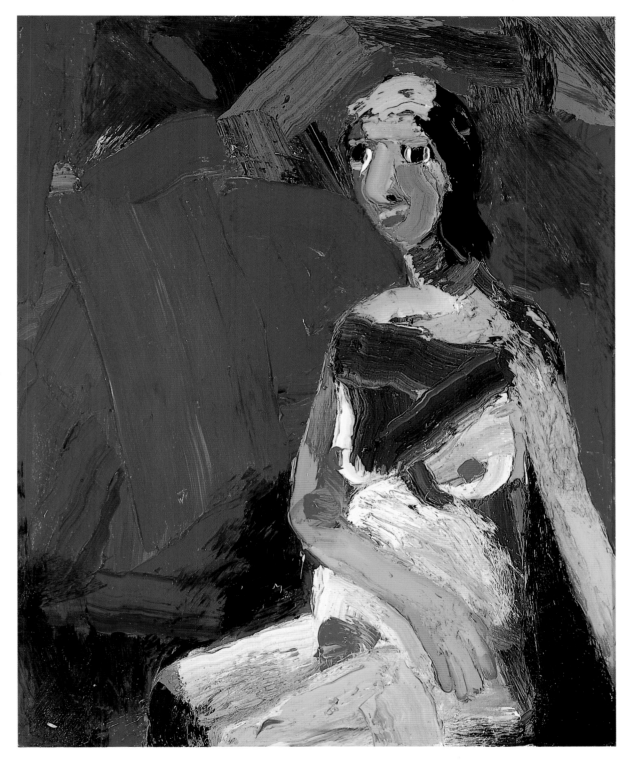

FIG. 5.38. Joan Brown, *Girl Sitting*, 1962. Oil on canvas,
60 × 47 ¾ in. (152.4 × 121.3 cm). The Oakland Museum.

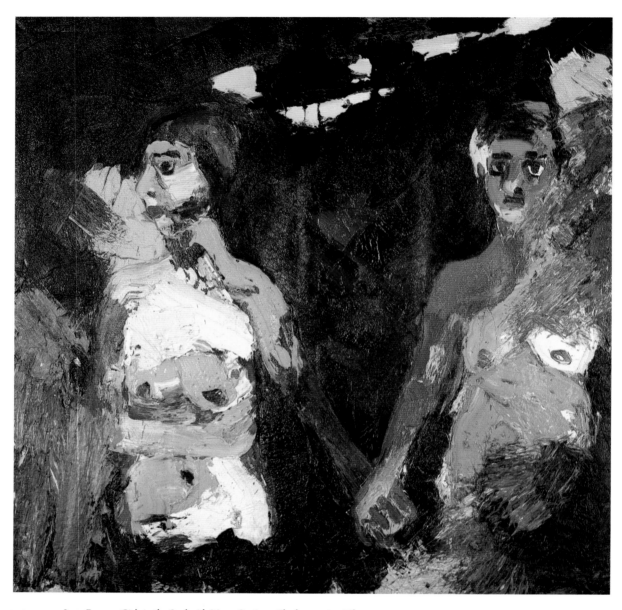

FIG. 5.39. Joan Brown, *Girls in the Surf with Moon Casting a Shadow*, 1962. Oil on canvas, 72×72½ in. (182.9×184.2 cm). Collection of Byron R. Meyer, San Francisco.

but with big yellow slashes of light."[77] Almost square, these canvases still show Brown reveling in thick, glutinous paint, probably the same local brands—Bay City paints, Foster and Kleiser, Fuller, Dana Colors—used by Weeks, Park, and Bischoff at this same time. Inexpensive and easily obtainable, Bay City paints (now manufactured under the brand name Byzantine) were particularly distinctive for their buttery texture and translucent hues, and they became Brown's favorite.[78] In *Girls in the Surf*, the creamy paint is troweled, knifed, and scraped as before, but there are also areas where it is flung, in a gesture redolent of Abstract Expressionism but here rawly descriptive of water splashing over the standing figures.

Brown was conscious of her relationship to both expressionism and Abstract Expressionism. Like Neri, she became aware of the New York School painters through the art magazines that began to circulate at the School of Fine Arts in the late fifties. "I just loved all that wild kind of crazy stuff, pouring paint on surfaces." She found de Kooning's women "angry, but sympathetic," and responded particularly to the work of Francis Bacon when it was shown at the Legion in the late fifties.

[Bacon] knocked me out. [His] hardness and his unyielding imagery. And his simplicity. . . . There's nothing there that isn't necessary. . . . The core to me is his connection, his sympathy, his anger, his understanding.

Although [Bacon's work] is strongly emotional, there is still an ability to stand back and view this situation for what it is. In other words, he's in control of the emotional situation. He can make order out of fantastically chaotic emotional responses.[79]

Brown may have responded to Bacon as intensely as she did because she labels her own work as expressionist, for both technical and emotional reasons. Regardless of whether she uses tight or loose paint handling, she believes that her manipulation of the medium can suggest a response to the viewer: "There's always a connection to the way I'm describing something, which is basically an expressionistic belief." Opposed to formalism, which she views as inimical to the humane aspects of painting, she sees her work as deeply personal, if not confessional. This also ties her to expressionist beliefs in the individuality of each artistic statement: "I feel most of my work, if not all of it, is like keeping a diary."[80]

This diaristic impulse, later celebrated by feminist artists and critics as a central aspect of women's art, became strongest immediately following the birth of Brown and Neri's child, Noel, in August 1962. In part this was owing to Brown's decision to move her studio into her home, where the change in environment provoked a change in content: "I realized that with a baby I would have to work at home. At that point, I had no choice. . . . As usual I painted what I saw around me, Noel being my main subject, of course."[81] Sketches of the infant Noel and a profusely illustrated baby book document the visual stimulation Brown found in her new son. Even the painting he ate—*Girl, Dog, and Clouds*—is duly recorded.[82]

One of the richest canvases from the period is *Noel on a Pony with Cloud* (fig. 5.40). Although based on a photograph (fig. 5.41), the image has become a fantasy entertainment for the young child. Painted with less troweling and more of the flung paint characteristic of the *Surf* pictures, this canvas is a riot of bold, storybook colors. A red and blue horse, blue and red cloud, and deep green background are vivid, but even they pale next to an enormous abstract shape outlined in bright blue on the right. Possibly it is a second cloud, but the brilliant yellow and red form seems to have another existence as a dream animal—a buffalo or lumpy pony—provided for Noel's delight as much as for the painting's formal balance.[83]

In 1964, Brown's impasto grew heavier—less involved with the expressionist act of painting and more constitutive of patterns and objects in the depicted image. Checkerboards, carved in paint and representing for Brown "order in a chaotic situation,"

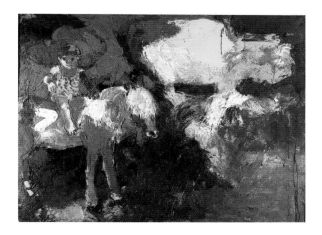

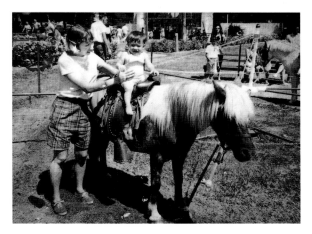

FIG. 5.40. Joan Brown, *Noel on a Pony with Cloud*, ca. 1963. Oil on canvas, 72 × 96 in. (182.8 × 243.8 cm). Phoenix Art Museum.

FIG. 5.41. Noel Neri, with mother Joan Brown, in photograph used for *Noel on a Pony with Cloud*, 1963. Courtesy Joan Brown.

provided the kind of control Bacon had brought to his emotional experiences.[84] Domestic subjects still predominated, as in *Refrigerator Painting* (fig. 5.42), in which Brown's bird sculpture and a black clock perch on top of the homely fridge against an assertive background of checkered wallpaper. The numberless black clock seems to dominate the image, reminiscent of the black mantel clock in Cézanne's early still lifes. Ever resistant to the idea that her work offers simple "updates to art history," Brown insists "it is just a clock I had."[85]

The depicted objects in *Refrigerator Painting* and the other 1964 impasto paintings are rigidly ordered, the painterly enthusiasm contained by the verticals and horizontals of the composition, echoing in turn the canvas edge. This order represented the first step away from the expressionism of Brown's Bay Area Figurative style, which was soon to be abandoned. Like so many others, Brown experienced a deep crisis of belief in the movement, which caused her to effect a radical shift in her work:

> [Around] 1964, I found myself beginning to be bored with impasto, and I felt guilty about being bored. Things were going great for me, but I was not excited about what I was doing. And one day I realized that I could actually fake spontaneity. I did not want to be "turning out a product," so I began to look at new things, artists I had not looked at before—Morandi, Oriental art, . . . Ingres. I made a decision to put away the trowels and the large format. I stretched a canvas 2 × 3 feet, and I took an egg and a cucumber out of the refrigerator, and I worked on painting only that for one whole year, and I found the freshness and energy I had lost.[86]

Apart from the trend in the sixties encouraging flatness and a new, cool style, pressures from Staempfli contributed to her turn. While Oliveira had been urged by his dealer to change and develop a new audience, Brown's wanted her to maintain her expressionistic style, which had been selling well. During the summer of 1964, Staempfli visited Brown and Neri when they were teaching in Denver. According to a former student who was close to Brown at the time, Staempfli "pressured her pretty hard to keep doing that thick paint," even though she was already beginning to explore a new style.[87]

Although her work on paper maintained a rough, improvisational character that summer (see the col-

lage *Portrait of Nude Woman*, fig. 5.35), her oils were undergoing a profound change. She finished her last impasto painting in December, having cut a corner from a work in progress to create a spare still life of a single yellow-green bowl on a gray table against an olive background (fig. 5.43).[88] Morandi is an obvious source for the reduced palette and intensely focused image; one is also reminded of Brown's admiration for Bacon's control of chaotic emotion.

Brown broke with Staempfli and remained without a New York representative for ten years. "It was something I had to do; I did not regret it then, nor have I regretted it in any way since."[89] Simultaneously, she and Neri decided to separate. Her work became stylistically more austere, as its imagery became at once more overtly symbolic and autobiographical.

Brown later recalled that contemporary critics of her Bay Area Figurative work had often written that she would be "a really good painter" as soon as she "got rid of that silly subject matter."[90] She delighted in the fact that she did the reverse—gave up the thick, "macho" slabs of paint and retained her quirky, personal imagery. Although generalized paintings such as *Girl Sitting* helped cement her reputation, she was working all along on other autobiographical and domestic themes such as *Day before the Wedding*, *The Oven Blew Out*, and *Getting Ready for the Bath*.[91] Counterbalancing the coolness of her stylistic shift, then, was an embrace of these "hot" personal subjects, which burgeoned in the seventies in works such as *In Memory of My Father*, and *Parts of a Woman (After the Operation)*.

As the youngest artist working in the Bay Area Figurative style, Brown's defection had a special significance. Her powerful technique had demonstrated that one could extend Park's late style, and even exaggerate it manneristically, while retaining the full impact of his hard-won tension between the representation of the figure and the abstraction of pure paint. Although her close friend Bischoff would continue to paint strong figurative canvases through the late sixties, Brown's shift signaled the end of Bay Area Figuration as a viable style for the second generation. Thenceforth, it would only be a tradition—to react against, to draw upon, to study, to ignore—but no longer something to participate in as a living movement.

FIG. 5.42. Joan Brown, *Refrigerator Painting*, 1964. Oil on canvas, 60×60 in. (152.4×152.4 cm). Collection of Harry Cohn, Hillsborough, California.

FIG. 5.43. Joan Brown, *Green Bowl*, 1964. Oil on canvas, 22×36 in. (55.9×91.5 cm). Collection of the artist.

CONCLUSION

CRITICAL CONSTRUCTS AND REGIONAL IDEN-
TITY · Criticism does not simply report on artists
and their work, it constructs them. In an important
sense, Roger Fry's Paul Cézanne, Clement Green-
berg's Barnett Newman, and Leo Steinberg's Jasper
Johns stand in the place of whatever originary
view we might imagine having had of these now-
important individuals. Similarly, each historian's
view of history is layered above stories already told,
like fresh quill marks on a poorly prepared palimp-
sest. Reading the new text requires knowing the old,
so that overlaps can be seen and irrelevancies ignored.

The tales told of Bay Area Figurative art through
the decades have been layered within the overwritten
histories of postwar American painting in New York.
Contemporary East Coast critics certainly saw the
Bay Area Figurative artists in that context, and to
some extent they were right—to the extent that New
York School painting constituted the national style of
Abstract Expressionism, and Bay Area Figuration
constituted a response to that national style. But be-
yond that the New York critics were ill-equipped to
understand the Bay Area development or the envi-
ronment from which it sprang, and their misunder-
standings laid the foundation for the marginalized
position of the movement in current histories of
American art.

There are three general themes to the tales of Bay
Area Figuration: first, that it represented a reaction-
ary retreat from the existential demands of "action
painting"; second, that while it may not have been
inherently reactionary, it was provincial; and third,
that it was merely an aspect of second-generation
New York School painting, presumably responding to
that far larger development.

The first theme emerged earliest. As a defender of
non-objective painting, Dore Ashton had endorsed
Hubert Crehan's criticism of Bay Area Figuration as
counterrevolutionary, its painters as suffering a "fail-
ure of nerve." The second theme appeared soon
thereafter, in the writings of critics eager to find some
criterion besides personal crisis for judging contem-
porary art. Although personally sympathetic to rep-
resentational art, Sidney Tillim and Hilton Kramer
had seen Bay Area Figuration in the context of a
hoped-for return to the figure in New York painting,
and, not surprisingly, it fell short in their estimation.
The paintings of Park, Bischoff, and Diebenkorn
lacked "necessity," argued Kramer, referring to their
apparent lack of concern for the Hegelian mainstream
in its historical march of progress. Tillim warned that
the new figurative painting might not "fulfill the
needs which shaped and inspired its reemergence"—
that it might not succeed in rescuing painting in New
York.[1]

The third theme surfaced in the criticism of
Thomas Hess and the largely figurative artists who
wrote for him in the columns of *Art News*. Since the
mid-fifties a critical schism had been developing be-
tween defenders of gestural Abstract Expressionists
such as de Kooning, and those who championed field
painters such as Rothko and Newman.[2] Attempting
to bridge the schism, Hess proposed that second-
generation New York School painters, most of them
figurative, would be the ones to rescue Abstract
Expressionism from its state of crisis. While their
own stylistic commitments might have made these
painters sympathetic to Bay Area Figuration, it was
not apparent. In addition to snide comments about
pretty but tasteless California oranges, more than
one writer castigated Bay Area artists for supposedly
basing their palettes on the acid hues of reproduc-
tions—epitomized by the glossy new art books pub-
lished by Skira—rather than on original artworks
(presumed to be unavailable on the West Coast). As
the figurative painter Fairfield Porter wrote in 1962:

A special case of art following criticism is found in the California artists, who bear the same relationship to modern art that Blake bore to Italy. As Blake knew Michelangelo from engravings, so the Californians know the impressionists and cubists from the color plates in Skira books. They follow the implicit criticism of Skira's printers.[3]

Such statements reflected the basic assumption that painting outside of New York was not just regional but *provincial*, as if that term from Imperial Rome had any meaning in a decentralized republic. More recent textbooks on the period reflect the assertion that to be good, artists had to be in New York:

> Artists in the "provinces" did get the word later, generally garbled, from *Art News*. The practice out-of-town was to execute variations of illustrations in magazines, as best they could, given the distortions in scale, color, and texture.[4]

This accusation of provincial misunderstanding dogs descriptions of Bay Area Figuration. In addition to the influential exhibitions of modern and contemporary painting mounted by the San Francisco Museum (often in advance of the artists' showings in New York museums), there were important local collections of Impressionism (the Palace of the Legion of Honor and the de Young Museum), Cubism, School of Paris (the Stein collection), and the Blue Four (Galka Scheyer). Beyond the mean-spirited ignorance of criticism such as Porter's, however, there lies an interesting possibility about artists' use of reproductions in the twentieth century. We know from Neri and others that the San Franciscans' response to the illustrations in art magazines was a highly creative one. They generously assumed greater radicality on the part of New York painters than in fact existed:

> We'd look at those little black and white reproductions of de Kooning in the magazines, and we'd think that he was using really wild, crazy colors and sloshing them in big, thick layers. So we started painting right out of the can and building up surfaces a half inch thick. Finally, some original de Koonings were exhibited at one of the museums. Most of us were really disappointed—the paint was so thin and the color was really dead. But the misinterpretation was a good thing.[5]

The younger artists felt that their misinterpretation was positive because it allowed them to exaggerate Abstract Expressionist facture, bringing a new exuberance to the Bay Area Figurative movement after the first-generation painters' accomplishments. Park, Bischoff, and Diebenkorn, of course, had no need of such willful misprision. Having been vigorous Abstract Expressionists themselves, and being deeply familiar with the paintings of Still and others, they came by their painterly styles and bold palettes directly, without need of reproductions. In this sense, the persistent grouping of the Bay Area Figurative artists as second-generation painters, New York School or otherwise, is the most pernicious of the existing stories. As the scribe prepares the vellum by scraping it down, so must this narrative be cleared away.

Superficial resemblances exist between the works of the Bay Area Figurative artists and the gestural figurative paintings by New York artists emerging in the early fifties, and both communities were responding to the sense of diminishing possibilities in the reigning Abstract Expressionist style. Intriguing correspondences include Larry Rivers's 1953–54 figurative plaster sculptures, produced when Neri was just beginning to explore the same format, or George Segal's figurative paintings of the early sixties, which have the same mysterious but loaded imagery as Theophilus Brown's. But these are coincidental parallels, with no evidence of contact between the figurative painters on the two coasts—other than the enduring friendship between Theophilus Brown and Elaine de Kooning. Their work is indeed related from 1950 to 1956, when both were doing gestural portraits of athletes based on photographs from the news media.[6] Other than Brown and de Kooning, the only remaining link might be between George McNeil and the first-generation Bay Area Figurative artists, and in this case the supposed influence seems to have emanated from the West Coast. McNeil's canvases were non-objective until after he spent a year teaching at the University of California, Berkeley, in 1956–57— where he would have been in direct contact with David Park. While McNeil's work is very different from that of the Bay Area painters, he must have been impressed by the local vitality of the figurative option.

Beyond the actual and conjectured contacts between the two groups of artists, there are three problems with the description of Bay Area Figuration as a second-generation variant of the New York School. As I argued in the introduction, the first problem with the New York–Bay Area pairing is chronological— Park turned to the figure as a mature abstract painter, when New York non-objective painting was at its peak, before the recognition of any new figurative developments in the New York press.[7] Related to this problem is the assumption that Bay Area painters

were responding to New York School Abstract Expressionism, rather than to their own vigorously dynamic San Francisco School. Although the issues regarding the future of Abstract Expressionism were national, its material lessons were local—and the regional character of San Francisco School Abstract Expressionism was unique in its physicality and almost exclusively non-objective cast. As I have proposed in previous chapters, the Bay Area painters were thus forced to distinguish their figurative work from the non-objective painting that preceded it, while New Yorkers could argue that their figurative canvases simply extended a broad gestural style.

The second problem is stylistic. While Bay Area Figurative work exhibited a strong coherence around pastoral themes, saturated colors, and thick, painterly facture, the paintings of the second-generation New York School were wildly divergent in their subjects and physical approaches. At approximately the same moment, Alex Katz painted flat, billboardlike portraits in high-key colors, Larry Rivers offered nose-thumbing history paintings such as *Washington Crossing the Delaware* (which he proposed as "another toilet seat—not for the general public, but for the painters")[8] Elaine de Kooning brushed dark, gestural groupings of athletes, Fairfield Porter portrayed deadpan pastel interiors, and Jan Müller constructed elaborate Faustian allegories of doom. Hess compared the diverse group of artists, clearly not unified enough to be seen as a revolutionary avant-garde, to the Impressionists rather than to the more tightly knit Cubists or Surrealists. "There is no Revolution anymore," he opined, since the Abstract Expressionists, like the Impressionists, had created "a look that was not erased in the work of the following generation."[9] Paradoxically, although the Bay Area Figurative artists had less vested in the concept that they might be "avant-garde," they made a cleaner break with Abstract Expressionism. Although still importantly involved with process and a bold, painterly style, their work always presented a clear subject, unobscured by a flurry of brushstrokes. While Hess saw the New York figurative style as spreading like a tree from its Abstract Expressionist roots, the San Francisco painters knew that their figurative work represented "the end of a love affair."

The final problem with the comparison is sociological. The second-generation New York School painters certainly knew each other, reviewed each other's shows, and occasionally grouped together around a gallery or special exhibition, but there was nothing like the complex network of interactions that linked the Bay Area Figurative artists together. Many of the New York figurative artists had studied with Hans Hofmann, but that was equally true of most non-objective painters in New York. By contrast, the Bay Area Figurative artists were related through a generational kinship structure that played a highly significant role in their careers: Diebenkorn studied with Park, and then became his colleague and close friend; Oliveira and Neri were students together, then Oliveira became Neri's teacher; Neri, who married Joan Brown, studied with Diebenkorn and Bischoff as well as with Oliveira, later teaching at the institution where all three held jobs; McGaw studied with Diebenkorn and worked at Diebenkorn's school immediately after graduating; Joan Brown studied with Oliveira and Bischoff, married Neri, and took critiques from Park; Wonner and Theophilus Brown shared studios in Diebenkorn's building and lived together throughout most of the Bay Area Figurative period; Bischoff arranged a job for Diebenkorn at the California School of Fine Arts and later replaced Park at Berkeley; and Diebenkorn helped Weeks get a job at the University of California, Los Angeles. In addition to these intertwining connections, the Bay Area artists met together for many years, in shifting constellations, to draw from the model.[10]

Critics like Crehan had sensed a conspiracy in such relationships, muttering darkly: "These older painters [David Park et al.] are all teachers and wield influence at the grass roots as well as through their tactics of awarding each other top prizes as they take turns on juries."[11] But such support systems were truly constructive in the case of the Bay Area Figurative movement. Unlike the divisive commercial and critical pressures that influenced artists in New York, San Francisco's artists could rely on a network of schools (such as the School of Fine Arts and the College of Arts and Crafts) and open art annuals (such as those run by the San Francisco Art Association and the Richmond Art Center) for financial support and exposure. The emotional support provided by this collegial network also distinguished San Francisco from New York, where even first-generation painters felt defeated by the competitive atmosphere. As Mark Rothko wrote to Barnett Newman in 1950: "We must find a way of living and working without the involvements that seem to have been destroying us one after another. I doubt whether any of us can bear much more of that kind of strain."[12]

Apart from the social differences between the two regions, there were obviously distinct geographic characteristics as well. One-time Californian Jackson

Pollock told an interviewer in 1944: "Living is keener, more demanding, more intense and expansive in New York than in the West. . . . At the same time, I have a definite feeling for the West: the vast horizontality of the land, for instance; here only the Atlantic ocean gives you that."[13] Few of the Bay Area Figurative works were as deeply involved with the local landscape as the non-objective San Francisco School had been in their metaphorical "equivalents" (to use Alfred Stieglitz's term), or the Society of Six in their Fauvist views of the area.[14] David Park's scenes of canoeists are not specifically Californian; indeed, their damp verdancy seems more in keeping with his memories of childhood summers in New Hampshire. Park's beach scenes, like those of Diebenkorn, Bischoff, and Joan Brown, are also intentionally generic. Only in Weeks's views of the Pacific, Diebenkorn's cityscapes, or Bischoff's fog-lit interiors, are we at all involved with the area's specifics.

Yet Bay Area Figuration is perhaps more strongly identified with place than the art of any other movement. Unlike Abstract Expressionism, it was born in the area; unlike Funk, it stayed. The crucial ingredient for this stability was not the sumptuous locale as much as the cultural and economic aspects of the region: its supportive schools and decentralized, gently bohemian life-style.

Kenneth Rexroth, a leader of the Beat poets, had described San Francisco in the fifties as "one of the easiest cities in the world to live in. . . . Its culture is genuinely . . . Mediterranean—*laissez faire* and *dolce far niente*."[15] Perhaps no other major American city offered such a combination of urban and natural beauty, low-rent studios, and art-related jobs. There was also a vibrant culture drawing on pioneer-prospector myths and the energies of Hispanic, Asian, and African-American peoples. None of this *determined* Bay Area Figuration, any more than it did the previous San Francisco School of Abstract Expressionism or the succeeding Funk. But it may have given these movements their characteristic counter-cultural qualities, their humor, and their accessibility.[16] Additionally, each drew on the area's sense of irreverent distance from the arbiters of taste and the writers of textbooks. As Rexroth observed, San Francisco "is a long way from Astor place [taste] or Kenyon College [textbooks]." Hence its hospitality to undergrounds:

[There] formed a dense crust of custom over American cultural life—more of an ice pack. Ultimately the living water underneath just got so damn hot the ice pack has begun to melt, rot, break up and drift away. . . . [All

that could be seen from above] was a kind of scum. By very definition, scum, ice packs, crusts, are surface phenomena. It is what is underneath that counts.[17]

The city's underground sensibility nurtured the blossoming of the San Francisco School during the days when Douglas MacAgy kept the doors of the California School of Fine Arts open all night long for group jazz and painting; the same sensibility fueled artists' desires to buck the dominance of Abstract Expressionism when it became the national style. Bay Area Figuration began underground, when David Park declared "I'd like to break the damn picture plane!" and Bischoff sketched surreptitiously from the cab of his truck.[18] In time, however, it became its own local tradition, anachronistic in the face of changes in American art. Once again, those who would maintain their individualism, and their involvement with contemporary art, were forced to move on.

The End, and the Endurance, of Bay Area Figuration

The status of Bay Area Figurative art has fluctuated over the years, sharing the fortunes of expressionistic painting and figurative art in general. During the 1960s, American art became increasingly formalist in its orientation, with Minimalism the ultimate intellectual and aesthetic expression of that critical development. Given the hard-edged, industrial emphasis of Minimal art and the contemporaneous Pop and Op movements, paint-laden figurative canvases were bound to seem outdated. To formalist critics, such work stood in the way of the advancing mainstream, which for them consisted of color-field paintings and "post-painterly abstraction." As Barbara Rose wrote in 1965:

[It was] not until the gestural aspect of Abstract Expressionism had played itself out by emerging more and more clearly as a style based on landscape or figurative motifs could the impact of the atmospheric abstractions of Newman, Rothko, and Gottlieb be absorbed.[19]

Thus the demise of gestural painting was seen as a prerequisite for the advance of field painting as the next avant-garde. The Bay Area Figurative artists themselves responded to this climate, and almost all of them shifted in their work toward smoother surfaces, more simplified images, and more geometric compositions after 1964–65.

There are countless influences determining individuals' reactions to a changing cultural and aesthetic

environment. One motivation for change lay in the success of Bay Area Figuration itself. Already by 1962, one writer characterized the movement in a national art magazine as "a sort of official University-type painting that is European in its sumptuous bravura brushwork and luscious color."[20] This could only make artists like Diebenkorn nervous. Other aspects of the changing environment undoubtedly contributed to that nervousness. For example, the peak moment of Bay Area Figurative art, when it could truly claim national recognition, coincided with the birth in 1962 of *Artforum*. As the first national art magazine to be based in San Francisco, *Artforum* signaled to the world that San Francisco was a thriving cultural center. It serves as a metaphor for the fortunes of Bay Area Figurative painting, for when area painters began to experience difficulty with their figurative styles, the magazine moved—first to Los Angeles, then to New York—and began to shift its editorial focus. Both developments reflected a change in American art to which Bay Area Figuration could not, or would not, easily adapt.

Artforum began with several explicit goals, one of which was to elevate the status of art criticism from journalism to something higher—some would argue, from descriptive commentary to prescriptive formulae.[21] The most trenchant criticism of the period was formalist, and *Artforum* ultimately became a major mouthpiece for the formalists' manifestos. Critics inveighed against "theatrical" effects in art, calling for flatness and truth to the medium; feature articles and advertisements alike focused on specific artists who met the criteria.

Significantly, another of *Artforum*'s initial goals was to bring national attention to art of the West Coast, within the perspective of international modern art.[22] National art publications, whether magazines or textbooks, had long marginalized West Coast art. Westerners realized that "national" publications were really New York publications; the price you paid for not living in The City was being dubbed provincial. *Artforum* initially attempted to correct such biases. Although it had its own editorial leanings, it did well in the early years to present Bay Area art. During its first year of publication (1962–63), there were five articles on Bay Area Figurative artists. One issue had on its cover David Park's *Man in a T-shirt*, another featured Joan Brown's painting *Flora*.[23] These beginnings must have been tantalizing to area artists, but they never really bore fruit. After the first few years, the balance of coverage tilted to the East Coast, and the formalist bias became more fully expressed.

For those artists who had initially accepted the magazine, the new editorial values opposing thick paint and humanistic subjects must have been an object lesson in constructive criticism—that is, in criticism that constructs its object.

The impact of this critical shift on Bay Area artists is difficult to assess, but it clearly contributed to the loss of momentum in the figurative style and the overall drive toward flatness that so many of them exhibited in their art. Neri stopped making figures and entered a Conceptualist-Minimalist phase in which he built installations of steps, corners, and platforms based on pre-Columbian architecture. Joan Brown spent a year "minimalizing" her work, paring the paint surface down and trying to *see* obsessively rather than to *paint* that way. Oliveira could no longer "find the figure," and simply stopped painting until a new studio inspired works of a minimal human form on a flat, empty stage. Weeks, Wonner, Brown, and McGaw continued their figurative work largely without interruption, but gestural touches became fewer and fewer, interiors emptied of the messy human self.

If *Artforum* was not the source of all this, the heightened critical climate it represented clearly was. When Diebenkorn was struggling with his later figurative work, he recalled his general reaction to all art magazines (of which *Artforum* must have been prominent): "at one point I just got so disgusted with art magazines and that kind of talk that I just canceled all the subscriptions, and I really didn't look at any again until, I guess, I came down [to Los Angeles]."[24] His resumption of art magazines thus coincided precisely with his escape from the Bay Area, with its tradition of painterly expressionism, and with his change from figurative canvases to the non-objective, beautifully formalist Ocean Park paintings that were so much more in tune with the emerging 1960s aesthetic.

It could be claimed, in light of the mid-sixties aesthetic trends that ultimately derailed Bay Area Figuration, that the movement's painterly figuration should be seen as a reactionary holdover from the past. Given subsequent developments, however, the exact opposite can also be argued: that the Bay Area Figurative movement represented part of the opening wedge in American artists' postwar rejection of utopian Modernism, and, as such, a step toward Postmodernism.[25] It can then be seen as setting the stage for many subsequent developments in American art of the 1970s and 1980s.

Pursuing this counterargument, the very formalism that made Bay Area Figuration seem irrelevant

by the late sixties was the last gasp of a Greenbergian "hegemonic modernism" that held the mainstream artistic canon to be unassailable. Broad cultural changes were brought about in the late sixties by militant civil rights activists, feminists, and others who had been systematically excluded from this mainstream. Such changes in turn brought art, and art institutions, to a crisis point from which the only escape was a pluralist expansion and inclusion of "outsider art."

Since that time, the legacy bequeathed by Pluralism and Postmodernism has affected the status of Bay Area Figurative art once again, building interest and facilitating reevaluation at the same time. For example, a prominent aspect of that legacy was Neo-Expressionism, a style of the 1980s that benefited directly from the perceived breakdown of the mainstream, gaining critical approval for its resurrection of expressionist figurative painting. With the coming of Neo-Expressionism, critics, collectors, and curators began to take a fresh look at previous American figurative movements, and at contemporary figurative painting by artists in Germany, Italy, and elsewhere. The quality of contemporary European and earlier American figurative painters seemed refreshingly high when compared to the 1980s productions of American Neo-Expressionists. As a result, there was renewed interest in Bay Area Figurative art, as documented by several recent exhibitions.[26]

The exhibition which this book accompanies is, of course, part of this broad reevaluation of expressionist figurative painting. As such, it confronts the analyses of previous writers, some of whom have questioned the position of Bay Area Figurative painting with regard to history (a euphemism for the discredited mainstream). In the words of Christopher Knight:

Should . . . the work [be] seen as a regional phenomenon wholly embodying a "Bay Area School?" Or should . . . these paintings [be] situated somewhere between abstract expressionism and more recent developments in painting which melds [sic] aspects of both expressionism and figuration?[27]

As Knight presents it, Bay Area Figuration was either a regional "Bay Area School" or a part of a general historical development within American art. The two choices represent a false dichotomy, for Bay Area Figurative art was both.

I have argued in these pages that Bay Area Figuration was indeed a movement. It was regional, but not provincial, in that the artist-participants were responding to problems with a national style from within a strong regional base of that style, using tools and drawing on strengths peculiar to the region in question. I have maintained that Bay Area Figuration was a movement in contrast to contemporaneous figurative painting in New York, and in spite of the participating artists' resistance to the phrase. The existence of the movement can be traced to that moment when a first generation came together with shared goals and evolved shared practices. Intensely aware of each others' work, David Park, Elmer Bischoff, and Richard Diebenkorn were determined to escape what had become exhausted in Abstract Expressionism, while regenerating the excitement of its stylistic approach. Park led the way, demonstrating that the discipline of figuration could solve his own crisis of belief, Bischoff's crisis of communication, and Diebenkorn's need for stylistic resistance.

A bridge generation pursued many of these same goals, responding to the emerging style with their own individual variations. These included a greater openness to symbolic and autobiographic content (particularly in the case of Theophilus Brown and Paul Wonner) together with a freely mannerist use of the medium, no longer fully connected to the Abstract Expressionist process of painting (Wonner and Nathan Oliveira). A second generation, students of the first, adopted the now-normative and vigorous style, extending it further in the directions indicated by the bridge painters—through even more explicit autobiography in the content of their works (especially in the canvases of Joan Brown and Bruce McGaw) and through exaggerated expressionism in the handling of their chosen medium (Brown and Manuel Neri).

Bay Area Figurative art has remained strong as a local tradition, cited as inspiration and antecedent for emerging artists such as Drew Beattie, Christopher Brown, Kristina Branch, Roger Herman, David Jones, and others.[28] Many of these artists came to the area as students or mature painters, attracted by the very traditions their works now engage; inevitably, some have since left to find a more active market for their work. As Knight notes, "German-born painter Roger Herman (who now lives in Los Angeles) left Europe for the Bay Area in the late 1970's precisely because of his interest in these [Bay Area Figurative] painters, particularly David Park."[29]

Other artists have responded to the tradition as something strong to react against (albeit still within the dominant figurative tradition), such as the painters Wayne Thiebaud and Mel Ramos, or Robert Bechtle and Richard McLean. Bechtle and McLean studied

with Diebenkorn and early on resisted his powerful influence. They found even Diebenkorn too hot, seeking to tone down the gestural tensions of the Bay Area Figurative style by working from photographs, which they felt were more emotionally neutral.[30] Thiebaud and Ramos similarly altered and extended the style. Thiebaud, who credits Diebenkorn's influence on his use of color (particularly the Fauvist blue shadows and rainbow halation around his objects), began with figurative paintings that were already tauter and harder-edged than Bay Area Figurative works. He then gained fame through his high-keyed paintings of banal culinary subjects, which won him critical acceptance as part of the Pop phenomenon. Ramos perfected his own cool, "processed," soft-porn Pop images which studiously avoided Bay Area Figuration's seriousness and emotional depth. Yet what-

ever extensions or alterations came to pass in the Bay Area Figurative style, it is significant that the region never participated in the high-tech abstractions of Los Angeles Minimalism. The hard edges of paintings in the sixties and early seventies always manifested themselves within a figurative mode, a mark of the deep endurance of the Bay Area Figurative tradition.

With this book and exhibition, we can hope that this local tradition will also offer its lessons to artists in other parts of the country, free from the stigmatization that the charges of provincialism have so long carried with them. Given its quality, stylistic integrity, and roots in national postwar developments—specifically, the debates over abstraction and representation in American art—it is time that Bay Area Figuration claimed a place in the national aesthetic memory as well.

Archival sources are abbreviated as follows: AAA, Archives of American Art, Smithsonian Institution, Washington, D.C.; ACA, Archives of California Art, The Oakland Museum.

CHAPTER ONE

1. Elmer Bischoff, in Thomas Albright, "Elmer Bischoff: Bay Area Figurative," *Currânt* 1, no. 5 (December 1975–January 1976): 40.

2. David Park, in Alfred Frankenstein, "Northern California," *Art in America* 42, no. 1 (Winter 1954): 49, 74.

3. David Park, in *Contemporary American Painting*, exh. cat. (Urbana: University of Illinois, 1952), p. 220.

4. Harold Rosenberg, "The American Action Painters," *Art News* 51, no. 8 (December 1952): 22–23, 48–50, anthologized in Rosenberg, *The Tradition of the New* (New York: McGraw-Hill, 1965; paperback ed., Chicago: University of Chicago Press, 1982), p. 35.

5. Richard Diebenkorn, in Susan C. Larsen, "A Conversation with Richard Diebenkorn," *Los Angeles Institute of Contemporary Art Journal* (July–August 1977): 30.

6. Paul Mills, *Contemporary Bay Area Figurative Painting*, exh. cat. (Oakland: The Oakland Art Museum, 1957), p. 22.

7. Mills, *Figurative Painting*, pp. 6 and 22.

8. Among the museums on the tour itinerary were the Los Angeles County Museum of Art and the Dayton Art Institute. It seems that only a selected portion of the exhibition, featuring Park and Diebenkorn, traveled to Dayton.

9. See, for example, the exhibitions at the Grey Art Gallery and Study Center, *The Figurative Mode: Bay Area Painting, 1956–1966* (New York, 1984), and the 871 Fine Arts Gallery, *The Triumph of the Figure in Bay Area Art, 1950–1965* (San Francisco, 1987).

10. As Mills pointed out to me, none of the Bay Area Figurative painters knew of the existence of the Six until their own figurative approaches were well established. He recalls showing Diebenkorn some of these paintings "behind the scenes at the Oakland Art Museum," and remembers that "neither Park nor Bischoff gave the Six works special attention at all." Note to the author, March 1989.

11. Mills, *Figurative Painting*, p. 5.

12. Clement Greenberg, "The Situation at the Moment," *Partisan Review* 15, no. 1 (January 1948): 82.

13. See Irving Sandler's triumphalist history, *The Triumph of American Painting* (New York: Praeger Publishers, 1970), and the more critical discussions by Max Kozloff, "American Painting during the Cold War," *Artforum* 13 (May 1973): 43–54, and Serge Guilbaut, *How New York Stole the Idea of Modern Art* (Chicago: University of Chicago Press, 1983).

14. In "The Varied Art of Four Pioneers," *Life*, 16 November 1959, 74–83, 85–86, photographs of "analogies with nature" were juxtaposed with canvases by Kline, Still, de Kooning, and Rothko to "help explain Abstract-Expressionist work." Kline's work was seen to be reminiscent of bridge girders, Still's, of flames, de Kooning's, of grasses and trees, and Rothko's, of a sunset. The *Vogue* of March 1951 featured Cecil Beaton photographs of models standing in front of Jackson Pollock canvases at the Betty Parsons Gallery.

15. Three early exhibitions of important Abstract Expressionist painters held at the San Francisco Museum of Art were: *Paintings by Arshile Gorky*, 9–24 August 1941; *Jackson Pollock*, 7–26 August 1945; and *Oils and Watercolors by Mark Rothko*, 13 August–8 September 1946. Each exhibition prompted an acquisition: Pollock's *Guardians of the Secret* (1943) was acquired in 1945 and Gorky's *Enigmatic Combat* (1936–37) in 1941. Rothko's *Slow Swirl by the Edge of the Sea* (1944) was acquired in 1946 but was later deaccessioned in order to buy a later painting by the same artist. The work of 1944 is now in The Museum of Modern Art, New York.

16. Jermayne MacAgy, *Contemporary American Painting*, exh. cat. (San Francisco: California Palace of the Legion of Honor, 1945), n.p. The exhibition was sponsored by the fledgling United Nations Conference Committee, then meeting in San Francisco.

17. See the chapter "Regionalism and Social Realism," in Matthew Baigell, *The American Scene* (New York: Praeger, 1974). I am grateful to Wanda Corn for sharing this reference with me and for reminding me that these political associations were nebulous and often unfounded. The stigmatization of Regionalism as a reactionary, isolationist movement was largely owing to the efforts of Social Realists; it was also furthered by the Abstract Expressionists.

18. See Hassel Smith's illustration for *The Communist Manifesto in Pictures* (San Francisco: International Book Store, Inc., 1948).

19. Arthur M. Schlesinger, Jr., "Not Left, Not Right, but a Vital Center," *The New York Times Magazine*, 4 April 1948. See also his book *The Vital Center: Our Purposes and Perils on the Tightrope of American Liberalism*, rev. ed. (1949; Boston: Houghton Mifflin, Riverside Press, 1962).

Abstraction abroad presented equally complex choices, particularly given its new identification with the victorious Yanks and "effete American capitalism." Artists in France moved toward Soviet-approved Social Realism, forming a left-wing salon that organized themes for each year's art, such as Work in 1951 and Sport in 1957. Similarly, many British artists rejected abstraction in favor of their own version of Social Realism, dubbed the Kitchen Sink School and viewed as analogous to the literary/theatrical group of "angry young men." German artists confronted an opposite legacy, in which figurative art had become completely identified with Nazi ideology. The only choice for the few remaining progressive artists seemed to be an uncompromising pursuit of non-objective art. But this route severed the links to indigenous figurative traditions, such as Expressionism and Neue Sachlichkeit. Artists such as Georg Baselitz and A. R. Penck (on opposite sides of a divided Germany) began in the fifties to form a synthesis of current and early modern styles. In an intriguing parallel to the Bay Area painters, Baselitz has said that American Abstract Expressionism helped him to rediscover German Expressionism and, through that, the figurative Neo-Expressionism for which he is now known.

For more information on abstraction abroad, see the following publications: entry on France from *The Oxford Companion to Twentieth-Century Art*, ed. Harold Osborne (New York: Oxford University Press, 1981), p. 203. Entry on Britain, *Oxford Companion*, pp. 82–83. Also see Dawn Ades, "Figure and Place: A Context for Five Post-War Artists," pp. 73–82, and "The School of London," pp. 308–11, in Susan Compton, ed., *British Art in the 20th Century: The Modern Movement*, exh. cat., London, Royal Academy of Arts (Munich: Prestel Verlag, 1986). Siegfried Gohr, "Art in the Post-War Period," pp. 465–67, and Günther Gercken, "Figurative Painting after 1960," pp. 473–75, in Christos M. Joachimides et al., eds., *German Art in the 20th Century: Painting and Sculpture, 1905–1985*, exh. cat., London, Royal Academy of Arts (Munich: Prestel Verlag, 1985). Wieland Schmied, "Art in Berlin, 1945–1970," in Kynaston McShine, ed., *Berlinart, 1961–1987*, exh. cat. (New York: The Museum of Modern Art, 1987).

20. For an excellent analysis of Hofmann and his impact on the Abstract Expressionists, see Dore Ashton, *The New York School: A Cultural Reckoning* (Harmondsworth: Penguin, 1972).

21. Glenn Wessels, letter to Fred Martin, ca. 1956–60, in the Martin papers, roll 1128, frame 857, AAA. The San Francisco Art Association was the organization behind the founding of the California School of Fine Arts.

22. Mills, *Figurative Painting*, pp. 21–22.

23. I am indebted to Susan Klein Landauer for her insights into the painters of the San Francisco School of Abstract Expressionism, the subject of her forthcoming dissertation for Yale University. Landauer suggests that Still's politics were very little known, as he liked to consider himself "above the fray." But one senses conservative libertarianism, bordering on Ayn-Randian megalomania, in his later writings. Landauer has also learned that one former colleague, Jon Scheuler, remembers being shocked at Still's support for McCarthy during the red-baiting years.

24. Clyfford Still, in *Fifteen Americans*, exh. cat. (New York: The Museum of Modern Art, 1952), pp. 21–22, and Benjamin Townsend, "An Interview with Clyfford Still," *Gallery Notes* [Albright Art Gallery] 24, no. 2 (Summer 1961): 10–16. Both sources are excerpted in Maurice Tuchman, ed., *New York School: The First Generation*, rev. ed. (Greenwich: New York Graphic Society, 1970), pp. 147 and 148.

25. Michael Leja, "The Formation of an Avant-Garde in New York," in *Abstract Expressionism: The Critical Developments*, exh. cat., Buffalo, Albright-Knox Art Gallery (New York: Harry N. Abrams, 1987), p. 17.

26. Clyfford Still, in *Clyfford Still*, exh. cat. (Philadelphia: Institute of Contemporary Art, University of Pennsylvania, 1963), p. 6.

27. Letter from Still to Gordon Smith, director of the Buffalo Fine Arts Academy at the Albright Art Gallery, in *Paintings by Clyfford Still*, exh. cat. (Buffalo: Albright Art Gallery, 1959); quoted in *Time*, 9 November 1959, 80–83.

28. Hassel Smith, in Paul Mills, "The Figure Reappears: The Art of David Park and Bay Area Figurative Painting from 1950 to 1960" (Master's thesis, University of California, Berkeley, 1962), p. 22. The revised copy I consulted is in the ACA. Mills has now published his thesis as *The New Figurative Art of David Park* (Santa Barbara: Capra Press, 1988). This quote appears on p. 29. The image of the elegant artist was also fostered on the East Coast by the monocled Barnett Newman, who insisted that an artist should never be photographed unless dressed in a business suit.

29. Hassel Smith, interviewed by Jan Butterfield, ca. 1975, in the Smith papers, roll 2008, frame 350, p. 27, AAA. Smith observed that Still influenced the way he teaches in that he never talks to a student directly about their work. "It's a question of sitting down from time to time and examining certain propositions which in due course, then have some meaning in relation to a painting. . . ."

30. Although Still had had a retrospective at the San Francisco Museum of Art in the spring of 1943 and lived in the area briefly during the war, he came to MacAgy with the imprimatur of New York: he had studied there, moved there in 1945, and had a solo show at the Art of This Century Gallery in the spring of 1946. The job at California School of Fine Arts brought him back to the West Coast, but he maintained his links to the East, spending occasional summers there and participating in the formation of the important Subjects of the Artist school in 1948. (Re-

garding the latter, it should be noted that Still's role is mentioned only in the biography prepared by his wife for his 1959 retrospective [see n. 27] and is *not* recorded by Ad Reinhardt and Robert Motherwell, the other founders, in their book *Modern Artists in America* [New York: Wittenborn Schultz, 1951].) It was probably Still's recommendation that brought Mark Rothko to teach in the summers of 1947 and 1949; he may also have initiated Ad Reinhardt's summer visit in 1950.

31. Elmer Bischoff, interviewed by Paul J. Karlstrom, 24 August 1977, p. 32, AAA, typescript at the San Francisco office. Albright, "Elmer Bischoff," pp. 38–39.

32. Kenneth Sawyer and Jack Jefferson, in Thomas Albright, *Art in the San Francisco Bay Area, 1945–1980* (Berkeley: University of California Press, 1985), p. 28.

33. Smith, interview with Butterfield, ca. 1975, frame 331, p. 5. Dorr Bothwell recollects Park's response to Still very differently: "Others immediately had a kind of conversion. . . . David Park . . . was really a martyr to the cause. He really was. It was just like saying, 'Well, all right, shoot me at dawn. I'm just going to put everything away.' I don't think he destroyed his paintings but he certainly, overnight, just changed everything." Dorr Bothwell, in Mary Fuller McChesney, *A Period of Exploration: San Francisco, 1945–1950* (Oakland: The Oakland Museum, 1973), p. 36.

34. Smith, interview with Butterfield, ca. 1975, frame 341, p. 15.

35. Hassel Smith, interviewed by Paul Mills, 27 October 1961, handwritten notes in the Mills papers, p. 66, ACA.

36. Called simply *Group Show—Bischoff, Park, and Smith,* the exhibition was installed at the San Francisco Museum of Art from 21 May to 15 June 1948. Interestingly, Bischoff numbered his paintings, Park gave his letters, and Smith offered a poetic spread of titles, from *Inchoate #1* to *Where Alph the Sacred River Ran.* Exhibition files, Louise Sloss Ackerman Fine Arts Library, San Francisco Museum of Modern Art.

37. The connection of Park's work to Motherwell's is the insight of Richard Armstrong, curator at the Whitney Museum of American Art and organizer of the 1988 David Park exhibition. I am grateful to him for sharing his thoughts on Park with me.

38. Fred Martin, "General Notes on the Art History of the Bay Area," n.d., in the Martin papers, roll 1129, frame 428, AAA.

39. Martin, in Mills, "The Figure Reappears," p. 13; Mills, *Park,* p. 23.

40. Mark Schorer, "Elmer Bischoff," in *Recent Paintings: Elmer Bischoff,* exh. brochure (New York: Staempfli Gallery, 1960); in Albright, *Art in the San Francisco Bay Area,* p. 37.

41. Erle Loran, "This Month in California: San Francisco," *Art News* 48, no. 6 (September 1949): 45; in Paul Mills, "David Park: His Art and His Relation to the University," manuscript on Park's Zellerbach Scroll at the University of California, Berkeley, n.d., in the Mills papers, pp. 3–4, ACA; Mills, *Park,* p. 23.

42. Richard Diebenkorn, in Mills, "The Figure Reappears," p. 13; Mills, *Park,* p. 23.

43. Bits Hayden, "Art Review: Two Exhibits Which Show the Dilemma of Modern Art," undated, unreferenced review from a local newspaper, ca. Spring 1948, in the Smith papers, roll 2009, frame 105, AAA.

44. Artists who failed to get good teaching jobs found that their work suffered, as when James Weeks was forced to become a billboard artist, or David Park briefly found himself arranging displays in liquor store windows. Rarely, artists took advantage of a bad situation and found that it enhanced their art. When she was consistently shunted to low-paying night classes by the administrators of the teaching program at the California School of Fine Arts, Joan Brown found positions in hospitals, private schools, and her kitchen, teaching all manner of people from the physically and mentally handicapped to the very young. She comments, "It was tough at that time, but I would never have had the experience of working with all those different groups of people if I had been able to sail from school into—like many of my male peers did—a university or college job." Joan Brown, in Andrée Maréchal-Workman in *Expo-see* no. 15 (March–April 1985): n.p.

45. Sam Francis, in Michel Tapié, "L'Ecole du Pacifique," *Cimaise* 1, no. 7 (June 1954): 9. The translation is mine; the original reads: "Parler d'école à propos de peintres américains et a fortiori de ceux de la côte du Pacifique, c'est peu ou prou faire abstraction des individualités pour dégager des traits communs. Cela reste très arbitraire. De toutes façons, le plus important c'est l'individu. L'analyse limite quelque chose qui n'a précisément pas de limites: un développement individuel, un sentiment intérieur."

46. For an excellent discussion of this tension between individuality and unification, see Leja, "The Formation of an Avant-Garde," pp. 13–33.

47. James Johnson Sweeney, *Younger American Painters,* exh. cat. (New York: Solomon R. Guggenheim Museum, 1954). Sweeney does not use the phrase *école du Pacifique,* but he adopts the theory in his unpaginated essay. The *Time* reference is alluded to by Hubert Crehan (see n. 48).

48. Hubert Crehan, "Is There a California School?" *Art News* 54, no. 9 (January 1956): 32–35, 64–65. Oakland Art Museum panel discussion, "California School—Yes or No?" held 21 February 1956. The participants were Hubert Crehan, David Park, Hassel Smith, and Richard Diebenkorn; Fred Martin was moderator. I have not been able to find a transcript of

this discussion and have relied on references in the Fred Martin and Hassel Smith papers in the AAA.

49. Crehan, "California School," p. 33.

50. Fred Martin and Hassel Smith were among the local defenders who saw Still's work as fundamentally different from that of the putative San Francisco School. The rough consensus is that the San Francisco School painters were more sensual, less formal, and less art-historically conscious than the New York School painters. Jorge Goya-Lukich describes both Still and Rothko opposing French painting, where "the San Francisco School didn't because they didn't know much about it"; in McChesney, *A Period of Exploration*, p. 76. Douglas MacAgy speaks of the late-forties work of San Francisco painters as being very different from the New York School, and different from Still: "diametrically opposed to Still's ideas . . . there were students who were emotional. . . . You can't imagine Johnny Grillo being influenced by Still. [Still] had a certain amount of respect for him but not . . . that kind of discipline Still likes"; MacAgy, in McChesney, *A Period of Exploration*, p. 74. Still is placed in the New York School by most present-day scholars; see Ashton, *The New York School* and Maurice Tuchman, *New York School: The First Generation* (Los Angeles: Los Angeles County Museum of Art, 1965; Greenwich: New York Graphic Society, Ltd., 1970). Clement Greenberg also praises Still as an important member of "a group of artists who came to notice in New York during and shortly after the war," although he does not use the label New York School. See "American-Type Painting" [1955], *Art and Culture* (1958; Boston: Beacon Press, 1961), pp. 208–29.

51. Hassel Smith and Joe Rayter, in the Smith papers, roll 2009, frame 294, AAA.

52. Fred Martin, "The Birth of the Thing; or, Some Recent Developments in the Art of the San Francisco Bay Area," n.d. [ca. 1956], in the Martin papers, roll 1129, frames 440–41, pp. 2–3, AAA.

CHAPTER TWO

1. David Park, in Paul Mills, *Contemporary Bay Area Figurative Painting*, exh. cat. (Oakland: The Oakland Art Museum, 1957), p. 7; Paul Mills, *The New Figurative Work of David Park* (Santa Barbara: Capra Press, 1988), p. 30.

2. Fred Martin, "General Notes on the Art History of the Bay Area," in the Martin papers, roll 1129, frame 429, AAA.

3. Edith Truesdell, interviewed by Paul Mills, 18 March 1961, in the Mills papers, ACA.

4. Richard Diebenkorn, interviewed by the author, 14 January 1988.

5. Diebenkorn, in Paul Mills, "The Figure Reappears: The Art of David Park and Bay Area Figurative Paint-

ing from 1950 to 1960" (Master's thesis, University of California, Berkeley, 1962), p. 41. The revised version I consulted is in the ACA. Also see Mills, *Park*, p. 70. Diebenkorn was responding to the illustration of *Kids on Bikes* in an issue of the *San Francisco Art Association Bulletin* 17, no. 3 (March 1951): 1.

6. *Horizontal Painting* was number 105 in the catalogue for the *Sixty-ninth Annual Oil, Tempera, and Sculpture Exhibition* of the San Francisco Art Association, held at the San Francisco Museum of Art from 10 February to 12 March 1950. No dimensions are given.

7. Park showed the figurative work *Rehearsal* at the San Francisco Art Association Members' Exhibition, held at the M. H. de Young Memorial Museum from 25 March to 4 April 1950.

8. Nan White, "Free-form Abstractions Stir Up Controversy in This Area; Leaders of New School, Variously Known as 'Spiritist' and 'Blob,' Tell Theories," *San Francisco News*, 18 March 1950. Elmer Bischoff file, San Francisco Art Institute Archives.

9. Park, in White, "Free-form Abstractions."

10. Fred Martin, "The Birth of the Thing; or, Some Recent Developments in the Art of the San Francisco Bay Area," n.d. [ca. 1956], in the Martin papers, roll 1129, frame 441, AAA.

11. The exhibition of *Rehearsal* early in 1950 has led Richard Armstrong to believe that it was begun the previous year, that is, 1949. Richard Armstrong, *David Park*, exh. cat. (New York: Whitney Museum of American Art, 1988), p. 31. Given Park's non-objective entries to other exhibitions in the 1950s, however, I see no reason to believe that the work was completed much earlier than February of that year.

12. *Seventieth Annual Oil and Sculpture Exhibition*, San Francisco Art Association, held at the San Francisco Museum of Art from 28 February to 8 April 1951. *Kids on Bikes* won the "$250.00 San Francisco Art Association Prize for Painting (open only to members of the San Francisco Art Association)."

13. The trumpet player is identified in Mills's notes simply as "Glines," and the trombonist remains unidentified. As the documentary photograph shows, Elmer Bischoff often played with the band; Wally Hedrick is also known to have done so. Paul Mills's notes on this painting were taken while viewing Park's works with Lydia Park on 16 March 1960; Mills papers, ACA.

14. Michael Fried, *Absorption and Theatricality: Painting and Beholder in the Age of Diderot* (Berkeley: University of California Press, 1980). Although it has been argued by some scholars that Fried's categories are ahistorical, his observation remains, for me, intriguing and persuasive: that by depicting their subjects looking inward, turning away from (or otherwise ignoring) the viewer, artists of the eighteenth century sought "to escape the theatricalizing consequences of the beholder's presence" (p. 4). I do not share Fried's antipathy toward the theatrical, but I find his opposi-

tion of the two tendencies a useful approach to narrative figurative painting.

15. Richard Diebenkorn, interviewed by Paul Mills, 23 March 1961, in the Mills papers, ACA. The first quote in Mills, "The Figure Reappears," p. 66; Mills, *Park*, p. 82.

16. Martin, in Mills, "The Figure Reappears," p. 41; Mills, *Park*, p. 70.

17. Bischoff, in Mills, "The Figure Reappears," p. 66; Mills, *Park*, p. 70.

18. Diebenkorn, interview with Mills, 23 March 1961; Mills, *Park*, p. 70.

19. An anonymous author in *Arts Magazine*, possibly Crehan, questioned whether the movement was a "failure of nerve" in an early review. "Figurative Painters in California," 32, no. 3 (December 1957): 25. Frank Lobdell called Park's shift "a betrayal," interview with Terry St. John, roll 3198, frame 353, p. 45, AAA. Smith, in Mills, "The Figure Reappears," p. 41; Mills, *Park*, p. 70.

20. Hassel Smith, in Kevin Power, "A Conversation with Hassel Smith," *Arts Review* [London] (Summer, before 1975): 313; in the Smith papers, roll 2008, frame 352, AAA.

21. James McCray, interviewed by Paul Mills, 19 March 1961, in the Mills papers, ACA. Mills also recalls that Still got a considerably higher salary than Park and the others, providing another impetus for Park's opposition to the New York School painter (Mills, note to the author, 11 March 1989).

22. Diebenkorn, interview with author, 14 January 1988.

23. Park, in White, "Free-form Abstractions."

24. Clyfford Still, course description, ca. 1947, San Francisco Art Institute Archives. David Park, course description, ca. 1947, San Francisco Art Institute Archives.

25. Park, course description. Wanda Corn has suggested to me that Park's pedagogical approach is similar to the early-twentieth-century classroom techniques of both Robert Henri and the New York Art Students' League. It would be intriguing to learn the source of Park's approach to teaching, which former students attest was highly effective.

 See also the folder marked "David Park, Summer 1954, His Suggestions," in the Mills papers, ACA. This fascinating file contains a slim sheaf of notes from a class or classes taught by Park, given to Mills by one of Park's students. Included are a series of "Emotional Experiments" and "Technical Experiments," as follows: "Emotional Experiments: 1) a still life, Van Gogh chair; 2) a landscape, Derain Fauvist landscape; 3) a portrait, Chagall portrait; 4) Greek myth; 5) 'Feel the Mondrian idea'; 6) Unbalanced painting." "Technical Experiments: 1) Painting all in blue—exhaust blueness; 2) Vague—'like the Orientals and transparent like Baziotes'; 3) Opaque; 4) Clear, precise, primitive. Miro's wheat; 5) Primitive with bright and primary colors; 6) All neutral colors; 7) Dark values; 8) Light values." At the very least, these notes suggest Park's wide range of art-historical interests and openness to formal experiment.

26. Still, course description. There is no description on file for Still's advanced painting class; this seems to have been a very unstructured course in which formal rules were abandoned in favor of general discussions about art and the art world.

27. Smith, in Mills, "The Figure Reappears," p. 24; Mills, *Park*, p. 30.

28. Elizabeth M. Polley, "San Francisco: David Park, University Art Gallery, University of California at Berkeley," *Artforum* 3, no. 3 (December 1964): 46.

29. Elmer Bischoff, interviewed by Paul J. Karlstrom, 24 August 1977, p. 42, AAA.

30. Jorge Goya-Lukich, Ad Reinhardt, and Seymour Locks, in Mary Fuller McChesney, *A Period of Exploration: San Francisco, 1945–1950*, exh. cat. (Oakland: The Oakland Museum, 1973), pp. 45, 48, and 49. Still is also said to have gone to the opening of his 1947 exhibition at the California Palace of the Legion of Honor wearing earmuffs, so that he would not have to listen to the babble of collectors and art buffs. Fred Martin, in Georgianna Lagoria, *Northern California Art of the 1960s*, exh. cat. (Santa Clara: de Saisset Museum, University of Santa Clara, 1982), p. 16.

31. Clyfford Still in the late fifties, in Dore Ashton, *The New York School: A Cultural Reckoning* (Harmondsworth: Penguin, 1972), p. 34.

32. David Park, letter to his mother, 4 July 1929. Original in the Mills papers, ACA.

33. Jean Varda, in McChesney, *Period of Exploration*, p. 48.

34. According to James McCray, "Jerry [MacAgy] was pretty T'd off about David. 'I wouldn't write a letter for him if he were the last painter on earth.' She thought David Park was talking about Douglas behind his back, while being nice to his face." McCray, interview with Mills, 19 March 1961.

35. Martin, "General Notes," roll 1129, frame 428.

36. Although Mundt was appointed director in the fall, as late as August Park was still being referred to as acting director. See "En Route to Boston," *Berkeley Gazette*, 24 August 1950, in the San Francisco Art Institute Archives, David Park file 2.

37. Like many other Abstract Expressionists, Still had also begun as a figurative artist, painting portraits to support himself during his early years in San Francisco. His turn to abstraction was slow and steady, unlike Park's convulsive change, and again unlike Park, he never looked back once abstraction had been

achieved. On the contrary, his non-abstract work was essentially suppressed during his lifetime: no exhibition approved by him (and none that I am aware of since) has ever documented or included these figurative canvases.

38. As Diebenkorn told Paul Mills, "I came into his studio one day, while he was hard at work on a nonobjective painting. At the top of the painting [there was] a dark strip, a large white area [and] a purplish shape. He said 'it's a wall and that's the shadow of a bird.'" Diebenkorn was shocked: "I don't know how much of this thinking of this sort he was doing and keeping to himself." Richard Diebenkorn, interviewed by Paul Mills, 15 September 1961, in the Mills papers, ACA. Armstrong (*Park*, p. 29) has also described a head in the image of *Still Life Non-Objective*.

39. David Park, in *Contemporary American Painting*, exh. cat. (Urbana: University of Illinois, 1952), p. 220, and *The Artist's View* no. 6 (September 1953): 4.

40. David Park, in Alfred Frankenstein, "Northern California," *Art in America* 42, no. 1 (Winter 1954): 49, 74.

41. Park, in Frankenstein, "Northern California," p. 49.

42. Diebenkorn, interview with Mills, 23 March 1961; Mills, *Park*, p. 81.

43. Elmer Bischoff, typescript of a talk given at the Oakland Museum in conjunction with the exhibition *A Period of Exploration*, 27 October 1973, in the Bischoff papers, roll 2787, frame 197, AAA.

44. Bischoff, interview with Karlstrom, 24 August 1977, p. 26.

45. Bischoff, typescript of Oakland talk, roll 2787, frames 195, 196, and 198.

46. Bischoff, interview with Karlstrom, 24 August 1977, p. 32.

47. Since deaccessioned, Rothko's *Slow Swirl by the Edge of the Sea* is now in The Museum of Modern Art, New York.

48. Bischoff, interview with Karlstrom, 24 August 1977, p. 36.

49. Bischoff, interview with Karlstrom, 24 August 1977, pp. 33, 31.

50. Bischoff, interview with Karlstrom, 24 August 1977, pp. 28, 29; Bischoff, typescript of Oakland talk, roll 2787, frame 197. As Graham Beal has pointed out to me, Esperanto is a language without a culture, abstract and divorced from real-life experience—Bischoff's choice of language is thus highly appropriate to the recondite world of Abstract Expressionism.

51. Bischoff, typescript of Oakland talk, roll 2787, frames 196–97.

52. Richard Diebenkorn, interviewed by Paul Mills, 21 September 1961, in the Mills papers, ACA; Richard Diebenkorn in 1983, in *David Park*, exh. cat. (New York: Salander-O'Reilly Galleries, 1987), n.p.

53. Bischoff, interview with Karlstrom, 24 August 1977, pp. 36, 29.

54. Bischoff, typescript of Oakland talk, roll 2787, frames 199–200.

55. Bischoff, interview with Karlstrom, 24 August 1977, p. 45.

56. Robert McChesney, in McChesney, *A Period of Exploration*, p. 85.

57. Dimitri Grachis, in McChesney, *A Period of Exploration*, p. 85.

58. Bischoff, interview with Karlstrom, 24 August 1977, p. 55.

59. Bischoff, interview with Karlstrom, 24 August 1977, p. 55.

60. Elmer Bischoff, in Thomas Albright, "Elmer Bischoff: Bay Area Figurative," *Currânt* 1, no. 5 (December 1975–January 1976): 40; Bischoff, interview with Karlstrom, 24 August 1977, p. 45. Mills also confirms that Bischoff was divorced around this same time, and that "he mentioned it to me as part of the cause of his mood then" (note to the author, 11 March 1989).

61. Bischoff, interview with Karlstrom, 24 August 1977, p. 46; Elmer Bischoff, in *Elmer Bischoff*, exh. brochure (San Francisco: California School of Fine Arts, 1956), n.p.; Bischoff, in Albright, "Bischoff," p. 40.

62. Elmer Bischoff, in Blake Green, "The Real Elmer Bischoff: He's the One Who Can't Paint People," *San Francisco Chronicle*, 30 December 1985, pp. 16, 19.

63. Bischoff's entry *Figure and Red Wall* won the first prize of $200 in the *Fifth Annual Oil and Sculpture Exhibition*, Richmond Art Center, 1–30 November 1955.

64. Elmer Bischoff, interviewed by Paul J. Karlstrom, 1 September 1977, p. 54, AAA. This was apparently the first full-scale exhibition of figurative work by any Bay Area artist, and Paul Mills notes that it was one of the inspirations for his 1957 exhibition (note to the author, 11 March 1989).

65. In *Bischoff*, n.p.

66. Elmer Bischoff, in *The Phillips Collection Newsletter* (Fall 1986), in the Bischoff file, folder 2, ACA.

67. Bischoff, in *Bischoff*, n.p.

68. Smith, in Power, "A Conversation," p. 314; and Hassel W. Smith, interviewed by Jan Butterfield, ca. 1975, in the Smith papers, roll 2008, frames 353 and 333, p. 7, AAA.

69. Bischoff, in *Bischoff*, n.p.

70. Bischoff, in Green, "The Real Elmer Bischoff," p. 16.

71. "[The figures] might look a little bit like you or look a little bit like your mother [laughs] or your wife. But that's not what they're about, no. That just creeps in whether you like it or not"; Bischoff, interview with Karlstrom, 1 September 1977, p. 51.

72. Mills feels that Park's new experience teaching a life drawing class at the University of California, Berkeley, was more significant for the classicism of this period than Park's renewed contact with Bischoff (note to the author, 11 March 1989). Since Park had been drawing from the model for years, I continue to believe that Bischoff's work was the more important influence.

73. Diebenkorn, interview with Mills, 23 March 1961; Mills, *Park*, p. 99.

74. There is a possibility that the young boy in Park's painting *City Street* (University of Nebraska Art Galleries, Sheldon Memorial Art Gallery), painted the following year, is also black; and since the setting has been identified as the brick-paved Boston of Park's youth (as Lydia Park noted, the car is vintage twenties), these associations may have deep roots in Park's memories of the past; Mills, "The Figure Reappears," p. 47. The observation that the boy is black is my own conjecture, based upon the treatment of his face and hair.

75. Bill Berkson, "David Park: Facing Eden," *Art in America* 75, no. 10 (October 1987): 199; Hubert Crehan, 1962 interview in Mills, "The Figure Reappears," p. 95.

76. Berkson, "David Park," p. 199. Both Mills and Armstrong reject this notion of self-portraiture and feel certain that the model for the figure was Page Schorer, the adolescent son of one of Park's closest friends.

77. Phyllis Diebenkorn, comment in Paul Mills's interview with Richard Diebenkorn, 1961, in the Mills papers, ACA.

78. Dore Ashton, "First One-Man Show at Poindexter Gallery," *Arts and Architecture* 73 (April 1956): 11.

79. Robert Motherwell and Ad Reinhardt, eds., *Modern Artists in America* (New York: Wittenborn Schultz, 1951). Bischoff's work was also illustrated in this important text.

80. Diebenkorn tells a revealing story about his inevitable falling out with Still. Still honored Diebenkorn by inviting him to his studio, where Diebenkorn knew enough not to say anything. Still then returned the visit, coming to Diebenkorn's studio in Sausalito, where he in turn said nothing. Then, before lunch, Still commented, "I like that," about one painting. Diebenkorn modestly muttered that he was not sure that the color worked, and Still stormed out in disgust at Diebenkorn's talk, which was "for pedants and old-fashioned art teachers." Diebenkorn confessed that he later allowed himself some sweet revenge during a friendly ball game with Still, when he

"burned [Still's] mitt with fastballs." See Dan Hofstadter, "Profiles: Almost Free of the Mirror," *The New Yorker*, 7 September 1987, 63.

81. According to Dan Hofstadter, Diebenkorn first saw de Kooning's work in depth in *Partisan Review* 15, no. 4 (April 1948); Hofstadter, "Profiles," p. 63. Gerald Nordland also thinks Diebenkorn first responded to magazine reproductions of de Kooning's work in 1948; see Gerald Nordland, "Richard Diebenkorn: A Fifteen-year Retrospective Is Organized by the Washington Gallery of Modern Art," *Artforum* 3 (January 1965): 23. However, Maurice Tuchman believes Diebenkorn first saw this 1948 issue in 1950, a date I question given the evidence of the work (assuming the paintings' dates are correct). See Maurice Tuchman, in Robert T. Buck, Jr., et al., *Richard Diebenkorn: Paintings and Drawings, 1943–1976*, exh. cat. (Buffalo: Albright-Knox Art Gallery, 1976), p. 15.

82. Richard Diebenkorn in June 1985, in Gerald Nordland, *Richard Diebenkorn* (New York: Rizzoli International Publications, 1987), p. 35.

83. Elmer Bischoff in June 1985, in Nordland, *Diebenkorn*, p. 35.

84. Richard Diebenkorn, letter to Hassel Smith, 22 August 1979, photocopy in Diebenkorn file, ACA.

85. Richard Diebenkorn, in Mark Lavatelli, "Richard Diebenkorn: The Albuquerque Years," *Artspace* 4, no. 3 (June 1980): 21.

86. Diebenkorn in June 1985, in Nordland, *Diebenkorn*, p. 36.

87. Diebenkorn, in Buck et al., *Diebenkorn*, p. 12.

88. Richard Diebenkorn, in James Schevill, "Richard Diebenkorn," *The Frontier* 8, no. 3 (January 1957): 21–22. See also Diebenkorn's statement in Charles Chetham et al., *Modern Painting, Drawing, and Sculpture Collected by Louise and Joseph Pulitzer, Jr.*, vol. 1 (Cambridge, Mass.: Fogg Art Museum, Harvard University, 1957), p. 31.

89. Richard Diebenkorn, in *California Painting—Forty Painters*, exh. cat. (Long Beach: Long Beach Municipal Art Center, 1955), n.p.

90. Richard Diebenkorn, in Robert Hughes, "California in Eupeptic Color," *Time*, 27 June 1977, 58.

91. De Kooning began his Abstract Urban Landscape series in 1955 (*Gotham News, Street Corner*), but these did not have a true landscape orientation. That would only emerge in 1957 with the Kline-influenced series of Abstract Parkway Landscapes (*Bolton Landing, Parc Rosenberg*).

92. Richard Diebenkorn, letter to Erle Loran, 28 November 1952, in the Loran papers, roll 1716, frame 303, AAA.

93. According to Mark Lavatelli, the drawing teacher was

John Tatschl, who did not share the other faculty members' awe of Diebenkorn's mature and impassioned painting. Lavatelli, "The Albuquerque Years," p. 21.

94. Diebenkorn, interview with author, 14 January 1988.

95. Paul Mills dates the beginning of this group to 1955, but Bischoff did not return to the Bay Area until 1956. It is true, however, that Bischoff made an effort to drive down to San Francisco regularly even when he was living in Marysville, so the joint sessions may well have begun in 1955.

96. Richard Diebenkorn, in response to a questionnaire from Dan Tooker, 3 April 1973, in preparation for a book and filmstrip to be published by Harcourt Brace Jovanovich, in Nordland, *Diebenkorn*, p. 88.

97. Diebenkorn, in Mills, *Figurative Painting*, p. 12.

98. Diebenkorn referred to these drawings in the interview with the author of 14 January 1988. One of them has since been published; see John Elderfield, *The Drawings of Richard Diebenkorn*, exh. cat. (New York: The Museum of Modern Art, 1988), p. 25.

99. Richard Diebenkorn in 1969, in Gail Scott, *New Paintings by Richard Diebenkorn*, exh. brochure (Los Angeles: Los Angeles County Museum of Art, 1969), p. 6.

100. Richard Diebenkorn, in John Gruen, "Richard Diebenkorn: The Idea Is to Get Everything Right," *Art News* 85 (November 1986): 84.

101. See Nordland, *Diebenkorn*, p. 86 and n. 58, for a discussion of the two descriptions of Diebenkorn's first figurative works.

102. Bruce Conner, interviewed by Paul Cummings, 16 April 1973, in the Conner papers, roll 3197, frame 15, p. 19, AAA.

103. Diebenkorn, in Gruen, "The Idea Is to Get Everything Right," p. 85.

104. Nordland, *Diebenkorn*, p. 86.

105. Richard Diebenkorn, 2 July 1985, in Nordland, *Diebenkorn*, p. 86.

106. Hofstadter, "Profiles," p. 68.

107. Diebenkorn, in Gruen, "The Idea Is to Get Everything Right," p. 85.

108. Herschel B. Chipp, "Diebenkorn Paints a Picture," *Art News* 56 (May 1957): 44–47. Nordland notes that the article was commissioned in 1956 on the basis of Diebenkorn's show of abstractions at the Poindexter Gallery; Nordland, *Diebenkorn*, p. 89.

109. *For I have known them all already, known them all—*
Have known the evenings, mornings, afternoons,
I have measured out my life with coffee spoons;
I know the voices dying with a dying fall
Beneath the music from a farther room.

From "The Love Song of J. Alfred Prufrock," 1917, *T. S. Eliot: Collected Poems, 1909–1962* (New York: Harcourt Brace and World, 1963), pp. 4–5.

Although this association occurred to me independently, I was interested to note that T. S. Eliot "had long been a favorite writer" of Diebenkorn's, according to Maurice Tuchman, in Buck et al., *Diebenkorn*, p. 13.

110. Diebenkorn, in Hofstadter, "Profiles," p. 61.

111. Diebenkorn, 1 July 1985, in Nordland, *Diebenkorn*, p. 92.

112. Diebenkorn, 1 July 1985, in Nordland, *Diebenkorn*, p. 92.

113. Hassel Smith to "M & R" (probably Mary and Robert McChesney), ca. February 1957, in *Hassel Smith*, the brochure for his San Francisco Art Association Gallery exhibition at the California School of Fine Arts, 8–29 March 1957; Smith, exh. brochure. Smith did "go back," producing a group of satirical, Pop-styled figurative works around 1964. The experiment was largely unsuccessful and he moved on to a highly geometric form of abstraction more in tune with Op and hard-edged painting than with his earlier Abstract Expressionism.

114. Hubert Crehan, "Woman Trouble," *Arts Digest* 27, no. 14 (15 April 1953): 5. De Kooning's first Woman series began in 1938 and culminated in 1944, before his great black-and-white abstractions. He returned to the theme in 1947, executing the seated women in 1948 concurrent with the exhibition of the black-and-white works. Then in 1950, in the same year he painted *Excavation*, he began the third series of Woman paintings, which would be exhibited for the first time in 1953 at Sidney Janis, causing a critical uproar over the "return" of the figure in de Kooning's work. Emphasis my own.

115. Willem de Kooning, to David Sylvester, "Painting as Self-discovery," BBC broadcast, 30 December 1960; transcript edited and published as "Content Is a Glimpse . . .," *Location* [New York] 1 (Spring 1963): 46.

116. I have in preparation a lengthy study of formalist criticism and American art from which this discussion is drawn. A useful treatment of selected aspects of the phenomenon can be found in Bradford R. Collins, "Clement Greenberg and the Search for Abstract Expressionism's Successor: A Study in the Manipulation of Avant-Garde Consciousness," *Arts Magazine* 61, no. 9 (May 1987): 36–43.

117. Dorothy Gees Seckler, "Gallery Notes: Preview of 1960," *Art in America* 4 (Winter 1959): 116.

118. Frank Getlein, "Kidding the Id in Minneapolis," *The New Republic*, 26 August 1957, 21.

119. Bischoff, interview with Karlstrom, 24 August 1977, p. 44.

120. Bischoff, interview with Karlstrom, 1 September 1977, p. 50.

Chapter Three

1. Richard Diebenkorn, interviewed by Susan Larsen, 24 and 31 May 1977, tape 4, AAA.

2. See *The Triumph of the Figure in Bay Area Art, 1950–1965*, exh. brochure (San Francisco: 871 Fine Arts Gallery, 1987).

3. Wally Hedrick, in Joan Chambliss Bossart, "Bay Area Figurative Painting Reconsidered" (Master's thesis, University of California, Berkeley, 1984), p. 12. I am grateful to Paul Wonner and Theophilus Brown for bringing Bossart's work to my attention and loaning me their personal copy of her manuscript.

4. The job at Berkeley paid approximately $5,300 per annum for a fixed course load (see Bossart, "Bay Area Figurative," p. 20), as contrasted with the payment per course at the School of Fine Arts, which totaled $13 per unit per week. For a three-unit course a teacher's income at the School of Fine Arts would thus be roughly $600 per course per semester (in San Francisco Art Institute Archives, letters for Diebenkorn, Bischoff, and Park; Still and Rothko were probably paid more). All who knew Park saw the Berkeley job as the opportunity of a lifetime, and there were rumors that Berkeley had offered $10,000. "People were just staggered by that," recalled Nathan Oliveira, who was at the time teaching eighteen hours a week for $2.50 per hour; Nathan Oliveira, interviewed by Paul J. Karlstrom, 2 October 1978, roll 3198, frame 1045, p. 32, AAA.

5. Many feel that Mundt was a problematic choice as director, because his strong commitment to a Bauhaus-type curriculum had little in common with the local community of artists and teachers. But he was successful in getting the school accredited, which was a crucial prerequisite for establishing a graduate program, obtaining federal grants and student loans, and allowing the school to compete nationally for talented students. Joan Brown was a member of the first class to obtain graduate degrees in 1960.

6. Hedrick, in Bossart, "Bay Area Figurative," p. 13.

7. Nathan Oliveira, interviewed by Paul J. Karlstrom, 9 August 1978, roll 3198, frame 1051, p. 38, AAA.

8. Oliveira himself, however, declared in the late sixties to the scholar Noreen Mary Richeda that his "concern for the figure is primarily a formal one . . . the implications are unconscious." This suggests the pervasive grip of formalist values on American artists at that moment more than it does any real formalist leanings on Oliveira's part. See Noreen Mary Richeda, "San Francisco Bay Area 'New Figurative' Painters, 1950–65" (Ph.D. diss., University of California, Los Angeles, 1969), p. 193.

9. Fred Martin, in Bossart, "Bay Area Figurative," p. 13.

10. Oliveira, interview with Karlstrom, 2 October 1978, frame 1059, p. 46.

11. The annual discussed here was the *San Francisco Art Association Artist Members' Show*, held in December 1956 at the M. H. de Young Memorial Museum. The *Seventy-fifth San Francisco Art Association Annual* held at the San Francisco Museum earlier that year (from 29 March to 6 May) contained figurative works by Park, Bischoff, Brown, McGaw, and others, but Diebenkorn was still represented by a Berkeley series abstract landscape.

William Theophilus Brown has changed his professional name to Theophilus Brown because of persistent confusion between his name and that of the painter William H. Brown and others (a confusion extending even to Mills's 1957 Oakland show, the catalogue for which identifies William T. Brown as William A. Brown). Following his preference, the present book identifies him as Theophilus Brown.

12. *Directions: Bay Area Painting, 1957*, Richmond Art Center, 1 August–25 September 1957.

13. Martin, in Bossart, "Bay Area Figurative," p. 1.

14. Paul Mills, "The Figure Reappears: The Art of David Park and Bay Area Figurative Painting from 1950 to 1960" (Master's thesis, University of California, Berkeley, 1962), p. 122. I consulted the revised version in the ACA.

15. Richard Diebenkorn, in John Gruen, "Richard Diebenkorn: The Idea Is to Get Everything Right," *Art News* 85 (November 1986): 82.

16. Richard Diebenkorn, interviewed by the author, 14 January 1988.

17. Elmer Bischoff, interviewed by the author, 9 March 1988.

18. Diebenkorn, interview with author, 14 January 1988.

19. "Next Direction Show," *Oakland Tribune*, 28 April 1957. Duplicates of article in Park and Diebenkorn artist files, ACA.

20. Mills recalls: "Nathan Oliveira was one prominent figurative painter who was considered, and whom I advocated, but whom the triad did not include on their approved list." Although in some ways better known at the time than Park, Bischoff, or even Diebenkorn, Oliveira was not personally close to the three older artists. He had been a student at the California College of Arts and Crafts—looked down upon locally as commercial and less avant-garde than the California School of Fine Arts. In addition, Oliveira was a printmaker, a medium abjured by many contemporary artists as old-fashioned and unspontaneous. Mills states: "I thought then and still think his work should have been included in the 1957 show" (note to the author, 11 March 1989).

21. With the exception of McGaw, these artists are not included in the 1989 exhibition. Qualters soon moved away from the Bay Area, and most of his

work from the period has been lost. Downs also left the area, produced little further figurative work, and later committed suicide. Villierme, whom Diebenkorn remembers as one of his most promising students, stopped painting soon after the exhibition when his new wife persuaded him that painting was not a suitable career.

22. Brown enjoyed a close friendship with Elaine de Kooning; thus it is not surprising that his style and choice of subject matter were closer to hers than to those of colleagues who were physically much nearer. See, for example, Elaine de Kooning's *High Man*, a brushy painting of a group of basketball players dating from 1954 (repro. in Paul Schimmel et al., *The Figurative Fifties*, exh. cat., Newport Beach, Newport Harbor Art Museum [New York: Rizzoli International Publications, 1988], p. 63, pl. 5).

23. Paul Mills, *Contemporary Bay Area Figurative Painting*, exh. cat. (Oakland: The Oakland Art Museum, 1957), p. 16.

24. John L. Ward, "American Realist Painting, 1945– 1980" (Ph.D. diss., Boston University, 1984), pp. 125–26. I am indebted to Charlotte Wellman for bringing this dissertation to my attention.

25. Bonny B. Saulnier, *James Weeks*, exh. cat. (Waltham, Mass.: Rose Art Museum, Brandeis University, 1978), p. 14.

26. James Weeks, interviewed by the author, 19 March 1988.

27. Saulnier, *Weeks*, p. 14.

28. Lydia Park to Paul Mills, 16 March 1960, in the Mills papers, ACA.

29. See Sketchbook #1, which contains another drawing dated 6 January 1926, in the Park papers, roll 3002, frame 51.

30. Paul Mills discusses Park's admiration for Piero, referring to the memory of Park's friend Mark Schorer, who recalled Park admiring the rhythm of the horses' legs in the *True Cross* fresco and the interlocking frieze of people in *King Solomon Meeting with the Queen of Sheba* (both Arezzo, Church of S. Francesco). Mills, "The Figure Reappears," p. 71; Mills, *Park*, p. 85.

31. The Munch exhibition of 1951 was organized by the Institute of Contemporary Art in Boston, in cooperation with the Norwegian government. It traveled to ten American cities, having its San Francisco showing from 10 February to 10 March 1951 at the M. H. de Young Memorial Museum. According to Jeffrey Wechsler, who interviewed many of the artists, "Bischoff, Oliveira, Diebenkorn, Park, and Smith all saw the show; it made a great impression on them"; in Greta Berman and Jeffrey Wechsler, *Realism and Realities: The Other Side of American Painting, 1940– 1960*, exh. cat. (New Brunswick, N.J.: Rutgers University Art Gallery, 1981), p. 158.

32. Joan Brown, interviewed by the author, 15 May 1988. Brown further recalled a group drawing session from the early seventies when Bischoff announced that he was no longer going to be working with the group, or working with figures at all. "He said he was getting worried about psychologically what was coming out in the canvas—the unconscious bubbling up." Similarly, Nathan Oliveira remembers visiting Bischoff's studio several times around 1957–58 when the two men were teaching together at the School of Fine Arts, and hearing Wagner pouring out in the background. "Elmer Bischoff and I . . . we'd literally fight over the figure—I felt the figure as a symbol, and he denied that. I felt looking at his paintings— they were loaded with symbolism and emotional content, but he couldn't see it. . . . His life was loaded with drama at the time, it had to spill into his paintings." Nathan Oliveira, interviewed by the author, 21 January 1988.

33. Playing-card motifs in particular seem to function for Diebenkorn as negotiators bridging the gap between figurative and abstract imagery; these seem to be more female than male. Note, for example, the sensuously suggestive forms of his 1981 Playing Card series of gouaches (particularly *Untitled #51*, illustrated in Gerald Nordland, *Richard Diebenkorn* [New York: Rizzoli International Publications, 1987], p. 215). These works did not meet with much critical success when they were first shown in New York, which may have discouraged Diebenkorn from pursuing such a potentially fruitful, apparently new (but actually old and personally rich) direction. Although he made prints incorporating these motifs, he returned in his painting to the Ocean Park format of more purely linear geometries. Perhaps with his recent move from Ocean Park back to Northern California, the heraldic negotiators will reappear.

34. Conservation report by Gustav Berger for The Phillips Collection, 10 May 1976, in collection files for *Interior with View of the Ocean*. Berger notes that the repainting of the canvas has contributed to its poor condition. Photographs of the canvas back show the inscription *Berkeley #54, January 1955*, crossed out and replaced by the current title. The history of the canvas must be interesting, for a torn label for a *Young Col[lectors'] Exhibition* from the San Francisco Museum of Art suggests that the Berkeley painting was in a private collection before it was repainted.

35. Maurice Tuchman, in Robert T. Buck, Jr., et al., *Richard Diebenkorn: Paintings and Drawings, 1943–1976*, exh. cat. (Buffalo: Albright-Knox Art Gallery, 1976), p. 6.

36. Matisse's odalisque in striped pantaloons occurs most frequently in his prints, images that were even more accessible to Diebenkorn than the paintings.

37. The erotic content of Diebenkorn's figures may not be entirely unconscious, as suggested by a number of items in the estate of the late Carey Stanton, a friend of Diebenkorn's since the two were undergraduates

together at Stanford. These items include a small, much more explicit painting of a model wearing the same skirt. Seated on a chair with one foot on the floor and the other on the chair's seat, she raises her front leg; her skirt parts to allow an unobstructed view between her legs. Although it is an interior, the painting could almost be a study for *Girl on the Beach*, for her raised front leg bars physical, but not visual, access in the same manner as the foremost leg in *Girl on the Beach*. Underscoring the significance of these raised-leg, parted-thigh poses is a Christmas card sent to Stanton from Diebenkorn and his wife (undated, signed *Phil + Witz* in Diebenkorn's hand). The card consists of a blown-up photographic detail from a nineteenth-century painting depicting two women in hoop skirts sitting on the ground so that their hoops balloon up and reveal to the viewer the absence of underwear.

38. Hilton Kramer, "Pure and Impure Diebenkorn," *Arts Magazine* 38, no. 3 (December 1963): 51.

39. The effect of light shining through skin, particularly ears, was created again and again by Park, becoming a kind of signature in works such as *Man in a T-shirt* at the San Francisco Museum of Modern Art. The ears may have their specific source in the early figurative paintings of Hassel Smith, especially his many self-portraits of the forties in which the ears are even ruddier than the rest of his face.

40. George Stillman, a fellow painter and colleague of Park's at the California School of Fine Arts, recalls waiting for Park to finish painting on days when they would share a ride back to Berkeley. He remembers Park constantly reworking his canvases, layering the paint on again and again, rarely ready to quit even for the day. George Stillman, interviewed by the author, 25 August 1988.

41. The Galka Scheyer collection, mentioned previously in connection with Park's possible exposure to the German Expressionists, contained several great Jawlensky heads as well, which may have resonance in *Four Men*.

42. Morgan Flagg, the painting's current owner, conversation with the author, 21 May 1988.

43. Mills, *Park*, pp. 83–85.

44. I am grateful to Richard Armstrong for reminding me of this particular detail in Piero's fresco, and for stressing Park's undoubted interest in it.

45. Richard Armstrong, *David Park*, exh. cat. (New York: Whitney Museum of American Art, 1988), p. 45. Betsy Fryberger also cites the number of gouaches as one hundred, in *David Park: Works on Paper*, exh. cat. (Stanford: Stanford University Museum of Art, 1988). Fryberger and Armstrong have each corrected a prevalent misunderstanding of Park's chronology by identifying these gouaches as the artist's last works. Prior to their research, scholars had relied upon Mills, who had erroneously described the

1959–60 felt-tip pen drawings as Park's last efforts, based on their premonitory suggestions of death. Mills has since stated that he believes the gouaches "could well be the last," but cautions that there is little solid information for such dating (note to the author, 11 March 1989).

46. Mills, "The Figure Reappears," p. 118; Mills, *Park*, p. 110.

47. H[ubert] C[rehan], "Reviews and Previews," *Art News* 58, no. 9 (January 1960): 12.

48. Richard Diebenkorn, in Beth Coffelt, "Doomsday in the Bright Sun," *San Francisco Examiner and Chronicle, California Living Magazine*, 16 October 1977, 28.

49. Mark Stevens, in *Richard Diebenkorn: Etchings and Drypoints, 1949–1980* (Houston: Houston Fine Arts Press, 1981), p. 17. Also note Diebenkorn's statement to Gail Scott in "New Paintings by Richard Diebenkorn," exh. brochure (Los Angeles: Los Angeles County Museum of Art, 1969), n.p.: "I've been very conscious in a lot of paintings of things, that I select them because they're simply there in a way that gets to me, and to say things beyond that would negate the nice simplicity of the thereness."

50. Nordland, *Diebenkorn*, p. 94.

51. In comparison to *Interior with Book* see Picasso's etching from the Vollard Suite showing a model contemplating a Surrealist sculpture of herself, in which an open book is mounted on a chair frame to form her legs and groin. Attesting to the fame of this image, George Segal offered a three-dimensional homage to it in his sculpture *Picasso's Chair* from 1973.

52. Nordland, *Diebenkorn*, p. 104.

53. Richard Diebenkorn, response to artist questionnaire regarding the subject of *Interior with Doorway*, object file, Pennsylvania Academy of the Fine Arts, Philadelphia.

54. The thieves actually came later, during the 1977 showing of the Diebenkorn retrospective at The Oakland Museum. A twenty-four-year-old student from San Francisco State University named James Gibbons stole a small still life during the exhibition opening, later claiming "it was a prank to spoof 'all those people who thought the painting, a rather unattractive work, was consecrated.'" "Stolen Art 'Prank' Ending Up in Court," *San Francisco Chronicle*, 16 November 1977, 63.

55. I intend the pun, and possibly Weeks does too.

56. Saulnier, *Weeks*, p. 15. See also Richeda, "'New Figurative' Painters," p. 112.

57. Saulnier, *Weeks*, p. 15.

58. Anita Ventura, "James Weeks: The Plain Path," *Arts Magazine* 38, no. 5 (February 1964): 51.

59. Richeda writes that Weeks worked in "an abstract manner" after the Second World War. Whether these

works were non-objective is not discussed. Richeda, "'New Figurative' Painters," p. 105.

60. Weeks, interview with author, 19 March 1988.

61. Weeks, interview with author, 19 March 1988.

62. Although my reading suggests that Bischoff's treatment of the sky is against the traditional formulae of landscape painting, Mills recalls that Bischoff was tremendously excited by the freedom he felt in his new figurative work to rediscover the example of nineteenth-century landscape painting, with its evocation of the sky's gradual modulation from light to dark (as opposed to modernism's emphasis on bold juxtapositions of planes of color) (note to the author, 11 March 1989).

63. Elmer Bischoff, in Suzaan Boettger, "Energy and Light," *California Monthly* [University of California at Berkeley Alumni Magazine] (May 1985): 16.

64. Bischoff, in Boettger, "Energy and Light," p. 16.

65. Richeda, "'New Figurative' Painters," p. 61.

66. Mrs. Walter Salant, owner with her husband of Bischoff's 1960 painting *Figures, Back and Profile*, remarked that both women in this canvas resemble the young Adelie Bischoff in the early sixties.

67. Elmer Bischoff, interviewed by Paul J. Karlstrom, 1 September 1977, p. 79, AAA.

68. Bischoff, interview with author, 9 March 1988.

69. Elmer Bischoff, conversation with the author, 15 December 1988.

70. Bischoff, in Boettger, "Energy and Light," p. 17. The painting Bischoff is discussing is *Interior and Cityscape*, at the time of writing on extended loan from the artist to the University Art Museum, University of California, Berkeley.

71. Albert Elsen, professor of art history at Stanford University, recalls that Diebenkorn had already tentatively begun moving back into abstraction in 1964, while he was artist-in-residence at the university. Reminiscent of the almost surreptitious manner of his move toward the figure ten years earlier, Diebenkorn showed Elsen some of the abstract paintings he kept in a closet in his studio on campus. If any of these abstractions survive, they have not been made public by the artist.

72. Nordland, *Diebenkorn*, p. 140.

73. Paul Mills, "Bay Area Figurative," *Art in America* 52, no. 3 (June 1964): 43, 44, 42.

74. "Figurative Painters in California," *Arts* 32, no. 3 (December 1957): 25.

75. Richard Diebenkorn, in Stanley Eichelbaum, "An Abstract Artist's Return to Landscapes and Figures," *San Francisco Examiner*, *Highlight* section, 23 October 1960. Duplicate in Diebenkorn file, Louise Sloss Ackerman Fine Arts Library, San Francisco Museum of Modern Art.

76. Sidney Tillim, "Month in Review," *Arts Magazine* 35, no. 7 (April 1961): 46.

77. Hubert Crehan, letter of February 1957, in Dore Ashton, "The San Francisco School," *Evergreen Review* 1, no. 2 (1957): 159.

78. George Staempfli had gone to the West Coast to search for talent at the suggestion of Robert Beverly Hale, curator at The Metropolitan Museum of Art. Although Diebenkorn was represented by Poindexter, none of the other Bay Area artists had galleries in New York. Staempfli's advocacy of the older artists and his support for younger painters and sculptors such as Joan Brown and Manuel Neri were crucial factors in the survival of the movement.

79. Dore Ashton, "Art: Elmer Bischoff's Paintings at the Staempfli," *The New York Times*, 8 January 1960.

80. Hilton Kramer, "Month in Review," *Arts Magazine* 34, no. 4 (January 1960): 42, 45.

CHAPTER FOUR

1. Wonner showed *Landscape II*, 1953, oil and charcoal on canvas, 36 × 44 in.; James Johnson Sweeney, *Younger American Painters*, exh. cat. (New York: Solomon R. Guggenheim Museum, 1954); "Camera Kickoff for Art," *Life*, 8 October 1956, 14–15.

2. See Elaine de Kooning, "Subject: What, How, or Who?" *Art News* 54, no. 4 (April 1955): 27, in which she discusses using another artist's work as a subject for painting, as valid as if it were an aspect of the natural world.

3. Paul Wonner, in Paul Mills, *Contemporary Bay Area Figurative Painting*, exh. cat. (Oakland: The Oakland Art Museum, 1957), p. 17.

4. Paul Wonner, in *Paul Wonner*, exh. brochure (San Francisco: San Francisco Art Association Gallery, California School of Fine Arts, 1956), n.p.

5. Theophilus Brown, paraphrased in Mills, *Figurative Painting*, p. 17.

6. Wonner was born in 1920, Brown in 1919, and Diebenkorn in 1922. Born in 1916, Bischoff would have been the senior member of the group after Park's death.

7. Nathan Oliveira, interviewed by Paul J. Karlstrom, 6 October 1978, roll 3198, frame 1050, pp. 37 and passim, AAA.

8. Theophilus Brown, in Yvette Friedli Shaak, "The Bay Area School of Figurative Painting: An Analysis" (Master's thesis, California State College at Long Beach, 1967), p. 127; quoted in Noreen Mary Richeda, "San Francisco Bay Area 'New Figurative' Painters, 1950–1965" (Ph.D. diss., University of California, Los Angeles, 1969), p. 138.

9. Paul Wonner, in Shaak, "Bay Area School," p. 128; quoted in Richeda, "'New Figurative' Painters," p. 149.

10. Wonner, in *Wonner*, n.p.

11. Wonner, in *Wonner*, n.p.

12. Wonner, in Mills, *Figurative Painting*, p. 17.

13. Richeda, "'New Figurative' Painters," p. 139.

14. Brown, in Mills, *Figurative Painting*, p. 16.

15. Wonner, in Mills, *Figurative Painting*, p. 17.

16. The self-portrait pose was first noted to the author by Harry Rand, curator at the National Museum of American Art, Washington, D.C.

17. Allan Temko, "Wonner at the Modern: A Disappointing Show from a One-time Middleweight Contender," *San Francisco Examiner-Chronicle*, 18 October 1981. Temko's passion for the heroic Abstract Expressionists rendered him less than sympathetic to what he termed Wonner's "cheap postcard allusions to masters" and "giggling effrontery." The reading of bourgeois capitalism is by Suzaan Boettger and Sandy Ballatore, "Morandi and Wonner: The Metaphysical Philosopher Meets the Abstract Realist," *Spotlight* (Summer 1982): 51.

18. In this trajectory from a more painterly to a hard-edged style, Wonner mirrors (in some sense paradoxically) the career of Alfred Leslie, who began painting in a second-generation Abstract Expressionist style and converted to a hard-edged figurative one in the 1960s. Some would argue that Leslie's figurative paintings were more accessible, and in depicting figures were thus more about life. But to an art historian, they are oppressively art-historical pictures, slavish updatings of Caravaggio with suburban characters as bathetic as they are alienating. Similarly, while Wonner's "Dutch still lifes" offer their audience the immediate reward of recognizability, they ultimately forfeit some of the empathy available to the patient viewer of the earlier figurative work.

19. Brown, in Shaak, "Bay Area School," p. 142; quoted in Richeda, "'New Figurative' Painters," p. 138.

20. L[awrence] C[ampbell], "Reviews and Previews: William T. Brown," *Art News* 61, no. 2 (April 1962): 15.

21. Theophilus Brown to the author, 13 April 1988. In 1957 Brown told Mills, "I wanted to do figure compositions but I was tired of the classic kind with everybody just standing around, so I used photos in sports magazines as a starting point"; Mills, *Figurative Painting*, p. 16. As he moved to nudes, he shifted to magazines that offered this kind of imagery.

22. C[ampbell], "William T. Brown," p. 15.

23. William Inge, in *William Theo Brown*, exh. cat. (Lawrence: The Museum of Art, University of Kansas, 1967), n.p.

24. See reproductions of both *The Swing* and *Pedestrian Crossing* in *William Theo Brown*, nos. 23 and 22.

25. In this discussion, I do not mean to suggest that the classicizing and voyeuristic domains are mutually exclusive. Feminist scholars and critics such as Laura Mulvey and Linda Nochlin have demonstrated that the erotics of the male gaze animate most paintings of the female nude in the Western tradition, whether classic or pornographic. The phenomenon is complicated in the case of Bay Area Figurative painting by the presence of male nudes in the work of Wonner, Brown, Park, Bischoff, Oliveira, and Neri, and by the range of implications generated (from homoerotic to autobiographic). I hope to pursue these implications in another essay.

26. Oliveira, interview with Karlstrom, 6 October 1978, roll 3198, frame 1068, p. 55.

27. Nathan Oliveira, letter to Charles Alan, 3 December 1957, in the Alan Gallery papers, roll 1381, frame 812, AAA. Oliveira's response is quite measured and generous, considering that Alan had written him on 21 November about the exhibition catalogue: "Who is Mr. Paul Mills? I have never heard of him. The catalogue depressed me because all the paintings looked like School of Diebenkorn. I am really so happy that you seem to have withstood the onslaught so well"; in the Alan Gallery papers, roll 1981, frame 810.

28. Nathan Oliveira, interviewed by Paul J. Karlstrom, 2 October 1978, roll 3198, frame 1049, p. 36, AAA. Oliveira's distancing himself from his figurative colleagues may also mask "anxieties of influence," to use Harold Bloom's phrase describing the urge to separate oneself from close and powerful examples (as in Bischoff's adamant rejection of Hopper as an influence).

29. Nathan Oliveira, letter to the author, 11 February 1988.

30. Nathan Oliveira, interviewed by Paul J. Karlstrom, 9 August 1978, roll 3198, frame 1019, p. 6, AAA. Biographical information is taken largely from this interview; additional data from Thomas Garver et al., *Nathan Oliveira: A Survey Exhibition, 1957–1983*, exh. cat. (San Francisco: San Francisco Museum of Modern Art, 1984).

31. Oliveira, in Garver et al., *Oliveira*, p. 9.

32. Oliveira, interview with Karlstrom, 9 August 1978, frame 1028, p. 15; frame 1025, p. 12; frame 1035, p. 22.

33. Oliveira, interview with Karlstrom, 9 August 1978, frame 1027, p. 14.

34. Oliveira, interview with Karlstrom, 9 August 1978, frame 1030, p. 17; frame 1031, p. 18.

35. Oliveira, interview with Karlstrom, 9 August 1978, frame 1028, p. 15. The article in *Time* was a review of de Kooning's famous 1953 exhibition at the Sidney Janis gallery, *Paintings on the Theme of the Woman*.

36. Oliveira, interview with Karlstrom, 9 August 1978, frame 1036, p. 22.

37. Oliveira, interview with Karlstrom, 6 October 1978, roll 3198, frame 1043, p. 30.

38. Oliveira, ca. 1967, in Shaak, "Bay Area School," p. 134; quoted in Richeda, "'New Figurative' Painters," p. 118.

39. I do not find persuasive Richeda's flat claim that Oliveira "turned from abstract to figurative painting because of the influence of David Park and Richard Diebenkorn." As the studio photograph in Fig. 4.1 indicates, Oliveira was exploring the figure *simultaneously* with his abstract works, and before Diebenkorn's or Bischoff's figurative works had been shown. See Richeda, "'New Figurative' Painters," p. 117. Her discussion of the impact that the joint drawing sessions had in forcing Oliveira to articulate his differences with the older, more established figurative artists is undoubtedly correct.

40. Nathan Oliveira, interviewed by the author, 21 January 1988.

41. Oliveira, in Shaak, "Bay Area School," pp. 129–30; quoted in Richeda, "'New Figurative' Painters," p. 120.

42. Oliveira, interview with Karlstrom, 2 October 1978, roll 3198, frame 1049, p. 36.

43. Oliveira, in Garver et al., *Oliveira*, p. 12.

44. Oliveira, in Garver et al., *Oliveira*, p. 12.

45. Oliveira, interview with Karlstrom, 9 August 1978, roll 3198, frame 1040, p. 27.

46. Oliveira, interview with Karlstrom, 9 August 1978, frame 1034, p. 21.

47. Nathan Oliveira, letter to Charles Alan, 11 September 1959, in the Alan Gallery papers, roll 1381, frame 870, AAA.

48. Nathan Oliveira, letter to Charles Alan, 29 September 1957, in the Alan Gallery papers, roll 1381, frame 801, AAA.

49. Nathan Oliveira, in *Contemporary American Painting and Sculpture*, exh. cat. (Urbana: University of Illinois at Urbana, 1961), p. 208; quoted in Richeda, "'New Figurative' Painters," p. 129.

50. S[idney] T[illim], "In the Galleries: Nathan Oliveira," *Arts Magazine* 33, no. 3 (December 1958): 57–58.

51. Nathan Oliveira, letter to Charles Alan, 12 December 1957, in the Alan Gallery papers, roll 1381, frame 816, AAA.

52. Oliveira, interview with Karlstrom, 2 October 1978, frames 1058 and 1057, pp. 45 and 44.

53. Oliveira, letter to Charles Alan, 11 September 1959, roll 1381, frame 870.

54. In a letter dated 14 August 1960 to Charles Alan, Oliveira notes that he is shipping the painting; see Alan Gallery papers, roll 1381, frame 898. Observations of moths were made by the author when examining the painting 2 May 1988.

55. *New Images of Man*, The Museum of Modern Art, New York, 30 September–29 November 1959.

56. Nathan Oliveira, interviewed by Paul J. Karlstrom, 7 September 1980 and 9 August 1978, roll 3198, frame 1099, p. 86, and frame 1040, p. 27, AAA.

57. Nathan Oliveira, letter to Charles Alan, 13 September 1960, in the Alan Gallery papers, roll 1381, frame 900, AAA.

58. See newspaper clippings in the Alan Gallery papers, roll 1391, frames 261 and 262, AAA.

59. Charles Alan, letter to Nathan Oliveira, 7 December 1960, in the Alan Gallery Papers, roll 1381, frame 907, AAA.

60. Nathan Oliveira, letters to Charles Alan, 14 December 1960 and 27 January 1960, in the Alan Gallery papers, roll 1381, frames 910 and 890, AAA.

61. Nathan Oliveira, letter to Charles Alan, 12 March 1959, in the Alan Gallery papers, roll 1381, frame 856, AAA.

62. Garver, in Garver et al., *Oliveira*, p. 15.

63. Oliveira, in Garver et al., *Oliveira*, p. 13.

64. Nathan Oliveira, interviewed by Paul J. Karlstrom on the subject of artists and models, 29 December 1981, pp. 6 and 10, typescript in San Francisco office, AAA.

65. Nathan Oliveira and Charles Alan correspondence, 3 March and 5 April 1961, in the Alan Gallery papers, roll 1381, frames 929–932, AAA.

66. Nathan Oliveira, letters to Charles Alan, 1 May and 23 May 1963, in the Alan Gallery papers, roll 1381, frames 978, 983, and 984, AAA.

67. Oliveira, interview with the author, 21 January 1988.

68. Oliveira, interview with Karlstrom, 2 October 1978, roll 3198, frame 1059, p. 46. Oliveira has corrected the Archives' transcript, which reads "dump change," to read "don't change."

69. Unidentified review in Oliveira press file, in the Alan Gallery papers, roll 1391, frame 262; Nathan Oliveira to Charles Alan, 1 May 1963, in the Alan Gallery papers, roll 1381, frame 976, AAA.

70. Nathan Oliveira, *Baboon*, 1957, mixed media on paper, Solomon R. Guggenheim Museum, 1957.1716. Oliveira recalls that this work is related to Kokoschka's painting of a mandrill, which he greatly admired (conversation with the author, 14 February 1989).

71. Nathan Oliveira, letter to Charles Alan, 12 March 1959, in the Alan Gallery papers, roll 1381, frame 856, AAA.

CHAPTER FIVE

1. Joan Brown, conversation with the author, 15 March 1988.

2. See taped panel discussion, "Funk Art Symposium," chaired by Peter Selz on 28 April 1967, including Mowry Baden, Joan Brown, Bruce Conner, Jim Melchert, Manuel Neri, and Peter Voulkos; AAA.

3. Bruce McGaw, interviewed by the author, 19 February 1988.

4. Joan Brown, "Funk Art Symposium."

5. Richard Armstrong, *David Park*, exh. cat. (New York: Whitney Museum of American Art, 1988), p. 46.

6. Bruce McGaw, interview with author, 19 February 1988.

7. McGaw, interview with author, 19 February 1988.

8. McGaw, interview with author, 19 February 1988.

9. McGaw, interview with author, 19 February 1988.

10. Paul Mills, *Contemporary Bay Area Figurative Painting*, exh. cat. (Oakland: The Oakland Art Museum, 1957), p. 18.

11. Mills, *Figurative Painting*, p. 18.

12. Bruce McGaw, conversation with the author, 20 April 1988.

13. The spelling of the gallery name is based on the memory of Wally Hedrick, one of its founding members. Printed announcements from the gallery give the title variously as The Six Gallery, The 6 Gallery, The "6," The 6, and 6 Gallery. Announcements from the gallery file, Louise Sloss Ackerman Fine Arts Library, San Francisco Museum of Modern Art.

14. McGaw, interview with author, 19 February 1988.

15. Mills and McGaw, in Mills, *Figurative Painting*, p. 19.

16. McGaw, interview with author, 19 February 1988.

17. McGaw, conversation with author, 20 April 1988.

18. Miró's *Portrait #1* is reproduced on p. 95 of *Miró in the Collection of The Museum of Modern Art* (New York: The Museum of Modern Art, 1959). The Rembrandt self-portrait, from 1668, is plate no. 124 in Ludwig Goldscheider, *Rembrandt: Paintings, Drawings, and Etchings* (London: Phaidon, 1960).

19. Manuel Neri, interviewed by George Neubert, 19 July 1976, p. 2 of transcript in Neri file, ACA.

20. Manuel Neri, in Thomas Albright, "Manuel Neri's Survivors: Sculpture for the Age of Anxiety," *Art News* 80, no. 1 (January 1981): 59.

21. Manuel Neri, in Thomas Albright, "Manuel Neri: A Kind of Time Warp," *Currânt* 1, no. 1 (April–May 1975): 14.

22. Manuel Neri, interview with Neubert, 19 July 1976, p. 6, ACA.

23. Manuel Neri, in Hugh J. Delehanty, "Manuel Neri: Cast from a Different Mold," *Focus* (January 1982): 24.

24. Neri, in Albright, "A Kind of Time Warp," p. 11.

25. Manuel Neri papers, roll 2290, frame 43, AAA.

26. Manuel Neri, interviewed by the author, 1 March 1988.

27. Neri, in Delehanty, "Cast from a Different Mold," p. 24.

28. McGaw, interview with author, 19 February 1988.

29. Neri, interview with author, 1 March 1988.

30. Neri, in Albright, "A Kind of Time Warp," p. 13.

31. Albert Elsen has pointed out to me that there was a surge of interest in color on sculpture in the early sixties, as evidenced by a number of articles on the subject in art magazines.

32. Neri, in Albright, "A Kind of Time Warp," p. 13.

33. Neri, in Albright, "A Kind of Time Warp," p. 13.

34. Brown, conversation with author, 15 March 1988.

35. Neri, in Albright, "A Kind of Time Warp," p. 13.

36. Sandra Leonard Starr and Wally Hedrick, in Sandra Leonard Starr, *Lost and Found in California: Four Decades of Assemblage Art*, a three-part cat. accompanying exhibition organized by James Corcoran Gallery in cooperation with Shoshana Wayne Gallery and Pence Gallery in Los Angeles, 16 July–7 September 1988, p. 83. I am grateful to Starr for sharing some of her research on this period, and to Amelia Jones for bringing the exhibition catalogue to my attention.

37. Allen Ginsberg, "Howl," *Evergreen Review* 1, no. 2 (1957): 137; the poem extends to p. 147, with censored passages on pp. 139, 140, and 143; p. 145.

38. See Robert Alexander, in Starr, *Lost and Found*, p. 57:

> The atom bomb was the final touch . . . in a world that had just seen the ugliest war in the history of mankind. . . . We were sustained by the literature of people whose history is a lot older, who endured much more than we did on a continuing basis, who were more at ease with . . . the pain and suffering of being a creative, sensitive person . . . isolated from . . . society by virtue of your feelings about the status quo. In our case, the French poets, . . . the Surrealists and Dada, gave us continuity at a time when, without that body of stuff plus our own jazz blues, I don't think any of us would have made it. We'd have all been candidates either for an insane asylum or suicide.

39. Neri, in Albright, "A Kind of Time Warp," p. 13.

40. Neri, in Starr, *Lost and Found*, pp. 71–72.

41. Neri, in Albright, "A Kind of Time Warp," p. 13.

42. Dated by Neri to 1957, this figure was probably not completed until 1958. Accordingly, I refer to it as 1957–58. The dating of Neri's work is generally

problematic, since the artist continually reworks pieces in his possession for decades.

43. Joan Brown, interviewed by Paul J. Karlstrom, 15 July 1975, roll 3196, frame 1081, p. 32, AAA.

44. Manuel Neri, in Jan Butterfield, "Ancient Auras—Expressionist Angst, Sculpture by Manuel Neri," *Images and Issues* (Spring 1981): 40. Albert Elsen has pointed out to me that Rodin's fragmentary sculptures were probably also models for Neri's sculptural fragments.

45. Albright, "Manuel Neri's Survivors," p. 56.

46. Neri, interview with Neubert, 19 July 1976, p. 8.

47. Neri, in Butterfield, "Ancient Auras," p. 41.

48. Thomas Albright, "The Art World: The Magnificence of Manuel Neri," *San Francisco Chronicle*, 30 September 1976, p. 49.

49. Manuel Neri, conversation with the author, 4 April 1988.

50. Neri, conversation with author, 4 April 1988.

51. Neri, interview with Neubert, 19 July 1976, p. 3.

52. Marina Warner, *Monuments and Maidens: The Allegory of the Female Form* (New York: Atheneum, 1985).

53. Manuel Neri, talk given at the Palo Alto Cultural Center, 14 April 1988, my notes.

54. Brown, interview with Karlstrom, 15 July 1975, roll 3196, frame 1076, p. 27.

55. Neri, interview with author, 1 March 1988.

56. Brown, conversation with author, 15 March 1988.

57. Brown told Karlstrom that she loved the Egyptians' simplicity and wit, which made them substitute animal bones when the human ones could not be found, or give one lucky mummy a permanent erection. See Brown, interview with Karlstrom, 15 July 1975, roll 3196, frame 1160, pp. 11 and passim.

58. Joan Brown, interviewed by Paul J. Karlstrom, 1 July 1975, roll 3196, frame 1042, p. 59, AAA.

59. Neri, in Albright, "A Kind of Time Warp," p. 14.

60. Neri, interview with author, 1 March 1988.

61. Neri, Palo Alto Cultural Center, 14 April 1988.

62. Neri, in Albright, "A Kind of Time Warp," p. 10.

63. In the area of sculpture, one thinks only of tracks parallel to Neri's, such as those of Stephen de Staebler or Oliver Jackson.

64. Brown, interview with Karlstrom, 1 July 1975, frames 995 and 994, pp. 14, 12. Biographical details of this period are drawn from this excellent interview, frames 982–1131, pp. 6–19.

65. Biographical details from Brown, interview with the author, 15 March 1988.

66. Brown, interview with Karlstrom, 1 July 1975, frames 1027, 1023, pp. 44, 40.

67. Bischoff "opened every door. . . . [He said] 'it doesn't matter that you've never painted, or have no ability—just dive in. . . .' He had such a love of painting himself, that makes such a difference"; Brown, conversation with author, 15 March 1988.

68. Brown, interview with Karlstrom, 1 July 1975, frame 1032, p. 49.

69. Brown, interview with author, 15 March 1988.

70. Brown, interview with Karlstrom, 1 July 1975, frame 1035, p. 52.

71. Dorothy Walker, "Painters Shy? These Youngsters Invited Critics to Joint Exhibit," *San Francisco News*, 26 January 1957, in Joan Brown artist file, San Francisco Art Institute Archives.

72. Brown, interview with Karlstrom, 1 July 1975, frames 1043 and 1048, pp. 60 and 65.

73. The smaller left-hand panel of the diptych was always titled *Model with Manuel's Sculpture*, but the larger right-hand canvas was published as, simply, *Ladies and Dog in Studio*. Although this title makes little sense, since there is only one figure in this half and it is plaster-white with no arms, the title is inscribed on the back of the canvas. It was not until quite recently that Brown made known her preference to have the two canvases shown together, and in fact it appears that from the outset they had been framed differently. Examination shows that the left canvas was painted later, judging by the corrections and changes added to the right canvas to make it match. Seeing the paintings together makes it clear that they form a diptych, although they may not have begun as such. The whole is greater than the sum of the individual parts, and is now in a single public collection, thanks to the efforts of The Oakland Museum and the sacrifice of private collectors.

74. Brown, interview with author, 15 March 1988.

75. Joan Brown, conversation with the author, 14 December 1988.

76. Gordon Cook, interviewed by Paul J. Karlstrom, 2 June 1981, roll 3197, frame 90, p. 54, AAA.

77. Joan Brown, in *The Early Sixties: Jack Beal, Joan Brown*, exh. cat. (New York: Alan Frumkin Gallery, 1984), n.p.

78. Brown's former student John Fudge recalls that when Brown and Neri came to teach in Denver, they brought substantial supplies of Bay City paint. The paint, which was packaged in big buckets, was coarsely ground in a thick oil medium ("the white would turn yellow in about six months"). It became so popular that some of the Denver painters got in

touch with the San Francisco firm and ordered it for many years. John Fudge, conversation with the author, 20 May 1988.

79. Brown, interview with Karlstrom, 1 July 1975, frame 1036, p. 53; 15 July 1975, frame 1057, p. 8; 1 July 1975, frame 1039, p. 56; 15 July 1975, frame 1051, p. 2.

80. Brown, interview with Karlstrom, 15 July 1975, frame 1052, p. 3.

81. Brown, in *The Early Sixties*, n.p.

82. Sketches of Noel are in Joan Brown's collection; the baby book is recorded on roll 722, frames 1063–1451, AAA.

83. The characterizations of the cloud form as a dream animal or buffalo are supported by later developments in Brown's work, which involve images of animals in dreamlike situations, such as *Wolf in Studio* (1972) or, most appropriately for the painting under discussion, *Buffalo in Golden Gate Park* (1967–68). The latter may depict an actual situation, but is no less fantastical in contemporary American culture.

84. Brown, interview with Karlstrom, 15 July 1975, frame 1062, p. 13.

85. Joan Brown, in Andrée Maréchal-Workman, *Exposee*, no. 15 (March–April 1985): n.p.; quoted in *The Early Sixties*, n.p.

86. Brown, in Maréchal-Workman. Brown also mentions looking at Expressionism for the first time, but this must be an error in transcription. She had received and enjoyed a book on German Expressionism from her dealer, George Staempfli, as early as November 1960 (letter from Staempfli to Brown, roll 722, frame 1165, AAA), and she was certainly aware that her Bay Area Figurative style was expressionistic. At a talk given at the California Palace of the Legion of Honor on 13 April 1988, Brown also discussed the 1964–65 stylistic break specifically in terms of anti-expressionism: "I wanted a whole other way of working that wasn't expressionist—either abstract [expressionist] or other."

87. Fudge, conversation with the author, 20 May 1988.

88. Joan Brown, conversation with the author, 18 January 1988.

89. Brown, in Maréchal-Workman.

90. Brown, conversation with author, 18 January 1988.

91. *Day before the Wedding* was renamed *Susannah at the Bath*—possibly to generalize its reference and facilitate its sale.

CHAPTER SIX

1. Hilton Kramer, "Month in Review," *Arts Magazine* 34, no. 4 (January 1960): 42; Sidney Tillim, "Month in Review," *Arts Magazine* 35, no. 7 (April 1961): 46. See also "Figurative Painters in California," *Arts Magazine* 32, no. 3 (December 1957): 25.

2. For an excellent discussion of this schism between defenders of gestural and field painters and the resulting effect on perceptions of art during the fifties, see the provocative essay by Phyllis Rosenzweig, "The Fifties: Aspects of Criticism in New York," in *The Fifties: Aspects of Painting in New York*, exh. cat. (Washington, D.C.: Hirshhorn Museum and Sculpture Garden, Smithsonian Institution Press, 1980), pp. 10–34.

3. Fairfield Porter, 1962 review of an exhibition of figurative painting at The Museum of Modern Art, New York, anthologized in Rackstraw Downes, ed., *Fairfield Porter: Art in Its Own Terms—Selected Criticism, 1935–1975* (New York: Taplinger Publishing Co., 1979), p. 72; quoted in John Arthur's review of *Richard Diebenkorn: Works on Paper* (Houston: Houston Fine Arts Press, 1987), in *Art New England* 8, no. 10 (November 1987): 7. Although Porter's criticism was not specifically directed at him, Diebenkorn seems to have taken it most to heart. He recalls Thomas Hess restating the canard: "Tom Hess once said that he didn't believe my light. He said, 'This person is looking at Skira books, and that's where it comes from.' . . . Well, it was a common thing for people who hadn't been to California to say there's something bogus about all this." Diebenkorn, quoted by John Gruen, "Richard Diebenkorn: The Idea Is to Get Everything Right," *Art News* 85 (November 1986): 87.

4. Irving Sandler, in *The New York School: The Painters and Sculptors of the Fifties* (New York: Harper and Row, 1978), p. 281. In the chapter "The New Academy" Sandler discusses the Bay Area Figurative painters Park, Diebenkorn, and Bischoff, grouping them with the second-generation painters of the New York School.

5. Manuel Neri, quoted in Thomas Albright, "Manuel Neri: A Kind of Time Warp," *Currânt* 1, no. 1 (April–May 1975): 13. Edgar Wind has speculated about the effect of the graphic reproducibility of art: "Our eyes have been sharpened to those aspects of painting and sculpture that are brought out effectively by a camera. What is more decisive, in the artist's own vision we can observe the growth of a pictorial and sculptural imagination that is positively attuned to photography, producing works photogenic to such a degree that they seem to find a vicarious fulfillment in mechanized after-images"; from "The Mechanization of Art," in Harold Spencer, ed., *Readings in Art History*, vol. 2 (New York: Charles Scribner's Sons, 1969), p. 382; the original essay appears in Edgar Wind, *Art and Anarchy* (London and New York: Faber and Faber and Alfred A. Knopf, Inc., 1963).

6. Whether Elaine de Kooning or Theophilus Brown had priority in generating this imagery of athletes, it was Brown whose paintings were featured by *Life* magazine in 1956 (see Brown's bibliography).

7. As Rosenzweig points out, the emergence of the second-generation painters was almost simultaneous with the peaking of the Abstract Expressionists ("The Fifties," pp. 9 and passim). As she also makes clear, this simultaneity was obscured by the critical rhetoric, which described both non-objective and figurative canvases in the same existential terms, as confrontational crises acted out in violently applied paint (pp. 12, 15, and passim). In regard to David Park, the point to be made is that the first exhibition in New York to include the younger gestural figurative painters was *Talent 1950* at the Kootz Gallery from 25 April to 15 May 1950, selected by Clement Greenberg and Meyer Schapiro. This was still a month later than Park's exhibition of his first new figurative work.

8. Larry Rivers, in Irving Sandler, *New York School*, p. 105.

9. Thomas Hess, "Inside Nature," *Art News* 56, no. 10 (February 1958): 64; and in Sandler, *New York School*, p. 280.

10. The only comparison to this cohesion in New York, to my knowledge, might be the drawing group organized by Mercedes Matter during the late fifties. George McNeil, Philip Pearlstein, and Philip Guston were among those who attended; it goes without saying that their interaction had little impact upon their highly divergent styles.

11. Hubert Crehan, letter of February 1957, in Dore Ashton, "The San Francisco School," *Evergreen Review* 1, no. 2 (1957): 159.

12. Mark Rothko, letter to Barnett Newman, 8 August 1950, in Michael Leja, "The Formation of an Avant-Garde in New York," in Michael Auping, ed., *Abstract Expressionism: The Critical Developments* exh. cat. (Buffalo and New York: Albright-Knox Art Gallery and Harry N. Abrams, Inc., 1987), p. 22.

13. Jackson Pollock, in *Arts and Architecture* 61, no. 2 (February 1944): 14; anthologized in Maurice Tuchman, *New York School: The First Generation*, rev. ed. (1965; Greenwich, Conn.: New York Graphic Society, Ltd., 1970), p. 115.

14. I am thinking of the non-objective painters Clyfford Still, Jon Schueler, and Lawrence Calcagno. Susan Klein Landauer's forthcoming study on the San Francisco School of Abstract Expressionism will analyze these and other painters' use of nature as a theme. Interestingly, when I spoke to Richard Diebenkorn about the cliché that Still's paintings are "about" the parched landscape of the Dakotan badlands, he said, "Oh, but they are! When I was coming back from my first trip to Europe, we were flying over Canada, Wyoming, or the Dakotas—I looked down at the ochres and blacks, with a bit of snow—it was Still!" (interview with the author, 14 January 1988). Diebenkorn himself feels that his early abstract landscapes were deeply influenced by his first airplane trip from Albuquerque back to California in 1951; Gerald Nord-land, *Richard Diebenkorn* (New York: Rizzoli International Publications, 1987), p. 43.

15. Kenneth Rexroth, "San Francisco Letter," *Evergreen Review* 1, no. 2 (January 1957): 6.

16. As Landauer points out in her forthcoming study on the San Francisco Abstract Expressionists: "The first generation of the New York School possessed no counterpart to the whimsical humor of Clay Spohn or the joyful whiplash calligraphy of Hassel Smith"; unpublished prospectus, p. 2. Similarly, San Francisco's Minimalism was rough, mystical, and conceptual, in contrast to Los Angeles's high-tech, "fetish finish" sculptures, which were not critiques of the dominant culture as much as reified icons of it.

17. Rexroth, "San Francisco Letter," p. 5.

18. Paul Mills, *The New Figurative Work of David Park* (Santa Barbara: Capra Press, 1988), p. 82.

19. Barbara Rose, "The Second Generation: Academy and Breakthrough," *Artforum* 4, no. 1 (September 1965): 56.

20. Valerie Petersen, "U.S. Figure Painting: Continuity and Cliché," *Art News* 61, no. 4 (Summer 1962): 37.

21. Although the elevation of art criticism would not become pronounced until the later sixties, with the inspired dogmatism of Michael Fried and others, the very first issue of *Artforum* opened with "Sidney Geist on Criticism," a statement that asserted the importance of critical judgments in no uncertain terms: "An authoritative critic is as rare and valuable a social asset as a great artist, embodying, as he does, a set of values which become symbolic"; *Artforum* 1, no. 1 (June 1962): 5.

22. "*Artforum* is an art magazine—published in the west—but not only a magazine of western art. We are concerned first with western activity but claim the world of art as our domain"; editorial statement, *Artforum* 1, no. 1 (June 1962): inside of front cover.

23. The Park painting, *Man in T-shirt*, appeared on the July 1962 cover of *Artforum*, Joan Brown's *Flora* in June 1963.

24. Richard Diebenkorn, interviewed by Susan Larsen, 24 and 31 May 1977, tape 4, AAA.

25. This may read to some as a highly simplistic reduction of Modernism to its utopian variants, and a valorization of Postmodernism as a pragmatic solution to the crisis of such utopian visions following World War II. While I cannot argue the point fully here, I want to suggest that a powerful, if not dominant, aspect of Modernism in America *was* its utopian promise to communicate internationally and universally, thereby changing the world. It was precisely this aspect that governed Bischoff's participation in the San Francisco School of Abstract Expressionism, for example, and while none of the participants in Bay Area Figurative art would ever describe themselves

as "post" Modern, their movement was a reactive one in this restrictive sense. Bay Area Figurative art is obviously *not* an example of that postmodernism which critiques the "master narrative" of the solitary (male) artist-genius who creates unique works of art.

26. Most prominent among the general surveys were the exhibitions and publications *The Figurative Mode: Bay Area Painting, 1956–1966* (New York: Grey Art Gallery and Study Gallery, New York University, 1984) and Greta Berman and Jeffrey Wechsler, *Realism and Realities: The Other Side of American Painting, 1940–1960* (New Brunswick, N.J.: Rutgers University Art Gallery, 1981). There have also been one-person exhibitions of the primary Bay Area Figurative artists, such as the 1984 survey of the work of Nathan Oliveira at the San Francisco Museum of Modern Art, the exhibition of David Park's work in 1988 at the Whitney Museum of American Art, the retrospective of drawings by Richard Diebenkorn at the Museum of Modern Art, New York in 1988, and the 1989 exhibition of figurative plaster sculptures by Manuel Neri at the San Francisco Museum of Modern Art. All save the Neri traveled, and all were accompanied by catalogues.

27. Christopher Knight, "The Ambiguity of Where: A Journey to the City Dump," in *The Figurative Mode*, p. 18. I disagree with important aspects of Knight's provocative essay, particularly his acceptance of the idea that Abstract Expressionism was a specifically urban style, alien to San Francisco: "abstract expressionism was largely a received style in the small province of San Francisco. Transplanted from the intensely urban milieu in which it had originated, . . . it became ever more remote and academic with ever increasing force"; pp. 6 and 8. As Landauer's forthcoming dissertation will establish, the evolution of Abstract Expressionism in San Francisco had its own dynamic, and some innovations occurred on the West Coast before they happened in New York.

28. See Christopher Brown and Judith Dunham, *New Bay Area Painting and Sculpture* (San Francisco: Squeezer Press, 1982). Brown and Dunham correctly generalize the Bay Area tradition as expressionistic, not just figurative. But of the artists they include in their book, more seem to be responding to the figurative aspect of that tradition than to the abstract expressionist. Kristina Branch came to the Bay Area to work alongside Nathan Oliveira and Frank Lobdell at Stanford University, but she was also drawn to the region by her deep admiration for Elmer Bischoff and his work (conversation with the author, 25 April 1989).

29. Knight, "The Ambiguity of Where," p. 21 n. 27.

30. Georgianna M. Lagoria, *Northern California Art of the 1960s*, exh. cat. (Santa Clara: de Saisset Museum, University of Santa Clara, 1982), p. 30.

	David Park	Elmer Bischoff	Richard Diebenkorn	James Weeks	Theophilus Brown
PRE-1950	Born 17 March 1911, Boston, to Mary Turner and Charles Edward Park. Attends Loomis School, Windsor, Conn. Moves to Los Angeles, 1928; studies at Otis Art Institute. Moves to Berkeley, 1929. Marries Lydia Newell, 1930; two daughters. Solo show, Oakland Art Gallery, 1933. Begins teaching, CSFA, 1943. Discards recent abstract works, 1949.	Born Elmer Nelson Bischoff 9 July 1916, Berkeley, to Elna and John Albert Bischoff. Attends Williams High School, Oakland. Married to Jean Corse, 1936– early fifties; 3 children: Steven, Laurie, Thomas. B.A., U.C. Berkeley, 1938; M.A., 1939. U.S. Air Force, England, 1942–45. Begins teaching at CSFA, 1946. Teaches at U.C. Berkeley, 1946– 47. First solo show, CPLH, S.F., 1947.	Born 22 April 1922, Portland, Oreg; moves to S.F., mid-1920s. Graduates from Lowell High School, 1940; enters Stanford Univ. Marries Phyllis Gilman, 1943; 2 children. Serves with U.S. Marines, 1943–45. Continues at CSFA, 1946. Lives in Woodstock, N.Y., 1946– 47. Teaches at CSFA, 1947–50. First solo show, CPLH, S.F., 1948. B.A., Stanford Univ., 1949.	Born James David Northrup Weeks, 1 December 1922, Oakland, to Ruth Daly and Anson Weeks. Graduates from Lowell High School, S.F., 1940; enrolls at CSFA. Stationed with U.S. Air Force, 1943–46. Returns to CSFA, 1946, and studies at Hartwell School of Design, S.F. B.A., CSFA, 1947. Begins teaching, CSFA, Hartwell, 1948. Marries Lynn Williams, 1949.	Born William Theophilus Brown, 7 April 1919, Moline, Ill., to Elise Koehler and Theophilus Brown. Graduates from Lake Forest Academy, Ill., 1937. B.A., Yale Univ., 1941, in music. U.S. Army, 1941– 45; stationed in U.S. and Europe. Lives in New York, 1946–48. Studies on G.I. Bill with Amédée Ozenfant, New York, 1948; Atelier Léger, Paris, 1949.
1950	Completes *Rehearsal* in new figurative style that perplexes peers. Revives beach and boating subjects. Summer Session Director, CSFA, before Ernest Mundt replaces Douglas MacAgy as director.	Continues teaching at CSFA, working abstractly. Birth of fourth child, John, December, with wife, Jean.	Leaves Bay Area, January, to begin graduate studies at Univ. of New Mexico, Albuquerque, on G.I. Bill. Continues abstract painting and experiments with sculpture. Develops friendship with Raymond Jonson.	Continues teaching at CSFA at night and supplements income by working in sandwich factory. Shares studio with Bill Wolff on Magnolia Street until 1955.	Returns to New York from European travel. Through Thomas Hess meets Philip Guston, the Rothkos, and the de Koonings; develops lasting friendship with the latter. De Kooning and Matta become strong influences.
1951	*Kids on Bikes*, shown at SFAA annual at de Young Museum, creates stir in art community.		M.F.A., Univ. of New Mexico. Continues painting at University of New Mexico after graduation. Summer trip to S.F.; impressed by aerial views of landscape during flight. Sees Gorky retrospective at SFMA.	Leaves CSFA. Birth of first daughter, Rebecca. Two-artist show, Lucien Labaudt Gallery, S.F. Studies at Escuela de Pintura y Escultura, Mexico City, on G.I. Bill, summer. Returns to Bay Area; works at Railway Express.	

Paul Wonner	Nathan Oliveira	Manuel Neri	Bruce McGaw	Joan Brown	
Born 24 April 1920, Tucson, Ariz., to Mabel Shephard and John M. Wonner. Graduates from Tucson Senior High School, 1937; enters CCAC. B.A., CCAC, 1941. Stationed with U.S. Army, San Antonio, Tex., 1941–46. Lives in New York, 1946–50; attends lectures at Robert Motherwell's Studio 35; participates in drawing sessions, Art Students League, New York, 1947.	Born Nathan Joseph Mendonca Roderick, 19 December 1928, Oakland. Lives with mother, maternal grandmother, aunt after 1932 in S.F. Mother, Elvera Furtado, marries George Oliveira, 1934, who adopts Nathan; family lives in Niles (now Fremont), Oakland, and S.F. Graduates from George Washington High School, 1946. Enrolls at CCAC, 1947.	Born Manuel John Neri, 12 April 1930, between Reedly and Sanger, Calif., to Manuel and Guadalupe Pinella Neri. Grows up around San Joaquin and San Fernando valleys. Moves with mother and two sisters to Oakland, Calif., 1944 after death of father and older brother. Attends Fremont High School, Oakland, 1946–49. Enrolls at San Francisco City College, 1949.	Born Bruce Alanson McGaw 5 April 1935, Berkeley, Calif., to Clara Emma Eça da Silva and Sidney McGaw. Moves with family to Albany, Calif., in late 1930s. Family supportive of interests in art. Enters Albany High School, 1949.	Born Joan Vivien Beatty, 13 February 1938, S.F., only child of Vivien Beck and John Beatty. Grows up in S.F.; attends Catholic grade school. Early interest in the ancient world; considers becoming an archaeologist.	PRE-1950
Returns from New York to Calif.; enrolls at U.C. Berkeley to study art. Works in main campus library throughout both undergraduate and graduate studies. Begins accepting standards of Abstract Expressionist standards.	Continues studying painting and printmaking at CCAC. Summer session course with Max Beckmann, Mills College, Oakland.	Continues at SFCC. Summer ceramics course taken to offset heavy load of science courses presents art as a viable activity. Teacher Roy Walker encourages him to sit in on courses at CSFA.	Continues at Albany High School. Interested in both commercial art and cartooning. Begins life drawing in class with Fred Martin, then a student teacher from U.C. Berkeley, in which students serve as models.		1950
Continues studies at U.C. Berkeley.	Marries Ramona Christensen. Sees *Edvard Munch: Paintings and Drawings*, M. H. de Young Memorial Museum. B.F.A., CCAC.	Attends classes at CCAC, where he meets fellow student Oliveira. Becomes involved with ceramics department; influenced by graduate student Peter Voulkos. Makes life-sized clay figures, since destroyed.		Enters parochial Presentation High School, S.F. Works in city department stores during Christmas vacations and summers.	1951

	David Park	Elmer Bischoff	Richard Diebenkorn	James Weeks	Theophilus Brown
1952	Resigns in protest from CSFA when Hassel Smith is dismissed. Works briefly designing window displays for liquor stores.	Resigns from CSFA when Hassel Smith is dismissed. Begins working representationally, with emphasis on the figure. Birth of son Gregory in June with new wife, Pat Baskett. Works for Railway Express; draws but does not paint.	Returns to Calif. for summer. Sees Matisse retrospective at Los Angeles Municipal Art Gallery before moving to Urbana, Ill., to teach drawing and painting at Univ. of Ill. for academic year.	Receives Abraham Rosenberg Fellowship. Paints series of studio still lifes. Begins billboard painting for Foster and Kleiser. Paints only on nights and weekends. Creative output drops. Destroys entire output of period, 70 paintings.	Returns to Europe for spring and summer. Begins graduate studies at U.C. Berkeley in the fall. Meets Wonner in painting class. Lives in Berkeley.
1953	Paints for two years on "fellowship" from wife, who works in library at U.C. Berkeley. Lives with family in cramped quarters with studio in living room.	Begins teaching in art department at Yuba College, Marysville, Calif., fall. Very productive period.	Moves to New York, June. Meets Clement Greenberg, Willem de Kooning. Makes contact with Poindexter Gallery. Moves to Berkeley, October. Begins Berkeley series of Abstract Expressionist paintings.		M.A., U.C. Berkeley, in art. Teaching assistant, Berkeley art department, for three years.
1954			Receives Abraham Rosenberg Traveling Fellowship for advanced study in art; paints full-time.		
1955	Appointed to faculty of U.C. Berkeley. Works from models in drawing sessions with Bischoff, Diebenkorn, and at various times with T. Brown, Oliveira, Weeks, and Wonner. Also working on street scenes, interiors, portraits.	Travels to Berkeley from Marysville to participate in drawing sessions with Park, Diebenkorn, and Weeks, summer.	Begins still lifes, then landscapes, as prelude to figurative work, summer. Initiates group drawing sessions at Shattuck Avenue studio, Berkeley. Begins teaching at CCAC.	Birth of second daughter, Ellen. In summer participates in figure drawing sessions at Shattuck Avenue, Berkeley, with Bischoff, Park, Diebenkorn, and others.	Teaches drawing, painting, at CSFA; commutes from East Bay with Oliveira. Shares studio on Shattuck Avenue, Berkeley, with Wonner. Diebenkorn works in same building; also meets Park, Bischoff. Participates in drawing sessions.

Paul Wonner	Nathan Oliveira	Manuel Neri	Bruce McGaw	Joan Brown	
B.A., U.C. Berkeley, in art; begins graduate program. Meets T. Brown in painting class.	M.F.A., painting and printmaking, CCAC. Receives temporary draft deferment to teach printmaking at CCAC.	Enrolls at U.C. Berkeley. Abandons engineering after first year to study art.			1952
M.A., U.C. Berkeley, in art. Receives Anne Bremer Memorial Award upon graduation.	Drafted; begins 2-year service in U.S. Army with 8 months at Fort Lewis, Wash., for basic training.	Joins Voulkos in Helena, Mont., to work in ceramics workshop, summer. Marries Meme Hampson. Drafted; after basic training, serves at Communications Center in Seoul, Korea, fall. Takes studio classes at Univ. of Seoul.	Graduates from Albany High School; enters CCAC on scholarship. Studies drawing with commercial artist Carol Purdie, design with Ralph Cornell Siegle. Develops friendships with students Bill Morehouse and Henry Villerme.		1953
	Continues military service as cartographic draftsman at Fort Winfield Scott, Presidio Army Base, S.F. Birth of first child, Lisa Louise. Sees *Hyman Bloom: Paintings and Drawings*, at de Young Museum.	Continues military service in Korea. Birth of first child, Raoul Garth, in March.			1954
Begins library studies at U.C. Berkeley. Shares studio with T. Brown on Shattuck Avenue, Berkeley. Participates in drawing sessions. Meets Park, who encourages working from nature. Awarded Walter Haas Fellowship.	Discharged from Army. Begins teaching painting at CCAC and drawing, printmaking at CSFA; establishes studio in North Oakland. Invited by T. Brown to join drawing sessions at Shattuck Avenue studio, Berkeley.	Discharged from Army. Returns on G.I. Bill to CCAC; studies with Frank Lobdell, Jeremy Anderson, Oliveira, Diebenkorn. Begins assemblage, use of plaster. Travels in Mexico. Hears Ginsberg's first reading of *Howl* at "6" Gallery.	Continues studies at CCAC under Diebenkorn. Also studies with Leon Goldin and Sabro Hasegawa. Goes with classmate Neri to hear Allen Ginsberg's second reading of *Howl* at the Telegraph Hill Neighborhood Center.	Graduates from high school. Encouraged by parents to attend Lone Mountain College, S.F. Responds, instead, to newspaper advertisement for CSFA and signs up for drawing and design classes. Meets William H. Brown.	1955

	David Park	Elmer Bischoff	Richard Diebenkorn	James Weeks	Theophilus Brown
1956	Group drawing sessions continue in Park's studio. Executes still lifes. Bathing scenes decrease, and nudes become most common subject. Sale of eleven paintings to Walter P. Chrysler, Jr., receives much local press coverage.	Returns to Bay Area from Marysville. Solo show of figurative works, CSFA; becomes chairman of graduate department under Gurdon Woods. Lives and paints in old "Monkey Block" on Montgomery Street, S.F.	First New York solo show, Poindexter Gallery. Takes two-month break from painting in summer to build studio behind Berkeley house. Continues painting figuratively, to consternation of his dealers.		Two-page color spread on football paintings appears in *Life* magazine, 8 October. Receives prize for oil painting *Football* in the SFAA members' show at the de Young, December.
1957	Purchases small redwood house in Berkeley hills. Paints constantly in top-floor studio with skylight, fireplace, and view of bay through redwoods. Five works in Oakland Art Museum's figurative painting show.	Six works included in Oakland Art Museum's *Contemporary Bay Area Figurative Painting* exhibition.	Leaves teaching position at CCAC. Five works included in Oakland Art Museum's *Contemporary Bay Area Figurative Painting* exhibition.	Leaves Foster and Kleiser for freelance design and brief appointment as staff artist for KPIX-TV. Two works in Oakland Art Museum's figurative painting show.	Leaves teaching position at CSFA. Joins Wonner in Davis, Calif., late in year. Lives on D Street and later purchases home with Wonner on Lehigh Drive. *Football, No. 33* in Oakland Art Museum's figurative painting show.
1958	Designs sets and costumes for Darius Milhaud's opera *The Sorrows of Orpheus*, presented at opening of Hertz Hall, U.C. Berkeley.			Returns to teaching part-time, CSFA. Shares studio on Broadway with painter John Saccaro. Birth of son, Benjamin.	Appointed lecturer at U.C. Davis, where he teaches 1 painting course per semester for 2 years. First solo show, Landau Gallery, Los Angeles.
1959	Chronic back pain prompts first disc operation. Begins working with ink sticks on thirty-foot roll of shelf paper. As condition worsens, paints sitting down using makeshift easel. Completes last major oil painting, *Cellist*.	Awarded $10,000 Ford Foundation Grant; takes yearlong leave from CSFA. Building with living space, studio demolished for Transamerica Pyramid; establishes studio on Shattuck Avenue, Berkeley, in old organ factory.	Receives second Abraham Rosenberg Traveling Fellowship. Teaches at CSFA.	Teaches graduate painting at CCAC for academic year in position vacated by Diebenkorn.	Continues teaching at U.C. Davis. Travels in Europe.

Paul Wonner	Nathan Oliveira	Manuel Neri	Bruce McGaw	Joan Brown	
Master of Library Science, U.C. Berkeley. First solo show, de Young Museum. Moves to Davis, Calif., to work at university library. Paints with T. Brown on weekends; occasional drawing sessions with Diebenkorn, Park.	Birth of second daughter, Gina Marie. Hired by Gurdon Woods to head graphic arts department, CSFA.	First daughter, Laticia Elizabeth born; moves to Powell Street, S.F., summer. Makes sculptures from manzanita branches, small fetishlike figures from found materials. Two-artist show with McGaw, "6" Gallery, S.F.	Develops strong rapport with Diebenkorn in senior year, which continues after graduation. Works at Campus Text Book. Two-artist show with Neri, "6" Gallery, S.F. Marries CCAC classmate Pat Violette in October.	First year at CSFA discouraging, considers leaving. Stays through summer for landscape painting class with Bischoff, who "opened every door" for her. Marries William H. Brown, August. Lives on Filbert Street, S.F.	1956
Establishes studio behind dairy in Davis. Moves to D Street and later purchases home with T. Brown on Lehigh Drive. *The Glider* in Oakland Art Museum's figurative painting show.	Receives Louis Comfort Tiffany Foundation Grant for lithography. First solo show, Eric Locke Gallery, S.F. Begins affiliation with New York dealer Charles Alan.	Transfers to CSFA, primarily to study with Bischoff. Begins life-sized plaster figurative sculptures and executes *Stelae* series of painting/sculpture hybrids. Serves as "6" Gallery director.	B.F.A., CCAC. Moves to house behind parents' home, Albany; daughter Caitlin born, June. Hired by Gurdon Woods to teach Form and Color, CSFA, fall. Four works in Oakland Art Museum's figurative painting show.	Continues at CSFA. Studies with Frank Lobdell and Bischoff. Begins to consider herself a serious painter. Two-artist show, "6" Gallery, S.F.	1957
	With Stuart Davis, Franz Kline, Clyfford Still, receives John Simon Guggenheim Fellowship for Printmaking; travels in Europe from September to December. First New York solo show, The Alan Gallery.	Goes to New York to visit Mark Di Suvero, who was injured in an elevator accident; leaves after 3 days. Shares basement studio with Alvin Light in S.F.'s North Beach under Caffè Trieste.		With William Brown, moves to living space and studio on Fillmore Street, S.F., next door to Wally Hedrick and Jay De Feo; poet Michael McClure lives upstairs. First solo show, The Cellar Foyer, S.F.	1958
	Upon return from Europe, moves in with wife's parents in San Leandro; paints in their empty garage. Resumes teaching at CSFA. Visits New York; meets and develops friendships with Willem de Kooning, Philip Guston.	Begins living with J. Brown in North Beach. Stops studies and begins teaching at CSFA when G.I. money runs out. Receives Nealie Sullivan Award, CSFA. Paints surfaces of sculptures, makes plaster heads and busts.		New York dealer George Staempfli purchases paintings, offers her exhibition and support. B.F.A., CSFA. Begins living with Neri on Powell St. Works in Mission St. studio; attempts to paint abstractly. Teaches high school in S.F.	1959

	David Park	Elmer Bischoff	Richard Diebenkorn	James Weeks	Theophilus Brown
1960	Completes shelf-paper scroll. Cancer diagnosed in second operation. Works exclusively in gouache to create conscious final statement. Dies 20 September at home in Berkeley, at age 49.	Returns to position as chairman of graduate department at CSFA.		Teaches art at San Francisco Museum of Art. Begins lasting friendship with painter Julius Hatofsky.	Moves from Davis to Mason Street, S.F., and establishes studio on the Embarcadero. Life-drawing sessions with Wonner and Weeks (who lives nearby).
1961		Visiting artist at Skowhegan School of Painting and Sculpture, Maine, summer.		Life drawing sessions with Wonner and T. Brown, who live nearby on Mason Street. Receives Purchase Prize, Howard Univ., Washington, D.C.	First N.Y. solo exhibition, Barone Gallery. Moves to Santa Monica, Calif., at end of year.
1962		Marries painter and former student Adelie Landis.	Tamarind Lithography Workshop, Inc. Fellowship, spring. National Institute of Arts and Letters award.		Moves to Malibu, Calif., October, where shares home with Wonner. Receives first-prize award from L.A. Municipal Art Gallery, Barnsdall Park, in city-wide annual exhibition.
1963		Resigns from SFAI (formerly CSFA). Appointed associate professor of art, U.C. Berkeley. Receives National Institute of Arts and Letters Grant, New York.	Leaves teaching position at SFAI (formerly CSFA). Artist-in-residence, Stanford Univ., for academic year. Lives in Palo Alto. Lull in painting; concentrates on intaglios and drawings.		Drawing sessions with Oliveira and Wonner.

Paul Wonner	Nathan Oliveira	Manuel Neri	Bruce McGaw	Joan Brown	
Moves from Davis to Mason Street, S.F., and establishes studio on the Embarcadero. Drawing sessions with T. Brown and Weeks (who lives nearby).	Begins teaching graduate painting at CCAC. Leaves CSFA in response to "political" pressures.	Executes series of cardboard and mixed-media sculptures of birds and small figures.	Teaches painting at the Palo Alto Art Club, Calif.	M.F.A., CSFA. Begins teaching, CSFA. Featured in September issue of *Look*. First New York solo show, Staempfli Gallery. Youngest artist in Whitney Museum's *Young America 1960*.	1960
Guest instructor at UCLA; teaches painting.	Artist-in-residence, Univ. of Illinois, Urbana, for academic year. Develops friendships with Midwestern figurative painters George Cohen, Richard Hunt, Ivan Albright. Visiting artist, San Antonio Art Institute.	Travels to Europe with J. Brown. Inspired by European art traditions, Elgin marbles, works by Picabia. Turning point for him. Upon return reworks many earlier sculptures.	Daughter Cecily Parsley born, May.	Stops in New York en route to Europe. Visits Metropolitan Museum, where Goya's *Don Manuel Osorio Manrique de Zuñiga* makes deep impression. Spends 3 months based at Staempfli's Spanish home in Cadaques.	1961
Moves to Malibu, Calif., where shares home with T. Brown, October. Life-drawing sessions with T. Brown and Don Bachardy.	Moves to house in Piedmont, Calif., in which an architect friend builds him a studio.	Marries J. Brown in February; birth of son, Noel Elmer, in fall. Maintains studio on Lombard Street, S.F.		Marries Neri after marriage to W. Brown annulled. Birth of son, Noel Elmer. Moves studio to Lombard Street. Awarded *Mademoiselle* magazine's Outstanding Single Achievement in Art and Senator James D. Phelan awards.	1962
Drawing sessions with T. Brown and Oliveira.	Birth of son, Joseph Furtado. Artist-in-residence and visiting lecturer, UCLA, for academic year. Shares studio with Sam Arnato in Ocean Park. Painterly output wanes. Draws with T. Brown and Wonner.	Moves to Saturn Street, S.F. Teaches at U.C. Berkeley for academic year, 1963–64.	Builds enlarged studio behind Albany house, summer.	Moves to Saturn Street, S.F.	1963

	David Park	Elmer Bischoff	Richard Diebenkorn	James Weeks	Theophilus Brown
1964			Travels to Europe and Soviet Union on Cultural Exchange Grant, U.S. State Dept. Lectures at artists' unions in Soviet Union; very impressed by Matisse works in Leningrad. Father dies, La Jolla, Calif.		
1965		Promoted to professor, U.C. Berkeley.	Begins late figurative works characterized by flat, planar color areas and geometric compositions.	Paints on "Pat Foran Grant-in-Aid," appreciative name for financial support from wife's family.	Invited by Oliveira to be guest instructor at Stanford Univ., where he teaches drawing and painting, summer.
POST-1965		Continues working representationally until early 1970s, when shifts to large acrylic abstractions. Adopts son Mark with wife, Adelie, 1971. Elected to National Academy of Design, 1973; American Academy of Arts and Sciences, 1988. Retires from professorship at U.C. Berkeley, 1985. Lives with wife, Adelie, and has studio in Berkeley, Calif.	Moves to Santa Monica, Calif., 1966; teaches at UCLA, 1966–73. Paints last figurative canvases, 1967; begins Ocean Park series. Represents U.S. in painting at Venice Biennale, 1978. Recipient of numerous national awards. Moves with wife, Phyllis, to Northern Calif., 1988; lives and works in Healdsburg.	Shifts from oil to acrylic for most of subsequent work. Moves to Los Angeles for teaching appointment at UCLA, 1967; on faculty with Diebenkorn for three years. Moves to Bedford, Mass., for associate professorship at Boston Univ., 1970; full professor, 1975; retires 1988. Lives with wife, Lynn, and works in Bedford.	Visiting professor, Univ. of Kansas, Lawrence, 1967. Lives primarily in Southern Calif. until 1974, then moves to Berkeley. Commutes to teach at U.C. Davis, 1975–76. Moves to S.F., 1976. Drawing sessions with Wayne Thiebaud, Mark Adams, Beth Van Hoesen, and Gordon Cook, 1978–86. Lives with Wonner in Noe Valley area of S.F.; maintains studio in neighbor's house next door.

Paul Wonner	Nathan Oliveira	Manuel Neri	Bruce McGaw	Joan Brown	
	Tentatively accepts teaching position at Cornell Univ., Ithaca, N.Y. Spends summer in Ithaca. In the fall, begins appointment as associate professor of art, Stanford Univ., and moves to campus.	Visiting artist at Univ. of Colorado, Denver, with J. Brown, summer. Leaves teaching position at SFAI. Purchases former Congregational church for studio in Benicia, Calif. Separates from J. Brown.	First solo exhibition of paintings, Distel Gallery, Palo Alto.	Visiting artist at Univ. of Colorado, Denver, with Neri, summer. Staempfli visits. Executes ten monumental collages.	1964
Teaches painting at Otis Art Institute, Los Angeles, for academic year.	Guest summer artist, Univ. of Colorado, Boulder; executes over 200 figure drawings. Travels in Spain. Establishes studio in vacant lodge hall, formerly owned by Native Sons of the Golden West, Palo Alto, Calif.	National Art Foundation Award. Creates living space at studio and moves to Benicia. Appointed visiting lecturer at U.C. Davis, summer. Ceases work on figurative sculpture until early seventies.		Separates from Neri. Enthusiasm for expressionist painting, heavy impasto wanes. Impressed by Avery Brundage collection at Asian Art Museum. Receives Louis Comfort Tiffany Foundation Scholarship.	1965
Lives primarily in Southern Calif. until 1974. Moves to Berkeley, 1974; to S.F., 1976. Teaches at: Coll. of Creative Studies, Santa Barbara, 1969–71; The Art Center, L.A., 1973; Calif. State Univ., Long Beach, 1975; U.C. Davis, 1975–76; Univ. of Hawaii, Honolulu, 1978; Calif. State Univ., Long Beach, 1981; Univ. of New Mexico, Albuquerque, 1985; U.C. Santa Barbara, 1987. Lives in Noe Valley area of S.F. with T. Brown. Maintains studio in home.	Begins painting after 3-year hiatus, 1966. Honorary Doctor of Fine Arts, CCAC, 1968. Appointed professor of art, Stanford Univ., 1970. Establishes studio in abandoned Ryan High Energy Laboratory, Stanford, 1980. Elected associate member, National Academy of Design, New York, 1982. Appointed Ann O'Day Maples Professor in the Arts, Stanford, 1988. Lives with wife, Ramona, and continues to work and teach at Stanford.	Divorced from J. Brown, 1966. Married to Susan Morse, 1967–76; two children. Begins working with model Mary Julia, 1970. Promoted to professor, U.C. Davis, 1976. Awards include Guggenheim Fellowship Grant, 1979; Academy-Institute Award in Art, American Academy and Institute of Arts and Letters, 1982. S.F. Arts Commission Award, 1985. Marries Kate Rothrock, 1983; one son. Lives and works in Benicia.	Chairman, dept. of painting and drawing, SFAI (formerly CSFA), 1966–73. Teaches at the Pacific Basin School of Textile Arts, Berkeley, co-founded by wife, 1978; U.C. Berkeley, School of Architecture, 1981–83; Stanford Univ., 1984. Acting director, SFAI, 1988. Lives and works in Richmond, Calif. Continues to teach at SFAI; presently chairman of dept. of painting and drawing.	Divorced from Neri, 1966. Married to artist Gordon Cook, 1968–76. Teaches at Univ. of Victoria, B.C., 1969; Sacramento State Coll., 1970–71; returns to S.F. Teaches at Academy of Art, S.F., 1971–77; visiting assistant professor, Mills Coll., Oakland, 1973. Begins teaching at U.C. Berkeley, 1974. Lives in Diamond Heights area of S.F. with husband since 1980, Michael Hebel.	POST-1965

ELMER BISCHOFF

Solo Exhibitions

1953
Paintings and Drawings: Elmer Bischoff.
King Ubu Gallery, San Francisco, 22
August–9 September.

1955
Elmer Bischoff. Paul Kantor Gallery,
Los Angeles, opened 17 January.

1956
Elmer Bischoff. San Francisco Art Asso-
ciation Gallery, California School of
Fine Arts, San Francisco, 4 January–
1 February. Catalogue; statement by
Bischoff.

1960
Recent Paintings: Elmer Bischoff.
Staempfli Gallery, New York, 5–23
January. Catalogue.

1961
Elmer Bischoff. M. H. de Young Me-
morial Museum, San Francisco, 26
October–26 November. Brochure.

1962
Elmer Bischoff: Recent Paintings.
Staempfli Gallery, New York, 23
January–10 February. Catalogue.

1964
Elmer Bischoff: Drawings. E. B. Crocker
Art Gallery, Sacramento, 1–31
January.

Elmer Bischoff: Paintings. E. B. Crocker
Art Gallery, Sacramento, 15 January–
16 February.

*Elmer Bischoff: Recent Paintings and
Drawings.* Staempfli Gallery, New
York, 14 April–2 May. Brochure.

Group Exhibitions

1950
*Fifteen Paintings by Nine San Francisco
Artists.* Henry Gallery, University of
Washington, Seattle, 30 January–22
February.

*Sixty-Ninth Annual Oil, Tempera, and
Sculpture Exhibition of the San Francisco
Art Association.* San Francisco Mu-
seum of Art, 10 February–12 March.
Catalogue.

*Large-Scale Drawings by Modern Art-
ists.* California Palace of the Legion of
Honor, San Francisco, 17 February–9
April. Catalogue.

1951
*Seventieth Annual Oil and Sculpture Ex-
hibition of the San Francisco Art Associa-
tion.* San Francisco Museum of Art,
28 February–8 April. Catalogue.

*Contemporary Painting in the United
States.* Los Angeles County Museum.

1953
*Seventy-Second Annual Painting and
Sculpture Exhibition of the San Francisco
Art Association.* San Francisco Mu-
seum of Art, 5 February–1 March.
Catalogue.

1955
*Fifth Annual Oil and Sculpture Exhibi-
tion.* Richmond Art Center, California,
1–30 November. First prize in painting
for *Figure and Red Wall.* Catalogue.

1956
*Seventy-Fifth Annual Painting and
Sculpture Exhibition of the San Francisco
Art Association.* San Francisco Mu-
seum of Art, 29 March–6 May.
Catalogue.

*Sixth Annual Oil and Sculpture Exhibi-
tion.* Richmond Art Center, California,
1–30 November. First prize for paint-
ing. Catalogue.

1957
*Seventy-Sixth Annual Painting and
Sculpture Exhibition of the San Francisco
Art Association.* San Francisco Mu-
seum of Art, 28 February–31 March.
Catalogue.

California Painters' Exhibition. Oakland
Art Museum, 9–31 March. Purchase
Prize for *Interior.* Catalogue.

Painting and Sculpture Now. San Fran-
cisco Museum of Art, 23 April–
12 May.

American Paintings: 1945 to 1957.
The Minneapolis Institute of Arts,
18 June–1 September. Catalogue.

Directions: Bay Area Painting, 1957.
Richmond Art Center, California,
1 August–25 September. Circulated by
Western Association of Art Museum
Exhibitions. Catalogue.

*Contemporary Bay Area Figurative
Painting.* Oakland Art Museum, 8–29
September. Traveled to Los Angeles
County Museum; Dayton Art Insti-
tute, Ohio. Catalogue.

*Seventh Annual Oil and Sculpture Exhi-
bition.* Richmond Art Center, Califor-
nia, 1–30 November. Catalogue.

1958
*Seventy-Seventh Annual Painting and
Sculpture Exhibition of the San Fran-
cisco Art Association.* San Francisco
Museum of Art, 10 April–4 May.
Catalogue.

Artist Members' Exhibition. California
Palace of the Legion of Honor, San
Francisco, 27 September–26 October.
Catalogue.

*Eighth Annual Oil and Sculpture Exhibi-
tion.* Richmond Art Center, California,
30 October–6 December. Catalogue.

New Talent in the U.S.A., '58. American
Federation of the Arts, New York,
traveling exhibition. Catalogue.

1959
1959 California Painters' Exhibition.
Oakland Art Museum, 1 January–
1 February. Catalogue.

New Directions in Painting. Florida
State University Gallery, Tallahassee,
March. Traveled to John and Mable
Ringling Museum of Art, Sarasota,
Florida; Norton Gallery and School
of Art, West Palm Beach, Florida.
Catalogue.

*Contemporary American Painting and
Sculpture.* Krannert Art Museum,
University of Illinois, Champaign,
1 March–5 April. Catalogue.

Seventy-Eighth Annual Painting and Sculpture Exhibition of the San Francisco Art Association. San Francisco Museum of Art, 2 April–3 May. Catalogue.

San Francisco Art Association Artist Members' Exhibition. M. H. de Young Memorial Museum, San Francisco, December. Catalogue.

Sixty-Third American Exhibition: Paintings, Sculpture. The Art Institute of Chicago, 2 December 1959–31 January 1960. Catalogue.

1959 Annual Exhibition of Contemporary American Painting. Whitney Museum of American Art, New York, 9 December 1959–31 January 1960. Catalogue.

1960
Winter Invitational Exhibition. California Palace of the Legion of Honor, San Francisco, 23 January–28 February. Catalogue.

Elmer Bischoff, Richard Diebenkorn, David Park. Staempfli Gallery, New York, 8–26 November.

Second Winter Invitational. California Palace of the Legion of Honor, San Francisco, 23 December 1960–21 January 1961.

The Figure in Contemporary American Painting. American Federation of the Arts, New York, traveling exhibition.

1961
Contemporary American Painting and Sculpture. Krannert Art Museum, University of Illinois, Champaign, 26 February–2 April. Catalogue.

Faculty Exhibition. San Francisco Art Institute, 13–25 March.

Painting from the Pacific: Japan, America, Australia, New Zealand. Auckland City Art Gallery, New Zealand, May. Catalogue.

Painting and Sculpture from All Over. Felix Landau Gallery, Los Angeles, 17 July–5 August.

Annual Exhibition 1961: Contemporary American Painting. Whitney Museum of American Art, New York, 13 December 1961–4 February 1962. Catalogue.

1962
One Hundred Fifty-Seventh Annual Exhibition of American Painting and Sculpture. Pennsylvania Academy of the Fine Arts, Philadelphia, 12 January–25 February. Catalogue.

Recent Painting USA: The Figure. The Museum of Modern Art, New York, 23 May–4 September. Traveled to Columbus Gallery of Fine Arts; Colorado Springs Fine Arts Center; Baltimore Museum of Art; City Art Museum of St. Louis; Walker Art Center, Minneapolis. Catalogue.

Recent Acquisitions. Staempfli Gallery, New York, 18 September–13 October. Brochure.

Contemporary American Painting: Selections from the Collection of Mr. and Mrs. Roy R. Neuberger. The University of Michigan Museum of Art, Ann Arbor, 21 October–18 November. Catalogue.

Fifty California Artists. Organized by the San Francisco Museum of Art with assistance of Los Angeles County Museum of Art for the Whitney Museum of American Art, New York, 23 October–2 December. Traveled to Walker Art Center, Minneapolis; Albright-Knox Art Gallery, Buffalo; Des Moines Art Center. Catalogue.

Some Points of View—'62: San Francisco Bay Area Painting and Sculpture. Stanford University Museum of Art, California, 30 October–20 November. Catalogue.

The Artist's Environment: West Coast. Amon Carter Museum of Western Art, Fort Worth, Texas, 6 November–23 December. Traveled to Art Galleries, University of California, Los Angeles; Oakland Art Museum. Catalogue.

Fourth Winter Invitational. California Palace of the Legion of Honor, San Francisco, 15 December 1962–27 January 1963. Catalogue.

Ford Foundation Grant Winners' Exhibition. Silvermine Guild of Artists, Connecticut.

1963
Twenty-Eighth Biennial Exhibition. The Corcoran Gallery of Art, Washington, D.C., 18 January–3 March.

Eighty-Second Annual Exhibition of the San Francisco Art Institute. San Francisco Museum of Art, 21 March–21 April. Honorable mention for *Figure with Ocean.* Catalogue.

Annual Exhibition 1963: Contemporary American Painting. Whitney Museum of American Art, New York, 11 December 1963–2 February 1964. Catalogue.

Drawings by Bischoff, Diebenkorn, Lobdell. The Achenbach Foundation for Graphic Arts, California Palace of the Legion of Honor, San Francisco.

Landscape in Recent American Painting. The Art Center, New School for Social Research, New York.

1964
Sixty-Seventh Annual American Exhibition: Directions in Contemporary Painting and Sculpture. The Art Institute of Chicago, 28 February–12 April. Normon Wait Harris Bronze Medal and Prize. Catalogue.

54–64: Painting and Sculpture of a Decade. Organized by the Calouste Gulbenkian Foundation, The Tate Gallery, London, 22 April–28 June. Catalogue.

Seven California Painters. Staempfli Gallery, New York, 22 June–31 July. Catalogue.

Between the Fairs: Twenty-Five Years of American Art, 1939–1963. Whitney Museum of American Art, New York, 24 June–23 September. Catalogue.

Current Painting and Sculpture of the Bay Area. Stanford University Museum of Art, California, 8 October–29 November. Catalogue.

The 1964 Pittsburgh International Exhibition of Contemporary Painting and Sculpture. Museum of Art, Carnegie Institute, Pittsburgh, 30 October 1964–10 January 1965. Catalogue.

Man: Glory, Jest, and Riddle—A Survey of the Human Form through the Ages. M. H. de Young Memorial Museum, San Francisco; California Palace of the Legion of Honor, San Francisco; San Francisco Museum of Art, 10 November 1964–3 January 1965. Catalogue.

A Decade of New Talent. American Federation of the Arts, New York, traveling exhibition.

Art Gallery '64. Hall of Education, World's Fair, New York.

Four California Painters. Obelisk Gallery, New York.

1965
The Twenty-Ninth Biennial Exhibition of Contemporary American Painting. The Corcoran Gallery of Art, Washington, D.C., 26 February–18 April. Catalogue.

Contemporary American Painting and Sculpture. Krannert Art Museum, University of Illinois, Champaign, 7 March–11 April. Catalogue.

Selections from the Work of California Artists. Witte Memorial Museum, San Antonio, Texas, 10 October–14 November. Catalogue.

Three California Painters: Elmer Bischoff, Joan Brown, David Park. Staempfli Gallery, New York, 7 December 1965–8 January 1966. Brochure.

JOAN BROWN

Solo Exhibitions
1958
The Cellar Foyer, San Francisco.

1959
Batman Gallery, San Francisco.

Spatsa Gallery, San Francisco.

1960
Joan Brown: Paintings. Staempfli Gallery, New York, 29 March–16 April. Brochure.

1961
Recent Paintings by Joan Brown. Batman Gallery, San Francisco, 12 January–8 February.

Joan Brown: Recent Paintings. Staempfli Gallery, New York, 21 February–11 March.

Joan Brown. Primus-Stuart Galleries, Los Angeles, 13 November–9 December.

1962
Joan Brown. Primus-Stuart Galleries, Los Angeles, 5 November–1 December.

1964
Joan Brown. Staempfli Gallery, New

York, 14 January–1 February. Brochure.

Group Exhibitions
1957
Paintings by Joan Beatty & Mike Nathan. "6" Gallery, San Francisco, 9–31 January.

Seventh Annual Oil and Sculpture Exhibition. Richmond Art Center, California, 1–30 November. Second prize for *Brambles.* Catalogue.

1958
Seventy-Seventh Annual Painting and Sculpture Exhibition of the San Francisco Art Association. San Francisco Museum of Art, 10 April–4 May. Catalogue.

1959
Ninth Annual Oil and Sculpture Exhibition. Richmond Art Center, California, 30 October–6 December. Catalogue.

1960
Young America 1960: Thirty American Painters under Thirty-Six. Whitney Museum of American Art, New York, 14 September–30 October. Traveled to Baltimore Museum of Art; Contemporary Art Center, Cincinnati; City Art Museum of St. Louis; Columbus Gallery of Fine Arts. Catalogue.

Batman Gallery, San Francisco, December (with Manuel Neri and Wally Hedrick).

Women in American Art. World House Galleries, New York.

1961
Sixty-Fourth American Exhibition: Painting, Sculpture. The Art Institute of Chicago, 6 January–5 February. Catalogue.

Contemporary American Painting and Sculpture. Krannert Art Museum, University of Illinois, Champaign, 26 February–2 April. Catalogue.

1962
One Hundred Fifty-Seventh Annual Exhibition of Painting and Sculpture. Pennsylvania Academy of the Fine Arts, Philadelphia, 12 January–25 February. Catalogue.

The Nude: Graphics by Five Artists. California Palace of the Legion of

Honor, San Francisco, 18 August–16 September.

Recent Acquisitions. Staempfli Gallery, New York, 18 September–13 October. Brochure.

1963
Contemporary American Painting and Sculpture. Krannert Art Museum, University of Illinois, Champaign, 3 March–7 April. Catalogue.

Eighty-Second Annual Exhibition of the San Francisco Art Institute. San Francisco Museum of Art, 21 March–21 April. Catalogue.

Some New Art in the Bay Area. San Francisco Art Institute, 8–24 May. Brochure.

Artists West of the Mississippi: The Realistic Image. Colorado Springs Fine Arts Center, 19 August–27 October. Catalogue.

1963 Fine Arts Auction of the San Francisco Art Institute: Preview Exhibition. California Palace of the Legion of Honor, San Francisco, 11–19 September. Catalogue.

Four Bay Area Artists: Dennis Beal, Matt Glavin, Joan Brown, Mel Henderson. Art Unlimited, San Francisco, 14 November–5 December.

1964
Seven California Painters. Staempfli Gallery, New York, 22 June–31 July. Catalogue.

Arts of San Francisco: Part I. San Francisco Museum of Art, 7 July–2 August.

Current Painting and Sculpture of the Bay Area. Stanford University Museum of Art, California, 8 October–29 November. Catalogue.

The 1964 Pittsburgh International Exhibition of Contemporary Painting and Sculpture. Museum of Art, Carnegie Institute, Pittsburgh, 30 October 1964–10 January 1965. Catalogue.

Joan Brown: Collages; Manuel Neri: Sculpture. David Stuart Galleries, Los Angeles, 9 November–5 December.

1965
Selections from the Work of California Artists. Witte Memorial Museum, San

Antonio, Texas, 10 October–14 November. Catalogue.

Three California Painters: Elmer Bischoff, Joan Brown, David Park. Staempfli Gallery, New York, 7 December 1965–8 January 1966.

THEOPHILUS BROWN

Solo Exhibitions

1958
William Brown: Recent Paintings. Landau Gallery, Los Angeles, 6–25 January.

1960
William Brown: Recent Paintings. Felix Landau Gallery, Los Angeles, 26 September–15 October.

1961
Barone Gallery, New York.

1962
William Brown: Oils, Drawings. Kornblee Gallery, New York, 27 March–14 April.

1963
Recent Paintings: William Brown. Felix Landau Gallery, Los Angeles, 11–30 March. Catalogue.

1964
William Theo Brown. Hollis Galleries, San Francisco, 20 October–14 November. Brochure.

1965
Recent Paintings: Wm. Theo Brown. Felix Landau Gallery, Los Angeles, 15 February–6 March.

William Theo Brown: Landscape and Figurative Paintings. E. B. Crocker Art Gallery, Sacramento, February. Catalogue.

Group Exhibitions

1953
Seventy-Second Annual Painting and Sculpture Exhibition of the San Francisco Art Association. San Francisco Museum of Art, 6 February–1 March. Catalogue.

Annual Exhibition: Oil Paintings and Sculpture. Oakland Art Gallery, 8 March–5 April. Catalogue.

Seventeenth Annual Watercolor Exhibition of the San Francisco Art Association. San Francisco Museum of Art, 15 October–15 November. Catalogue.

1954
Eighteenth Annual Watercolor Exhibition of the San Francisco Art Association. San Francisco Museum of Art, 30 September–24 October. Catalogue.

Western Painters' Annual Exhibition. Oakland Art Museum, opened 5 November. Catalogue.

1955
Fifth Annual Oil and Sculpture Exhibition. Richmond Art Center, California, 1–30 November. Catalogue.

1956
Seventy-Fifth Annual Painting and Sculpture Exhibition of the San Francisco Art Association. San Francisco Museum of Art, 29 March–6 May. Catalogue.

San Francisco Art Association Members Show, M. H. de Young Memorial Museum, San Francisco, December. Prize for *Football.*

1957
Seventy-Sixth Annual Painting and Sculpture Exhibition of the San Francisco Art Association. San Francisco Museum of Art, 28 February–31 March. Catalogue.

Art of the Bay Region: Nell Sinton, William Brown. San Francisco Museum of Art, 23 April–12 May.

American Paintings: 1945–1957. The Minneapolis Institute of Arts, 18 June–1 September. Catalogue.

Ninth Annual Gallery Group Show. Landau Gallery, Los Angeles, 3–21 September.

Contemporary Bay Area Figurative Painting. Oakland Art Museum, 8–29 September. Traveled to Los Angeles County Museum; Dayton Art Institute, Ohio. Catalogue.

Second Pacific Coast Biennial. Santa Barbara Museum of Art, 10 September–13 October. Traveled to California Palace of the Legion of Honor, San Francisco; Seattle Art Museum; Portland Art Museum, Oregon. Catalogue.

1958
Seventy-Seventh Annual Painting and Sculpture Exhibition of the San Francisco Art Association. San Francisco Museum of Art, 10 April–4 May. Catalogue.

Tenth Anniversary Loan Exhibition. Landau Gallery, Los Angeles, 21 April–10 May. Brochure.

Fresh Paint. M. H. de Young Memorial Museum, San Francisco, 10 July–10 August. Catalogue.

Artist Members' Exhibition. California Palace of the Legion of Honor, San Francisco, 27 September–26 October. Catalogue.

Twenty-Second Annual Drawing and Print Exhibition of the San Francisco Art Association. San Francisco Museum of Art, 4–28 December. Catalogue.

1959
Third Pacific Coast Biennial. Santa Barbara Museum of Art, 9 October–8 November. Traveled to The Fine Arts Gallery of San Diego; Municipal Art Gallery, Los Angeles; Portland Art Museum, Oregon; Henry Gallery, University of Washington, Seattle; M. H. de Young Memorial Museum, San Francisco.

1960
Winter Invitational. California Palace of the Legion of Honor, San Francisco, 23 January–28 February. Catalogue.

Twentieth-Century Drawing. Art Center in La Jolla, California, 18 August–25 September. Catalogue.

Bay Printmakers' Society Sixth National Exhibition. Oakland Art Museum, 5–27 November. Catalogue.

Second Winter Invitational. California Palace of the Legion of Honor, San Francisco, 23 December 1960–21 January 1961. Catalogue.

East-West. Zabriskie Gallery, New York (with Paul Wonner and John Paul Jones).

1961
Sixty-Fourth American Exhibition: Painting, Sculpture. The Art Institute of Chicago, 6 January–5 February. Catalogue.

Third Winter Invitational. California Palace of the Legion of Honor, San Francisco, 23 December 1961–21 January 1962. Catalogue.

1962
Lithographs from the Tamarind Workshop. Art Galleries, University of California, Los Angeles. Traveling exhibition. Catalogue.

1963
Artists West of the Mississippi: The Realistic Image. Colorado Springs Fine Arts Center, 19 August–27 October. Catalogue.

1964
Paul Wonner: Watercolors and Drawings; Theo William Brown: Paintings and Drawings. Esther Bear Gallery, Santa Barbara, 12 January–7 February.

Paintings and Constructions of the 1960s: Selected from the Richard Brown Baker Collection. Museum of Art, Rhode Island School of Design, Providence, 2–25 October. Catalogue.

1965
The Painter and the Photograph. University of New Mexico, Albuquerque, 4 April–9 May. Traveled to Rose Art Museum, Brandeis University, Waltham, Mass.; Museum of Art, Indiana University, Bloomington; The Art Gallery, The State University of Iowa, Iowa City; Isaac Delgado Museum of Art, New Orleans; Santa Barbara Museum of Art, California. Catalogue.

RICHARD DIEBENKORN

Solo Exhibitions

1951
Master's Degree exhibition, The Art Gallery, University of New Mexico, Albuquerque, spring.

1952
Paintings and Drawings by Richard Diebenkorn. Paul Kantor Gallery, Los Angeles, opened 10 November.

1954
Richard Diebenkorn. Allan Frumkin Gallery, Chicago, February.

Paintings and Drawings by Richard Diebenkorn. Paul Kantor Gallery, Los Angeles, opened 22 March.

1955
Recent Paintings: Richard Diebenkorn. Art Department Building, University of California, Berkeley, 12 September–12 October.

1956
Richard Diebenkorn. Poindexter Gallery, New York, 28 February–21 March.

Richard Diebenkorn. Oakland Art Museum, 8–30 September.

1958
Richard Diebenkorn. Poindexter Gallery, New York.

1960
Paintings by Richard Diebenkorn. Pasadena Art Museum, California, 6 September–6 October. Traveled to California Palace of the Legion of Honor, San Francisco. Catalogue.

1961
Richard Diebenkorn. Poindexter Gallery, New York, 13 March–8 April.

Richard Diebenkorn. The Phillips Collection, Washington, D.C., 19 May–26 June. Catalogue.

1962
Richard Diebenkorn. National Institute of Arts and Letters, New York.

1963
Richard Diebenkorn: Paintings, 1961–1963. M. H. de Young Memorial Museum, San Francisco, 7 September–13 October.

Richard Diebenkorn. Poindexter Gallery, New York, 29 October–16 November.

1964
Drawings by Richard Diebenkorn. Stanford University Museum of Art, California, 3–26 April.

Richard Diebenkorn. Washington Gallery of Modern Art, Washington, D.C., 6 November–31 December. Traveled to The Jewish Museum, New York; Pavilion Gallery, Newport Beach, California. Fifteen-year retrospective. Catalogue.

1965
Richard Diebenkorn. Waddington Galleries, London.

Recent Drawings by Richard Diebenkorn. Paul Kantor Gallery, Los Angeles.

Group Exhibitions

1950
Fifteen Paintings by Nine San Francisco Artists. Henry Gallery, University of Washington, Seattle, 30 January–22 February.

Large-Scale Drawings by Modern Artists. California Palace of the Legion of Honor, San Francisco, 17 February–9 April. Catalogue.

1951
Seventy-First Annual Painting and Sculpture Exhibition of the San Francisco Art Association. San Francisco Museum of Art, 21 February–23 March. Catalogue.

Contemporary Paintings. Paul Kantor Gallery, Los Angeles.

Contemporary Painting in the United States. Los Angeles County Museum.

1952
An Exhibition of Paintings, Etchings, Lithos, Drawings. Paul Kantor Gallery, Los Angeles, opened 8 December.

1953
Christmas Tree for '53: Paintings, Collages, Drawings, Posters, Graphics. Paul Kantor Gallery, Los Angeles, opened 7 December.

1954
Group Exhibition. Paul Kantor Gallery, Los Angeles, opened 3 May.

Younger American Painters. Solomon R. Guggenheim Museum, New York, 12 May–25 July. Traveled to Los Angeles County Museum. Catalogue.

Bay Region Artists: Ruth Armer, Richard Diebenkorn, Ralph Du Casse. San Francisco Museum of Art, 17 August–5 September.

Fourth Annual Oil and Sculpture Exhibition. Richmond Art Center, California, 9 November–9 December. Catalogue.

New Accessions USA. Colorado Springs Fine Arts Center. Catalogue.

1955
The Twenty-Fourth Biennial Exhibition of Contemporary American Oil Paintings.

The Corcoran Gallery of Art, Washington, D.C., 13 March–8 May. Catalogue.

Three Young Americans: Clasco, McCullough, Diebenkorn. Allen Memorial Art Museum, Oberlin College, Ohio, 15 April–7 May. Catalogue.

Art in the Twentieth Century. San Francisco Museum of Art, 17 June–10 July. Catalogue.

III Bienal. Museu de Arte Moderna, São Paulo, Brazil, opened 29 June. Catalogue.

Opening Exhibition. Poindexter Gallery, New York, September.

The 1955 Pittsburgh International Exhibition of Contemporary Painting. Museum of Art, Carnegie Institute, Pittsburgh, 13 October–18 December. Catalogue.

Vanguard 1955. Walker Art Center, Minneapolis, 23 October–5 December. Catalogue.

Fifth Annual Oil and Sculpture Exhibition. Richmond Art Center, California, 1–30 November. Catalogue.

1955 Annual Exhibition of Contemporary American Painting. Whitney Museum of American Art, New York, 9 November 1955–8 January 1956. Catalogue.

Painters under Thirty-Five. Congress for Cultural Freedom, Rome. Traveled to Musée National d'Art Moderne, Paris; Palais des Beaux-Arts, Brussels.

Contemporary Arts. Poindexter Gallery, New York.

Contemporary American Painting and Sculpture. Krannert Art Museum, University of Illinois, Champaign. Catalogue.

California Painting: Forty Painters. The Municipal Art Center, Long Beach, California. Catalogue; statement by Diebenkorn.

1956
Seventy-Fifth Annual Painting and Sculpture Exhibition of the San Francisco Art Association. San Francisco Museum of Art, 29 March–6 May. Catalogue.

Pacific Coast Art: United States' Representation at the Third Biennial at São Paulo. San Francisco Museum of Art, 15 May–15 July. Traveled to Cincinnati Art Museum; Colorado Springs Fine Arts Center; Walker Art Center, Minneapolis. Catalogue.

Sixth Annual Oil and Sculpture Exhibition. Richmond Art Center, California, 1–30 November. Catalogue.

San Francisco Art Association Members Show. M. H. de Young Memorial Museum, San Francisco, December. Top prize for *Flowers and Cigar Box.*

Group Exhibition. Paul Kantor Gallery, Los Angeles, 10 December 1956–5 January 1957.

Twelve Gallery Painters. Poindexter Gallery, New York, 16 December 1956–4 January 1957.

1957
The Twenty-Fourth Biennial Exhibition of Contemporary American Oil Paintings. The Corcoran Gallery of Art, Washington, D.C., 13 January–10 March. Catalogue.

Richard Diebenkorn: Paintings; Kenneth Armitage: Sculpture. Swetzoff Gallery, Boston, 16 January–9 February.

Sixty-Second American Exhibition: Paintings, Sculpture. The Art Institute of Chicago, 17 January–3 March. Catalogue.

Seventy-Sixth Annual Painting and Sculpture Exhibition of the San Francisco Art Association. San Francisco Museum of Art, 28 February–31 March. Catalogue.

Modern Painting, Drawing, and Sculpture Collected by Louise and Joseph Pulitzer. M. Knoedler and Co., Inc., New York, 9 April–4 May. Traveled to Fogg Art Museum, Cambridge, Mass. Catalogue.

Painting and Sculpture Now. San Francisco Museum of Art, 23 April–12 May.

American Paintings: 1945 to 1957. The Minneapolis Institute of Arts, 18 June–1 September. Catalogue.

Directions: Bay Area Painting, 1957. Richmond Art Center, California, 1 August–25 September. Circulated by Western Association of Art Museum Exhibitions. Catalogue.

Contemporary Bay Area Figurative Painting. Oakland Art Museum, 8–29 September. Traveled (with additional paintings by Richard Diebenkorn and David Park from the collection of Walter P. Chrysler, Jr.) to Los Angeles County Museum; Dayton Art Institute, Ohio. Catalogue.

Second Pacific Biennial Exhibition. Santa Barbara Museum of Art, 10 September–13 October. Traveled to California Palace of the Legion of Honor, San Francisco; Seattle Art Museum; Portland Art Museum, Oregon. Women's Board of the SBMA Award of Merit for *Woman and Checkerboard.* Catalogue.

Seventh Annual Oil and Sculpture Exhibition. Richmond Art Center, California, 1–30 November. Honorable mention. Catalogue.

Objects the Landscape Demanding of the Eye. Ferus Gallery, Los Angeles (opening exhibition).

1958
American Painting, 1958. Virginia Museum of Fine Arts, Richmond, 28 March–27 April. Catalogue.

Seventy-Seventh Annual Painting and Sculpture Exhibition of the San Francisco Art Association. San Francisco Museum of Art, 10 April–4 May. Catalogue.

Fresh Paint—1958. Stanford University Museum of Art, California, 19 May–22 June. Catalogue.

Artist Members' Exhibition. California Palace of the Legion of Honor, San Francisco, 27 September–26 October. Catalogue.

Eighth Annual Oil and Sculpture Exhibition. Richmond Art Center, California, 30 October–7 December. Catalogue.

Annual Exhibition: Sculpture, Paintings, Watercolors, Drawings. Whitney Museum of American Art, New York, 19 November 1958–4 January 1959. Catalogue.

The 1958 Pittsburgh International Exhibition of Contemporary Painting and Sculpture. Museum of Art, Carnegie Institute, Pittsburgh, 5 December 1958–8 February 1959. Catalogue.

Contemporary Art: Acquisitions, 1957–1958. Albright Art Gallery, Buffalo, 8 December 1958–18 January 1959. Catalogue.

Contemporary American Art. American Pavilion, Brussels World's Fair, 15 December 1958–17 January 1959. Catalogue.

1959
The Twenty-Sixth Biennial Exhibition of Contemporary American Painting. The Corcoran Gallery of Art, Washington, D.C., 17 January–8 March. Catalogue.

New Directions in Painting. Florida State University Gallery, Tallahassee, March. Traveled to John and Mable Ringling Museum of Art, Sarasota, Florida; Norton Gallery and School of Art, West Palm Beach, Florida. Catalogue.

Seventy-Eighth Annual Painting and Sculpture Exhibition of the San Francisco Art Association. San Francisco Museum of Art, 2 April–3 May. SFAA cash award for *Girl in a Striped Chair*. Catalogue.

First Annual Group Show. Dilexi Gallery, Los Angeles, 13 April–16 May.

New Images of Man. The Museum of Modern Art, New York, 30 September–29 November. Catalogue.

Sixty-Third American Exhibition: Paintings, Sculpture. The Art Institute of Chicago, 2 December 1959–31 January 1960. Catalogue.

New Imagery in American Painting. Indiana University Art Museum, Bloomington, December. Catalogue.

Aspects of Representation in Contemporary Art. William Rockhill Nelson Gallery of Art and Mary Atkins Museum of Fine Arts, Kansas City, Missouri.

1960
Winter Invitational. California Palace of the Legion of Honor, San Francisco, 23 January–28 February. Catalogue.

Seventy-Fifth Annual Painting and Sculpture Exhibition of the San Francisco Art Association. San Francisco Mueum of Art, 24 March–24 April. Catalogue.

The Image Lost and Found. Institute of Contemporary Art, Boston, May. Catalogue.

Oliver Andrews, Richard Diebenkorn, Bryan Wilson: Three Stanford Alumni. Stanford University Museum of Art, California, 27 May–26 June. Catalogue.

American Art, 1910–1960: Selections from the Collection of Mr. and Mrs. Roy R. Neuberger. M. Knoedler and Co., Inc., New York, 8 June–9 September. Catalogue.

Twentieth-Century Drawing. Art Center in La Jolla, California, 18 August–25 September. Catalogue.

The Figure in Contemporary American Painting. American Federation of the Arts, New York, November 1960–November 1961. Traveling exhibition.

Elmer Bischoff, Richard Diebenkorn, David Park. Staempfli Gallery, New York, 8–26 November.

Second Winter Invitational. California Palace of the Legion of Honor, San Francisco, 23 December 1960–21 January 1961. Catalogue.

Venticinque anni di pittura americana, 1933–1958. Italy. Traveled. Catalogue.

Moderne amerikanische Malerei, 1930–1958. Organized by the City Art Museum, St. Louis, Missouri, for the United States Information Agency. Traveled to Hessisches Landesmuseum, Darmstadt, Germany, and to Göteborg Konstmuseum, Sweden, as *Moderne amerikanische Malerei, 1932–1958*. Catalogue.

1961
The Twenty-Seventh Biennial Exhibition of Contemporary American Painting. The Corcoran Gallery of Art, Washington, D.C., 14 January–26 February. Catalogue.

Contemporary American Painting and Sculpture. Krannert Art Museum, University of Illinois, Champaign, 26 February–2 April. Catalogue.

Faculty Exhibition. San Francisco Art Institute, 13–25 March.

Painting from the Pacific: Japan, America, Australia, New Zealand. Auckland City Art Gallery, New Zealand, May. Catalogue.

The 1961 Pittsburgh International Exhibition of Contemporary Painting and Sculpture. Museum of Art, Carnegie Institute, Pittsburgh, 27 October 1961–7 January 1962. Catalogue.

Annual Exhibition 1961. Whitney Museum of American Art, New York, 13 December 1961–4 February 1962. Catalogue.

Third Winter Invitational. California Palace of the Legion of Honor, San Francisco, 23 December 1961–21 January 1962. Catalogue.

VI Bienal. Museu de Arte Moderna, São Paulo, Brazil. Catalogue.

1962
One Hundred Fifty-Seventh Annual Exhibition of American Painting and Sculpture. Pennsylvania Academy of the Fine Arts, Philadelphia, 12 January–25 February. Catalogue.

Selections, 1934–1961: American Artists from the Collection of Martha Jackson. Martha Jackson Gallery, New York, 6 February–3 March. Catalogue.

Vanguard American Painting. American Embassy, United States Information Service Gallery, London, 28 February–30 March. Catalogue.

American Art since 1950. Seattle World's Fair, Fine Arts Pavilion, 21 April–21 October. Traveled to Rose Art Museum, Brandeis University, Waltham, Mass.; Institute of Contemporary Art, Boston. Catalogue.

Fifty California Artists. Organized by the San Francisco Museum of Art with assistance of Los Angeles County Museum of Art for the Whitney Museum of American Art, New York, 23 October–2 December. Traveled to Walker Art Center, Minneapolis; Albright-Knox Art Gallery, Buffalo; Des Moines Art Center. Catalogue.

Some Points of View: '62. Stanford University Museum of Art, California, 30 October–20 November. Catalogue.

Treasures from East Bay Collections. Oakland Art Museum, 3–25 November. Catalogue.

The Gifford and Joann Phillips Collection.
Art Galleries, University of California,
Los Angeles, 4 November–9 December. Catalogue.

The Artist's Environment: West Coast.
Amon Carter Museum of Western
Art, Fort Worth, Texas, 6 November–
23 December. Traveled to Art Galleries, University of California, Los
Angeles; Oakland Art Museum.
Catalogue.

Fourth Winter Invitational. California
Palace of the Legion of Honor, San
Francisco, 15 December 1962–27 January 1963. Catalogue.

Lithographs from the Tamarind Workshop. Art Galleries, University of California, Los Angeles. Traveling exhibition. Catalogue.

*Exhibition of Contemporary Painting and
Sculpture.* National Institute of Arts
and Letters, New York.

*Exhibition of Work by Newly Elected
Members and Recipients of Honors and
Awards.* National Institute of Arts and
Letters, New York.

1963
Sixty-Sixth Annual American Exhibition: Directions in Contemporary Painting and Sculpture. The Art Institute of
Chicago, 11 January–10 February.
Catalogue.

Twenty-Eighth Biennial Exhibition. The
Corcoran Gallery of Art, Washington,
D.C., 18 January–3 March.

*Eighty-Second Annual Painting and
Sculpture Exhibition of the San Francisco
Art Institute.* San Francisco Museum of
Art, 21 March–21 April. Prize award
for *Eve with Mirror.* Catalogue.

1963 Fine Arts Auction of the San Francisco Art Institute: Preview Exhibition.
California Palace of the Legion of
Honor, San Francisco, 11–19 September. Catalogue.

*Annual Exhibition 1963: Contemporary
American Painting.* Whitney Museum
of American Art, New York, 11 December 1963–2 February 1964.

Drawings by Bischoff, Diebenkorn, Lobdell. Achenbach Foundation for
Graphic Arts, California Palace of the
Legion of Honor, San Francisco.

1964
One Hundred Fifty-Ninth Annual Exhibition of American Painting and Sculpture. Pennsylvania Academy of the
Fine Arts, Philadelphia, 15 January–
1 March. Catalogue.

*Eighty-Third Annual Painting and Sculpture Exhibition of the San Francisco Art
Institute.* San Francisco Museum of
Art, 17 April–17 May. Emilie Sievert
Weinberg Award for *Landscape #4.*
Catalogue.

54–64: Painting and Sculpture of a Decade. Organized by the Calouste Gulbenkian Foundation, The Tate Gallery,
London, 22 April–28 June. Catalogue.

Seven California Painters. Staempfli
Gallery, New York, 22 June–31 July.
Catalogue.

*Between the Fairs: Twenty-Five Years of
American Art, 1939–1964.* Whitney
Museum of American Art, New York,
24 June–23 September. Catalogue.

*The 1964 Pittsburgh International Exhibition of Contemporary Painting and
Sculpture.* Museum of Art, Carnegie
Institute, Pittsburgh, 30 October
1964–10 January 1965. Catalogue.

*Man: Glory, Jest, and Riddle—A Survey
of the Human Form through the Ages.*
M. H. de Young Memorial Museum,
San Francisco; California Palace of the
Legion of Honor, San Francisco; San
Francisco Museum of Art, 10 November 1964–3 January 1965. Catalogue.

Seventy-Fifth Anniversary Alumni Exhibition. University Art Museum, University of New Mexico, Albuquerque.

Six Americans. Arkansas Arts Center,
Little Rock.

1965
The Drawing Society: Regional Exhibition. California Palace of the Legion of
Honor, San Francisco, 27 February–
11 April. Catalogue.

*Selections from the Work of California
Artists.* Witte Memorial Museum, San
Antonio, Texas, 10 October–14 November. Catalogue.

*1965 Annual Exhibition of Contemporary
American Painting.* Whitney Museum
of American Art, New York, 8 December 1965–30 January 1966. Catalogue.

California Printmakers. San Francisco
Art Institute. Catalogue.

*Two American Painters, Abstract and
Figurative: Sam Francis, Richard Diebenkorn.* Scottish National Gallery of
Modern Art, Edinburgh. Catalogue.

The San Francisco Collector. M. H.
de Young Memorial Museum, San
Francisco.

BRUCE McGAW

Solo Exhibition
1964
Distel Gallery, Palo Alto, California.

Group Exhibitions
1955
Fifth Annual Oil and Sculpture Exhibition. Richmond Art Center, California,
1–30 November. Catalogue.

*Bay Printmakers Society: First National
Exhibition of Prints.* Oakland Art Museum, 12 November–4 December.
Catalogue.

1956
*Seventy-Fifth Annual Painting and
Sculpture Exhibition of the San Francisco
Art Association.* San Francisco Museum of Art, 29 March–6 May.
Catalogue.

"6" Gallery, San Francisco, spring
(two-artist show with Manuel Neri).

1957
*Contemporary Bay Area Figurative
Painting.* Oakland Art Museum, 8–29
September. Traveled to Los Angeles
County Museum; Dayton Art Institute, Ohio. Catalogue.

1958
Group Show, "6" Gallery, San
Francisco.

1959
Ninth Annual Oil and Sculpture Exhibition. Richmond Art Center, California,
30 October–6 December. Catalogue.

1961
Faculty Exhibition. San Francisco Art
Institute, 13–25 March.

Third Winter Invitational. California
Palace of the Legion of Honor, San

Francisco, 23 December 1961–21 January 1962. Catalogue.

1965
St. Aidan's Episcopal Church, San Francisco (five-artist show).

MANUEL NERI

Solo Exhibitions
1959
Spatsa Gallery, San Francisco.

1960
An Exhibition of Sculpture and Drawings by Manuel Neri. Dilexi Gallery, San Francisco, 20 June–16 July.

1963
New Mission Gallery, San Francisco.

1964
Berkeley Gallery, Berkeley, California.

Group Exhibitions
1956
"6" Gallery, San Francisco, spring (two-artist show with Bruce McGaw).

1957
Recent Works by Manuel Neri and Jo-Ann Bilow. "6" Gallery, San Francisco, February.

California Painters' Exhibition. Oakland Art Museum, 9–31 March. Bronze medal for *For AM, Grand Canyon.* Catalogue.

Annual Watercolor, Drawing, and Print Exhibition of the San Francisco Art Association. San Francisco Museum of Art, 19 September–6 October. Catalogue.

Seventh Annual Oil and Sculpture Exhibition. Richmond Art Center, California, 1–30 November. Catalogue.

1958
Seventy-Seventh Annual Painting and Sculpture Exhibition of the San Francisco Art Association. San Francisco Museum of Art, 10 April–4 May. Catalogue.

Eighth Annual Oil and Sculpture Exhibition. Richmond Art Center, California, 30 October–7 December. Catalogue.

Berkeley Gallery, Berkeley, California.

Ferus Gallery, Los Angeles (exchange exhibition between "6" Gallery and Ferus Gallery artists).

1959
Paintings by Sam Francis, Wally Hedrick, and Fred Martin; Sculpture by Wally Hedrick and Manuel Neri. San Francisco Museum of Art, 3–22 February.

Ninth Annual Oil and Sculpture Exhibition. Richmond Art Center, California, 30 October–6 December. Catalogue.

1960
Batman Gallery, San Francisco, December (with Joan Brown and Wally Hedrick).

1961
Faculty Exhibition. San Francisco Art Institute, 13–25 March.

Staempfli Gallery, New York.

1962
The Nude: Graphics by Five Artists. California Palace of the Legion of Honor, San Francisco, 18 August–16 September.

Some Points of View: '62. Stanford University Museum of Art, California, 30 October–20 November. Catalogue.

Work in Clay by Six Artists. San Francisco Art Institute, closed 21 December.

San Francisco Nine. Museum of Contemporary Art, Houston. Catalogue.

1963
Eighty-Second Annual Exhibition of the San Francisco Art Institute. San Francisco Museum of Art, 21 March–21 April. Honorable mention for *A Couple*, mixed-media sculpture. Catalogue.

Some New Art in the Bay Area. San Francisco Art Institute, 8–24 May. Brochure.

Thirty Sculptors. Berkeley Gallery, Berkeley, California, 1–23 June.

California Sculpture Today. Oakland Art Museum, 4 August–15 September.

1964
Current Painting and Sculpture of the Bay Area. Stanford University Museum of Art, California, 8 October–29 November. Catalogue.

Joan Brown: Collages; Manuel Neri: Sculpture. David Stuart Galleries, Los Angeles, 9 November–5 December.

1965
Bay Region: Prints and Drawings. San Francisco Museum of Art, 12 January–21 February (two-artist show with Wayne Thiebaud).

NATHAN OLIVEIRA

Solo Exhibitions
1957
Lithographs by Nathan Oliveira. Eric Locke Gallery, San Francisco, 25 March–20 April.

1958
Nathan Oliveira. The Alan Gallery, New York, 20 October–8 November.

1959
Nathan Oliveira. Paul Kantor Gallery, Beverly Hills, California, 7 December 1959–2 January 1960. Catalogue.

1960
Nathan Oliveira: Paintings. The Alan Gallery, New York, 3–22 October.

1961
Nathan Oliveira: Paintings and Drawings. McNay Art Museum, San Antonio, Texas, 15 March–1 April.

Nathan Oliveira: Watercolor Studies of the Nude. R. E. Lewis, Inc., San Francisco, 6–29 April.

Nathan Oliveira. Paul Kantor Gallery, Beverly Hills, California, 8 May–3 June. Brochure.

Recent Work by Nathan Oliveira. Krannert Art Museum, University of Illinois, Champaign, 9 September–1 October. Traveled to University of Minnesota Art Museum, Minneapolis. Catalogue.

1963
Nathan Oliveira. The Alan Gallery, New York, 5–23 February. Brochure.

Nathan Oliveira. Art Galleries, University of California, Los Angeles, 15 September–20 October. Traveled to San Francisco Museum of Art; Fort Worth Art Center, Texas; Colorado Springs Fine Arts Center. Catalogue.

Nathan Oliveira. Paul Kantor Gallery, Los Angeles, 7 October–1 November. Catalogue.

1964
Recent Lithographs: Nathan Oliveira. R. E. Lewis, Inc., San Francisco, 8 June–3 July.

1965
Ten Years of Printmaking: Nathan Oliveira. Stanford University Museum of Art, California, 19 January–7 February. Traveled to San Francisco Museum of Art.

Nathan Oliveira: "Twelve Intimate Fantasies." Felix Landau Gallery, Los Angeles, 28 June–31 July. Brochure.

Nathan Oliveira: Drawings and Watercolors of the Figure. Lanyon Gallery, Palo Alto, California, 12 October–6 November.

Nathan Oliveira: Paintings and Collages, 1965. The Alan Gallery, New York, 26 October–13 November.

Group Exhibitions

1950
Eighteenth Annual Exhibition: Watercolors, Pastels, Drawings, and Prints. Oakland Art Gallery, 8 October–5 November. Catalogue.

1951
Nineteenth Annual Exhibition: Watercolors, Pastels, Drawings, and Prints. Oakland Art Gallery, 7 October–4 November. Catalogue.

Richmond Art Center First Annual Open Exhibition in Painting and Sculpture. Richmond Art Center, California, 9–28 October. Catalogue.

1952
Second Annual Biennial of Contemporary Color Lithography. The Cincinnati Art Museum, 21 March–28 April. Catalogue.

First Annual Exhibition of Watercolors, Prints, and Decorative Arts. Richmond Art Center, California, 25 March–25 April. Catalogue.

Sixteenth Annual Drawing and Print Exhibition of the San Francisco Art Association. San Francisco Museum of Art, 8 May–1 June. Catalogue.

California State Fair Art Exhibit. Sacramento, 28 August–7 September. Catalogue.

First Annual Pacific Art Festival. Exposition Building, Oakland, 1–5 October. Catalogue.

Third Annual Exhibition: Oil and Sculpture. Richmond Art Center, California, 5 November–6 December. Catalogue.

1953
Seventy-Second Annual Painting and Sculpture Exhibition of the San Francisco Art Association. San Francisco Museum of Art, 5 February–1 March. Catalogue.

California State Fair Art Exhibit. Sacramento. Catalogue.

1954
Eighteenth Annual Drawing and Print Exhibition of the San Francisco Art Association. San Francisco Museum of Art, 8 July–1 August. Catalogue.

Western Sculpture and Print Exhibition. Oakland Art Museum, 10 July–1 August. Catalogue.

Western Painters' Annual Exhibition. Oakland Art Museum, 5–30 November. Catalogue.

Prints and Methods of Printmaking by Forty Contemporary American Artists. The Santa Monica Art Gallery, California, 6 December 1954–7 January 1955. Brochure.

Third International Biennial of Contemporary Color Lithography. The Cincinnati Art Museum. Catalogue.

1955
Fourth Annual Exhibition: Watercolors, Prints, Decorative Arts. Richmond Art Center, California, 24 March–27 April. Catalogue.

The 1955 Pittsburgh International Exhibition of Contemporary Painting. Museum of Art, Carnegie Institute, Pittsburgh, 13 October–18 December. Catalogue.

Fifth Annual Oil and Sculpture Exhibition. Richmond Art Center, California, 1–30 November. Catalogue.

Nineteenth Annual Watercolor Exhibition of the San Francisco Art Association.

San Francisco Museum of Art, 10 November–11 December. Catalogue.

Nineteenth Annual Drawing and Print Exhibition of the San Francisco Art Association. San Francisco Museum of Art, 9 December 1955–8 January 1956. Catalogue.

Western Painters' Annual Exhibition. Oakland Art Museum, 10 December 1955–8 January 1956. Catalogue.

1956
Fourth International Biennial of Contemporary Color Lithography. The Cincinnati Art Museum, 13 April–31 May. Catalogue.

Ten Years of American Prints, 1947–1956. The Brooklyn Museum, 2 May–1 July. Catalogue.

Sixty-Second Annual for Western Artists. Denver Art Museum, 11 June–30 July. Catalogue.

Twenty-First Annual Midyear Show. Butler Institute of American Art, Youngstown, Ohio, 1 July–3 September. Catalogue.

Twentieth Annual Watercolor Exhibition of the San Francisco Art Association. San Francisco Museum of Art, 6–30 September. Catalogue.

A National Exhibition: Contemporary Arts of the United States, 1956. Art Building, Los Angeles County Fair, Pomona, California, 14–30 September. Catalogue.

East Bay Artists Association: Inaugural Exhibition. Oakland Art Museum, 5 October–2 November. Brochure.

Sixth Annual Oil and Sculpture Exhibition. Richmond Art Center, California, 1–30 November. Catalogue.

The Bay Printmakers Society: Second Annual National Exhibition. Oakland Art Museum, 11 November–2 December. Catalogue.

1957
Contemporary American Painting and Sculpture. Krannert Art Museum, University of Illinois, Champaign, 3 March–7 April. Catalogue.

Northwest Printmaking: Twenty-Ninth International Exhibition. Seattle Art Museum, 7 March–7 April. Brochure.

Sixth Annual Exhibition: Watercolor, Graphics, Decorative Arts. Richmond Art Center, California, 4 April–6 May. Catalogue.

Fifteenth National Exhibition of Prints Made during the Current Year. Library of Congress, Washington, D.C., 1 May–1 September. Catalogue.

Directions: Bay Area Painting, 1957. Richmond Art Center, California, 1 August–25 September. Circulated by Western Association of Art Museum Exhibitions. Catalogue.

Annual Watercolor, Drawing, and Print Exhibition of the San Francisco Art Association. San Francisco Museum of Art, 19 September–6 October. Catalogue.

Four Leading Printmakers of the Bay Area. Eric Locke Gallery, San Francisco, 25 September–26 October. Catalogue.

The Bay Printmakers Society: Third National Exhibition of Prints. Oakland Art Museum, 5–27 October. Purchase award. Catalogue.

Seventh Annual Oil and Sculpture Exhibition. Richmond Art Center, California, 1–30 November. Catalogue.

1958
Exhibition of New Paintings and Sculpture. The Alan Gallery, New York, 20 January–8 February.

Third Biennial Invitational Exhibition: Recent American Prints. Krannert Art Museum, University of Illinois, Champaign, 16 February–16 March. Catalogue.

Fifth International Biennial of Contemporary Color Lithography. The Cincinnati Art Museum, 28 February–15 April. Catalogue.

Seventy-Seventh Annual Painting and Sculpture Exhibition of the San Francisco Art Association. San Francisco Museum of Art, 10 April–4 May. Catalogue.

The Alan Gallery, New York, 14 April–3 May.

The 1958 Pittsburgh International Exhibition of Contemporary Painting and Sculpture. Museum of Art, Carnegie Institute, Pittsburgh, 5 December 1958–8 February 1959. Catalogue.

1959
Nebraska Art Association: Sixty-Ninth Annual Exhibition. The University of Nebraska Art Galleries, Lincoln, 1–31 March. Catalogue.

Painting since 1945: A Collection in the Making, Lent by Richard Brown Baker. Rhode Island School of Design, Providence, 18 March–19 April. Catalogue.

New Paintings, Sculpture. The Alan Gallery, New York, 1 June–2 July.

New Work 1. The Alan Gallery, New York, 8–26 September.

New Images of Man. The Museum of Modern Art, New York, 30 September–29 November. Catalogue.

Première Biennale de Paris. Musée d'Art Moderne de la Ville de Paris, 2–25 October. Catalogue.

Eleven American Printmakers. The Hetzel Union Building Gallery, Pennsylvania State University, University Park, 21 November–10 December.

Sixty-Third American Exhibition: Paintings, Sculpture. The Art Institute of Chicago, 2 December 1959–31 January 1960. Norman Wait Harris Bronze Medal and Prize in Painting for *For Manolete*. Catalogue.

San Francisco Art Association Artist Members' Exhibition. M. H. de Young Memorial Museum, San Francisco, 18 December 1959–17 January 1960.

1960
Nebraska Art Association: Seventieth Annual Exhibition. The University of Nebraska Art Galleries, Lincoln, 28 February–27 March. Catalogue.

Main Currents of Contemporary American Painting. The Department of Art, State University of Iowa, Ames, 26 May–7 August. Catalogue.

New Work IV. The Alan Gallery, New York, 1–30 June. Brochure.

American Art, 1910–1960: Selections from the Collection of Mr. and Mrs. Roy R. Neuberger. M. Knoedler and Company, Inc., New York, 8 June–9 September. Catalogue.

Twentieth-Century Drawing. La Jolla Art Center, California, 18 August–25 September. Catalogue.

Guggenheim International Award 1960. The Solomon R. Guggenheim Museum, New York, 1 November 1960–29 January 1961. Catalogue.

1961
Sixty-Fourth American Exhibition: Painting, Sculpture. The Art Institute of Chicago, 6 January–5 February. Catalogue.

Contemporary American Painting and Sculpture. Krannert Art Museum, University of Illinois, Champaign, 26 February–2 April. Catalogue; statement by Oliveira.

Eighty Works from the Richard Brown Baker Collection. Walker Art Center, Minneapolis, 12 March–16 April. Catalogue.

Faculty Exhibition. San Francisco Art Institute, 13–25 March.

Painting from the Pacific: Japan, America, Australia, New Zealand. Auckland City Art Gallery, New Zealand, May. Catalogue.

New Work. The Alan Gallery, New York, 8–26 May.

Dedication Exhibition. Krannert Art Museum, University of Illinois, Champaign, 20 May–25 June. Catalogue.

From 1700 to 1961: Painting, Drawing, Sculpture. The Alan Gallery, New York, 12–30 September.

The 1961 Pittsburgh International Exhibition of Contemporary Painting and Sculpture. Museum of Art, Carnegie Institute, Pittsburgh, 27 October 1961–7 January 1962. Catalogue.

Man. The Alan Gallery, New York, 13 November–2 December.

The Art of San Francisco: Painting, Sculpture, and Architecture since 1871 by Artists Associated with the San Francisco Art Institute. San Francisco Museum of Art, 29 November 1961–7 January 1962. Brochure.

Annual Exhibition 1961: Contemporary American Painting. Whitney Museum of American Art, New York, 13 December 1961–4 February 1962. Catalogue.

1962
Sixty-Fifth Annual American Exhibition: Some Directions in Painting. The Art Institute of Chicago, 5 January–18 February. Catalogue.

Increase in Riches: The Growth of the Museum's Collections, 1959–1961. San Francisco Museum of Art, 10 January–25 February. Brochure.

American Printmakers, 1962. School of Art, Syracuse University, New York, 21 January–28 February. Catalogue.

Linearity in Paintings and Drawings (from the Collections of the San Francisco Museum of Art). University Art Gallery, University of California, Berkeley, 5 February–11 March. Catalogue.

New Work by Hunt, Ohashi, Oliveira. The Alan Gallery, New York, 12 February–3 March.

American Art since 1950. Seattle World's Fair, Fine Arts Pavilion, 21 April–21 October. Traveled to Rose Art Museum, Brandeis University, Waltham, Mass.; Institute of Contemporary Art, Boston. Catalogue.

Recent Painting U.S.A.: The Figure. The Museum of Modern Art, New York, 23 May–4 September. Traveled to Columbus Gallery of Fine Arts, Ohio; Colorado Springs Fine Arts Center; Baltimore Museum of Art; City Art Museum of St. Louis; San Francisco Museum of Art; Walker Art Center, Minneapolis. Catalogue.

Fifty California Artists. Organized by the San Francisco Museum of Art with assistance of Los Angeles County Museum of Art for the Whitney Museum of American Art, New York, 23 October–2 December. Traveled to Walker Art Center, Minneapolis; Albright-Knox Art Gallery, Buffalo; Des Moines Art Center. Catalogue.

Some Points of View: '62. Stanford University Museum of Art, California, 30 October–20 November. Catalogue.

Treasures from East Bay Collections. Oakland Art Museum, 3–25 November. Catalogue.

The Gifford and Joann Phillips Collection. Art Galleries, University of California, Los Angeles, 4 November–9 December. Catalogue.

The Artist's Environment: West Coast. Amon Carter Museum of Western Art, Fort Worth, Texas, 6 November–23 December. Traveled to Art Galleries, University of California, Los Angeles; Oakland Art Museum. Catalogue.

1963
Contemporary American Painting and Sculpture. Krannert Art Museum, University of Illinois, Champaign, 3 March–7 April. Catalogue.

Eighty-Second Annual Exhibition of the San Francisco Art Institute. San Francisco Museum of Art, 21 March–21 April. Catalogue.

Arte de America y España. Palacios de Velázquez y Cristal de Reiro, Madrid, May–June. Traveled to Kunstmuseum, Bern, Switzerland. Special prize. Catalogue.

1964
Jack Levine, Nathan Oliveira. Galeria George Lester, Rome, 2–30 May. Brochure.

Nieuwe realisten. Haags Gemeentemuseum, The Hague, Netherlands, 24 June–30 August. Catalogue.

Opening Exhibition. The Alan Gallery, New York, 8–26 September.

Contemporary Painters and Sculptors as Printmakers. The Museum of Modern Art, New York, 15 September–25 October. Catalogue.

Fourth Biennial Print Exhibition. Pasadena Art Museum, California, 6 October–6 November. Catalogue.

Current Painting and Sculpture of the Bay Area. Stanford University Museum of Art, California, 8 October–29 November. Catalogue.

"Old Hundred": Selections from the Larry Aldrich Contemporary Collection, 1954–1964. The Larry Aldrich Museum, Ridgefield, Connecticut, November 1964–15 April 1965. Catalogue.

New Dimensions in Lithography: Tamarind Lithography Workshop. Fisher and Quinn Galleries, University of Southern California, Los Angeles, 6–25 November. Catalogue.

Man: Glory, Jest, and Riddle—A Survey of the Human Form through the Ages. M. H. de Young Memorial Museum, San Francisco; California Palace of the Legion of Honor, San Francisco; San Francisco Museum of Art, 10 November 1964–3 January 1965. Catalogue.

1965
One Hundred Contemporary American Drawings. Museum of Art, University of Michigan, Ann Arbor, 24 February–28 March. Catalogue.

The Drawing Society Regional Exhibition. California Palace of the Legion of Honor, San Francisco, 27 February–11 April. Catalogue.

Some Aspects of California Painting and Sculpture. La Jolla Museum of Art, California, 28 February–11 April. Catalogue.

Seventy Works by Seventeen Artists: Tamarind Lithography Workshop. Otis Art Institute of Los Angeles County, 1 April–9 May. Catalogue.

Opening Exhibition. The Alan Gallery, New York, 8 September–2 October.

Selections from the Works of California Artists. San Antonio Art League, Witte Memorial Museum, San Antonio, Texas, 10 October–14 November. Catalogue.

Art on Paper 1965. Weatherspoon Art Gallery, The University of North Carolina, Greensboro, 1–24 November. Catalogue.

DAVID PARK

Solo Exhibitions

1953
Paintings by David Park. King Ubu Gallery, San Francisco, 1–19 August.

1954
David Park. Paul Kantor Gallery, Los Angeles, 14 June–16 July.

1955
David Park. Richmond Art Center, California, 8 August–26 September.

1956
David Park. College of Architecture, University of California, Berkeley.

1959
David Park. M. H. de Young Memorial Museum, San Francisco, 26 March–26 April. Catalogue; statement by Park.

May Formal: David Park Decors and Costume Design. Department of Music, University of California, Berkeley, 14–25 May.

Inaugural Exhibition: David Park, Recent Paintings. Staempfli Gallery, New York, 30 September–17 October. Catalogue; statement by Park.

1961
David Park: Gouaches and Drawings. La Jolla Art Center, California, 31 January–26 February.

David Park. Artists Cooperative Gallery, Sacramento, 17 March–6 April.

David Park, 1911–1960: Retrospective Exhibition. Staempfli Gallery, New York, 5–30 December. Traveled to Institute of Contemporary Art, Boston; Tennessee Fine Arts Center, Nashville; Corcoran Gallery of Art, Washington, D.C.; Oakland Art Museum; University of Minnesota Gallery, Minneapolis; Krannert Art Museum, University of Illinois, Champaign. Catalogue.

1962
David Park. The Obelisk Gallery, Washington, D.C., in association with Staempfli Gallery, New York, 20 April–13 May. Brochure.

1964
David Park, Memorial Exhibition: The University Years, 1955–1960. University Art Gallery, Berkeley, 6 October–8 November. Traveled to Dickson Art Center, University of California, Los Angeles; Art Gallery, University of California, Santa Barbara. Catalogue.

Group Exhibitions

1950
New Works by Bay Region Artists. San Francisco Museum of Art, 12 January–5 February.

Fifteen Paintings by San Francisco Artists. Henry Gallery, University of Washington, Seattle, 30 January–22 February.

Sixty-Ninth Annual Exhibition of Oil, Tempera, and Sculpture of the San Fran-cisco Art Association. San Francisco Museum of Art, 10 February–12 March. Catalogue.

Large-Scale Drawings by Modern Artists. California Palace of the Legion of Honor, San Francisco, 17 February–9 April. Catalogue.

Members' Exhibition. M. H. de Young Memorial Museum, San Francisco, 25 March–23 April.

1951
Seventieth Annual Oil and Sculpture Exhibition of the San Francisco Art Association. San Francisco Museum of Art, 28 February–8 April. SFAA Prize for Painting for *Kids on Bikes*. Catalogue.

Opening Exhibition. Richmond Art Center, California, 17 April–13 May. Catalogue.

1952
Contemporary American Painting and Sculpture. Krannert Art Museum, University of Illinois, Champaign, 2 March–13 April. Catalogue; statement by Park.

Art Makes Contact. San Francisco Museum of Art, 26 March–4 May.

Bay Region Painting and Sculpture. San Francisco Museum of Art, 8 October–9 November.

1953
Seventy-Second Annual Painting and Sculpture Exhibition of the San Francisco Art Association. San Francisco Museum of Art, 5 February–1 March. Catalogue.

1954
Seventy-Third Annual Painting and Sculpture Exhibition of the San Francisco Art Association. San Francisco Museum of Art, 18 February–28 March. Catalogue.

Group Exhibition. Paul Kantor Gallery, Los Angeles, opened 3 May.

Fourth Annual Oil and Sculpture Exhibition. Richmond Art Center, California, 9 November–9 December. Catalogue.

1955
Seventy-Fourth Annual Painting and Sculpture Exhibition of the San Francisco Art Association. San Francisco Museum of Art, 7 April–8 May. William L. Gerstle Memorial Prize for Figure Composition for *Bathers*. Catalogue.

Art in the Twentieth Century. San Francisco Museum of Art, 17 June–10 July. Catalogue.

III Bienal. Museu de Arte Moderna, São Paulo, Brazil, opened 29 June. Catalogue.

Fifth Annual Oil and Sculpture Exhibition. Richmond Art Center, California, 1–30 November. Catalogue.

California Painting: Forty Painters. The Municipal Art Center, Long Beach, California. Catalogue.

1956
Seventy-Fifth Annual Painting and Sculpture Exhibition of the San Francisco Art Association. San Francisco Museum of Art, 29 March–6 May. Catalogue.

Pacific Coast Art: United States' Representation at the Third Biennial of São Paulo. San Francisco Museum of Art, 15 May–15 July. Traveled to Cincinnati Art Museum; Colorado Springs Fine Arts Center; Walker Art Center, Minneapolis. Catalogue.

1957
Contemporary American Painting and Sculpture. Krannert Art Museum, University of Illinois, Champaign, 3 March–7 April. Catalogue.

California Painters' Exhibition. Oakland Art Museum, 9–31 March. Catalogue.

Painting and Sculpture Now. San Francisco Museum of Art, 23 April–12 May.

American Paintings, 1945 to 1957. The Minneapolis Institute of Arts, 18 June–1 September. Catalogue.

Directions: Bay Area Painting, 1957. Richmond Art Center, California, 1 August–25 September. Circulated by Western Association of Art Museum Exhibitions. Catalogue.

Contemporary Bay Area Figurative Painting. Oakland Art Museum, 8–29 September. Traveled (with additional paintings by Richard Diebenkorn and David Park from the collection of Walter P. Chrysler, Jr.) to Los Angeles County Museum; Dayton Art Insti-

tute, Ohio. Gold medal for *Figure in Landscape*. Catalogue.

Seventh Annual Painting and Sculpture Exhibition. Richmond Art Center, California, 1–30 November. Honorable mention. Catalogue.

1958
American Painting, 1958. Virginia Museum of Fine Arts, Richmond, 28 March–27 April. Catalogue.

Seventy-Seventh Annual Painting and Sculpture Exhibition of the San Francisco Art Association. San Francisco Museum of Art, 10 April–4 May. Prize for Painting for *The Canoe*. Catalogue.

Artist Members' Exhibition. California Palace of the Legion of Honor, San Francisco, 27 September–26 October. Catalogue.

Eighth Annual Exhibition of Oil Paintings and Sculpture. Richmond Art Center, California, 30 October–7 December.

1959
1959 California Painters' Exhibition. Oakland Art Museum, 1 January–1 February. Catalogue.

New Directions in Painting. Florida State University Gallery, Tallahassee, March. Traveled to John and Mable Ringling Museum of Art, Sarasota, Florida; Norton Gallery and School of Art, West Palm Beach, Florida. Catalogue.

Contemporary American Painting and Sculpture. Krannert Art Museum, University of Illinois, Champaign, 1 March–5 April. Catalogue; statement by Park.

Art: USA. New York Coliseum, 3–19 April.

Second Biennial of American Painting and Sculpture. The Detroit Institute of Arts, 29 November 1959–3 January 1960. Catalogue.

San Francisco Art Association Artist Members' Exhibition. M. H. de Young Memorial Museum, San Francisco, December. Catalogue.

1959 Annual Exhibition of Contemporary American Painting. Whitney Museum of American Art, New York, 9 December 1959–31 January 1960. Catalogue.

1960
Winter Invitational. California Palace of the Legion of Honor, San Francisco, 23 January–28 February. Catalogue.

One Hundred Fifty-Fifth Annual Exhibition. Pennsylvania Academy of the Fine Arts, Philadelphia, 24 January–28 February. Prize for *Three Bathers*. Catalogue.

The First Exhibition of the Permanent Collection of F.S.U. Florida State University Art Gallery, Tallahassee, 2–21 February.

Sixty-Sixth Annual Exhibition. The Denver Art Museum, 5 March–10 April.

Hallmark Fifth International Art Award: The Question of the Future. Wildenstein & Co., New York, 5–26 October.

Elmer Bischoff, Richard Diebenkorn, David Park. Staempfli Gallery, New York, 8–26 November.

David Park Memorial Exhibition. Oakland Art Museum, 8–26 December.

The Figure in Contemporary American Painting. American Federation of the Arts, New York, traveling exhibition.

1961
Sixty-Fourth American Exhibition: Painting, Sculpture. The Art Institute of Chicago, 6 January–5 February. Catalogue.

The Twenty-Seventh Biennial Exhibition of Contemporary American Painting. The Corcoran Gallery of Art, Washington, D.C., 14 January–26 February. Catalogue.

Contemporary American Painting and Sculpture. Krannert Art Museum, University of Illinois, Champaign, 26 February–2 April. Catalogue.

Provisional Collection. Institute of Contemporary Art, Boston, March. Catalogue.

The Face of the Fifties: Recent Painting and Sculpture from the Collection of the Whitney Museum of American Art. The University of Michigan Museum of Art, Ann Arbor, 12 April–28 May. Catalogue.

A Selection from the Josephine and P. A. Bruno Collection. Krannert Art Mu-

seum, University of Illinois, Champaign, 11 November–3 December. Traveled to the Fine Arts Center, Nashville.

1962
Increase in Riches: The Growth of the Museum's Collections, 1959–1961. San Francisco Museum of Art, 10 January–25 February. Brochure.

Vanguard American Painting. American Embassy, United States Information Service Gallery, London, 28 February–30 March. Catalogue.

New Accessions USA. Colorado Springs Fine Arts Center, 27 June–12 September.

Recent Acquisitions. Staempfli Gallery, New York, 18 September–13 October. Brochure.

Fifty California Artists. Organized by the San Francisco Museum of Art with assistance of Los Angeles County Museum of Art for the Whitney Museum of American Art, New York, 23 October–2 December. Traveled to Walker Art Center, Minneapolis; Albright-Knox Art Gallery, Buffalo; Des Moines Art Center. Catalogue.

Treasures from East Bay Collections. Oakland Art Museum, 3–25 November. Catalogue.

The Gifford and Joann Phillips Collection. Art Galleries, University of California, Los Angeles, 4 November–9 December. Catalogue.

1964
54–64: Painting and Sculpture of a Decade. Organized by the Calouste Gulbenkian Foundation, The Tate Gallery, London, 22 April–28 June. Catalogue.

Seven California Painters. Staempfli Gallery, New York, 22 June–31 July. Catalogue.

Between the Fairs: Twenty-Five Years of American Art, 1939–1964. Whitney Museum of American Art, New York, 24 June–23 September. Catalogue.

1965
American Paintings from the Bloedel Collection. Leeds City Art Center, England, 31 May–3 July. Traveled to Chelsea School of Art, London. Catalogue.

Selections from the Work of California Artists. Witte Memorial Museum, San Antonio, Texas, 10 October–14 November. Catalogue.

Three California Painters: Elmer Bischoff, Joan Brown, David Park. Staempfli Gallery, New York, 7 December 1965–8 January 1966. Brochure.

Collection of Paintings and Sculpture from Mr. and Mrs. A. H. Maremont. Greenville County Museum of Art, South Carolina, 16 December 1965–23 January 1966. Catalogue.

JAMES WEEKS

Solo Exhibitions

1955
James Weeks. "6" Gallery, San Francisco, 2–31 August.

1957
Lucien Labaudt Art Gallery, San Francisco.

1958
James Weeks: Paintings. East & West Gallery, San Francisco, 9 April–4 May.

1960
James Weeks. Poindexter Gallery, New York, 12 December 1960–7 January 1961.

1961
Drawings, Poindexter Gallery, New York.

1963
James Weeks. Poindexter Gallery, New York, 14 May–1 June. Catalogue.

1964
Recent Paintings: James Weeks. Felix Landau Gallery, Los Angeles, 6–25 January. Catalogue.

1965
James Weeks. San Francisco Museum of Art, 3 July–3 August. Catalogue.

James Weeks. Poindexter Gallery, New York, 5–23 October.

Group Exhibitions

1950
Sixty-Ninth Annual Oil, Tempera, and Sculpture Exhibition of the San Francisco Art Association. San Francisco Museum of Art, 10 February–12 March. Catalogue.

Fourteenth Annual Drawing and Print Exhibition of the San Francisco Art Association. San Francisco Museum of Art, 24 May–18 June. Catalogue.

1951
California School of Fine Arts Faculty Show. M. H. de Young Memorial Museum, San Francisco, March–April.

Paintings by James Weeks and Julian Phillips. Lucien Labaudt Art Gallery, San Francisco, 25 April–18 May.

1953
Seventy-Second Annual Painting and Sculpture Exhibition of the San Francisco Art Association. San Francisco Museum of Art, 5 February–1 March. Catalogue.

Works by Four Contemporary Artists: Jeremy Anderson, James Weeks, Hassel Smith, Ernest Briggs. California Palace of the Legion of Honor, San Francisco, 26 September–11 November.

1957
Contemporary Bay Area Figurative Painting. Oakland Art Museum, 8–29 September. Traveled to Los Angeles County Museum; Dayton Art Institute, Ohio. Catalogue.

1958
Artist Members' Exhibition. California Palace of the Legion of Honor, San Francisco, 27 September–26 October. Catalogue.

1959
San Francisco Art Association Members' Exhibition. M. H. de Young Memorial Museum, San Francisco, December.

1960
Winter Invitational. California Palace of the Legion of Honor, San Francisco, 23 January–28 February. Catalogue.

Second Winter Invitational. California Palace of the Legion of Honor, San Francisco, 23 December 1960–21 January 1961. Catalogue.

1961
Faculty Exhibition. San Francisco Art Institute, 13–25 March.

Painting from the Pacific: Japan, America, Australia, New Zealand. Auckland City Art Gallery, New Zealand, May. Catalogue.

Third Winter Invitational. California Palace of the Legion of Honor, San Francisco, 23 December 1961–21 January 1962. Prize Award. Catalogue.

Figure Painting in America. Birmingham Museum of Art, Alabama.

1962
Some Points of View, '62. Stanford University Museum of Art, California, 30 October–20 November. Catalogue.

San Francisco Nine. Contemporary Arts Museum, Houston, 29 November–29 December. Catalogue.

Fourth Winter Invitational. California Palace of the Legion of Honor, San Francisco, 15 December 1962–27 January 1963. Prize Award. Catalogue.

Four Artists. Felix Landau Gallery, Los Angeles.

Five Decades of the Figure. State University of Iowa Art Gallery, Iowa City.

1963
Eighty-Second Annual Exhibition of the San Francisco Art Institute. San Francisco Museum of Art, 21 March–21 April. Prize Award for #1, 1963. Catalogue.

Artists West of the Mississippi: The Realistic Image. Colorado Springs Fine Arts Center, 19 August–27 October. Catalogue.

1963 Fine Arts Auction of the San Francisco Art Institute, Preview Exhibition. California Palace of the Legion of Honor, San Francisco, 11–19 September. Catalogue.

Fourth Art Center Annual of California Painting and Sculpture. Art Center in La Jolla, California, 17 November–15 December. Catalogue.

1964
Sixty-Seventh Annual American Exhibition: Directions in Contemporary Painting and Sculpture. The Art Institute of Chicago, 28 February–12 April. Catalogue.

Seven California Painters. Staempfli Gallery, New York, 22 June–31 July. Catalogue.

The 1964 Pittsburgh International Exhibition of Contemporary Painting and Sculpture. Museum of Art, Carnegie Institute, Pittsburgh, 30 October 1964–10 January 1965. Catalogue.

1965
One Hundred Contemporary American Drawings. Museum of Art, University of Michigan, Ann Arbor, 24 February–28 March. Catalogue.

Contemporary American Painting and Sculpture. Krannert Art Museum, University of Illinois, Champaign, 7 March–11 April. Catalogue.

Selections from the Work of California Artists. Witte Memorial Museum, San Antonio, Texas, 10 October–14 November. Catalogue.

PAUL WONNER

Solo Exhibitions
1956
M. H. de Young Memorial Museum, San Francisco, 3 March–1 April.

Paul Wonner. San Francisco Art Association Gallery, California School of Fine Arts, 14 December 1956–4 January 1957. Brochure; statement by Wonner.

1959
Felix Landau Gallery, Los Angeles.

1960
Paintings by Paul Wonner. Santa Barbara Museum of Art, California, 4–27 March.

Paul Wonner: Recent Paintings. Felix Landau Gallery, Los Angeles, 18 April–7 May.

1962
Paintings by Paul Wonner. California Palace of the Legion of Honor, San Francisco, 20 January–18 February.

Felix Landau Gallery, Los Angeles.

Poindexter Gallery, New York.

1963
Recent Paintings: Paul Wonner. Felix Landau Gallery, Los Angeles, 7–26 January. Catalogue.

1964
Paul Wonner: Recent Paintings. Felix

Landau Gallery, Los Angeles, 7 December 1964–14 November 1965. Brochure.

Poindexter Gallery, New York.

1965
Paul Wonner: Watercolours, 1963–1964. Waddington Galleries, London, 7–30 January. Brochure.

Paul Wonner: Paintings. Marion Koogler McNay Art Institute, San Antonio, Texas, 15 October–14 November. Catalogue.

Group Exhibitions
1950
Sixty-Ninth Annual Oil, Tempera, and Sculpture Exhibition of the San Francisco Art Association. San Francisco Museum of Art, 10 February–12 March. Catalogue.

1952
Sixteenth Annual Drawing and Print Exhibition of the San Francisco Art Association. San Francisco Museum of Art, 8 May–1 June. Catalogue.

1953
Seventy-Second Painting and Sculpture Exhibition of the San Francisco Art Association. San Francisco Museum of Art, 5 February–1 March. Catalogue.

1954
Seventy-Third Annual Painting and Sculpture Exhibition of the San Francisco Art Association. San Francisco Museum of Art, 18 February–28 March. Catalogue.

Younger American Painters. Solomon R. Guggenheim Museum, New York, 12 May–25 July. Traveled to Los Angeles County Museum. Catalogue.

Western Painters' Annual Exhibition. Oakland Art Museum, 5–30 November. Catalogue.

Fourth Annual Oil and Sculpture Exhibition. Richmond Art Center, California, 9 November–9 December. Catalogue.

1955
Art in the Twentieth Century. San Francisco Museum of Art, 17 June–10 July. Catalogue.

III Bienal. Museu de Arte Moderna, São Paulo, Brazil, opened 29 June. Catalogue.

Vanguard 1955. Walker Art Center, Minneapolis, 23 October–5 December. Catalogue.

Fifth Annual Painting and Sculpture Exhibition. Richmond Art Center, California, 1–30 November. Second prize in painting for *Femme au coq.* Catalogue.

1956
Pacific Coast Art: United States' Representation at the Third Biennial of São Paulo. San Francisco Museum of Art, 15 June–15 July. Traveled to Cincinnati Art Museum; Colorado Springs Fine Arts Center; Walker Art Center, Minneapolis. Catalogue.

1957
Contemporary Bay Area Figurative Painting. Oakland Art Museum, 8–29 September. Traveled to Los Angeles County Museum; Dayton Art Institute, Ohio. Catalogue.

1958
Seventy-Seventh Annual Painting and Sculpture Exhibition of the San Francisco Art Association. San Francisco Museum of Art, 10 April–4 May. Prize for Painting. Catalogue.

Artist Members' Exhibition. California Palace of the Legion of Honor, San Francisco, 27 September–26 October. Catalogue.

The 1958 Pittsburgh International Exhibition of Contemporary Painting and Sculpture. Museum of Art, Carnegie Institute, Pittsburgh, 5 December 1958–8 February 1959. Catalogue.

Spoleto Art Festival. Spoleto, Italy.

1959
Seventy-Eighth Annual Painting and Sculpture Exhibition of the San Francisco Art Association. San Francisco Museum of Art, 2 April–3 May. Catalogue.

Art U.S.A. New York Coliseum, 3–19 April.

1959 Annual Exhibition of Contemporary American Painting. Whitney Museum of American Art, New York, 9 December 1959–31 January 1960.

1960
Winter Invitational Exhibition. California Palace of the Legion of Honor, San

Francisco, 23 January–28 February. Catalogue.

Seventy-Ninth Annual Painting and Sculpture Exhibition of the San Francisco Art Association. San Francisco Museum of Art, 24 March–24 April. Catalogue.

Third Pacific Coast Biennial. Santa Barbara Museum of Art, 9 October–8 November. Traveled to The Fine Arts Museum of San Diego; Municipal Art Gallery, Los Angeles; Portland Art Museum, Oregon; Henry Gallery, University of Washington, Seattle; M. H. de Young Memorial Museum, San Francisco.

Second Winter Invitational. California Palace of the Legion of Honor, San Francisco, 23 December 1960–21 January 1961. Catalogue.

East-West. Zabriskie Gallery, New York, with Theophilus Brown and John Paul Jones.

1961
1961 Northern California Painters' Annual. Oakland Art Museum, 7–29 January. Brochure.

Twenty-Fourth Annual Drawing, Print, and Sculpture Exhibition of the San Francisco Art Association. San Francisco Museum of Art, 2 February–5 March. Catalogue.

Contemporary American Painting and Sculpture. Krannert Art Museum, University of Illinois, Champaign, 26 February–2 April. Catalogue.

Third Winter Invitational. California Palace of the Legion of Honor, San Francisco, 23 December 1961–21 January 1962.

1962
Treasures from East Bay Collections. Oakland Art Museum, 3–25 November. Catalogue.

1963
Contemporary American Painting and Sculpture. Krannert Art Museum, University of Illinois, Champaign, 3 March–7 April. Catalogue.

Artists West of the Mississippi: The Realistic Image. Colorado Springs Fine Arts Center, 19 August–27 October. Catalogue.

1964
Paul Wonner: Watercolors and Drawings; Theo William Brown: Paintings and Drawings. Esther Bear Gallery, Santa Barbara, 12 January–7 February.

Sixty-Seventh Annual American Exhibition: Directions in Contemporary Painting and Sculpture. The Art Institute of Chicago, 28 February–12 April. Catalogue.

Seven California Painters. Staempfli Gallery, New York, 22 June–31 July. Catalogue.

The 1964 Pittsburgh International Exhibition of Contemporary Painting and Sculpture. The Carnegie Institute, Pittsburgh, 30 October 1964–10 January 1965. Catalogue.

1965
Contemporary American Painting and Sculpture. Krannert Art Museum, University of Illinois, Champaign, 7 March–11 April. Catalogue.

Selections from the Work of California Artists. Witte Memorial Museum, San Antonio, Texas, 10 October–14 November. Catalogue.

Exhibition catalogues for individual artists from the years 1950 through 1965 can be found in the listings of their exhibition histories.

GENERAL

Albright, Thomas. "Bay Area Art: Time of Change." *Horizon*, July 1980, 24–35.

———. "San Francisco: Different and Indifferent Drummer." *Art News* (January 1982): 87–89.

———. *Art in the San Francisco Bay Area, 1945–1980: An Illustrated History*. Berkeley and Los Angeles: University of California Press, 1985.

Amerikanische Malerei, 1930–1980. Exhibition catalogue. Munich: Haus der Kunst, 1981.

Arnason, H. H. *History of Modern Art: Painting, Sculpture, Architecture*. New York: Harry N. Abrams, Inc., 1968.

The Artist's Environment: West Coast. Exhibition Catalogue. Fort Worth: The Amon Carter Museum of Western Art, 1962.

Ashton, Dore. "An Eastern View of the San Francisco School." *Evergreen Review* 1, no. 2 (1957): 148–59.

Baird, Joseph Armstrong, Jr., ed. *Directions in Bay Area Painting: A Survey of Three Decades, 1940s–1960s*. Exhibition catalogue. Richard L. Nelson Gallery. Davis: The Regents of the University of California, 1983.

Baker, Kenneth. "When Bay Area Art Turned to the Figure." *San Francisco Chronicle*, 7 October 1987.

"Bay Region Art during Two Decades." *San Francisco Museum of Art Quarterly Bulletin* ser. 2, vol. 3, no. 3 (1954): 19–22.

Berman, Greta, and Jeffrey Wechsler. *Realism and Realities: The Other Side of American Painting, 1940–1960*. Exhibition catalogue. New Brunswick, N.J.: Rutgers University Art Gallery, 1981.

Bogat, Regina. "Fifty California Artists." Review. *Artforum* 1, no. 7 (1963): 24–26.

Bossart, Joan Chambliss. "Bay Area Figurative Painting Reconsidered." Master's thesis, University of California, Berkeley, 1984.

Brown, Christopher, and Judith Dunham. *New Bay Area Painting and Sculpture*. Exhibition catalogue. San Francisco: Squeezer Press for California State University, Northridge, 1982.

Chipp, Herschel B. "San Francisco." Review. *Art News* (December 1957): 50.

Colt, Priscilla. "Remarks on the Figure and Lester Johnson." *Art International* (January 1964): 65.

Coplans, John. "The Nude" in "San Francisco." Review. *Artforum* 1, no. 5 (1962): 39.

———. "Circle of Styles on the West Coast." *Art in America* (June 1964): 24–41.

Crehan, Hubert. "Is There a California School?" *Art News* (January 1956): 32–35, 64–65.

Culler, George D. *Fifty California Artists*. Exhibition catalogue. San Francisco: San Francisco Museum of Art for the Whitney Museum of American Art, 1962.

A Decade in the West: Painting, Sculpture, and Graphics from the Anderson Collection. Exhibition catalogue. Stanford: Stanford University Museum of Art, 1971.

Directions: Bay Area Painting, 1957. Exhibition catalogue. Richmond, Calif.: Richmond Art Center, 1957.

Donnell-Kotrozo, Carol. "Bay Area Art." Review. *Arts Magazine* (March 1980): 4.

Feldman, Anita. "The Figurative, the Literary, the Literal: American Figurative Tradition at the Venice Biennale." *Arts Magazine* (June 1968): 22–27.

Ferling [Ferlinghetti], Lawrence. "Expressionism in San Francisco Painting Today." *Counterpoint* (January 1952): 16–19.

Figurative Four: Elmer Bischoff, Joan Brown, David Park, Roland Peterson. Exhibition brochure. Los Angeles: Adele Bednarz Gallery, 1968.

The Figurative Mode: Bay Area Painting, 1956–1966. Exhibition catalogue. New York: Grey Art Gallery and Study Center, New York University, 1984.

"Figurative Painters in California." Review. *Arts Magazine* (December 1957): 26–27.

Frankenstein, Alfred. "Contemporary Styles in Painting and Sculpture." Review. *San Francisco Chronicle*, 8 May 1957, 25.

———. "Oakland Displays New Figurative Paintings." Review. *San Francisco Chronicle*, 23 September 1957, 21.

Fried, Alexander. "Two Artists Hint New Modern Trend." Review. *San Francisco Examiner, Pictorial Review*, 15 February 1953, 19.

Fuller, Mary. "Was There a San Francisco School?" *Artforum* (January 1971): 46–53.

Getlein, Frank. "Kidding the Id in Minneapolis." *The New Republic*, 26 August 1957, 21.

Goodyear, Frank H., Jr. *Contemporary American Realism since 1960*. Boston: New York Graphic Society for the Pennsylvania Academy of the Fine Arts, Philadelphia, 1981.

Hassel Smith. Exhibition catalogue. San Francisco: California School of Fine Arts, 1957.

Hills, Patricia, and Roberta K. Tarbell. *The Figurative Tradition and the Whitney Museum of American Art*. Exhibition catalogue. New York: Whitney Museum of American Art, 1980.

Hopkins, Henry. *Fifty West Coast Artists: A Critical Selection of Painters and Sculptors Working in California*. San Francisco: Chronicle Books, 1981.

"Human Figure Returns in Separate Ways and Places." *Life*, 8 June 1962, 54–61.

Kaufman, B. "New Kind of Humanism." *Commonweal*, 16 June 1961, 310–11.

Kramer, Hilton. "Month in Review." Review. *Arts Magazine* (January 1960): 42–45.

Lagoria, Georgianna, et al. *Northern California Art of the 1960s*. Exhibition catalogue. Santa Clara, Calif.: de Saisset Museum, University of Santa Clara, 1982.

Lanes, Jerrold. "Brief Treatise on Surplus Value; or, The Man Who Wasn't There; Exhibition Called New Images of Man at the Modern." Review. *Arts Magazine* (November 1959): 30–31.

Leider, Philip. "California after the Figure." *Art in America* (October 1963): 73–83.

Loran, Erle. "San Francisco." Review. *Art News* (September 1949): 45, 52.

McChesney, Mary Fuller. *A Period of Exploration: San Francisco, 1945–1950*. Exhibition catalogue. Oakland: The Oakland Museum, 1973.

Mendelowitz, Daniel M. *A History of American Art*. New York: Holt, Rinehart & Winston, 1970.

Mills, Paul. *Contemporary Bay Area Figurative Painting*. Exhibition catalogue. Oakland: Oakland Art Museum, 1957.

———. "Bay Area Figurative." *Art in America* (June 1964): 42–45.

M[onte], J[ames]. "Eighty-Second Annual Exhibition of the San Francisco Art Institute" in "Reviews." Review. *Artforum* (May 1963): 11.

———. "Drawings by Elmer Bischoff, Richard Diebenkorn, and Frank Lobdell." Review. *Artforum* (July 1963): 7–8.

Munro, Eleanor C. "Figures to the Fore." *Horizon*, July 1960, 16–24, 114–16.

"Next Direction Show." *Oakland Tribune*, 28 April 1957.

Painters behind Painters. Exhibition catalogue. San Francisco: California Palace of the Legion of Honor, 1967.

Painting and Sculpture in California: The Modern Era. Exhibition catalogue. San Francisco: San Francisco Museum of Modern Art, 1977.

Painting from the Pacific: Japan, America, Australia, New Zealand. Exhibition catalogue. Auckland: Auckland City Art Gallery, 1961.

Plagens, Peter. *Sunshine Muse: Contemporary Art on the West Coast*. New York: Praeger, 1974.

P[olley], E[lizabeth] M. "Some Points of View, '62, Stanford University Art Gallery" in "Reviews." Review. *Artforum* 1, no. 7 (1963): 41.

Raynor, Vivien. "Art: California School." *The New York Times*, 30 March 1984, C25.

Recent Painting U.S.A.: The Figure. Exhibition catalogue. New York: The Museum of Modern Art, 1962.

Reflections: Alumni Exhibitions. Exhibition catalogue. San Francisco: San Francisco Art Institute, 1981.

Resource/Reservoir, CCAC: Seventy-Five Years. Exhibition catalogue. San Francisco: San Francisco Museum of Modern Art, 1983.

Rexroth, Kenneth. "Figurative Art Revival." *San Francisco Examiner*, 15 September 1963, sec. 3, p. 2.

Richardson, E. P. *A Short History of Painting in America*. New York: Crowell, 1963.

Richeda, Noreen Mary. "San Francisco Bay Area 'New Figurative' Painters, 1950–1965." Ph.D. diss., University of California, Los Angeles, 1969.

Roditi, Edouard. "Border Art: California Meets the 'Real Thing.'" *Arts Magazine* (March 1967): 50–51.

S[andler], I[rving] H. "Elmer Bischoff, Richard Diebenkorn, and David Park" in "Reviews and Previews." Review. *Art News* (December 1960): 15.

S[awin], M[artica]. "Park, Bischoff, Diebenkorn" in "In the Galleries." Review. *Arts Magazine* (December 1960): 50.

Schimmel, Paul, Judith Stein, et al. *The Figurative Fifties: New York Figurative Expressionism*. Exhibition catalogue. Newport Beach, Calif.: Newport Harbor Art Museum, 1988.

Selz, Peter. *New Images of Man*. Exhibition catalogue. New York: The Museum of Modern Art, 1959.

Shaak, Yvette Friedli. "The Bay Area School of Figurative Painting: An Analysis." Master's thesis, California State College, Long Beach, 1967.

Starr, Sandra Leonard. *Lost and Found in California: Four Decades of Assemblage Art*. Exhibition catalogue. Los Angeles: James Corcoran Gallery in cooperation with Shoshana Wayne Gallery and Pence Gallery, 1988.

Styron, Thomas W. *American Figure Painting, 1950–1980*. Exhibition catalogue. Norfolk, Va.: The Chrysler Museum, 1980.

Tapié, Michel. "L'Ecole du pacifique." *Cimaise* (June 1954).

Temko, Allan. "The Flowering of San Francisco." *Horizon*, January 1959, 4–23.

Triumph of the Figure in Bay Area Art: 1950–1965. Exhibition brochure. San Francisco: 871 Fine Arts Gallery, 1987.

Turk, Rudy H. *Bay Area Art: Then and Now*. Exhibition catalogue. Scottsdale, Ariz.: Suzanne Brown Gallery, 1980.

Van der Marck, Jan. "The Californians." Review. *Art International* (May 1963): 29–31.

Ventura, Anita. "The Prospect over the Bay." Review. *Arts Magazine* (May 1963): 19–21.

V[on] B[reton], H[arriet]. "Paul Wonner, William (Theo) Brown" in "Los Angeles." Review. *Artforum* (March 1964): 11–12.

Ward, John L. "American Realist Painting, 1945–1980." Ph.D. diss., Boston University, 1984; University Microfilms, Ann Arbor, Michigan, 1986.

Watercolor and Related Media by Contemporary Californians. Exhibition catalogue. Pasadena: Baxter Art Gallery, California Institute of Technology, 1977.

White, Nan. "Free-form Abstractions Stir Up Controversy in This Area; Leaders of New School, Variously Known as 'Spiritist' and 'Blob,' Tell Theories." *San Francisco News*, 18 March 1950.

Wilmerding, John, ed. *The Genius of American Painting*. London: Weidenfeld and Nicolson, 1973.

ELMER BISCHOFF

Albright, Thomas. "A Figurative Explosion." Review. *San Francisco Chronicle*, 29 October 1975, 46.

———. "Elmer Bischoff: Bay Area Figurative." *Currânt* (December 1975–January 1976): 34–41, 56–57.

Ashton, Dore. "Art: Elmer Bischoff's Paintings at the Staempfli." Review. *The New York Times*, 8 January 1960, 22.

Baker, Kenneth. "Bischoff: Abstracts in Disguise." *San Francisco Sunday Chronicle and Examiner*, *Review*. 22 December 1985, 11–12.

Benet, James. "Award-winning Artist to Work On, in Tiny Studio." *San Francisco Chronicle*, 17 February 1959.

Bischoff, Elmer, quoted in *The Phillips Collection Newsletter*, Fall 1986.

Bloomfield, Arthur. "A Big One-man Exhibit." Review. *San Francisco Examiner*, 18 October 1975, 5.

Boettger, Suzaan. "Energy and Light." *California Monthly* [University of California at Berkeley Alumni Magazine] (May 1985): 15–17. Statements by Bischoff.

C[rehan], H[ubert]. "Elmer Bischoff" in "Reviews and Previews." Review. *Art News* (January 1960): 12.

Dunham, Judith L. "Continuing Bay Area Traditions." Review. *Artweek*, 8 November 1975, 1, 16.

E[dgar], N[atalie]. "Elmer Bischoff" in "Reviews and Previews." Review. *Art News* (March 1962): 18.

Elmer Bischoff: Figurative Paintings, 1957–1972. Exhibition catalogue. Oakland: The Oakland Museum, 1975.

Forgey, Benjamin. "Elmer Bischoff, Walking a Tightrope." Review. *Washington Post*, 21 September 1986, G1, G4–5.

Frank, Peter. "Elmer Bischoff at the San Francisco Art Institute." Review. *Art in America* (May–June 1975): 96.

Frash, Robert M. *Elmer Bischoff, 1947–1985*. Exhibition catalogue. Laguna Beach, Calif.: Laguna Art Museum, 1985.

Fried, Alexander. "Bischoff's Newest Oils Show Him at His Best." Review. *San Francisco Examiner, Highlight*, 29 October 1961, 9.

"From the Golden Land." *Apollo* (March 1962): 67.

Green, Blake. "The Real Elmer Bischoff." *San Francisco Chronicle*, 30 December 1985, 16, 19.

Klein (Landauer), Susan. "Elmer Bischoff." *Issue* (Fall 1985): 8–11.

Langsner, Jules. "Art News from Los Angeles." Review. *Art News* (March 1955): 60.

Martin, Fred. "San Francisco Letter." Review. *Art International* (November 1975): 55.

Motherwell, Robert, and Ad Reinhardt, eds. *Modern Artists in America*. New York: Wittenborn Schultz, 1951.

Muchnic, Suzanne. "Forty Years of Bischoff's 'Best Shots.'" *Los Angeles Times*, 1 December 1986, 3.

P[olley], E[lizabeth] M. "Elmer Bischoff" in "San Francisco." Review. *Artforum* (March 1964): 47.

Raynor, Vivien. "Elmer Bischoff" in "In the Galleries." Review. *Arts Magazine* (March 1962): 44.

St. John, Terry. "Bischoff: Figurative Paintings." *Art* [The Oakland Museum bulletin] (September–October 1975).

Seckler, Dorothy Gees. "Preview of 1960." *Art in America* (Winter 1959): 101–2.

Seldis, Henry J. "Los Angeles." Review. *Arts Digest* (15 February 1955): 15.

S[wenson], G. R. "Elmer Bischoff" in "Reviews and Previews." Review. *Art News* (Summer 1964): 15.

T[illim], S[idney]. "Elmer Bischoff" in "In the Galleries." Review. *Arts Magazine* (September 1964): 65.

Wallace, Dean. "San Francisco—A Case History." Review. *Art in America* 1 (1962): 136, 138.

Wilson, William. "A Tribute to Bischoff by the Bay." Review. *Los Angeles Times, Calendar,* 2 February 1986, 80–81.

JOAN BROWN

Brown, Joan. "In Conversation with Jan Butterfield." *Visual Dialog* (December 1975–February 1976): 15–18.

Coplans, John. "The Nude: Drawings by Alvin Light, Manuel Neri, Gordon Cook, Joan Brown." Review. *Artforum* (November 1962): 39.

The Early Sixties: Jack Beal, Joan Brown. Exhibition catalogue. New York: Alan Frumkin Gallery, 1984.

Leider, Philip. "Joan Brown: Her Work Illustrates the Progress of a San Francisco Mood." *Artforum* (June 1963): 28–31.

Marechal-Workman, Andrée. "An Interview with Joan Brown." *Expo-See* (March-April 1985).

Richardson, Brenda. *Joan Brown.* Exhibition catalogue. Berkeley: University Art Museum, University of California, 1974.

S[andler], I[rving] H. "Joan Brown" in "Reviews and Previews." Review. *Art News* (March 1961): 16.

Walker, Dorothy. "Painters Shy? These Youngsters Invited Critics to Joint Exhibit." *San Francisco News,* 26 January 1957.

"Women of American Art." *Look,* 27 September 1960, 70.

THEOPHILUS BROWN

"Camera Kickoff for Art." *Life Magazine,* 8 October 1956, 14–15.

C[ampbell], L[awrence]. "William T. Brown" in "Reviews and Previews." Review. *Art News* (April 1962): 15.

Danieli, Fidel A. "Figurative." *Artforum* (Summer 1964): 53.

H[ess], T[homas] B. "William Brown" in "Reviews and Previews: New Names this Month." Review. *Art News* (March 1961): 18.

Inge, William. *William Theo Brown.* Exhibition catalogue. Lawrence: The Museum of Art, University of Kansas, 1967.

Langsner, Jules. "Art News from Los Angeles." Review. *Art News* (January 1958): 51.

M[cClellan], D[oug]. "William Brown" in "Reviews." Review. *Artforum* (June 1963): 16.

Polley, Elizabeth M. "East Bay" in "San Francisco." *Artforum* (May 1966): 57.

Preston, Stuart. "Art." Review. *The New York Times,* 10 February 1961, 23.

Recent Paintings by William Theo Brown. Exhibition catalogue. Los Angeles: Felix Landau Gallery, 1967.

S[tiles], K[nute]. "William Theo Brown, Hollis Gallery" in "San Francisco." Review. *Artforum* (December 1964): 50.

W[ilson], W[illiam]. "William Theo Brown" in "Los Angeles." Review. *Artforum* (April 1965): 14.

Wm. Theo Brown. Exhibition catalogue. New York: Landau-Alan Gallery, 1968.

RICHARD DIEBENKORN

Alloway, Lawrence. "London Chronicle." Review. *Art International* (December 1958–January 1959): 36.

Ashbery, John. "Paris Notes." Review. *Art International* (June 1963): 77.

Ashton, Dore. "Young Painters in Rome." Review. *Arts Digest* (June 1955): 6.

———. "Art." Review. *Arts and Architecture* (April 1956): 11.

———. "Art: Rebel in the West." *The New York Times,* 25 February 1958.

Baker, Richard Brown. "Notes on the Formation of My Collection." *Art International* (20 September 1961): 42.

Butterfield, Jan. In *Resource/Response/Reservoir, Pentimenti: Seeing and Then Seeing Again.* Exhibition brochure for *Richard Diebenkorn: Paintings, 1948–1983.* San Francisco: San Francisco Museum of Modern Art, 1983.

———. "Diebenkorn: A Painter's 'Pentimento.'" *United* [in-flight magazine] (June 1983): 108–18.

C[ampbell], L[awrence]. "Richard Diebenkorn" in "Reviews and Previews." *Art News* (March 1958): 13.

Canaday, John. "Richard Diebenkorn: Still Out of Step." *The New York Times,* 26 May 1968, D37.

Cebulski, Frank. "Richard Diebenkorn and the Humanly Abstract." Review. *Artweek,* 2 July 1983, 1.

Chipp, Herschel B. "Diebenkorn Paints a Picture." *Art News* (May 1957): 44–47.

———. "Art News from San Francisco." Review. *Art News* (February 1961): 54.

Coffelt, Beth. "Doomsday in the Bright Sun." *San Francisco Examiner and Chronicle, California Living Magazine,* 16 October 1977, 22–28.

Coplans, John. "Notes from San Francisco." Review. *Art International* (May 1963): 73.

"Diebenkorn, Woelffer, Mullican: A Discussion." *Artforum* (April 1963): 23, 25–28.

Drawings by Richard Diebenkorn. Stanford, Calif.: Department of Art and Architecture, Stanford University, 1965.

"Edging Away from Abstraction." *Time*, 17 March 1958, 64, 67.

Eichelbaum, Stanley. "An Abstract Artist's Return to Landscapes and Figures." *San Francisco Chronicle and Examiner, Highlight*, 23 October 1960.

Elderfield, John. *The Drawings of Richard Diebenkorn*. Exhibition catalogue. New York: The Museum of Modern Art, 1988.

"Exhibition at Poindexter Gallery." Review. *Arts Magazine* (March 1956): 56–57.

Fried, Alexander. "Art." Review. *San Francisco Examiner, Showtime*, 15 September 1963, 18.

Green, Blake. "Diebenkorn Reflects on Art and Fame." *San Francisco Chronicle*, 18 May 1983, 35.

Greenberg, Clement. "After Abstract Expressionism." *Art International* (October 1962): 25.

Gruen, John. "Richard Diebenkorn: The Idea Is to Get Everything Right." *Art News* (November 1986): 84.

Hofstadter, Dan. "Profiles: Almost Free of the Mirror." *The New Yorker*, 7 September 1987, 54–73.

Hughes, Robert. "California in Eupeptic Color." *Time*, 27 June 1977, 58.

Kessler, Charles S. "Los Angeles: The Seasonal Tide." Review. *Arts Magazine* (November 1960): 19.

Kramer, Hilton. "Month in Review." Review. *Arts Magazine* (December 1958): 48–49.

———. "The Latest Thing in Pittsburgh." Review. *Arts Magazine* (January 1962): 26.

———. "Pure and Impure Diebenkorn." Review. *Arts Magazine* (December 1963): 46–53.

———. "The Diebenkorn Case." *The New York Times*, 22 May 1966, D29.

Langsner, Jules. "Los Angeles Letter." Review. *Art International* (December 1962): 38.

Larsen, Susan C. "A Conversation with Richard Diebenkorn." *Los Angeles Institute of Contemporary Art Journal* (July–August 1977): 30.

———. "Cultivated Canvases." *Artforum* (January 1986): 66–71.

Lavatelli, Mark. "Richard Diebenkorn: The Albuquerque Years." *Artspace* (June 1980): 21.

Leider, Philip. "Diebenkorn Drawings at Stanford." Review. *Artforum* (May 1964): 41–43.

Magloff, Joanna. "Art News from San Francisco." Review. *Art News* (January 1964): 52.

Martini, Chris. "Richard Diebenkorn at the San Francisco Museum of Modern Art." Review. *Studio International* (August 1983): 60–61.

Mills, Paul. "Richard Diebenkorn: Painting against the Tide." *Saturday Review*, 4 November 1972, 55–59.

M[onte], J[ames]. "Richard Diebenkorn, de Young Museum" in "Reviews." Review. *Artforum* (November 1963): 43.

Morch, Al. "Diebenkorn's Figurative Straitjacket." *San Francisco Examiner*, 16 May 1983.

Murphy, Richard. "A Painting Should Have Flex." *Horizon*, July 1978, 66–71.

Nordland, Gerald. "6 × 5." Review. *Frontier* (October 1956): 23–24.

———. "Diebenkorn." *Artforum* (January 1965): 21–25.

———. *Richard Diebenkorn*. New York: Rizzoli International Publications, Inc., 1987.

Pellegrini, Aldo. *New Tendencies in Art*. New York: Crown, 1966.

Perrone, Jeff. "Richard Diebenkorn" in "Reviews." Review. *Artforum* (Summer 1975): 78–79.

P[etersen], V[alerie]. "Richard Diebenkorn" in "Reviews and Previews." Review. *Art News* (March 1961): 13.

———. "Richard Diebenkorn" in "Reviews and Previews." Review. *Art News* (December 1963): 54.

Rexroth, Kenneth. "Figurative Art Revival." Review. *San Francisco Examiner*, 15 September 1963, sec. 3, p. 2.

Richard Diebenkorn: Etchings and Drypoints, 1949–1980. Houston: Houston Fine Art Press, 1981.

Richard Diebenkorn: Paintings and Drawings, 1943–1976. Exhibition catalogue. Buffalo: Albright-Knox Art Gallery, 1976.

Richard Diebenkorn: Works on Paper. Houston: Houston Fine Arts Press, 1987.

Sandler, Irving Hershel. "New York Letter." Review. *Art International* (May 1961): 54.

Schevill, James. "Richard Diebenkorn." *Frontier* (January 1957): 21–22.

Scott, Gail. *New Paintings by Richard Diebenkorn*. Exhibition brochure. Los Angeles: Los Angeles County Museum of Art, 1969.

Seckler, Dorothy Gees. "Painting." *Art in America* (Winter 1958–1959): 34.

Tillim, Sidney. "Month in Review." Review. *Arts Magazine* (April 1961): 48.

T[yler], P[arker]. "Richard Diebenkorn" in "Reviews and Previews." Review. *Art News* (March 1956): 51.

Venice 34: The Figurative Tradition in Recent American Art. Exhibition catalogue. Washington, D.C.: Smithsonian Institution Press, 1969.

V[entura], A[nita]. "Richard Diebenkorn" in "In the Galleries." Review. *Arts Magazine* (March 1958): 56.

Bruce McGaw

The Contemporary Landscape: Seven Touring Exhibitions, 1968–1969. San Francisco: San Francisco Art Institute, 1972.

Faculty Exhibition. Exhibition catalogue. San Francisco: San Francisco Art Institute, 1972.

MANUEL NERI

Albright, Thomas. "Manuel Neri: A Kind of Time Warp." *Currânt* (April–May 1975): 10–16.

———. "The Art World: The Magnificence of Manuel Neri." *San Francisco Chronicle*, 30 September 1976.

———. "Manuel Neri's Survivors: Sculpture for the Age of Anxiety." *Art News* (January 1981): 54–59.

Andersen, Wayne. *American Sculpture in Process, 1930–1970*. Boston: New York Graphic Society, 1975.

Butterfield, Jan. "Ancient Auras—Expressionist Angst: Sculpture by Manuel Neri." *Images and Issues* (Spring 1981): 38–43.

Delehanty, Hugh J. "Manuel Neri: Cast from a Different Mold." *Focus* [San Francisco], January 1982, 24–26.

Dickson, Joanne. *Manuel Neri: Sculpture and Drawings*. Exhibition catalogue. Seattle Art Museum and John Berggruen Gallery, 1981.

Jones, Caroline A. *Manuel Neri: Plasters*. Exhibition catalogue. San Francisco: San Francisco Museum of Modern Art, 1989.

Mennon, Mark. "Innovations with the Figure: The Sculpture of Manuel Neri." *Arts Magazine* (April 1986): 76–77.

Neri, Kate. *Manuel Neri: A Personal Selection*. Exhibition brochure. Belmont, Calif.: Weigand Gallery, College of Notre Dame, 1988.

Neubert, George. *Manuel Neri: Sculptor*. Exhibition catalogue. Oakland: The Oakland Museum, 1976.

Nordland, Gerald. *Art of San Francisco: Manuel Neri*. Exhibition catalogue. San Francisco: San Francisco Museum of Art, 1971.

Restany, Pierre. *Manuel Neri*. San Francisco: Ann Kohs & Associates, 1984.

Zickerman, Lynne. "In Art with Manuel Neri." *The Daily Californian Arts Magazine*, 29 September 1972, 9–13, 18.

NATHAN OLIVEIRA

Adrian, Dennis. "Nathan Oliveira: New York." *Artforum* (January 1966): 57.

Albright, Thomas. "Isolated Human Figure." *San Francisco Chronicle*, 21 September 1973, 59.

Art U.S.A. Now, vol. 2. New York: Viking Press, 1962.

Ashton, Dore. "Art USA 1962." *Studio* (March 1962): 91.

———. "What about the Figure?" Review. *Studio* (August 1962): 70.

———. "Modern Symbolism and Strained 'Pop.'" Review. *Studio* (April 1963): 196–97.

Berkowitz, Marc. "Arte de America y España." *Das Kunstwerk* (August–September 1963): 57.

B[ochner], M[el]. "Nathan Oliveira" in "In the Galleries." Review. *Arts Magazine* (January 1966): 60.

Boettger, Suzaan. "Nathan Oliveira: Phantoms and Fragments." Review. *Artweek*, 22 September 1984, 1.

Burrey, Suzanne. "A Decade of American Printmaking." Review. *Arts Magazine* (May 1956): 28.

C[ampbell], L[awrence]. "Nathan Oliveira" in "Reviews and Previews." Review. *Art News* (November 1960): 14.

Chesney, Lee. "Recent American Prints." Review. *Impression* (Spring–Summer 1958): 29.

Chetham, Charles, et al. *Modern Painting, Drawing, and Sculpture Collected by Louise and Joseph Pulitzer, Jr.*, vol. 2. Exhibition catalogue. Cambridge, Mass.: Fogg Art Museum, Harvard University, 1972.

DeShong, Andrew. "Nathan Oliveira: An Interview." *Artweek*, 13 October 1973, 1, 15.

Dunham, Judith L. "Nathan Oliveira and the Lithograph." Review. *Artweek*, 16 August 1980, 5.

Eager, Gerald. "The Missing and the Mutilated Eye in Contemporary Art." *Journal of Aesthetics and Art Criticism* (Fall 1961): 49, 56–57.

F[actor], D[on]. "Nathan Oliveira, U.C.L.A. Art Galleries" in "Reviews." Review. *Artforum* (November 1963): 11.

Frankenstein, Alfred. "Oliveira's Unforgettable Force." *San Francisco Chronicle*, This World, 17 November 1963, 23–34.

———. "A Nod to Abstract Expressionism." *San Francisco Chronicle*, 22 February 1975, 32.

Garver, Thomas, et al. *Nathan Oliveira: A Survey Exhibition, 1957–1983*. Exhibition catalogue. San Francisco: San Francisco Museum of Modern Art, 1984.

Humphrey, John. *Nathan Oliveira: Works on Paper, 1960–1969*. Exhibition catalogue. San Francisco: San Francisco Museum of Modern Art, 1969.

J[ohnston], J[ill]. "Richard Hunt, Yutaka Ohashi, and Nathan Oliveira" in "Reviews and Previews." Review. *Art News* (April 1962): 18.

Jones, Harvey L. *Nathan Oliveira: Paintings, 1959–1973*. Exhibition catalogue. Oakland: The Oakland Museum, 1973.

J[udd], D[onald]. "Nathan Oliveira" in "In the Galleries." Review. *Arts Magazine* (November 1960): 54.

Langsner, Jules. "Art News from Los Angeles." Review. *Art News* (Summer 1961): 66.

Linhares, Phil. "Nathan Oliveira." *Currânt* (December 1975–January 1976): 14–17.

McCann, Cecile N. "Nathan Oliveira Survey." Review. *Artweek*, 28 April 1973, 3.

M[cClellan], D[oug]. "Group Show, Paul Kantor" in "Reviews and Previews." Review. *Artforum* (September 1962): 15.

Nadaner, Dan. "Site of Subjectivity: Nathan Oliveira." *Vanguard* (December 1984–January 1985): 26–29.

"New Talent, 1959: Painting." *Art in America* (Spring 1959): 52–53.

R[aynor], V[ivien]. "Yutaka Ohashi, Richard Hunt, Nathan Oliveira" in "In the Galleries." Review. *Arts Magazine* (April 1962): 53.

———. "Nathan Oliveira" in "In the Galleries." Review. *Arts Magazine* (March 1963): 67.

S[andler], I[rving] H. "Nathan Oliveira" in "Reviews and Previews." Review. *Art News* (December 1958): 19.

———. "Nathan Oliveira" in "Reviews and Previews." Review. *Art News* (April 1963): 13.

Seldis, Henry J. "Oliveira's Search for Confrontation." *Los Angeles Times*, 27 May 1968, sec. 4, p. 17.

Thiebaud, B. J. *Nathan Oliveira*. 16mm film. Sacramento, Calif.: Carr Films, 1974.

T[illim], S[idney]. "Nathan Oliveira" in "In the Galleries." Review. *Arts Magazine* (December 1958): 57–58.

Von Groschwitz, Gustave. "American Colour Lithography, 1952 to 1954." Review. *Studio* (July 1954): 8.

Weller, Allen S. *The Joys and Sorrows of Recent American Art*. Urbana: University of Illinois Press, 1968.

DAVID PARK

Armstrong, Richard. *David Park: Paintings and Drawings of the 1950s*. Exhibition catalogue. New York: Whitney Museum of American Art, 1988.

Baker, Kenneth. "Park and Judd: Two Styles of Control." Review. *San Francisco Chronicle*, 25 November 1988, E4.

Belz, Carl. "To Acknowledge the Self: The Paintings of David Park." *Arts Magazine* (September 1983): 66–68.

Berkson, Bill. "David Park: Facing Eden." *Art in America* (October 1987): 164–71, 199.

Brenson, Michael. "In the Galleries." Review. *The New York Times*, 6 September 1985, 15, 18.

"David Park." *The Artist's View*, September 1953.

David Park, 1911–1960. Exhibition catalogue. Newport Beach, Calif.: Newport Harbor Art Museum, 1977.

David Park. Exhibition catalogue. New York: Salander-O'Reilly Galleries, 1985.

David Park. Exhibition catalogue. New York: Salander-O'Reilly Galleries, 1987.

David Park: His World. Exhibition catalogue. Santa Barbara: Santa Barbara Museum of Art, 1968.

Frankenstein, Alfred. "Northern California." *Art in America* (Winter 1954): 49.

Fryberger, Betsy. *David Park: Works on Paper*. Exhibition catalogue. Stanford, Calif.: Stanford University Museum of Art, 1988.

"The Image and the Void." *Time*, 9 November 1959, 80–83.

Klein, Ellen Lee. "David Park." Review. *Arts Magazine* (November 1983): 38.

Kramer, Hilton. "Month in Review." Review. *Arts Magazine* (January 1960): 42, 45.

M[artin], F[red]. "David Park Retrospective." Review. *Artforum* (August 1962): 35–36.

Mills, Paul. "David Park: His Art and His Relation to the University." MS on Park's Zellerbach scroll at the University of California, Berkeley, n.d. Archives of California Art, The Oakland Museum.

———. "David Park." *Artforum* (July 1962): 36.

———. "David Park and the New Figurative Painting." Master's thesis, University of California, Berkeley, 1962.

———. *The Figure Reappears: The Art of David Park and Bay Area Figurative Painting from 1950 to 1960*. Revised Master's thesis, University of California, Berkeley, 1962.

———. *The New Figurative Art of David Park*. Santa Barbara: Capra Press, 1988.

P[olley], E[lizabeth] M. "David Park, University Art Gallery, U.C. Berkeley" in "San Francisco." Review. *Artforum* (December 1964): 48.

St. John, Terry. "David Park: A Retrospective Exhibition." *Art* [The Oakland Museum Bulletin] (November–December 1977).

Seckler, Dorothy Gees. "Painting." *Art in America* (Winter 1958–1959): 33.

Smith, Sean K. "A Search for the Enduring Personal." Review. *Artweek*, 25 June 1988, 5.

Stepan, R. F. "David Park Paintings." Review. *Artweek*, 19 April 1975, 4.

Tillim, Sidney. "Month in Review." Review. *Arts Magazine* (March 1962): 36–40.

"Up from Goopiness." *Time*, 27 April 1962, 48–49.

Adrian, Dennis. [James Weeks's new paintings] in "New York." Review. *Artforum* (December 1965): 54–55.

Albright, Thomas. "Musicians, Comedians, and Canvas." *San Francisco Chronicle*, 22 January 1977, 35.

———. "The Evolution of James Weeks." *San Francisco Chronicle*, 15 June 1978, 63.

D[anieli], F[idel] A. "James Weeks, Felix Landau Gallery" in "Los Angeles." Review. *Artforum* (March 1964): 13.

Frankenstein, Alfred. "Around the Galleries." Review. *San Francisco Chronicle, This World*, 6 May 1951, 20.

———. "A New Exhibition of the Works of Recent Prize-winning Artists." Review. *San Francisco Chronicle, This World*, 11 October 1953, 21.

———. "'Bottom Jelly,' 'White Fire' and '4/26/5.'" Review. *San Francisco Chronicle, This World*, 21 August 1955, 23.

Fried, Alexander. [Review of East-West Gallery solo exhibition]. Review. *San Francisco Examiner, Pictorial Review*, 4 May 1958, 21.

———. "Fine Strong Paintings by Weeks." Review. *San Francisco Examiner, Show Time*, 11 July 1965, 19.

H[opkins], H[enry] T. "Enrique Montenegro, Reginald Pollack, James Weeks, Bryan Wilson." Review. *Artforum* (September 1962): 16.

"James Weeks Exhibition." *San Francisco Art Association Bulletin* (May 1951): 2.

James Weeks: Paintings and Drawings, 1961–1971. Exhibition catalogue. Boston: Boston University Art Gallery, 1971.

"James Weeks Rosenberg Fellowship Winner." *San Francisco Art Association Bulletin* (December 1951–January 1952): 4.

Livingston, Jane. [James Weeks] in "Los Angeles." Review. *Artforum* (May 1967): 63.

Painters behind Painters. Exhibition catalogue. San Francisco: California Palace of the Legion of Honor, 1967.

Recent Paintings by James Weeks. Exhibition catalogue. Los Angeles: Felix Landau Gallery, 1967.

Saulnier, Bonny. *James Weeks*. Exhibition catalogue. Waltham, Mass.: Rose Art Museum, Brandeis University, 1978.

Stiles, Knute. "San Francisco." Review. *Artforum* (October 1965): 42.

Taylor, Robert. "Weeks Knows Himself." Review. *Boston Sunday Globe*, 16 May 1976, 49.

Ventura, Anita. "James Weeks: The Plain Path." *Arts Magazine* (February 1964): 50–57.

Wallace, Dean. "Weeks's Realism—and Wild Orgies." Review. *San Francisco Chronicle, This World*, 11 July 1965, 35.

PAUL WONNER

"Bay Region Styles: Exhibition at the de Young." Review. *Art News* (June 1956): 22.

Boettger, Suzaan, and Sandy Ballatore. "Morandi and Wonner: The Metaphysical Philosopher Meets the Abstract Realist." *Spotlight* (Summer 1982): 51.

Curtis, Cathy. "Paul Wonner: Reworking the Past." Review. *Artweek*, 24 October 1981, 1.

D[esenberg], I[rma] E. "Eight Figurative Painters from Los Angeles" in "Reviews." Review. *Artforum* 1, no. 7 (1963): 17.

Frankenstein, Alfred. "The Vigorous Art of Sargent and Wonner." *San Francisco Chronicle, This World*, 11 March 1956.

Kessler, Charles S. "Los Angeles: Paul Wonner" in "Nationwide Reviews." Review. *Arts Magazine* (June 1960): 16.

M[armer], N[ancy]. "Paul Wonner, Felix Landau Gallery" in "Los Angeles." Review. *Artforum* (February 1965): 39.

McClellan, Douglas. "Exhibition at Felix Landau Gallery." Review. *Artforum* (May 1963): 44.

Paul Wonner: Abstract Realist. Exhibition catalogue. Los Angeles: Fellows of Contemporary Art for San Francisco Museum of Modern Art, 1981.

Raynor, Vivien. "Exhibition at Poindexter Gallery." Review. *Arts Magazine* (September 1964): 66.

"Recent Oils and Gouaches at Landau Gallery." Review. *Art News* (April 1959): 65.

Temko, Allan. "Wonner at the Modern." Review. *San Francisco Chronicle and Examiner*, 18 October 1981.

Tillim, Sidney. "Exhibition at Poindexter Gallery." Review. *Arts Magazine* (May 1962): 89.

ARCHIVAL

Archives of American Art, West Coast Regional Center (AAA). The papers and interviews of the following were consulted: Charles Alan Gallery, Robert Bechtle, Billy Al Bengston, Elmer Bischoff, Harry Bowden, Joan Brown, William Theophilus Brown, Bruce Conner, Gordon Cook, Jay De Feo, Richard Diebenkorn, Dilexi Gallery, Funk Art Symposium, Clement Greenberg, Wally Hedrick, Frank Lobdell, Erle Loran, Mary Fuller McChesney, Fred Martin, Manuel Neri, Nathan Oliveira, David Park, Poindexter Gallery, Nell Sinton, Hassel Smith, James Weeks, and Paul Wonner.

Archives of California Art (ACA), The Oakland Museum. The papers and artist files of the following were consulted: Elmer Bischoff, Joan Brown, William Theophilus Brown, Richard Diebenkorn, Paul Mills, Manuel Neri, Nathan Oliveira, David Park, and Paul Wonner.

Archives of the San Francisco Art Institute. The following files were consulted: Course descriptions and photographs, ca. 1947, Job correspondence, Artist/faculty files for Elmer Bischoff, Joan Brown, Richard Diebenkorn, Bruce McGaw, Manuel Neri, Nathan Oliveira, and David Park.

Louise Sloss Ackerman Fine Arts Library, San Francisco Museum of Modern Art. Consulted were the exhibition and artist files of Elmer Bischoff, Joan Brown, William T. Brown, Richard Diebenkorn, Bruce McGaw, Manuel Neri, Nathan Oliveira, David Park, James Weeks, and Paul Wonner.

Works shown in San Francisco only are indicated by (SF); those shown in San Francisco and Washington, D.C., only, by (SF/W).

ELMER BISCHOFF

Orange Sweater, 1955
Oil on canvas
48½ × 57 in. (123.2 × 144.8 cm)
San Francisco Museum of Modern Art, Gift of Mr. and Mrs. Mark Schorer

Figure in Landscape, ca. 1957
Oil on canvas
52 × 57½ in. (132.1 × 146.1 cm)
The Oakland Museum, Gift of the Women's Board, Oakland Museum Association (SF)

Girl Wading, 1959
Oil on canvas
82⅝ × 67¾ in. (209.9 × 172.1 cm)
The Museum of Modern Art, New York, Blanchette Rockefeller Fund

Woman with Dark Blue Sky, 1959
Oil on canvas
67⅞ × 67⅞ in. (172.4 × 172.4 cm)
Hirshhorn Museum and Sculpture Garden, Smithsonian Institution, Washington, D.C., Gift of Joseph H. Hirshhorn Foundation

Girl with Towel, 1960
Oil on canvas
59¼ × 59⅝ in. (151.8 × 151.5 cm)
The Morgan Flagg Family Collection, Monterey, California

Girl with Mirror, 1961
Oil on canvas
37¾ × 33¾ in. (95.9 × 85.7 cm)
Collection of Mr. and Mrs. David Lloyd Kreeger

Girl Looking in Mirror, 1962
Ink on paper
14¾ × 17⅞ in. (37.5 × 45.4 cm)
San Francisco Museum of Modern Art, Purchase

Breakers, 1963
Oil on canvas

61 × 70 in. (154.9 × 177.8 cm)
Archer M. Huntington Art Gallery, The University of Texas at Austin, Gift of Mari and James Michener (SF)

Untitled (Woman Seated on a Couch), 1963
Pen and ink, and ink wash on paper
26½ × 11½ in. (67.3 × 29.2 cm)
Collection of Byron R. Meyer, San Francisco

Cityscape, 1965
Oil on canvas
80 × 80 in. (203.2 × 203.2 cm)
Yale University Art Gallery, New Haven, Connecticut, Solomon Byron Smith, B.A. 1928, Fund

Yellow Sky, 1967
Oil on canvas
79⅝ × 92⅛ in. (202.2 × 233.9 cm)
San Francisco Museum of Modern Art, Paul L. Wattis Special Fund Purchase

Interior with Two Figures, 1968
Oil on canvas
80 × 80 in. (203.2 × 203.2 cm)
The Lobell Family Collection, New York

JOAN BROWN

Untitled (Bird), ca. 1957–60
Cardboard, twine, gauze, wood, and electrical wire
12 × 6 × 8 in. (30.5 × 15.2 × 20.3 cm)
Collection of the artist, San Francisco

Figure with Manuel's Sculpture, 1961
Gouache, charcoal, fake fur, and collage on paper
40 × 30 in. (101.6 × 76.2 cm)
La Jolla Museum of Contemporary Art, California, Gift of Mr. and Mrs. Robert J. Silver

Models with Manuel's Sculpture, 1961
Oil on canvas
Left panel: 72¾ × 36 in. (184.8 × 91.4 cm)
Right panel: 72 × 120 in. (182.7 × 304.8 cm)
The Oakland Museum, Gift of

Concours d'Antiques, Art Guild, Oakland Museum Association; and Heafey Foundation Fund

Girls in the Surf with Moon Casting a Shadow, 1962
Oil on canvas
72 × 72½ in. (182.9 × 184.2 cm)
Collection of Byron R. Meyer, San Francisco (SF/W)

Girl Sitting, 1962
Oil on canvas
60 × 47¾ in. (152.4 × 121.3 cm)
The Oakland Museum, Gift of Dr. Samuel A. West (SF)

Noel on a Pony with Cloud, ca. 1963
Oil on canvas
72 × 96 in. (182.8 × 243.8 cm)
The Phoenix Art Museum, Museum Purchase with funds provided by the Luther and Louise Dilatush Fund of the Arizona Community Foundation

Refrigerator Painting, 1964
Oil on canvas
60 × 60 in. (152.4 × 152.4 cm)
Collection of Harry Cohn, Hillsborough, California

Portrait of Nude Woman, ca. 1964
Watercolor, gouache, and collage
28¼ × 25¼ in. (71.7 × 64.2 cm)
The Oakland Museum, Gift of Dr. Samuel A. West (SF)

THEOPHILUS BROWN

Football Painting #2, 1956
Oil on board
34¾ × 62 in. (88.3 × 157.5 cm)
Santa Barbara Museum of Art, California, Gift, Paul Wonner

Male Nude Seated, 1960
Pen and ink wash on paper
8½ × 11 in. (21.6 × 27.9 cm)
Collection of the artist, San Francisco

Male Models, 1961
Gouache on board
8½ × 11¼ in. (21.6 × 28.6 cm)

Collection of Mr. and Mrs. Charles
Campbell, San Francisco

Untitled (Interior), 1963
Oil on canvas
46¼×48 in. (117.3×121.9 cm)
Hirshhorn Museum and Sculpture
Garden, Smithsonian Institution,
Washington, D.C., Gift of Joseph H.
Hirshhorn

Portrait of D. K. (Don Knutson), 1964
Oil on canvasboard
11½×9¾ in. (29.2×24.8 cm)
Collection of the artist, San Francisco

Figure Reading, 1965
Pen and ink on paper
7¼×9¼ in. (18.4×23.5 cm)
Collection of the artist, San Francisco

Pedestrian Crossing, 1966
Acrylic on canvas
48×47⅞ in. (121.9×121.6 cm)
Hirshhorn Museum and Sculpture
Garden, Smithsonian Institution,
Washington, D.C., Joseph H.
Hirshhorn Bequest

The Swing, 1966
Acrylic on canvas
52×56 in. (132.1×142.4 cm)
Collection of Daniel and Virginia
Mardesich

RICHARD DIEBENKORN

Coffee, 1956
Oil on canvas
67×58 in. (170.2×147.3 cm)
The Chrysler Museum, Norfolk, Vir-
ginia, Gift of Walter P. Chrysler, Jr.
(SF)

Seated Man under a Window, 1956
Graphite, pen and ink, ink wash,
and watercolor on paper
14×17 in. (35.6×43.2 cm)
The Michael and Dorothy
Blankfort Collection

Man and Woman in Large Room, 1957
Oil on canvas
71⅛×62½ in. (180.7×158.8 cm)
Hirshhorn Museum and Sculpture
Garden, Smithsonian Institution,
Washington, D.C., Gift of Joseph H.
Hirshhorn Foundation

Woman on Porch, 1958
Oil on canvas
72×72 in. (182.9×182.9 cm)

New Orleans Museum of Art
Museum Purchase through National
Endowment for the Arts Matching
Grant (SF)

Interior with Book, 1959
Oil on canvas
70×64 in. (177.8×162.6 cm)
The Nelson-Atkins Museum of Art,
Kansas City, Missouri, Gift of the
Friends of Art

Scissors, 1959
Oil on canvas
10¾×13¼ in. (27.3×33.7 cm)
Private collection

Still Life with Letter, 1961
Oil on canvas
20⅝×25⅝ in. (52.4×65.1 cm)
Collection City and County San
Francisco, Courtesy San Francisco
Arts Commission

Interior with Doorway, 1962
Oil on canvas
70¼×59½ in. (178.1×152.2 cm)
Pennsylvania Academy of the Fine
Arts, Philadelphia, Gilpin Fund
Purchase

Cityscape I (formerly *Landscape I*),
1963
Oil on canvas
60¼×50½ in. (153.1×128.3 cm)
San Francisco Museum of Modern
Art, Purchased with funds from
Trustees and Friends in memory of
Hector Escobosa, Brayton Wilbur, and
J. D. Zellerbach

Scissors, 1963
Oil on canvas
10×12⅝ in. (25.4×32.1 cm)
Private collection

Untitled (For Gilda), 1964
Ink on paper
17×14 in. (43.2×35.6 cm)
Collection of Mr. and Mrs.
Charles Campbell, San Francisco

Seated Figure with Hat, 1967
Oil on canvas
60×60 in. (152.4×152.4 cm)
Collection of Mr. and Mrs. Lawrence
Rubin, New York (SF/W)

Window, 1967
Oil on canvas
92×80 in. (233.7×203.2 cm)
Stanford University Museum of Art,
Stanford, California, Gift of Mr. and

Mrs. Diebenkorn and Anonymous
Donors (SF)

BRUCE MCGAW

Figure, 1957
Oil on canvas
13¼×18¼ in. (33.6×46.4 cm)
The Oakland Museum,
Gift of Bruce McGaw

Palette Table Top, 1958
Oil on canvas
25×24¾ in. (63.5×62.8 cm)
Collection of the artist,
Richmond, California

Figure, ca. 1958–59
Watercolor on paper
13¾×16¾ in. (34.9×42.5 cm)
Collection of the artist,
Richmond, California

Paint Cans, ca. 1958–59
Watercolor on paper
13¾×17 in. (34.9×43.2 cm)
Collection of the artist,
Richmond, California

Studio Interior, 1960–61
Oil on canvas
28×26½ in. (71.2×67.3 cm)
Collection of the artist,
Richmond, California

Chair, ca. 1961
Ink and gouache on paper
24×19 in. (61×48.2 cm)
Collection of the artist,
Richmond, California

Chemical Plant by Freeway, Emeryville,
ca. 1961
Oil on canvas
73½×66½ in. (186.7×168.9 cm)
Collection of the artist,
Richmond, California

Self-portrait, ca. 1962–64
Oil on canvas
24¼×25¾ in. (61.6×65.4 cm)
Collection of the artist,
Richmond, California

MANUEL NERI

Untitled Standing Figure, ca. 1956–57
Wood, cloth, and paint

Approx. 20 × 5 × 10 in.
(50.8 × 12.7 × 25.4 cm)
Collection of Joan Brown,
San Francisco

Untitled Standing Figure, 1957–58
Plaster with enamel on wood and
wire armature
61 × 22 × 16 ½ in.
(154.9 × 55.9 × 41.9 cm)
Private collection, San Francisco

Untitled, ca. 1957
Wood, cardboard, newspaper, cloth,
wire, plaster, and paint
35 ⅜ × 20 ¾ × 18 ¾ in.
(89.9 × 52.7 × 47.6 cm)
Courtesy of the artist and John
Berggruen Gallery, San Francisco/
Charles Cowles Gallery, New York

*Untitled (Nude Model with Bischoff
Painting)*, ca. 1958
Tempera, charcoal, and pastel on paper
30 ⅝ × 25 ½ in. (77.8 × 64.8 cm)
Collection of William and Penny True,
Seattle

Chula, ca. 1958–60
Plaster and pigment over wood
46 × 14 × 16 ½ in.
(116.8 × 35.6 × 41.9 cm)
San Francisco Museum of Modern
Art, Gift of Mary Heath Keesling

Untitled (Standing Figure), 1959
Plaster with enamel
60 × 22 × 13 ½ in. (152.4 × 56 × 34.3 cm)
San Francisco Museum of Modern
Art, William L. Gerstle Fund Purchase
(SF)

Untitled, 1961–62
Wood, cardboard, paint, wire,
string, and staples
15 ¾ × 15 × 9 ½ in. (40 × 38.1 × 24.1 cm)
Private collection, San Francisco

Untitled Kneeling Figure No. 1, 1962
Plaster and enamel over steel armature
28 ¼ × 18 ¼ × 20 in.
(71.8 × 46.4 × 50.8 cm)
Courtesy of the artist and John
Berggruen Gallery, San Francisco/
Charles Cowles Gallery, New York

Seated Girl (Bather), ca. 1964
Plaster and enamel on wood and
burlap armature
44 × 29 ½ × 27 ½ in.
(111.8 × 74.9 × 69.8 cm)
Collection of Norma H. Schlesinger
(SF)

NATHAN OLIVEIRA

Seated Man with Dog, 1957
Oil on canvas
58 ⅜ × 49 ½ in. (148.2 × 125.7 cm)
Hirshhorn Museum and Sculpture
Garden, Smithsonian Institution,
Washington, D.C., Gift of Joseph H.
Hirshhorn

Man Walking, 1958
Oil on canvas
60 ⅛ × 48 ⅛ in. (152.7 × 122.1 cm)
Hirshhorn Museum and Sculpture
Garden, Smithsonian Institution,
Washington, D.C., Gift of Joseph H.
Hirshhorn

Adolescent by the Bed, 1959
Oil on canvas
60 ¼ × 60 ⅛ in. (153.1 × 152.7)
San Francisco Museum of Modern
Art, William L. Gerstle Collection,
William L. Gerstle Fund Purchase

Seated Figure with Pink Background,
1960
Oil on canvas
82 × 62 in. (208.3 × 157.5 cm)
Collection of Thomas W. Weisel,
San Francisco (SF)

Walking Man No. 3, 1960
Oil on canvas
77 ¼ × 71 ¾ in. (196.2 × 182.3 cm)
Private collection (SF)

Nineteen Twenty-Nine, 1961
Oil on canvas
54 ⅛ × 50 ⅛ in. (137.9 × 127.3 cm)
National Museum of American Art,
Smithsonian Institution, Washington,
D.C., Gift of S. C. Johnson & Son, Inc.

Nude with Raised Leg, 1961
Gouache and oil over graphite on
paper
20 ½ × 25 ½ in. (52 × 64.8 cm)
Collection of Mr. and Mrs. Charles
Campbell, San Francisco

Seated Woman, 1961
Gouache on paper
25 ½ × 20 ½ in. (64.8 × 52.1 cm)
Private collection, Phoenix, Arizona

Studies of Nudes, 1961
Watercolor and pencil on paper
Left sheet: 11 ⅝ × 8 ¹³⁄₁₆ in.
(29.8 × 22.2 cm)
Right sheet: 9 ⁹⁄₁₆ × 7 ¹³⁄₁₆ in.
(24.4 × 18.7 cm)

Los Angeles County Museum of Art,
Gift of Gerhard and Marianne Pinkus

Spring Nude, 1962
Oil on canvas
96 × 76 in. (243.8 × 193 cm)
The Oakland Museum, Gift of the
artist in memory of Edna Stoddard
Siegriest

DAVID PARK

Rehearsal, ca. 1949–50
Oil on canvas
46 × 35 ¾ in. (116.8 × 90.8 cm)
The Oakland Museum, Gift of the
Anonymous Donor Program of the
American Federation of Arts

Kids on Bikes, 1950
Oil on canvas
48 × 42 in. (121.9 × 106.7 cm)
The Regis Collection, Minneapolis

Nudes by a River, 1954
Oil on canvas
59 ½ × 47 ¾ in. (151.1 × 121.3 cm)
The Chrysler Museum, Norfolk,
Virginia, Gift of Walter P. Chrysler, Jr.

Standing Male Nude in the Shower, 1955
Oil on canvas
70 ¼ × 37 ¾ in. (178.4 × 95.9 cm)
Private collection, Courtesy Salander-
O'Reilly Galleries, New York

Nude with Hand on Hip, ca. 1955–58
Graphite on paper
12 × 7 ½ in. (30.5 × 19.1 cm)
Collection of Mr. and Mrs. Roy
Moore, Santa Barbara, California

Bather with Knee Up, 1957
Oil on canvas
56 × 50 in. (142.2 × 127 cm)
Newport Harbor Art Museum,
Newport Beach, California,
Gift of Mr. and Mrs. Roy Moore

Male with Raised Knee, 1957
Graphite on paper
19 × 12 in. (48.3 × 30.5 cm)
Newport Harbor Art Museum,
Newport Beach, California,
Purchased with funds provided by
Mrs. Charles Ullman

Cup and Saucer, 1957
Oil on canvas
8 ¼ × 11 ¼ in. (20.9 × 28.6 cm)
Collection of Mr. and Mrs. Roy
Moore, Santa Barbara, California

Interior, 1957
Oil on canvas
54 × 48 in. (137.2 × 121.9 cm)
The Lobell Family Collection,
New York

Four Men, 1958
Oil on canvas
57 × 92 in. (144.8 × 233.7 cm)
Whitney Museum of American Art,
New York, Purchase, with funds from
an anonymous donor

Couple, 1959
Oil on canvas
25½ × 47 in. (64.8 × 119.4 cm)
Flagg Family Foundation,
Monterey, California

Ethiopia, 1959
Oil on canvas
52 × 60 in. (131.1 × 152.4 cm)
Lowe Art Museum, University of
Miami, Coral Gables, Florida,
Museum purchase through Beaux
Arts Endowment Funds

Crowd of Ten, 1960
Gouache on paper
13¼ × 19¾ in. (33.6 × 50.2 cm)
Collection of Mr. and Mrs. Harry W.
Anderson

Standing Nude Couple, 1960
Gouache on paper
15½ × 13¼ in. (39.4 × 33.6 cm)
The Oakland Museum, Museum
Donors Acquisition Fund

JAMES WEEKS

Fighter with Manager, 1960
Oil on canvas
84¼ × 66⅛ in. (214 × 168 cm)
Private collection, Phoenix, Arizona

Two Musicians, 1960
Oil on canvas

84 × 66⅛ in. (212.3 × 168 cm)
San Francisco Museum of Modern
Art, Thomas Weisel Fund Purchase

Benjamin in a Chair, 1961
Graphite on paper
15 × 10 in. (38.1 × 25.4 cm)
Collection of Theophilus Brown,
San Francisco

Portrait of Hayward King, 1961
Graphite on paper
26 × 17⁵⁄₁₆ in. (66 × 44 cm)
Collection of Hayward King,
San Francisco

Pacific Ocean—Rocks and Surf, 1962
Oil on canvas
24½ × 18½ in. (62.2 × 47 cm)
The Lobell Family Collection,
New York

Portrait of a Man in a Blue Suit, 1962
Polymer-tempera on board
11 × 7¾ in. (27.9 × 19.7 cm)
The Oakland Museum, Gift of the
Hamilton-Wells Collection

Large Studio, Embarcadero, 1964
Oil and acrylic on canvas
79½ × 65 in. (201.9 × 165.1 cm)
The Oakland Museum, Gift of the
American Academy and Institute of
Arts and Letters, Hassam and Speicher
Purchase Fund

PAUL WONNER

The Glider, 1957
Oil on canvas
58 × 38 in. (147.3 × 96.5 cm)
Collection of Adolph Mueller

Untitled (Two Men at the Shore),
ca. 1960

Oil and charcoal on canvas
50 × 40 in. (127 × 101.6 cm)
The Lobell Family Collection,
New York

*California Landscape (Mirror, Skull, and
Chair)*, ca. 1960–62
Oil on canvas
50 × 48 in. (127 × 121.9 cm)
Stanford University Museum of Art,
Stanford, California, Gift of the artist

Man Seated against the Light, 1961
Acrylic and pencil on paper
18 × 11⅞ in. (45.7 × 30.2 cm), irregular
Hirshhorn Museum and Sculpture
Garden, Smithsonian Institution,
Washington, D.C., Gift of Joseph H.
Hirshhorn

Woman with a Mirror and Skull, 1961
Watercolor on paper
17⅞ × 11⅞ in. (45.5 × 30.3 cm)
Hirshhorn Museum and Sculpture
Garden, Smithsonian Institution,
Washington, D.C., Gift of Joseph H.
Hirshhorn

Figure by Window, 1962
Oil on canvas
60 × 46½ in. (152.4 × 118.1 cm)
Collection of Mr. and Mrs. Harry W.
Anderson

The Kitchen (Breakfast), 1962
Oil on canvas
30¼ × 70 in. (76.8 × 177.8 cm)
Collection of Byron R. Meyer,
San Francisco

Model Drinking Coffee, 1964
Oil on canvas
49½ × 45⅞ in. (125.7 × 116.5 cm)
National Museum of American Art,
Smithsonian Institution, Washington,
D.C., Gift of S. C. Johnson & Son, Inc.

Loran, Erle, 9, 20
Los Angeles County Museum of Art, 53, 163 n. 8
Louvre, Musée du, 147

M

MacAgy, Douglas: 5, 6, 18, *18*, 20, 21, 159, 167 n. 34; at CSFA, 4, 17, 164 n. 30; and Dadaism, 9; on San Francisco and New York schools, 166 n. 50; in Studio 13 Jazz Band, 15, *16*
MacAgy, Jermayne: 6, 27; at California Palace of the Legion of Honor, 4; on Park, 167 n. 34
McCarthy, Joseph Raymond, 164 n. 23
McClure, Michael, 126, *127*
McCray, James, 17
McGaw, Bruce: 133; background of, 121–22; exhibitions of, 171 n. 11; member of second generation, 78, 120, 121–29, *121*, 161; and 1957 exhibition, 39, 40, 121, 122, 125, 171 n. 21; student of Diebenkorn, 121–22. Works: *Abstraction*, 122, *122*; *Books*, 126–27, *128*; *Chair*, 126, *127*; *Chemical Plant by Freeway, Emeryville*, 128, *130*; *Figure* (1957), 122–26, *123*; *Figure* (ca. 1958–59), 126, *127*; *Paint Cans*, 125, *125*; *Palette Table Top*, 124, 125–26; *Pat's Feet*, 122–25, *123*; *Self-portrait (First Version)*, 128, *131*; *Self-portrait (Second Version)*, 128, *131*; *Self-portrait* (with Miró), 128–29, *132*; *Studio Interior*, 126, *126*
McLean, Richard, 161–62
McNeil, George, 157, 180 n. 10
Magritte, René, 71
Male Models (T. Brown), 95, *103*
Male Nude Seated (T. Brown), 89–90, *90*
Male with Raised Knee (Park), 44, *48*
Man and Woman in Large Room (Diebenkorn), 53–55, *54*, 61
Man in a T-shirt (Park), 160, 173 n. 39, 180 n. 23
Man Seated against the Light (Wonner), 90, *92*
Man Walking (Oliveira), 105–6, 109, *110*, 113, 114
Manet, Edouard: 16; *Fifer*, *15*
Mann, Thomas, 127
Marca-Relli, Conrad, 143
Marini, Marino, 34, 143
Martin, Fred: 9, 10, 12, 15, 37, 38, 134, 166 n. 50; considered for 1957 exhibition, 39–40
Marxism, 103
Matisse, Henri: 43, 57, 121–22, 129, 147, 172 n. 36; Diebenkorn's interest in, 50, 52, 53, 77–78. Works: *Open Window, Collioure*, 78; *Conversation*, 55; *Interior at Nice*, 53; *Studio, Quai St. Michel*, 53–55, *55*
Matter, Mercedes, 180 n. 10
Memento mori, 90
Meninas, Las (Velázquez), 16
Metaphysical painters, 89
Mexican muralists, 5, 71
Mexican revolution, 5
Michelangelo, 137, 157
Mills, Paul: 3, 5, 89, 90, 127; interview notes of, 12; and 1957 exhibition, 19, 36, 37, 38–40, 84, 86, 96, 171 n. 20; on Bay Area Figurative painters, 81, 163 n. 10; on McGaw, 122–25

Mills College, 101
Minimalism, 4, 84, 143, 159, 162, 180 n. 16
Miró, Joan: 8, 167 n. 25; *Self-portrait* (with Miró; McGaw), 128–29, 132
Mirror, Skull, and Chair. See *California Landscape*
Models, Bay Area, 25. *See also* Flo Allen
Models with Manuel's Sculpture (J. Brown), 148, *148*, 178 n. 73
Modern Artists in America (Motherwell and Reinhardt), 27
Modernism, 5, 160, 180–81 n. 25
Mondrian, Piet, 5, 8, 22, 64, 167 n. 25
Montmartre, 65
Moon (Neri), 142–43, *142*
Moore, Lydia. *See* Lydia Park
Morandi, Giorgio, 127, 154
Morehouse, William: at CSFA, 37
Morley, Grace McCann, 4
Motherwell, Robert: 5, 6, 9, 27, 164–65 n. 30; influence of, 9, 165 n. 37
Müller, Jan, 158
Mulvey, Laura, 175 n. 25
Munch, Edvard: 48, 50, 92, 101; exhibition of, 172 n. 31; *Puberty*, 49, *50*, 107
Mundt, Ernest: director of CSFA, 18, *18*, 22, 37, 167 n. 36, 171 n. 5
Museum of Modern Art, New York, The, 4, 113, 129

N

Nabokov, Vladimir: *Lolita*, 109
Nadelman, Elie, 134, 140
Neo-Expressionism, 161, 164 n. 19
Neri, Manuel: 126, 147, 157; abstract work of, 129–32, 143; background of, 132–33; and Beats, 127; and J. Brown, 141, *141*, 142, 146, 153, 154; collaborations with J. Brown, 143; Conceptualist-Minimalist phase of, 160; dating of work, 177–78 n. 42; in Denver, 178–79 n. 78; in Europe, 141, 147; exhibitions of, 181 n. 26; influences on, 129; member of second generation, 78, 120, 121, 129–45, 161; nudes by, 175 n. 25; supported by Staempfli, 174 n. 78; work of, as subject of J. Brown's work, 148, 149. Works: *Chula*, 138–40, *139*, 140–41; *Joan Brown working on sculpture*, *143*; *Loops*, *141*; *Moon*, 42–43, *142*; *Pink Spooned Snap*, *141*; *Ring Necker Night Cutter*, *141*; *Seated Girl (Bather)*, 143, *144*; *Untitled (Nude Model with Bischoff Painting)*, 138, *138*; *Untitled Kneeling Figure No. 1*, *139*, 140–41, 143; *Untitled Standing Figure* (1957), 136, *136*; *Untitled Standing Figure* (1959), 136, *137*; *Untitled Standing Figure* (ca. 1956–57), 134, *135*; *Untitled* (1960–62), 140, *141*; *Untitled* (collage), 143, *145*; *Untitled* (ca. 1957), 134, *135*
Neri, Noel Elmer, 142, 153, *153*
Neue Sachlichkeit, 164 n. 19
New Realism. See *Contemporary Bay Area Figurative Painting*
New York figurative art, 2, 158
New York School: 4, 10, 11, 82, 87; T. Brown's ties with, 40; compared to San Francisco School, 166 n. 50; compared to Bay Area Figuration, 156–59; influence of, 152; as national style, 156; Park's opinion of, 19; second generation of, 86. *See also* Abstract Expressionism

Newman, Barnett, 9, 156, 158, 159, 164 n. 28
Next Direction, The. See *Contemporary Bay Area Figurative Painting*
Nighthawks (Hopper), 35
1957 exhibition. See *Contemporary Bay Area Figurative Painting*
Nineteen Twenty-Nine (Oliveira), 114, *114*
Nochlin, Linda, 175 n. 25
Noel on a Pony with Cloud (J. Brown), 153, *153*
Noland, Kenneth, 32
Nordland, Gerald, 29, 32, 78
Nude and Indian Rug (Wonner), 92–93, *98*
Nude—Green (Park), 56, *56*
Nude with Hand on Hip (Park), 44, *46*
Nude with Raised Leg (Oliveira), 114–15, *116*
Nudes: 4, 25–27, 32, 48, 50, 52, 72, 74, 175 n. 25; by T. Brown, 95; by Oliveira, 114–15; by Wonner, 92–93
Nudes by a River (Park), 25, *26*, 44, 50, 58

O

Oakland Art Museum, The, 3, 10, 37, 48, 127, 163 n. 10
Ocean Park paintings (Diebenkorn), 160, 172 n. 33
Oldfield, Otis, 99
Oliveira, George, 99
Oliveira, Nathan: 32, *87*, 147, 154, 181 n. 28; abstract painting of, 86, 87, *87*; as art student, 99–101; break with Bay Area Figurative style, 117; childhood of, 98–99; considered for 1957 exhibition, 40, 96, 171 n. 20; criticism of, 113; at CSFA, 37–38, 102, 171 n. 4; exhibitions of, 113, 181 n. 26; figurative work of, *87*, 102–17; and Guggenheim award, 106, 113; influences on, 175 n. 28; interest in symbols and allegory, 96; member of bridge generation, 78, 86, *87*, 96–120, 161; at Mills College, 101; minimalist phase of, 160; nudes by, 175 n. 25; and printmaking, 99, 101, 106, 171 n. 20; response to Abstract Expressionism, 99–103; in Southern California, 96, 116–17; travels to Europe, 106–7; turn to figure, 176 n. 39. Works: *Adolescent by the Bed*, 107–9, *111*, 113; *Baboon*, 176 n. 70; *Man Walking*, 105–6, 109, *110*, 113, 114; *Nineteen Twenty-Nine*, 114, *114*; *Nude with Raised Leg*, 114–15, *116*; *Seated Figure with Pink Background*, 109–13, *111*; *Seated Man with Dog*, 103–5, 109; *Seated Woman*, 115, *117*; *Spring Nude*, 115–16, *118*, 138; *Stage #2*, 117, *119*; Stage series, 117; *Studies of Nudes*, 114–16, *115*; *Walking Man No. 3*, *112*, 113; *Winter Nude*, 116
Op art, 159, 170 n. 113
Open Window, Collioure (Matisse), 78
Orange Sweater (Bischoff), 23, *24*, 44
Orozco, José Clemente, 67
Otis Art Institute, 18
Oven Blew Out, The (J. Brown), 154
Ozenfant, Amédée, 40

P

Pacific Ocean—Rocks and Surf (Weeks), 67, *72*
Pacific Stock Exchange, mural in (Rivera), 5

DESIGNER: Catherine Mills
COMPOSITOR: Wilsted & Taylor Publishing Services
CALLIGRAPHY: Christopher Stinehour
DISPLAY: Mergenthaler Linotron 202 Newtext
TEXT: Mergenthaler Linotron 202 Aldus
PRINTER: Dai Nippon Printing Company
BINDER: Dai Nippon Printing Company